The Destruction of Cultural Heritage in Iraq

British Institute for
the Study of Iraq

United Nations
Educational, Scientific and
Cultural Organization

United Kingdom
National Commission for UNESCO

Dedication

This book is dedicated to all of those who have struggled, since the 1991 invasion and sanctions, and struggle now to safeguard the cultural heritage in Iraq.

The Destruction of Cultural Heritage in Iraq

Edited by

Peter G. Stone and Joanne Farchakh Bajjaly

Foreword by Robert Fisk

THE BOYDELL PRESS

2008

First published 2008
The Boydell Press, Woodbridge
Reprinted in paperback 2009, 2010, 2011

ISBN 978-1-84383-384-0 hardback
ISBN 978-1-84383-483-0 paperback

The Boydell Press is an imprint of Boydell & Brewer Ltd
PO Box 9, Woodbridge, Suffolk IP12 3DF, UK
and of Boydell & Brewer Inc.
668 Mt. Hope Avenue, Rochester NY 14620, USA
website: www.boydellandbrewer.com

A CIP catalogue record for this title is available
from the British Library

This book is printed on acid-free paper

Printed and bound in the United States of America by
Edwards Brothers, Inc, Lillington NC

CONTENTS

LIST OF PLATES

(between pages 152 and 153)

ACKNOWLEDGEMENTS

In the summer of 2003 I read an article by Robert Fisk detailing the looting of the archaeological sites in southern Iraq (Fisk 2003). I immediately tried to get Robert to attend the fifth World Archaeological Congress, which was to be held in June of that year in Washington DC, to describe to a major international gathering of archaeologists what he had seen. His response was to say that I did not want him in Washington but the person with whom he had 'cadged a lift': a Lebanese archaeologist called Joanne Farchakh Bajjaly. Joanne had been working for the UK's Channel 4 news in Amman and, on hearing of the looting, had dropped everything and gone to see for herself allowing Robert to go with her. I duly contacted Joanne and made contact with a most remarkable individual. Joanne is an archaeology graduate who makes her living through journalism, who had visited Iraq a number of times over the previous years and who knew many of the senior archaeologists in the country. She agreed to come to WAC-5 at once and characteristically refused to let a small problem of not having an American visa get in her way (when Joanne arrived to collect her short term visa from the US Embassy in Beirut a perceptive administrator there decided to give her a five year visa as it was in her view perfectly clear Joanne would be asked back!).

When I discussed with her my idea for this book she immediately started suggesting names and topics that should be covered. In almost every feature, this book is her book. It was Joanne who had the confidence of our Iraqi colleagues that made them willing to contribute. The gestation of this book has not been straightforward or easy. In the middle of trying to put it together Israel invaded Lebanon and Joanne suddenly found war – and its impact on cultural heritage – on her own doorstep. As soon as the fighting stopped Joanne was again one of the first into the post-conflict area trying to chart the effect of the war on the cultural heritage. I remember vividly making contact with her once on her mobile phone and her asking me to hold on for a moment. A short time later her voice returned saying, 'It's OK now, I'm out of the minefield'. In a very real way Joanne lives the relationship between archaeology and conflict. It would have been impossible for me to have put this book together without Joanne and I dedicate it to her.

Any edited volume requires the patience and support of all of the contributors; we thank them all for staying with us through a sometimes tempestuous relationship. We sincerely hope that they approve of the final product. Our thanks also go to our spouses, Genevieve and Philip for, at times, living this book as much as we have. Finally, we could not have produced the book without the help of Catherine Todd, the conference and publications assistant in the International Centre for Cultural and Heritage Studies here in Newcastle nor of Matthew Champion, our publishing editor.

Peter G. Stone
Newcastle
January 2008

FOREWORD

In 1992, within the gaunt ruins of Sarajevo's magnificent public library, I waded through mountains of ash. Here, amid the cinders, lay the husks of thousands of precious books, early Bosnian manuscripts, precious atlases, volume after volume on the history of this tormented land, lost memories of a Bosnia that was at peace for hundreds of years, long before a youth called Gavrilo Princip fired two shots and sent a generation of Europeans to Ypres, the Somme, to Verdun and the Chemin des Dames. The only thing left in this vast, smouldering emporium – pointlessly unconsumed by the fire – was a card index file on the learning of Esperanto. Esperanto, I recall thinking as I stood amid the ash, was the weird cocktail of Euro-languages my mother had tried to learn before her first visit to France in the 1930s. She was planning her life in a 'new' Europe, I suppose, one in which we would borrow from French, Spanish, Italian, English, German to understand each other. Invented in 1887 Esperanto – inspired by 'esperanza', the Spanish for 'hope' – was Euro-speak. We were trying to create a new language, albeit destroyed, like so many other cultural constructs, in the Second World War.

The Serbs had quite deliberately shelled the Sarajevo library in an act of cultural barbarism, an attempt to destroy the history of Bosnia as surely as their snipers were killing its people. The library's treasures – like Esperanto – were supposed to belong to all of Bosnia's people, indeed to all the communities who still lived in the dying Yugoslavia. But history had to be erased. Multiculturalism had to be eliminated. The Croat gunner had mocked the need for 'these old things' before he blasted down the Ottoman stone bridge at Mostar. In Knin and other Krajina towns, the Croats vandalised Serb churches, just as the Serbs of Bosnia could be seen smashing the gravestones in Muslim cemeteries.

And so it goes on. Not long ago, photographs – snatched from a car or train window – were produced in Yerevan, clearly showing Muslim Azerbaijani troops bulldozing an ancient Armenian cemetery, a place of magnificently carved stones which had borne witness to thousands of years of Armenian culture. The destruction and pillaging of the history of the 'other' – the enemy, the alien, the 'barbarian' population next door to us – is nothing new. Churches were sacked and burned in the First World War. The great art of Europe was more systematically stolen in the next world conflict. Hermann Goering's cultural thieves moved through the museums of Europe in 1940 and 1941, stealing the greatest works of the Renaissance. In 1945, the Russians embarked on a more untidy act of mass theft. Where now are Schliemann's treasures of Troy? Who today, in basement or vault, is gazing upon the stolen face of Agamemnon?

'You ask me about the sack of Baghdad?' the Persian poet Saadi of Shiraz wrote in 1258. 'It was so horrible there are no words to describe it. I wish I had died earlier and had not seen how the fools destroyed these treasures of knowledge and learning. I thought I understood the world, but this holocaust is so strange and pointless that I am struck

dumb. The revolutions of time and its decisions have defeated all reason and knowledge.' Saadi was responding to the destruction of Baghdad by Genghis Khan, although exactly the same words of disgust and opprobrium and almost physical horror could be used about the armies of little Genghis Khans who have sacked and destroyed the very identity of ancient Mesopotamia.

The looting and laying waste of the lands of Sumeria and the destruction – of almost Biblical proportions – of its clay-walled cities were not, I fear, just a prophecy of things to come but our world's most sinister act of historical destruction. For the treasures of Mesopotamia belonged not just to the Iraqis or to the present-day Arabs and Muslims of the Middle East; they belonged to all of us. They contained the subtext of our human life, the key to all mythology and to all history. The lands of Gilgamesh belong to us, to our friends and to our enemies, to peoples whose languages we shall never speak and to whose shores we shall never travel. We invent clichés for such places. The 'Cradle of Civilisation'. And now it is civilisation's loss. The depredations of the looters of Iraq have accomplished more than Genghis Khan's hordes. In their search for treasures ever deeper in the sand, they have vandalised our ancestors, ripped the flesh from our history, left our folk memory in a million shards of broken pottery in the deserts of Iraq.

I was among the first to enter the looted Baghdad archaeological museum, crunching my way through piles of smashed Babylonian pots and broken Greek statues. I watched the Islamic library of Baghdad consumed by fire – 14th- and 15th-century Korans embraced by flames so bright that it hurt my eyes to look into the inferno. And I have spent days trudging through the looters' pits and tunnels of Sumeria, vast cities dug up, their precious remains smashed open – thousands upon thousands of magnificent clay jars, their necks as graceful as a heron's, all broken open for gold or hurled to one side as the hunters burrowed ever deeper for ever older treasures.

In Iraq in 2003, in the wake of the disastrous Anglo-American invasion, we witnessed something quite unique. Squads of organised youths would turn up in buses or trucks in Baghdad to set fire to the galleries and libraries, to the government records of a whole society, even to the central bank. At one fell swoop, they tore apart the history of Mesopotamia, of Islam, of the still living nation of Iraq. At this very same time, legions of thieves arrived in the deserts to hunt for the treasures of antiquity. These were not peasants, a famished, deprived community of beggars trying to earn money amid the anarchy of post-invasion Iraq. I had seen enough of these during Lebanon's civil war, digging through the crematory tombs of Phoenicia for bracelets of gold. In Iraq, the marauding pillagers were acting under orders, initially from archaeological experts who had forfeited their academic integrity by turning to theft on a world scale; for they were themselves under orders to seek the richest seams of antiquity, orders that came from private art collectors and their agents in the Middle East, in Europe and America. Of 4000 artefacts discovered by 2005 from the 15,000 objects looted from the Baghdad Museum two years earlier, a thousand were found in the United States, 1067 in Jordan, 600 in Italy and the remainder in countries neighbouring Iraq.

The instructions on how to cherry pick Mesopotamia's most precious heritage did not come from a 13th-century warrior or from hordes riding from the east. They came from billionaires, by email and coded fax, from around the globe. Greed has been – to use a word I don't like – 'globalised'. Pillage has been industrialised. Bulldozers rather than spades are used to erase the walls and civilisation of our ancestors, steel containers prepared for the stolen heritage beneath the land. It is now we who are being pillaged – and we are, in a sense, doing this to ourselves.

Why? Whence comes this extraordinary desire to destroy – for greed or from venom – which has embraced mankind for so many centuries? Is it because, in our dark hearts, we are searching for some primeval god, some deity for whom we must sacrifice all that we hold most dear? The Taliban tried to explain their theological vandalism when they destroyed the Buddhas of Bamian. Yet across Europe, our churches contain the broken-faced statues of a thousand saints, each hacked to oblivion by puritans bearing the sword of righteousness. The men and women in the Roman-Egyptian grave paintings, too, had their faces scratched off in antiquity.

What is it about graven images? Why are we humanoids so prone to destroy our own history and erase the memory of language? The videotape of the explosions which turned the Bamian Buddhas to dust are images of cultural genocide, of cultural rape – which is exactly the fate which befell Iraq. We are destroying art because we do not want others to possess it. Or we steal history because we wish to possess it so that others cannot take it from us. Or we liquidate history because we despise those who created it.

Somewhere in our hearts, perhaps we are all Talibans.

Robert Fisk
January 2008

Robert Fisk is Middle East Correspondent of *The Independent* of London. He has covered the region's wars and politics for 32 years and holds more press awards than any other British journalist. Fisk was in Iraq throughout the invasion of Iraq in 2003. He personally witnessed the looting of the country's treasures. He is the author of *Pity the Nation*, a history of the Lebanon war, and *The Great War for Civilisation: the Conquest of the Middle East*, published by 4thEstate/HarperCollins in 2005.

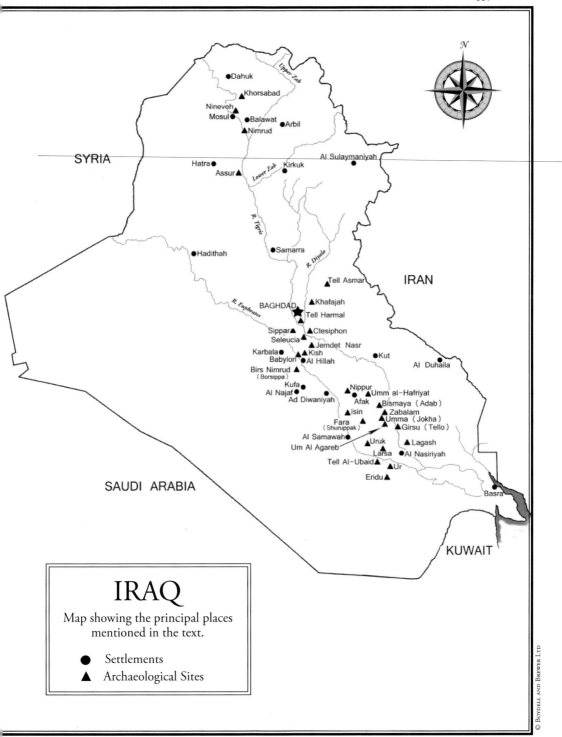

IRAQ

Map showing the principal places
mentioned in the text.

● Settlements

▲ Archaeological Sites

Introduction

Peter G. Stone with Joanne Farchakh Bajjaly

This is an unusual book. Perhaps mainly because all of the contributors wish that it had not been necessary for it to be written; wish that the events that caused it to be written had not happened; wish that they could have simply got on with their lives over the last five years without the interruptions and distractions that are chronicled in the following pages. Most, if not all of us, would gladly turn the clock back. These 'interruptions and distractions' have affected us all in different ways: for me, one of the least affected, their impact was concentrated in a short period when I found myself at the centre of discussions in the UK concerning the identification and protection of archaeological sites in Iraq prior to the 2003 invasion (chapter 8). For others the impact has been greater: Matthew Bogdanos has spent months, if not years, away from his home and his young family, first as an inconspicuous member of the Coalition forces that invaded Iraq in 2003, but soon thereafter as a military detective attempting to understand, and where possible put right, the looting and theft of the cultural heritage of Iraq. It was the same looting, that Joanne Farchakh Bajjaly saw at first hand in 2003, which obliged her to report on, and raise awareness of, what is happening to the heritage of this country at every possible opportunity. Many of the contributors – for example Jean-Louis Huot, McGuire Gibson, and John Russell – have had to come to terms with the fact that much of what they have worked on has been destroyed and that they may never be able to return to work in Iraq. For other contributors the last five years have encompassed enormous, life changing events. Not only have our Iraqi colleagues been forced to witness the widespread destruction of their cultural heritage but also the disintegration of their country and the normality of life that is so easily taken for granted. Mariam Moussa and Abdulamir Hamdani have been able, so far, to stay in Iraq. Donny George has been forced to leave his country, his job, his home, and his extended family to save his own life and the lives of those closest to him. I, like so many in the West, have watched appalled and impotent as international and national events have unfolded; events that have combined to force Donny, and so many other academics and professionals, to leave Iraq. I am awed and humbled by the work they put in before being forced to leave and I am awed and humbled by those who have been able to stay but face daily horror.

I am also angered by the events of the last five years, as are all of the contributors. However, our anger is focused in different directions and apportioned in different quantities. As a result most of this anger remains unspecified and unspoken in the following pages. As contributors, we have tried to leave our anger, and our wider political views, to one side, concentrating on the destruction of cultural property and telling our stories as objectively as possible. (That said, few of us would, I guess, claim that archaeology is anything but a subjective discipline that may aspire to, but rarely achieves, objectivity: given the context of our topic it is unavoidable that on occasion suggestion of our own views on the present situation have percolated into what we write.) We have all accepted that our wider views may, indeed almost certainly do, differ, but we accept that we have a common thread that binds us: a horror of the destruction of the cultural heritage, specifically in Iraq, but also more generally. In this process we lost one contributor, Yannis Hamilakis, whom I had asked to write for the book. Yannis found himself unable to contribute to a book where fellow contributors are in the military (and see below). I acknowledge and accept his view and his right to hold it; indeed I defend it, but am at the same time saddened and frustrated by his inability to contribute to the debate and the way forward.

For this is what this book must be: a contribution to the future. That we see it as a contribution to a debate and that we can envisage beginning to chart a way forward is crucial. When I first had the idea for this book in the spring of 2003 I was in the midst of a flurry of meetings, phone calls, letters, and email correspondence all concerning the immediate situation: the looting of museums and the first reports of isolated, and then, so quickly, the almost endemic, looting of sites. I was highly conscious that if those individuals who were involved at the time did not chronicle their contributions we would lose an understanding of what had happened, who was involved, and why particular decisions were made by particular groups of people at particular times. I wanted to produce as thorough a record as possible: a diary of the time from the key players' own perspectives.

Four and a half years later the scope of the book has moved on. The events of 2003 are chronicled: chapter 8 reviews my pre-invasion work with the UK Ministry of Defence (MoD) while Donny George (chapter 10) and Matthew Bogdanos (chapter 11) both provide descriptions of the looting of the Iraq Museum in April 2003. George adds a personal reflection as to how Iraqi society found itself in the position where the looting of the National Museum was possible and Bogdanos reflects on the search for the looted collections and on what the international community should be doing to protect sites and museums both now and in the future. Joanne Farchakh Bajjaly (chapter 12) charts the beginnings of the most devastating aspect of the destruction of the archaeological heritage in Iraq: the widespread post-invasion looting of sites that she witnessed first hand in 2003; we can only wish that her warnings, spread around the world by journalists such as Robert Fisk (2003), had been taken more seriously and that the occupying forces had been in a position to provide a security situation where her warnings could have been acted upon. Jeff Spurr (chapter 27) chronicles briefly the, frequently over-looked, disaster of the looting of Iraq's libraries.

The time-lapse between the invasion and today has allowed events that have unfolded over the intervening four years to be reported upon as seen from an Iraqi perspective: Abdulamir Hamdani (chapter 14) reports on the destruction caused by Coalition forces to the ancient city of Ur and Mariam Moussa (chapter 13) on her struggles to have Coalition forces' Camp Alpha removed from the ancient city of Babylon. Coalition troops did withdraw from Camp Alpha in December 2004, but as far as we understand, much of the site is now under the control of the Iraqi Army and is still therefore out-of-bounds to staff of the State Board of Antiquities and Heritage (SBAH). Other contributors write from the perspective of those who have tried through national archaeological agencies to assist Iraqi colleagues (Curtis, chapter 20; Lafont, chapter 22; Parapetti, chapter 23; Van Ess, chapter 21;). Others report on work being carried out within Iraq as part of military units (Olędzki, chapter 25; Zottin, chapter 24). Of course, more work is being done than is reflected here, for example and perhaps in particular by the Oriental Institute in Chicago. Unfortunately our efforts to cover all of this work failed. A number of useful and relevant websites have also grown up and are listed at the end of this Introduction.

Three key contributions are those of John Russell, Zainab Bahrani, and René Teijgeler (chapters 15, 16, 17) who present differing views of their varied roles as advisers to the Coalition Provisional Authority and Iraqi Ministry of Culture. Here are three colleagues who took on roles that many did not want and a number refused: actively, if not politically or philosophically, attaching themselves to the occupying forces in order to attempt to help preserve the cultural heritage of Iraq. Their contributions reflect the near impossibility of their task, their frequent frustrations, and occasional triumphs. The experience prompted John Russell to 'acknowledge defeat' but to be grateful to have been given the opportunity to have been part of the fight and provoked René Teijgeler to question his position as an 'embedded archaeologist' and to ask for a 'code of conduct' to help those who follow him. Zainab Bahrani paints perhaps the most despondent – and politically clear – picture in the book. She travelled to Iraq reluctantly, as she was totally opposed to the war, but hoped 'naively' that the Iraqi Ministry of Culture would have gained some independence from the occupying forces. Her 'naivety' was cruelly exposed and serves as a general warning to all archaeologists who decide to engage, for whatever reason, with occupying governments immediately post-conflict.

The book also attempts to place events in Iraq into a wider and deeper context as we hope it will not only be read by academics and students interested in heritage management and/or the archaeology of Mesopotamia, but also others outside the field. We have included therefore introductory chapters on why the cultural heritage of Iraq is so important (Huot, chapter 2; also see Matthews 2003; Roux 1992); the history of the Iraq Museum (al-Gailani Werr, chapter 3); a history of looting in Iraq (Gibson, chapter 4); and a review of the market for Mesopotamian antiquities (Brodie, chapter 5). Ghaidan (chapter 9) tells of the destruction to Iraq's built heritage over a long period culminating in damage done as the result of the 2003 invasion. Other contributors provide a more generalised context, placing recent events into a legal (Gerstenblith, chapter 18) and policing (Rapley, chapter 6) framework, while others provide an international heritage

management perspective (Cole, chapter 7 with respect to the International Committee for the Blue Shield; Delanghe, chapter 19 with respect to UNESCO).

Margaret Cox (chapter 26) moves the discussion on to look into the future by reporting on attempts to provide Iraqi colleagues with expertise, not in museum and site protection or conservation, but in forensic archaeology. Here the professional skills of the archaeologist can be deployed to play an active role in the rebuilding process of a shattered nation. Cox stresses that a fundamental premise of her work is that responsibility for how, where, when, and why these skills are deployed belongs to Iraqi specialists, thereby allowing archaeology to contribute to a nation coming to terms with its past. In perhaps a similar vein, Bernadette Buckley (chapter 28) discusses contemporary art in and out of Iraq since 2003. Buckley's contribution may, at first, seem out of place, but we believe it raises a series of key questions concerning what heritage is and to whom and why and how, it belongs, and that these questions themselves frame the debate as to why, if at all, heritage should be protected.

Together these chapters stress that the events of the last few years are simply a grossly exaggerated example of an endemic problem: the looting of sites for beautiful objects in order that they may be owned and cherished by private collectors. Despite claims by the military and politicians we knew this would happen if the museums and sites were not protected: archaeologists on both sides of the Atlantic told this to their governments and military – pleaded with anyone who would listen – but to no avail. McGuire Gibson, for instance, realised that if he were to do anything about saving the Iraq Museum he needed to meet the military, and he went straight to the Pentagon. Gibson fully understood that by giving the military information concerning the sites and museums in Iraq he was not going to save all of them: but he did what he could. Martin Sullivan, then Chair of the US Presidential Advisory Committee on Cultural Property resigned over the looting of the Iraq Museum stating that in his view the tragedy could have been averted but was not 'due to our nation's inaction'. We all know now that the Iraq Museum was looted in April 2003, as were many other museums around Iraq. We cannot turn the clock back. We all know that numerous archaeological sites were, and as I type are still being, looted. It is a strange and sobering feeling: sitting back in my chair on this cold November day in Newcastle and envisaging people half way around the world, digging into the remains of early civilisations in order to pay for the food for their families to eat (see George, chapter 10). I argued in July 2003, in a lecture to civil servants from a number of UK government departments and to military personnel, that there was a real danger of a systematic trade developing in material looted from archaeological sites in Iraq. That trade has now developed and appears to be blossoming (and see Brodie, chapter 5 and Rapley, chapter 6).

The looting, and resulting damage to and in some instances almost total destruction, of archaeological sites is a global issue and is by no means restricted to Iraq (Brodie *et al.* 2000; Brodie and Tubb 2002; Leyten 1995; O'Keefe 1997; Renfrew 2000). However the importance and nature of the archaeology in Iraq, together with the present security situation there, have combined to nurture this trade to an almost unprecedented level

and to destruction on an unprecedented scale. There is moreover increasing evidence that looting is helping fund what the British media refer to as the 'insurgency'. Interpol is hesitant to make this connection in public; Bogdanos (chapter 11) has no such qualms and makes an explicit connection between the looting and sale of antiquities and the funding of those fighting the Coalition forces (and see de la Torre 2006).

Trading in illicit antiquities will continue as long as rich individuals, mainly in rich countries in the world, prize real antiquities as objects of art to be owned privately. It is true that such a trade has probably always existed. However, it is clear that this illegal activity is growing and, as noted above, is becoming increasingly attractive to criminals and 'insurgents'. It is also very clear that a number of museums and archaeologists actively collude in the trade. There are institutions accepting bequests and gifts of, and individuals working on, artefacts with 'uncertain provenance' – a term that all too frequently translates as 'stolen'. These professional individuals and institutions need to act now and stop this collusion: they are being encouraged to do so by a number of so-called 'source countries' taking legal action against them in an attempt to retrieve objects in their collections. We can only applaud these countries' efforts. However the international community must do more and must be proactive in combating this trade: through increasing policing, strengthening legislation, and, perhaps most crucially, creating a public consciousness that the private ownership of illicit antiquities is as unacceptable as, for example, the trade in, or hunting of, exotic animals.

A WIDER CONTEXT

The necessity of chronicling events – and addressing the issues behind those events – became yet more pressing for me in the summer of 2003. In June of that year I travelled to Washington DC to attend the fifth World Archaeological Congress (WAC) and to give a presentation on the work I had carried out for the UK MoD earlier in the year. WAC is a non-governmental, not-for-profit organisation created in the mid-1980s and is the only archaeological body with elected global representation. It seeks to promote interest in the past, in all countries, through scientific investigation, ethical practice and the protection of cultural heritage worldwide. It is one of the few international academic organisations to recognise overtly the political contexts within which research is conducted and interpreted, and it strives to promote dialogue and debate among advocates of different views of the past (and see http://www.worldarchaeologicalcongress.org/site/home). I was then honorary Chief Executive Officer of WAC.

As I travelled to Washington I was very aware that many members of WAC were boycotting the meeting as it was held in the capital city of a country that, in their minds, had recently started an illegal war. At the conference I came under significant criticism for working with the military as a so-called 'embedded archaeologist' and I have been attacked in print for the same reason (Hamilakis 2003). My involvement had, so the argument went 'provided academic and cultural legitimacy to the invasion' (Hamilakis 2003: 107). Hamilakis, and others, saw my involvement as part of a wider 'ethical crisis in archaeology' where archaeologists could 'publicly mourn the loss of artefacts but find no words for the

loss of people' (*ibid.*). This is an interesting and I argue false accusation. The statement by WAC on the unfolding situation in Iraq, issued on 11 April 2003 by Professor Martin Hall, the then President of WAC, and drafted in collaboration with me, stressed, before mentioning the cultural heritage, the 'increasingly distressing humanitarian situation'. Martin and I had made a conscious decision to lead with our general humanitarian concerns, but then to focus our comments on WAC's area of expertise: archaeology. This detail aside, my critics essentially implied that my involvement, obviously over-and-above that of WAC's, had moved archaeology from being a passive on-looker, a recorder of the destruction caused by others, to becoming an active collaborator to the destruction. These seriously held and valid concerns convinced me even more that we needed to understand what had actually happened and what role archaeologists had, and should have, played. They took the debate out of the particular case of Iraq and questioned the role of archaeology as a discipline. Unsurprisingly these issues were not new to WAC. A previous conference held in New Delhi in 1994 had been badly disrupted over the banning of discussion of the destruction of the mosque at Ayodhya in 1992 (and see Golson 1996; Layton and Thomas 2001). This had led WAC to hold a meeting specifically on the *Destruction and Conservation of Cultural Property* in Croatia in 1998 and to produce a volume with the same title (Layton *et al.* 2001).

WHY DOES THE CULTURAL HERITAGE GET DESTROYED?

Theoretically, cultural heritage has been protected since 1954 by the *Convention for the Protection of Cultural Property in the Event of Armed Conflict* (commonly known as the Hague Convention) (http://www.icomos.org/hague/hague.convention.html) and its two Protocols (and see Boylan 2002 for a historical overview of heritage protection and Colwell-Chanthaphonh and Piper 2001 for a reflection on the status of USA ratification of the 1954 Convention). The Convention specifies a Blue Shield as the symbol for marking cultural sites to give them protection from attack in the event of armed conflict. The Blue Shield is also the name of an international organisation set up in 1996 to work to protect the world's cultural heritage threatened by wars and natural disasters (Cole, chapter 7). The International Committee of the Blue Shield (ICBS), which portrays itself as the cultural equivalent of the Red Cross, *should* have been the coordinating body for the identification and protection of the cultural heritage in Iraq. Unfortunately, it has almost no funding and almost no significant international profile. I have polled specialist audiences on seven occasions in four countries on three continents and less than 1% of those audiences had ever heard of the organisation, let alone understood its remit or powers. The heritage community has a major responsibility to engage with the ICBS, to ensure its better funding, and to raise its profile within the profession and more widely amongst decision makers.

The limitations of the ICBS were graphically and sadly illustrated during the recent conflict in former Yugoslavia, which not only saw the cynical and calculated targeting of cultural heritage for destruction as part of political and military strategy, but also the disregard and manipulation of the Hague Convention. In 1998, while planning the above

WAC meeting on *Destruction and Conservation of Cultural Property* I met (with Bob Layton) Mr Božo Biškupić, the then Croatian Minister of Culture. We were discussing the destruction of cultural property in general, and WAC's perception of the need for such a conference, when the Minister told us how he had been out-voted by his cabinet colleagues when he argued for non-compliance with the 1954 Hague Convention prior to the outbreak of hostilities. He told us how, against his better judgement, a list was sent to UNESCO by Croatia of those sites it regarded as being of particular cultural heritage importance. As he had feared, every one of the sites on this list, including the World Heritage Site of Dubrovnik, was *specifically* targeted by opposition forces during the war in an apparent attempt to undermine the Croatian psyche. The Minister acknowledged that blame was not only to be apportioned to one side and he accepted our noting that while these Croatian sites were being targeted, Croatian forces were destroying the medieval bridge at Mostar. This was a clear and recent case of the specific targeting of the cultural heritage to achieve political goals through the *destruction* of cultural heritage during conflict (and see Chapman 1994).

This example is not an isolated event nor does it represent a purely recent phenomenon. The area now referred to as Iraq has seen perhaps more than its share of almost endemic, and certainly dramatic, destruction of cities and civilisations over the last few thousand years (see for example Foster *et al.* 2005; Roux 1992). Much of this destruction came about simply as the result of fighting – so-called 'collateral damage'; however, without doubt, much of the damage was part of a predetermined policy to destroy the physical memory of a vanquished enemy. For example, the 8th and 7th centuries BC saw the destruction of the Assyrian Empire by the Medes during which Assyrian cities were 'given over to such a thorough slaughter, destruction, and plundering that nothing remained thereafter of Assyrian might and culture' (Foster *et al.* 2005, 83): a self-conscious, planned destruction of an enemy and its civilisation.

The questions facing us at the start of the 21st century must be why, after millennia of human conflict, have we not got better at protecting the cultural heritage and can we get better? The issue has three aspects: the targeted destruction of cultural heritage in an attempt to gain political advantage; so-called 'collateral damage' where the cultural heritage is destroyed as an 'innocent bystander' as fighting takes place; and destruction caused by the trade in illicit antiquities. All three are taking place in Iraq at present: particular buildings, especially mosques, are being targeted by 'professional terror groups' trying to gain control of different areas and cities (Ghaidan, chapter 9, 94); the insensitive use of major archaeological sites by Coalition forces has led to significant 'collateral' damage (al-Gailani Werr, chapter 3; Hamdani, chapter 14; Moussa, chapter 13); and the widespread looting of archaeological sites has been provoked by the trade in illicit antiquities (Brodie, chapter 5; Farchakh Bajjaly, chapter 12). So what should we do? What can we do?

THE DEEPER CONTEXT

In 1943 the British archaeologist Grahame Clark argued that post-war education would have to be 'nothing less that the universal experience of man' (Clark 1943, 115). Of

central importance in Clark's argument was that the essential role of post-war education was to prevent future war by creating 'an overriding sense of human solidarity such as can come only from consciousness of common origins' and that once such 'consciousness' has been aroused 'there seems no limit to the possibilities of human betterment'(113). Clark suggested a chronological and developmental syllabus for teaching about the past, dominated by the study of prehistory, that only introduced the complexities of modern history in the 'closing stages of secondary or even for higher and adult education' (119) and he argued that had the populations of Germany, Italy and Japan received such an education 'it seems impossible that they could have been mesmerised by the crazy dreams of racial and cultural domination which today are sweeping them to ruin' (119).

Clark was writing as people could see the beginning of the end of the Second World War and as academics searched for how to ensure nothing of the sort was ever repeated. I write as the situation in Iraq degenerates; as much of Afghanistan slips back into anarchy; as Lebanon recovers from its most recent invasion by Israel; as the stand-off between Iran and the West over its nuclear capabilities intensifies; and as, in general, the situation in the Middle East threatens to spin out of control and engulf the world. It is interesting to speculate whether, had Clark's suggestions been heeded, we would have been in the same position at the end of 2007.

The archaeology of early civilisations binds humanity together as much of it concentrates on how similar we are, not on our differences. It shows that societies globally have all struggled with similar problems and have overcome them in similar, yet very different, ways. If we could make such observations part of universal education then perhaps the population – and leaders – of the world might stop and think what binds us together as opposed to what differentiates us. An idealistic thought? Certainly; but, assuming we are all against at least the concept of war, let's not forget the opening lines of the UNESCO constitution:

> since war begins in the minds of men, it is in the minds of men that the defences of peace must be constructed.

I doubt very much, despite Clark's aspirations, whether archaeologists will ever be able to stop wars. That is not the nature of the relationship between archaeology and conflict. However by acting in a structured and ethical manner, by charting the archaeological evidence for conflict, by emphasising what we hold in common rather than what makes us different, by emphasising the stupidity and unacceptability of the destruction of the cultural heritage, through specific targeting, or through collateral damage, or through apparently random attrition, or through illicit trade, then perhaps archaeologists can contribute to an atmosphere where conflict and war are increasingly unacceptable.

THE PRESENT CONTEXT

Realistically we have to accept that neither archaeologists nor other heritage professionals have the power or influence to prevent the malicious politically motivated targeting of the cultural heritage. We may have more chance to address collateral damage affecting cultural

heritage by working with military planners, but this raises the question of archaeologists 'legitimising' war through collusion.

Over the last few decades archaeologists have been increasingly concerning themselves with the remains of recent wars (Schofield *et al.* 2002; Schofield *et al.* 2006) and with the relationship between archaeology and conflict (Chamberlain, K. 2005; Layton *et al.* 2001; Meskell 1998; Silberman 1989; Stone 2006; Toman 1996). Since the 2003 invasion of Iraq, archaeologists and others have focused on their specific responses and activities regarding Iraq (for example, Bernhardsson 2005; Bogdanos 2005; Cruickshank and Vincent 2003; Foster *et al.* 2005; Hamilakis 2003; Polk and Schuster 2005). Numerous conferences, or conference sessions, have been held to debate this relationship (Agnew and Bridgland 2006; Stanley-Price 2007). The issues raised have also been discussed at length in discussion areas on professional websites.

That the number of these conferences has grown over the last few years with respect to the particular circumstances in Iraq and Afganistan is both encouraging and depressing. Encouraging because the professional community is finally engaging with a serious issue endemic to wherever conflict arises; depressing as they reflect a profession waking up too late to affect the particular situation unfolding in Iraq.

When Iraq was under UN sanctions, between the two Gulf Wars, our profession allowed the world to forget about Iraq's archaeological heritage and failed to bring to its attention the irreparable damaged being caused to that heritage as the direct and indirect result of sanctions. No active, public debate about the protection of the archaeological heritage under sanctions was launched. Very few archaeologists stood up beside their Iraqi colleagues at that time, and those who did went through very difficult moments with their governments and official institutions. A number of contributors to this book disregarded their government's advice and travelled to Iraq during sanctions taking with them a few basic conservation chemicals and materials to help their Iraqi colleagues clean and restore archaeological objects.

The looting of the Iraq Museum, that a few anticipated and warned of, shook the profession out of its – at least public – complacency.

One of the most wide-ranging of these recent conferences was *Archaeology in Conflict* held at the Institute of Archaeology in London in November 2006, during the plenary session of which several participants argued – following René Teijgeler's plea (chapter 17) – for the introduction of a code of ethical conduct to guide practice in the 'heritage sector'. One of the main concerns of the conference was the way in which international agencies and overseas 'missions' can – and frequently do – fail the long-term needs of the communities with which they work. Participants noted that, unsurprisingly, this problem appears to become most acute during, and in the aftermath of, conflict – where the urgency of events can sometimes be at the expense of sustainable and locally based solutions that, almost by definition, require a longer lead-in, involving deep awareness of issues and careful, inclusive, planning and goal setting.

While several of the codes of practice governing different national professional bodies address local ethical issues; while international conventions and charters are framed by

ethical considerations; and while there is a growing literature on ethical archaeology; it is still clear that most practising archaeologists are guided by little more than individual conscience. This was certainly the case regarding my own involvement with the UK MoD. My own, personal line, was that I would work – as requested in secret – with the MoD but that I would not sign any Official Secrets Act or other document that would stop me, at an appropriate time, making public everything that I had done.

Participants at the London conference (and indeed other meetings in which I have participated and that I have had reported to me) were however unclear as to what the roles and responsibilities of archaeologists and other heritage professionals actually are when involved in identifying, protecting, conserving, managing, excavating, and interpreting other people's pasts in a conflict or post-conflict situation. With which, if any, of these activities should archaeologists involve themselves? Discussion focused on whether archaeologists and other heritage professionals need to define and agree on the difference between what is ethical, moral and proper, and what is not. Can archaeologists and others produce some form of code to which all could agree to abide?

This debate surrounding the conduct of archaeologists in conflict situations (and by this term I do not just mean war but occupation, sanctions and other conflict situations) will continue and will no doubt touch on wider, fundamental issues relating to the discipline, such as the continuing influence of neo-colonial assumptions (the very idea of 'universal' heritage) and agendas in internationally supported projects; the roles and values of international agencies, NGOs, and individual consultants (from expert missions to capacity building); issues surrounding sustainable development and the economic potential of the heritage; and the relationship of archaeology and heritage to international, national, and local politics: all huge and important areas for debate. But debate must lead to positive action. We need agreement on just how archaeologists should liaise with the military in attempting to prevent collateral damage. This is a pressing task and cannot be ignored.

The present situation

While many of the following chapters try to emphasise the positive things that have happened since 2003, they cannot mask the fact that much of the information coming out of Iraq has been bleak. The following, almost random, selection of news items serves to illustrate the complexity of the situation and how central a role the looting of antiquities has become.

In February 2006 Mohammed Mehdi, in charge of antiquities in the Province of Najaf, reported that seven illicit antiquities smugglers apprehended by police had been on their way to sell 174 artefacts to foreign troops. The smugglers had claimed that they were specifically working for foreign troops in the country and that they had been given badges that allowed them to enter foreign military camps in southern Iraq. Regardless of the veracity of the claims of the smugglers their very nature further undermines the reputation and standing of the Coalition forces. Things do not have to be true to be believed.

In April 2006 Rupert Cornwell reported for *The Independent* newspaper that Colonel John Coleman, former chief of staff for the 1st US Marine Expeditionary Force in Iraq, had said, on 14 April, that if the head of the SBAH wanted an apology, 'if it makes him feel good, we can certainly give him one'. Colonel Coleman however was reported to have repeated the claim that had US forces not occupied ancient Babylon, the site would have been targeted by looters. 'Is there a price for the presence? Sure there is,' Coleman stated. 'I'll just say that the price, had the presence not been there, would have been far greater.' Colonel Coleman may be correct that the site would have been looted, but he misses the point: how can a supposedly benevolent occupying force allow its own troops to destroy the heritage of the people it has come to liberate and protect? As Zainab Bahrani argues (chapter 16) of course no military camp should have been constructed at Babylon, or Ur, or at any other archaeological site for that matter, and of course military personnel should have been deployed to protect the site and all other significant archaeological sites across Iraq. Such protection should have been – is – not only a moral responsibility but a legal one (Gerstenblith, chapter 18). However, as was pointed out to me when I pleaded in the spring and summer of 2003 for deployment of British troops to guard archaeological sites in the British Area of Responsibility, there were simply not enough troops on the ground. This point is tacitly accepted by Matthew Bogdanos when he states 'Even if Coalition forces had properly planned for the Museum, however, given the lack of sufficient forces in country, there would have been no spare units to assign anyway' (chapter 11, page 116). Before we cast stones we must be realistic: we must accept that the soldiers on the ground cannot be blamed for their lack of numbers either in 2003 or now. It is also very important for all of us appalled at the loss of cultural heritage to take on board the fact that much of the original looting occurred while heavy fighting was still taking place and also that the security situation in Iraq in 2007 is such that, for much of the country, it would require significant numbers of Coalition forces, or unavailable resources such as dedicated helicopters and fuel – to protect most archaeological sites. That said, the work of the five strong Italian team, known as 'Viper 5', in Nassirieh has shown that a limited number of troops, with the use of a helicopter and satellite imagery, can enforce the law and make sure that looting is stopped. Perhaps what is required still is the resolve to put protection of cultural heritage high enough up on the military planning agenda for a senior officer to decide that resources should be used to police archaeological sites. But such a decision requires policing of heritage sites to be prioritised over other things and realistically, I accept, in a conflict situation military minds may not prioritise heritage protection. It was wrong for Camp Alpha to be constructed at Babylon: and while Colonel Coleman may be correct in his assertion that the damage would have been greater had the camp not been there evidence suggests that looting at major sites in the north of Iraq has not occurred. Perhaps Babylon would have been quite safe. Quite obviously – quite correctly once the war had begun – military units prioritised establishing themselves, securing power and clean water supplies, and safeguarding hospitals long before moving on to protect archaeological heritage. One also has to have a sense of understanding for the American officer in Baghdad (reported in *The Independent* (UK), on 9 November 2005) who is reported to have remarked: '[Finding stolen artefacts] does not even come into

the equation at the moment. When we have the time off from suicide bombings, from rockets and mortars then we will start playing Indiana Jones.' Despite the rather snide caricature the point is eloquently made: the security situation is such in parts of Iraq that it is impossible to protect the cultural heritage.

However, much more recently and even more worryingly, Dr Abbas al-Hussainy, the former Chairman of the SBAH reported, in a lecture in London in June 2007, that Europeans wearing the uniforms of Coalition forces had attempted to gain access to the Iraq Museum on no fewer than three occasions, once forcing the main gate and most recently arriving with an unsigned, typewritten authorisation for access to the Museum. On this final occasion it was only the threat of validating the document that led to those attempting entry to withdraw. Dr al-Hussainy also reported that, on more than one occasion, he and his staff had been refused access to archaeological sites by Coalition forces: once when they arrived at Ur specifically to work with John Curtis from the British Museum who was already in the camp (and see chapter 20) on the understanding that he was about to be joined by his Iraqi colleagues. It is possible to understand, if not easily accept, the logic of restricted access to military camps positioned on archaeological sites; however, it is surely impossible to accept the exclusion of Iraqi specialists while allowing Europeans in, a point totally agreed by John Curtis who found himself in a totally untenable situation through no fault of his own. Equally one can only wonder at why – and whether – Coalition forces would try to gain access to a museum that has been closed and sealed for a number of months or whether, more sinisterly, these were professional European thieves intent on gaining access to the Museum.

Perhaps even more worrying, given the number of bank robberies taking place in Baghdad, is that the Nimrud treasures along with other priceless material from the Iraq Museum such as the ivory collection, are still stored in the vaults of Baghdad's Central Bank. Not only are these objects under the real threat of theft but they are being held in appalling conservation conditions: ivories, golden objects, and ceramic vessels are lying in metal boxes in uncontrolled environmental conditions: excessive heat in summer and excessive humidity in winter. Just as with the books and archives discussed in chapter 27 these objects are degrading very fast and it seems that history is repeating itself. Once again, the world community is standing by and watching – some would say causing – the destruction of Iraq's history.

Collateral damage to archaeological sites is not restricted to Babylon and Ur. The ancient city of Samarra was inscribed by UNESCO in 2007 on both the World Heritage List and World Heritage in Danger List; the latter inscription because of the proximity of new military installations. Today, the site is in great danger as the Iraqi National Police, with the help, and under the supervision, of Coalition forces, are building a barracks and training centre for 1500 Iraqi security forces very close to the famous minaret and within the archaeological site. From initial pictures of the construction of this complex it appears that the Abbasid palace has been bulldozed. Destruction may not, of course, stop with the construction of the new facilities as they will by default become a target for those fighting the present regime.

There are positive stories – not least as shown in many of the following chapters. Dr al-Hussainy also reported in his lecture that the policing of some archaeological sites in Iraq had started again in 2006 as the SBAH had finally received enough funding to pay site guards their salaries. Unfortunately, the limitations of the 2007 budget means that once again there is no funding for salaries. Dr al-Hussainy also reported that he had been able to initiate 11 excavations on sites and that the presence of archaeological teams was keeping looters at bay. Finally Dr al-Hussainy reported that he had ordered the opening of the bricked-up doors of the Iraq Museum to check on the collections still within the Museum and that subsequently a new iron security door, provided by the Italians, has been fitted.

The Archaeological Institute of America (AIA) implemented a new educational programme in 2005 at the Marine Corps base at Camp LeJeune in North Carolina where some 2000 troops, en route to Iraq and Afghanistan, benefited from presentations on the archaeology, history and cultural heritage of the region by experts in the field. The AIA has had limited success in expanding the programme to other military bases and has succeeded in stimulating similar training in Bulgaria and Germany for troops being deployed to the Middle East (Rose 2007). The US Committee for the Blue Shield has also been training American troops prior to deployment, in this instance focusing on the mainly reservists in the US Army Civil Affairs and Psychological Operations Command, whose role is to advise military commanders on issues dealing with cultural property. The US military has, in conjunction with Colorado State University, also produced some 50,000 decks of cards meant to help troops avoid unnecessary damage to ancient sites and curb the illegal trade of stolen artefacts. These are to be shipped to troops in Iraq and Afghanistan as well as training sites in the United States. Each suit has a theme: diamonds for artefacts and treasures, spades for historic sites and archaeological digs, hearts for 'winning hearts and minds' and clubs for heritage preservation; and each card displays an artefact or site and gives a tip on how to avoid damaging historic treasures. In the UK, the MoD considers that it includes the requirements of the 1954 Hague Convention and its two Protocols in its doctrine and training and that it takes account of the Convention in its targeting considerations (although my somewhat unusual role in 2003 suggests that this may not have been always as structured an inclusion as many, no doubt including colleagues in the MoD, would wish!). Recently staff from English Heritage have provided training for Territorial Army units, the results of which are being fed into a wider review which will be completed during 2008 as part of the process leading to the UK ratifying the 1954 Convention. The draft *Cultural Property (Armed Conflicts) Bill* was published on 7 January 2008 which paves the way towards the UK's ratification and accession to the Convention. When this happens, and given the length of time political wheels turn this may not be until mid-2010, the UK will have a legal responsibility to include cultural heritage awareness training for all its forces.

THE FUTURE

So what should archaeologists do? Walk away because the issues are too difficult? Walk away because they are too political? Walk away because they are too real? Walk away

because people are losing their lives? Claim that it is nothing to do with us as we are objective scientists? Or should we accept that we have a specific responsibility, because our discipline is central to this, because we spend our time dealing with the past, trying to make sense of it and its importance for the present and future?

Matthew Bogdanos (2005) ends his book by concluding:

> One of the unpleasant truths to emerge from Baghdad is that, in assessing blame for the looting there, and for the confusion that followed, nobody gets off scot-free – not the military, not the press, not law enforcement, not the archaeologists, not the former regime, and not the staff. And in the sale of these stolen items, we find the same widespread distribution of guilt among scholars, museum directors, dealers, and private collectors. 'When everyone's culpable, is anyone guilty?'

The response of decision makers in the UK has not been encouraging. The UK is without doubt a major player in the trade in illicit antiquities, a situation reflected in the Metropolitan Police's decision to set up the Arts and Antiques Unit (AAU) in 1969 and in Cambridge University's later decision in 1996 to create the Illicit Antiquities Research Centre (IARC) to monitor and report upon the damage caused to cultural heritage by the international trade in illicit antiquities. Both are needed more than ever as the trade in illicit antiquities has grown to be worth an estimated US$ 7.8 billion, ranked behind only drugs (US$ 160 billion), and arms (US$ 100 billion), as the world's most profitable black market (UN 1999). Moreover this has happened at a time when the link between the trade and the funding of 'terrorism', and the 'insurgency' in Iraq, is becoming clearer. However Cambridge University saw fit to reallocate its resources and closed the IARC in September 2007. The AAU had its budget cut by about a half in 2007 and is due to be closed entirely in 2008 unless its own officers can identify a source of private funding that will allow the team to continue its work. These closures, real and threatened, will do much to enable the illicit trade in antiquities to grow and flourish, not only in the UK, but internationally.

The looting in Iraq currently feeding this apparently insatiable market represents a catastrophic loss to the common human heritage. We know, just about, what has been lost from the museums. We have photographs of many of the objects; we have inventories; much of the material has been studied already. We have an understanding of the damage being done to ancient sites in Iraq by their totally inappropriate use as large scale military bases, not only those reported in these pages, but also others such as the ancient cities of Kish and Samarra. However, we have no idea what we have lost, and are losing on a daily basis, from the archaeological sites being pillaged across the country: we have no photographs; we have no inventories; none of the material has been seen, let alone studied. All of the stories, all the messages from these pasts have been, are being, lost forever.

In 2003 I ended a presentation to various UK government departments and the military with the following words:

> I've tried to show that cultural heritage is important. I hope that together we can begin to develop the recognition of this importance. That we can begin to develop strategies that will attempt to protect it, to

use it, to interpret it, in the most suitable fashion. Not for any specific nationalistic agenda but for the explicit agenda of making the world a better, safer, more harmonious, and more civilised place to live.

In 2003 I was in an invidious position: chapter 8 outlines clearly why I was the wrong person, in the right place at a critical time. However my role did not legitimise the war, my role did not support the war, indeed I took every opportunity to show I was against this war. My experience, with respect to Iraq, India, and Croatia, has led me to believe that, as archaeologists, we have a collective duty to engage with our responsibilities, not just to piles of stones and archaeological sites but to the stories and messages held within them and their relevance to us all now and in the future. Those involved in the identification and protection of archaeological sites and museums did not get it right in 2003. We collectively tried, but failed, to impress on the military planners, or more precisely their political masters, to deploy sufficient troops to be able to protect the heritage resources in Iraq, a failure to which Matthew Bogdanos fully admits (chapter 11), as did those with whom I dealt in the British Ministry of Defence in 2003. We are certainly not getting it right now and the destruction of archaeological sites continues as I type. Bogdanos (chapter 11) calls for a five point plan of action

- a public relations campaign for mainstream society
- funding to establish or upgrade antiquities task forces
- a coordinated international law-enforcement response
- a code of conduct for trading in antiquities
- increased cooperation between the cultural heritage community and law enforcement agencies.

These are crucial but to them I would add

- the development of a code of conduct for archaeologists who might be considering working with the military (or their political masters)
- the agreement by all Coalition partners that cultural heritage awareness be introduced for their forces prior to deployment (and that this be considered in the long term for all NATO countries and countries supplying forces to UN missions)
- the active lobbying of the Metropolitan Police to secure the future, at full strength, of the AAU.

Failure in the past, in India, in former Yugoslavia, and in Iraq, does not give us the right or option to give up because it's too difficult. A depressing comment that I heard a number of times in 2003 from within the MoD was that they were aware they had not got the identification and protection of the cultural heritage right 'this time' but that they were keen to make sure they got it right 'next time'. In the spring and summer of 2003 it appeared very likely that 'the next time' might only be a few months away. Luckily further invasion has not, as yet, occurred but we would be stupid to believe that we have seen the last war. How the cultural heritage survives next time is in our hands.

Peter G. Stone, Joanne Farchakh Bajjaly

November 2007

BIBLIOGRAPHY

Agnew, N, and Bridgland, J, (eds), 2006 *Of the Past, for the Future: Integrating Archaeology and Conservation. Proceedings of the Conservation Theme at the 5th World Archaeological Congress, Washington DC, 22–26 June 2003*, The Getty Conservation Institute, Los Angeles

Bernhardsson, M, 2005 *Reclaiming a Plundered Past: archaeology and nation building in modern Iraq*, University of Texas Press, Austin

Bogdanos, M, (with Patrick, W), 2005 *Thieves of Baghdad*, Bloomsbury, New York and London

Boylan, P J, 2002 The concept of cultural protection in times of armed conflict: from the crusades to the new millennium, in *Illicit Antiquities: The theft of culture and the extinction of archaeology* (eds N Brodie and K Walker Tubb), Routledge, London and New York, 42–108

Brodie, N, and Tubb, K, (eds), 2002 *Illicit Antiquities: the theft of culture and the extinction of archaeology*, Routledge, London

Brodie, N, Doole, J, and Watson, P (eds), 2000 *Stealing heritage: the illicit trade in cultural material*, McDonald Institute, Cambridge

Chamberlain, K, 2005 *War and Cultural Heritage*, Institute of Art & Law, Leicester

Chapman, J, 1994 Destruction of a common heritage: the archaeology of war in Croatia, Bosnia and Hercegovina. *Antiquity* 68:120–126

Clark, G, 1943 Education and the study of man. *Antiquity* 27(67): 113–121

Colwell-Chanthaphonh, C, and Piper, J, 2001 War and cultural property: the 1954 Hague Convention and the status of US ratification. *International Journal of Cultural Property*, 10 (2): 217–245

Cruickshank, D, and Vincent, D, 2003 *People, Places and Treasure: Under Fire in Afghanistan, Iraq and Israel*, BBC Books, London

de la Torre, L, 2006 Terrorists raise cash by selling antiquities, *Government Security News* 4 (3): 1, 10, and 15

Fisk, R, 2003 The Rape of History. *The Independent Review Section*, Tuesday 3 June 2003, 1–5

Foster, B, Foster, K, and Gerstenblith, P, 2005 *Iraq beyond the headlines: history, archaeology, and war*, World Scientific, London

Golson, J, 1996 What Went Wrong with WAC-3 and an attempt to understand why, *WAC News: The World Archaeological Congress Newsletter* 4(1): 3–9

Hamilakis, Y, 2003 Iraq, stewardship and 'the record': An ethical crisis for archaeology, *Public Archaeology* 3(2): 104–111

Layten, H (ed), 1995 *Illicit traffic in cultural property: Museums against pillage*, Royal Tropical Institute, Amsterdam

Layton, R, and Thomas, J, 2001 Introduction: the destruction and conservation of cultural property. In *The Destruction and Conservation of Cultural Property*, (eds R Layton, P G Stone and J Thomas), Routledge, London: 1–21

Layton, R, Thomas, J, and Stone, P G (eds), 2001 *The Destruction and Conservation of Cultural Property*, Routledge, London

Mackenzie, S, 2005 *Going, Going, Gone: Regulating the Market in Illicit Antiquities*, Institute of Art and Law, Leicester

Matthews, R, 2003 *The Archaeology of Mesopotamia: theories and approaches*, Routledge, London

Meskell, L (ed), 1998 *Archaeology under fire: nationalism, politics, and heritage in the Eastern Mediterranean and Middle East*, Routledge, London

Polk, M, and Schuster, A M H (eds), 2005 *The Looting of the Iraq Museum, Baghdad: The Lost Legacy of Ancient Mesopotamia*, Abrams Inc, New York

Renfrew, C, *Loot, Legitimacy and Ownership: the ethical crisis in archaeology*, Duckworth, London

Rose, B, 2007 Talking to the troops about the archaeology of Iraq and Afganistan. In *The Acquisition and Exhibition of Classical Antiquities*, Notre Dame Press, Indiana

Roux, G, 1992 *Ancient Iraq*, Penguin, London

Schofield, J, Johnson, W G, and Beck, C M (eds), 2002 *Materiel Culture: The Archaeology of Twentieth Century Conflict*, Routledge, London

Schofield, J, Klausmeier, A, and Purbrick, L (eds), 2006 *Re-mapping the Field: New Approaches in Conflict Archaeology*, Westkreuz-Verlag, Berlin/Bonn

Silberman, N A, 1989 *Between Past and Present: Archaeology, Ideology, and Nationalism in the Modern Middle East*, Anchor Books/Doubleday, New York

Stanley-Price, N (ed), 2007 *Cultural Heritage in Postwar Recovery: Papers from the ICCROM Forum held on October 4–6, 2005*, ICCROM, Rome

Stone, P G, 2006 Archaeology and conflict – the Sixth Bassey Andah Memorial Lecture, University of Ibadan Press, Nigeria

Toman, J, 1996 *The Protection of Cultural Property in the Event of Armed Conflict*, UNESCO/Dartmouth, Aldershot

The Importance of Iraq's Cultural Heritage

Jean-Louis Huot

Every region and every nation knows or recognises its heritage. Every community seeks to keep its history alive, to maintain or rediscover their roots: the guarantor of the community's future. In this context, no one nation's heritage is more important or more attractive than another's. All aspects of heritage belong to humanity as a whole, and all, therefore, should be protected.

Iraq is no exception; we could debate *ad infinitum* the origins and reality of Iraq as a nation, or even as a country. Current events evoke neither an Iraqi nation, nor even the idea of a unified Iraq. The inhabitants of the land located to the south of the Anti-Taurus and to the west of the Zagros Mountains have however, as do all of their neighbours, a past and a history, a heritage.

This past is characterised by distinctive features which make the land crossed by the Tigris and the Euphrates different from adjacent regions. When, in the mid-19th century, apparently nobody in the country seemed to care, some Western diplomats, for example Botta, then Layard, had the notion of excavating the buried remains of previous civilisations. Before this time, residents had been happy to not give these remains, or their past, any thought, and those travelling from outside the area were happy to travel and look only at what was visible. The concept of exploring underground was a novelty. In fact, Mesopotamia, with the exception of Hatra, was never home to extensive, recognisable ruins visible to the naked eye, unlike for example Rome, Athens, Palmyra or Persepolis. This 'hidden past' was so invisible that the famous traveller Pietro Della Valle, who visited the site of ancient Babylon in 1616, wrote upon his return 'the surrounding land is very flat and it seems impossible that any notable buildings have ever existed there' (and see Della Valle 2001). This is why Botta, Layard and their numerous successors' realisation that one must 'excavate' in order to 'see' was truly brilliant and since the middle of the 19th century, such work has been the accepted norm.

These excavations rarely revealed any spectacular buildings or other remains, with the exception of the neo-Assyrian reliefs on stones which, the moment they were unearthed, were dispatched off to the large Western museums (although for a deeper analysis see Bernhardsson 2005, 55–56). Most of the time those involved in the excavations, using

shovels and pickaxes, found only insignificant remains of buildings made of bricks baked in kilns, or, much more often, simply dried in the sun, which could not be easily distinguished from the rubble covering them. It took the archaeologists some time to learn to distinguish what constituted walls in the ruins of buildings contained within the mounds, or 'tells', of dry earth that they were excavating. It took the experienced eye and patience of the German architect R Koldewey, working in Babylon in 1899, to identify the walls, to understand them and to draw plans of them. This lack of architectural remains, and the associated perceived insignificance bestowed upon Mesopotamian remains by architects, might explain why real archaeological research, rather than simple treasure hunting in search of 'the object', began earlier in Mesopotamia than elsewhere. Archaeologists have been excavating now in Iraq for over a century and a half. We should not, therefore, be surprised that our understanding is deeper than elsewhere, or even simply that the data are more abundant. When comparing our understanding of Iraq with the rest of the world there is some truth in the view that there are still regions of the world which remain *terra incognita*.

Archaeological excavation in Iraq has focused on and revealed the extraordinary turning point of urbanisation that took place, suddenly and inexplicably, at the end of the 4th millennium BC, and one consequence of this concentration on 'tell archaeology' has been a corresponding lack of interest in excavation relating to prehistory. This phenomenon of a relatively sudden concentration of people within an artificial context – the city – associated with, for example, the development of writing and irrigation, reflects a fundamental leap forward in the history of humanity.

Starting from the 4th millennium BC and for the duration of the next three millennia it can be argued that Mesopotamia was at the forefront of the ancient world's evolution. From 3500 to 2700 BC, during the critical phase of the development of urbanisation, a significant change took place in eastern Mesopotamia that affected the whole world. From that point forward, the world would be an urbanised one. The city is more than a simple agglomeration of houses, streets and monuments. The move towards an urban way of life is indicative of a much deeper change than a simple enlargement of the village. The city is at the head and the centre of a new social system. It is a centre of activity where people meet, where goods are bartered or traded, and where ideas are exchanged. This, in turn, leads to the formation of a particular, concentrated housing system which allows a complex society to develop and – crucially – to resolve its specific problems that cannot be resolved at an individual or family level. This marks the transmission of the village societies of the 5th millennium BC to a world that would in a short time equip itself with a system of administration, an army, and other attributes of centralised power.

During this same period, realistic human representations appeared for the first time. At last a recognisable human figure (in stone or clay) would take the place of the stylised and schematic figures of the Neolithic world, and would go on to assume, in the world of representative images, the eminent position it will never lose. This anthropomorphism of figured representations, coupled with the development of writing, prepared the ground for a notable development in society's ability to conceptualise religion. In the decisive

4th and 3rd millennia, the first theological views were elaborated in writing and the first divine figures were described. Texts would soon reveal a glimpse of divine existences, themselves conceived in the image of humankind.

These advances, first achieved in southern Mesopotamia, would be influential, to different degrees, all around the Orient. The large scale excavation by German archaeologists in Uruk, between Nasriyeh and Samawa, which lasted from 1912 until a few years ago, has identified a key stage in this development. It was here that the remains of a large monumental structure decorated with spectacular mosaics were found. It was also here that the first written tablets were excavated as were the first seals, in the form of small cylinders run over clay tablets, that bear witness to the presence of a particular individual. The first realistic sculptures were also found at this site, as were the first reliefs known in history. The civilisation of Uruk had an effect on communities as far away as eastern Turkey and western Iran. That is why we may speak of the Uruk era as a key bridge between prehistory and the beginning of history. The results were felt thousands of kilometres from eastern Iraq.

Thereafter, and for an entire millennium, it was in Mesopotamia that the most significant evolutionary developments of the ancient world took place. In fact, during the 3rd millennium, Mesopotamian cities seem to have been at the forefront of an urban civilisation that soon extended to neighbouring Syria. Local, European and American museums are full of artefacts that are testament to the high quality of life attained at the time by the cities of Uruk, Ur, Kish, Nippur, and Tello, and which are also almost certainly to be found on the as yet unexcavated sites of Tell Asmar and Khafajeh, among many others. The extraordinary discovery of the tombs of Ur, which can be admired in Philadelphia and London (one third of them remain in Baghdad), act as symbols of this quality of life. Alongside the advent of the writing and the swift development of its usage (texts of every nature, judicial, religious, poetic and economic), the quality of the sculptures, engravings, mosaics and architecture reflect a stable and successful civilisation. During the 2nd millennium, while Anatolia and the Levant congratulated themselves on their remarkable achievements, the Kassites of Babylon were at the root of unprecedented developments. Aqarquf, now a district of Baghdad, at that time known as Dur-Kurigalzu, was one of the world's biggest cities. Finally, the quasi 'universal' empires of the Assyrians, then the Babylonians, which stretched from the Iranian mountains to Egypt, ensured the wide-ranging influence of Nineveh and Babylon, considered among the most extraordinary cities ever built.

As noted above, the first excavations of the 'orientalist' archaeologists were conducted in 1842 in Nineveh and then in Khorsabad, a few kilometres from Mosul. The repercussions of the discovery of the Khorsabad reliefs, exhibited in the Louvre, and those of Nineveh, exhibited in London, were enormous, as was also the case with the exhibition of the cuneiform tablets which make up the famous 'library' of Assurbanipal, excavated from 1851. A world, contemporary with that of the Bible, was revealed to a public with a strong understanding of the period of the Old Testament and keen to have corroborative evidence of the stories around which their religion was founded. It was met

with astonishment by those who deciphered the cuneiform writing, who discovered, in 1872, a Mesopotamian version of the myth of the Flood, known until then only through the biblical text. In 1876 the 'Chaldean story of Genesis' was published; Assurbanipal, an Assyrian king of the 7th century BC knew of a story that was taken up by the Bible. There followed the revelation of the world of the Sumerians, of which the Bible never spoke. Thanks to the excavations in Mesopotamia, the world began to gain an awareness of the depth of time. Ever since, Mesopotamia has continued to produce hundreds of thousands of texts that reveal an ancient world far older than the era of biblical scriptures. In peace time, regular excavations increased in number annually. However, since the 2003 invasion thousands of texts have been, and continue to be, lost to illegal looting, and thus also lost for research. These losses are one of the most disastrous consequences of the present conflict.

Interest in the territories of Iraq did not cease with the end of the great Assyrian and Babylonian empires. Beyond the emergence of the Iranian world (although the Parthian Empire had one of its centres in Babylonia) and the majesty of the Sassanid empire, when Islam was introduced, the banks of the Euphrates and Tigris were no less renowned, for we are here in the land of the *one thousand and one nights* and of Harun-al-Raschid. The extraordinary scale of the Samarra ruins bears witness to the vitality of these Mesopotamian Islamic provinces, up until the catastrophic Mogul invasion and the several centuries of Ottoman rule that followed.

If the interest shown in this crucially important past was in the beginning solely the concern of foreigners (for example the role of Gertrude Bell in the development of Iraqi archaeological legislation and of the National Museum) it has, nevertheless, been picked up over the last 50 years by the intellectual elite of the country itself. The archaeological wealth of Iraq had initially prompted the representative power, in this case Great Britain, to create an archaeological service as similar as possible to the one it established in Palestine during the same period, just as the French authorities had done in Syria (and see Bernhardsson 2005, 116). It should be noted that, amongst the indifference and incomprehension of much of the local population and elite society, a small number of professionals in Iraq, and indeed across the wider Middle East region, had taken over control of departments of antiquities from the colonial powers, and had, very effectively, controlled authorised excavations, limited clandestine looting and facilitated the establishment of museums.

The National Museum in Baghdad, which has only occupied its present building since World War II, had been conceived and planned at an earlier date (and see al-Gailani Werr, chapter 3). With independence, concern for the past was certainly not forgotten. Even if, on occasion, it became influenced by increasingly ridiculous nationalistic and chauvinistic aims, it has served to engender amongst the population a new awareness of respect due to the past, even though pre-Islamic. A regime, supposedly secular, felt honoured by this concern for the relics of ancient times preceding Islam, favourably comparing this attitude to the 'narrow-minded' behaviour of its neighbours on this issue. Recent decades saw the development and functioning in Iraq, of a complete, competent

and professional archaeological service, and while certainly, nothing was perfect (there have been a number of officially proclaimed goals impossible to deliver in reality) the road taken was the right one and progress was real. The current tragedies have destroyed much of this progress: an effective Department of Antiquities has all but vanished; the museums have been looted; clandestine excavations have multiplied; the illegal traffic in antiquities has prospered and continues to prosper given the opportunities provided by the international art market and the greed of anonymous buyers (some suggest with the complicity of the occupiers). Perhaps excessive importance has been placed on the looting of museums in the aftermath of the USA-led invasion. It is difficult to get a precise idea of the extent of the damage and, in order to evaluate it with precision, we would need access to inventories taken before the recent wars. In some instances these have been lost; in others they never existed.

The principal damage to the archaeology of Iraq is, however, not in the losses suffered by the museums, great and grave though these have been. It is rather, on the one hand, the sudden unprecedented looting and trafficking of unprovenanced archaeological artefacts (despite the positive declarations made by all parties to try and stop the illegal excavations that provide these artefacts) and, on the other hand, the almost complete impotence of the Department of Antiquities, despite the courageous (though often ludicrously impossible) efforts of some Iraqi scholars, aware of the tragedy taking place before their eyes. Here, as in Afghanistan, the same causes have resulted in the same effects. In addition to the theft of a respectable people's past, the notion of the value of a country's past is lost from the local and wider-ranging consciousness and lost, possibly, for a long time. In the case of Iraq, it is clear that a part of us has also been lost.

SELECT BIBLIOGRAPHY

Bernhardsson, M T, 2005 *Reclaiming a Plundered Past: Archaeology and Nation Building in Modern Iraq*, University of Texas Press, Austin

Della Valle, P, 2001 *In viaggio per l'Oriente, Le mummie, Babilonia, Persepli, a cura di Antonio Invernizzi*, Edizione dei testi e Introduzione di Antonio Invernizzi, Edizioni dell'Orso, Torino

The Story of the Iraq Museum

LAMIA AL-GAILANI WERR

In 1923, Gertrude Bell established the Iraq Museum in response to the accumulation of antiquities in Baghdad from excavations conducted by foreign archaeologists in Iraq. However, the story of the Iraq Museum and antiquities in Iraq dates back to at least the middle of the 19th century, when British and French diplomats (for example Layard and Botta) started digging in the Assyrian capitals of Nimrud and Khorsabad, and later at Nineveh. The Americans came a little later in the 1880s and dug at Nippur, and in 1899 the Germans began to dig, first at Babylon and then at Assur and Samarra. Interest in Iraq, as in the other countries of the Near East, was, firstly, due to the association of many of the sites with biblical stories and the desire of Western scholars to prove the Bible's authenticity. Secondly, it coincided with the growth and development of museums in Europe and America, and the desire of their managing authorities to enrich their collections. Most of the expeditions to the Near East were supported and financed by their own governments, as was the case with the French and Germans, or by philanthropists like Layard's patron, Sir Stratford Canning, and then after Layard discovered the spectacular Assyrian reliefs from Nimrud, through support from the British Museum.

The Americans were primarily interested in the biblical connection and thus most of their funding came from people with a religious interest and even the excavators themselves were inclined to try to prove the Bible's historical authenticity. While many of the digs were organised and led by enthusiastic amateurs, the Germans, mostly architects by profession, conducted the first proper scientific excavations. Because of Germany's good relations with the Ottoman Government, they received concession to dig in Iraq, and were excavating until a few months before the beginning of World War I. When they left they were unable to ship hundreds of boxes filled with antiquities from Assur and Babylon. Only the antiquities from Samarra were sent by ship to Germany. However, during the journey, the war broke out and the captain of the ship took refuge in Portugal. This incident provoked a diplomatic crisis after the war; the British were by then occupying Iraq and claimed they should be the custodian of the collection. The Germans argued that, as the excavators, they were the owners of the boxes and their contents, while Portugal wanted to keep the boxes as war booty. Finally, following the formation of an international committee, the antiquities were distributed to a number of museums in the West. It was during this episode, while Iraq was in the process of gaining its independence, that the idea of a museum to be established in Baghdad was discussed, and some representative objects were set aside in the custody of the British Museum

to be returned to Iraq at a later date. It should be noted here that the Iraqi share of the Samarra collection was only returned in 1936. The Babylon boxes were eventually given to the Germans, except for a few representative objects which were given to Iraq. These antiquities can be considered the earliest objects of the Iraq Museum collection.

By 1922 there was renewed interest from Western institutions in resuming excavations in Iraq, and the Antiquities Department was established with Gertrude Bell as its first Director. In 1923, the Iraq Museum was established and Abdul Qadir al-Pachachi, an Iraqi civil servant who worked at the Turkish Archives in Istanbul, was appointed director of this tiny museum. One of Gertrude Bell's first tasks was to find a building in which to house the antiquities; initially she was given a room in the Qushla (Sarray), the Ottoman administrative complex which continued to be the centre of the new government when Iraq gained its independence up until the 1970s. This was, however, insufficient and in the Museum's archive there are many letters from Gertrude Bell to the cabinet, requesting that a new or larger building be found to house the increasing quantities of antiquities coming from the many new excavations taking place by the mid-1920s.

Perhaps the most important archaeological discovery of the 1920s was the Sumerian Royal Cemetery at Ur. The excavation was sponsored by the British Museum and the University of Pennsylvania Museum of Archaeology and Anthropology. Extraordinary finds dating back to the Early Dynastic Period (2600–2500 BC), including crowns, daggers, earrings, semi-precious bead necklaces and a wide range of funerary furniture, were found. This wonderful treasure is now one of the prize collections of three museums: the Iraq Museum, the British Museum and the University Museum, Pennsylvania.

Other foreign institutions also started excavating again, notably the Germans who started digging at Warka, and, as a result, the Iraq Museum is the proud owner of two unique pieces from the ancient world, namely the Warka Head and the Warka Vase (c 3300 BC), perhaps the first example of narrative relief in the world. Despite both falling victim to the 2003 looting, happily both were found essentially undamaged. Perhaps the most spectacular finds of the 1930s were through the excavations of the Oriental Institute, Chicago, at three Sumerian sites in the Diyala; Tell Asmar, Khafajeh and Tell Agrab. At Tell Asmar, in the early Dynastic II level, a cache of approximately 17 statues of worshippers were found buried under the floor of the Temple of Abu, most of which were then exhibited at the Iraq Museum.

World War II brought an end to all foreign expeditions and it was not until the 1950s that the Museum began acquiring more valuable antiquities, a result of the resumption of excavations by many foreign and Iraqi expeditions. The British School of Archaeology in Iraq, under the Directorship of Max Mallowan, started excavating at Nimrud, the Assyrian capital, almost a hundred years after Layard's first excavation. Mallowan, and later David Oates, excavated at Nimrud during the 1950s and 1960s. The Iraq Museum was enriched by the numerous objects that came from the site, such as the two-winged bulls, statues of Assyrian kings and many small antiquities and cuneiform tablets; one of the most important is a large tablet of a treaty between the Assyrian king Eserhaddon (680–669 BC) and a Medean prince from northern Iran. However, by far the most distinctive

finds from Nimrud are the ivories, which decorated much of the palaces' furniture. The majority were found stored in one building named Fort Shalmaneser, others were found discarded in a well after being stripped of their gold plating, in the north-west palace of King Ashurnasirpal II, presumably during the sacking of Nimrud in 612 BC by the Medes and the Babylonians. One piece that stands out among the thousands of complete ivories and fragments is the Mona Lisa from Nimrud; it was the star attraction in the Ivory Room of the Iraq Museum. Unfortunately, being of organic material, these ivories have suffered during the political instability and wars that Iraq has faced in the last two decades. During the First Gulf War in 1991, many of the ivories were either damaged or completely perished due to inadequate wrapping while stored for over ten years until the reopening of the Museum in 2001. While some of the ivories were looted in 2003, others were simply scattered on the storeroom floor and trampled on. As for the best ivories, including the Mona Lisa, which were stored in the Central Bank with many of the gold objects from the Museum, they were flooded by water from broken pipes, and were found in a very poor condition.

The remains of the city of Hatra supplied the Museum with one of its unique collections. Hatra is a Parthian site in north-east Iraq whose inhabitants were Arabs and whose rulers were allied to the Parthian kings in the last centuries BC and the first centuries AD. Many structures in Hatra were constructed from stone, particularly the temples and tombs. Today the site, inscribed on the World Heritage List in 1985, is one of the most impressive standing ruins in Iraq with hundreds of statues and other temple furniture. Visitors to the ruins in the 1950s or 1960s would have to walk over the statues that lay on the floors of the temples. Unique in style, a combination of Hellenistic, Parthian and Mesopotamian traditions, the Museum has devoted a whole room to exhibiting the finds. In 1951 the Department of Antiquities started an extensive programme of excavation and restoration which continued until the recent conflicts made such work impossible.

Perhaps the most sensational of the discoveries in the 1980s was the Assyrian Queens' tombs from Nimrud. In 1988, Iraqi archaeologists stumbled across the first tomb when undertaking restoration work in the Palace of Ashurnasirpal II. This led to excavations in the nearby rooms and three more tombs were discovered with spectacular funerary finds of gold and semi-precious stones. Over one thousand pieces were found, objects that archaeologists and art historians consider as important as the discovery of Tutankhamen in Egypt.

The Iraq Museum, in its long history, has had a number of remarkable directors. Gertrude Bell stands out as the first to establish the nucleus of all the departments, the laboratory and the library. In her will she left all her books in Baghdad and today the library has an excellent collection of most of the early books on ancient Mesopotamia from the American School of Oriental Research, which donated its library when the centre in Baghdad was closed. One of Bell's main duties was the drafting of the antiquities legislation which became law in 1924, to the dismay of the foreign expeditions that, as a result, 'lost' a proportion of their finds to the Iraq Museum. In its infancy the Antiquities Department was managed by a number of European scholars, firstly Sidney Smith then

Julius Jordan, and it was not until 1934 that an Iraqi, Sati' al-Husri, became the first Director of Antiquities, coming from the Ministry of Education and an advocate of Arab and Islamic culture. During his time in office, the first Iraqi excavation was conducted under the directorship of Fuad Safar, a recent graduate from the Oriental Institute, Chicago. The excavation was at the Islamic site of Wassit, the Umayyad capital in Iraq. Husri also embarked upon restoring the Islamic monuments in Baghdad, amongst them Khan Mirjan (1233), which became the Islamic Museum; he also amended the Antiquities Law to the additional benefit of the Museum. During World War II, Youssif Gahnima, who had been Minister of Education, became the Director of Antiquities. The exhibited antiquities in the Museum were arranged in chronological order and the Antiquities Department was promoted to become a Directorate General. Youssif Gahnima was followed by Dr Naji al-Assil, the last politician to be appointed Director. After the fall of the monarchy, Iraq became a republic and being a professional archaeologist became the requisite for the position of Director General. The first was Taha Baqir, followed by Dr Faysal al-Wailli; interestingly both were Oriental Institute graduates, and the final Director to help mould the institution was Muayad Said Dimirji, who was Director for over 16 years.

As previously mentioned, the issue of housing antiquities was a constant problem for all of the directors. One of the first requests Gertrude Bell made to the Iraqi cabinet was for a building to house the ever-growing collection. The archives of the Iraq Museum indicate that whenever she heard of a vacant government building, she would ask for it. Once it was a school, another time a laboratory; eventually it was a building close to the bazaars near the Shuhadaa Bridge. Originally a law school, the building became home to the Museum until it moved to its purpose-built premises in Salihiyah in 1966. Building a museum is a marathon undertaking and fully preoccupied all of the early directors. Location and finance for such a project were other problems, which again kept many officials busy. Iraq, being a new country, had other priority projects and at an early stage an American philanthropist offered to cover the expenses. By the mid-1930s, Sati' al-Husri had commissioned a German architect for the project, and a location was found in Salihiyah, west of the river, however the funds had not materialised. Fearing that the land would be appropriated by other ministries, to keep it for the Museum Sati' al-Husri asked Seton Lloyd, then adviser to the Department, to design a distinctly ancient structure. Sati's idea was to have a model of an Assyrian gate which Seton designed and built at one corner of the assigned site; this was much photographed and broadcast around the world in the aftermath of the looting in 2003. On the other side of the consigned plot, a copy of the Lion of Babylon was erected. World War II put a halt to any construction and it was only in the 1950s that the building of the new Museum began. The 1930s Art Deco design of the German architect was chosen, which although very modern, followed the traditional plan of Iraqi houses and towns. Offices were built around courtyards with gardens in the centre surrounded by porticoes and indoor passages lined with ceramic tiles like the bricks of Iraqi houses. The exhibition halls were also built around a courtyard. Most impressive is the Assyrian hall with the reliefs and winged bulls displayed in a spectacular way, evoking the atmosphere of an Assyrian palace. The Museum was subject

to a high-profile opening in 1966, featuring up-to-date display cabinets and a specialist was sent by UNESCO to help. Since then, the antiquities collection has grown larger and larger with numerous foreign and Iraqi expeditions, compounded in the 1970s and '80s by a major increase in development and irrigation projects which meant that the Antiquities Department had to conduct numerous rescue excavations. A new annex was built following the style of the original design of the courtyard and porticoes surrounded by rooms. This doubled the space available for both exhibits and storerooms.

Among the outstanding curators with a lasting legacy at the Museum was Faraj Basmachi. During World War II he was a student in Switzerland and on his return he was appointed Curator, a position he retained until his retirement in 1968. It was Basmachi who presided over the colossal task of moving over 50,000 antiquities from the old Museum to the new and he arranged and chose most of the objects for display. The nine curators appointed after him all followed the system he had established.

A laboratory is an essential part of any museum, but in Baghdad, in addition to its role in conserving the objects, the laboratory played an important role in the cultural life of Iraq. Sati' al-Husri encouraged the appointment of artists to work in the laboratory (and see Buckley, chapter 28).

Many of Iraq's well-known sculptors and painters began their careers working in the Museum, encouraged by the then Director of Antiquities, Naji al-Asil. Many were commissioned to make replicas or murals depicting Iraq's ancient past. One of the most photographed and published reconstructions of a Sumerian lady is the head of Queen Shubad or Pu-abi, the work of Khalid al-Rahal, a prominent artist. It was commissioned in the 1950s and exhibited in the Iraq Museum until recently. One of Iraq's foremost sculptors and painters, Jawad Salim, created a replica of an Assyrian chariot, which was paraded in the streets of Baghdad during the coronation festivities of King Faysal II in 1952. Hafidh al-Deroubi produced two murals, one of life in Babylon and the other a scene of life in a Hatra temple. Both were given prominent positions in the Hatra and Babylonian rooms of the old Museum. Abdulrahman al-Gailani produced a golden replica of the bull's head from the Lyre of Ur, also on the occasion of the coronation of King Faysal II. It was this replica that was stolen in April 2003, while the original was safely stored. In the 1950s and '60s, the Director of the Conservation Department was the painter Akram Shukri, who employed many of the young artist graduates from the Institute of Arts. Lastly, a statue of Hammurabi the Babylonian king, the work of Muhamad Ghani, stood outside the National Assembly in 1970.

Finally, no essay on the Museum should ignore the oldest employee, Haji Abid Atiya, the janitor who began work when he was 14 years old and is now 76 and still going. He regards the antiquities as his children and has the most knowledge about the ins and outs of the Museum; no archaeologist or curator can run the Museum without him. In a few years' time he will have worked at the Museum for 70 years, which according to the antiquities law will make him a heritage item.

SELECT BIBLIOGRAPHY

Lloyd, S, 1980 *Foundations in the Dust*, Thames & Hudson, London

Bernhardsson, M T, 2005 *Reclaiming a Plundered Past, Archaeology and Nation Building in Modern Iraq*, University of Texas Press, Austin

Basmachi, F, 1976 *Treasures of the Iraq Museum*, Al-Jumhuriya Press, Baghdad

al-Gailani Werr, L, 2005 A Museum is Born, in *The Looting of the Iraq Museum, Baghdad* (eds M Polk and A M H Schuster), Harry N Abrams Inc, New York

The Acquisition of Antiquities in Iraq, 19th Century to 2003, Legal and Illegal

McGuire Gibson

Mesopotamian antiquities became a focus of international interest in the 19th century, when British and French commercial officers and diplomats began to explore Iraq, map it, and try to identify sites that were known from biblical and classical sources. Claudius James Rich, a young representative of the British East India Company, correctly identified, explored and mapped Babylon and Nineveh, and visited numerous other sites before his death in 1821.[1] Several other British visitors mapped and described sites in Iraq in the ensuing years, but the real start of excavation and extraction of antiquities began in earnest in 1842, when Paul Emil Botta, the French Consul in Mosul, began to explore Assyrian palaces at Khorsabad and Nineveh, sending back to the Louvre shipments of huge winged bulls and wall-slabs decorated with the exploits of the Assyrian kings. The British diplomat, Austen Henry Layard, began excavations in Nimrud (the ancient capital Kalhu) in 1845 and worked until 1851 at this site and Nineveh, sending back to the British Museum many reliefs and other objects. In some years, the French and British were in unfriendly competition to extract objects, sometimes from the same site. Working with Layard was an Assyrian, Hormudz Rassam, who later carried out major digging at a number of sites in the north and south of Iraq on contract from the British Museum. Where the French and British were systematic in that they followed the edges of walls and drew the scenes on the stone slabs in the palaces, even when they did not remove them, Rassam mainly trenched and tunnelled, gathering up thousands of cuneiform tablets and other objects on contract with the British Museum.

Once it became clear that there was a monetary value in antiquities, and that limestone reliefs, for instance, had a greater value as objects to be sold to foreigners than just as a source for lime, local Iraqis began to dig on their own, removing thousands of objects, particularly cuneiform tablets, from sites. Especially important was the digging at Babylon and other sites in the south, especially Umma (see map, page xv) and Drehem, where very ancient layers were to be found right at the surface of the mounds rather than metres below, as at Babylon.

By the 1870s, however, the Ottoman government had also realised the importance of antiquities and had promulgated an antiquities law. Shortly after this, excavations were being carried out by scholars, rather than by diplomats and commercial agents, although

the digging methods were no better than before. The first American expedition in Iraq, by the University of Pennsylvania at Nippur (1888–1900), was far from scientific, but was important for supplying to the scholarly world a wealth of cuneiform documents that allowed the construction of ancient history, the continued understanding of the Akkadian language and the decipherment of Sumerian. In the notes and letters of that expedition, it is clear that the staff and scholars from other institutions in the USA and Europe were buying objects from dealers in Turkey, Baghdad, Hilla, and other places, having to sneak around the Ottoman representative who accompanied them. The trade was brisk, and many thousands of tablets and seals found their way to museum and university collections. The Ottoman attempts to control the trade were quite inadequate, and only the shipping of excavations' excavated finds to Istanbul seems to have been accomplished with any regularity. Although all antiquities were the property of the state, expeditions and even individual scholars could receive a portion of the finds once they had been inspected. It is interesting to note that the members of an expedition thought nothing of buying antiquities clandestinely for themselves or for institutions other than the one that was sponsoring the excavations. The ethics and economics of such a practice were not debated. That the Ottoman authorities cared about the loss of antiquities can be shown by the case of Edgar James Banks, a very promising young American scholar who had studied in Germany and was hired by the University of Chicago to dig at Adab in 1904–05. Banks was caught trying to smuggle objects out of Iraq and was banned

Fig 1. Umma, evidence of old looting, probably going back to the late 19th century.

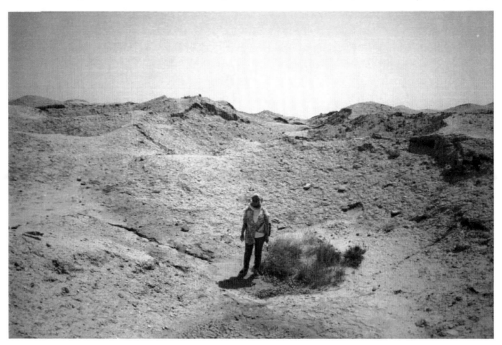

from digging further. Chicago fired him, and then he spent the rest of his life buying and selling antiquities. He bought a very large number of objects just prior to World War I, and with these he began to send letters to museums, libraries, and universities across America. He continued to do this well into the 1930s, with the letters often stating that the price had to be raised because the new restrictions of the Kingdom of Iraq had made it hard to get fresh supplies. If you go to almost any public library, university, college, or museum in the USA you have an excellent chance of finding a few clay tablets (often from Umma and Drehem) and even some cylinder seals. I have seen several of these collections and the accompanying papers, and although Banks' letters imply or even state clearly that these objects came out of Iraq without the permission of the authorities, there is never a hint that the buying institutions had any hesitation in making the purchase.

The German expedition to Babylon, from 1899 until 1917, finally brought an orderly system into the excavation of Mesopotamia's sites. German operations at Assur and Samarra, as well as other sites, laid the groundwork for the training not only of archaeologists but of local workmen as well. Captured objects from Babylon, Assur, and Samarra became the focus of a policy debate within the British government and among Britain, Germany, and Portugal after World War I. When the British forces arrived at Babylon, they found crates of objects that the excavator Koldewey had intended to send to Berlin under a special agreement with the Ottoman government. Those crates and others with objects from Samarra were impounded by the British forces and there ensued a long discussion in which the Foreign Office, the India Office, the officials and army officers on the ground in Iraq, and the British Museum debated the merits of keeping the objects as war booty as opposed to returning them to the Germans or the newly independent Iraq. Portugal became party to the debate because a ship with Assur objects was sequestered in Lisbon. Gertrude Bell, echoed by the Foreign Office, wanted the materials returned to the new Iraq Museum. All other parties wanted the objects for England or Portugal. Much of the collection of Assur objects in Lisbon eventually found their way to Berlin. The rest of the material sent to Britain was divided among 17 institutions in Europe, North America, and the Near East, the British Museum and the Berlin Museum receiving the best pieces (Bernhardsson 2005, 57–92).

With the founding of the Iraq Museum and the Iraqi Antiquities Service in 1922, Gertrude Bell, the first director, oversaw the adoption of an antiquities law, patterned after the Ottoman one. Criticised by some as favouring foreign expeditions in the division of objects found, the law actually ensured the very swift building-up of a collection for the Iraq Museum at little expense to the Kingdom. When the division was made in strict adherence to the law, the Museum had the choice of the best objects. There were instances in which British directors, especially Richard Cooke, who was caught smuggling objects, were not scrupulous in the divisions. An American archaeologist, Richard Starr, was implicated as a receiver of the objects sent out by Cooke (Bernhardsson 2005, 159–60). The illegal excavation and sale of objects was still continuing throughout the 1930s, with the Department officials unable to do much about it. In fact, one of the British Directors, Sidney Smith, in 1930 issued a memorandum to all expeditions about the purchase of antiquities. He was not so much concerned with the purchasing of antiquities

as with making sure that the objects came from the immediate area of the expeditions' concessions. Such objects could then be included in the official registers of the digs and would be eligible for the division (Bernhardsson 2005, 158).

With the end of the British Mandate, and the independence of the Kingdom in 1932, there was a decided change in the attitudes toward antiquities. Especially after the adoption of a new, stricter antiquities law in 1936, in which all antiquities and antiquities sites became the property of the state, the relationship of foreign scholars and expeditions to the Iraqi Directorate General of Antiquities was changed significantly. It was in this decade that the Iraqis began to carry out their own digs, initially at Islamic sites. It was also the time in which young scholars were sent abroad, on government fellowships, for graduate degrees. The problem of illicit digging still continued, but the gradual consolidation of the Antiquities Service, with representatives in all the provinces, began to curb the practice. Archaeology was seen as a means by which to bolster national identity and as a potentially important source of revenue from tourism.

World War II was a watershed for Iraqi archaeology. With the foreign expeditions gone, and with newly trained Iraqi archaeologists and philologists back from abroad, the Directorate General began to sponsor important excavations in prehistoric and pre-Islamic sites, although still with a British adviser, Seton Lloyd.

The production of oil in a major way after the war led to increased budgets for antiquities, coinciding with the return of foreign expeditions with improved methods of digging and recording. There was still some illicit digging and smuggling out of antiquities, but at a reduced rate.

The revolution of 1958 brought about the virtual elimination of illicit digging. From this point until 1990, there was very strong control over the antiquities sites of Iraq. With the oil boom of the 1970s, and the great increase in funding, the Antiquities Service could hire many more staff, including site guards and regional representatives, and enforce the law strictly. A few items might still come onto the international antiquities market, especially coins, but then Iraq had developed the best antiquities service in the Middle East and was one of the best countries in terms of protecting its cultural heritage. That situation changed drastically in the aftermath of the First Gulf War in 1991. In the chaos that accompanied the uprisings in the south and north of the country, 13 of the regional museums were looted and more than 5000 objects taken. One could take these events as merely the over-enthusiastic actions of people reacting to years of oppression, but there is a more nuanced context that has to be laid out.

Two events occurred in the late 1980s that were important for Iraqi antiquities. One was the collapse of the stock market in the USA and elsewhere, leading investors to seek profits in other fields away from traditional stocks and shares. At about the same time, the Erlenmeyer Collection, formed in the 1920s and 1930s and published, to a great extent, was put on sale in major auctions in Europe and the USA. Because this collection was so old, the Near Eastern items did not come under the strictures of the 1970 UNESCO agreement, which many museums and universities had agreed to observe. Because it was 'clean', this collection could be bid on with a clear conscience,

and the bidding was very spirited. Objects that would have fetched a few hundred dollars in the shadowy international market brought thousands of dollars. Tablets and cylinder seals were especially sought, and their prices rose greatly. This set of auctions raised the prices for Mesopotamian antiquities in general, and many new people became collectors. In 1990, I saw copies of the Erlenmeyer catalogues in a rug merchant's shop in Baghdad. Although there were no antiquities dealers, *per se*, in Iraq, there were dealers in antiques and rugs who were interested in antiquities, if not already involved in the trade. The looted objects from the regional museums found ready buyers in Baghdad, and they were sent on into the international market. When, later in the 1990s, cylinder seals began to fetch more than US$ 100,000, and one Iranian seal even reached US$ 400,000, the dealers in Baghdad began to encourage the illicit digging of sites, especially those that were in the desert to the south between the Tigris and Euphrates. Especially popular were those sites that had furnished museums with tablets, even in the 1880s, for instance Umma and Umm al-Aqarib (see Plate 1).

A third event, beginning in 1990, affected the cultural heritage of Iraq. This was the imposition of economic sanctions on Iraq enforced by the no-fly zones declared by the USA. The sanctions were most keenly felt by the poorest of the Iraqis, many of whom were in the south. Probably beginning as a means to find something to sell to feed their families, men began to go out to isolated sites and dig. It is not known if they were induced to do this by dealers, but it was clear as early as 1994 that there was large scale illicit excavation occurring at sites like Umma, Umm al-Hafriyat (near Nippur), Adab, and other sites in the south of Iraq. The evidence for this activity was a flood of objects reaching dealers in London and other centres of the trade, and the quick building-up of collections in Europe, the USA, Japan, and the Persian Gulf. One major collector in New York was heard to say, 'This is the golden age of collecting.' It is important to note that whereas other Iraqi products were forbidden entry into the USA, the antiquities of Iraq were allowed to be bought and sold freely.

The routes by which antiquities were being smuggled were varied, insofar as it could be determined. Anecdotal evidence, mainly from employees of the Antiquities Service, indicated some of those routes. In at least one case, a diplomatic car was being used to export objects through the Jordanian border point. The objects were confiscated and returned to the Iraq Museum. Border police patrolling the Iraq–Saudi border intercepted a pickup truck belonging to a Bedu, and sacks containing cuneiform documents were seized. The Museum mounted a small, short-term exhibition of these seized objects. The driver of the pickup had been contracted to take the objects to Saudi Arabia, where he was to hand them over to someone who would ship them by air to London. Other objects went overland to Iran by various routes or to Turkey, via the Kurdish area, which was no longer under Iraqi government control. Iraqi antiquities were surreptitiously sold in the antique shops of Damascus and Aleppo, so there was at least one route to Syria. Some shops in Amman were also dealing in Iraqi antiquities.

Regardless of the route by which an antiquity reaches the markets in Europe and America or Japan, there are several methods by which the smugglers and dealers 'legitimise'

the object. False papers give somewhat plausible provenances, and even though everyone involved in the transactions knows that the provenance papers mean little, they can pretend that they dealt in or bought the piece in good faith. Often, the papers say that an object has been in a European (preferably Swiss) collection for some time before the 1970 UNESCO convention. Or there are faked government papers that authorise the export of the object; the favourite country for such documents seems to be Jordan, although anyone who is knowledgeable about Mesopotamian antiquities knows that it could not be from Jordan, and also knows that Jordan would not have authorised the export anyway.

One very important inscribed object that was the subject of much excitement and quiet discussion in the 1990s was the trunk of a black stone statue that had a long historical inscription on the back. The upper and lower portions of the statue had been broken away. A London dealer sent large-format, glossy photographs to some cuneiform scholars, who showed them around an American Oriental Society meeting. I was not at the meeting, but I was shown the photographs shortly thereafter. The excitement was caused by the fact that this object recorded a rebellion against Samsuiluna, the son and successor of King Hammurabi of Babylon, by most of the cities of southern Babylonia. The rebellion was led by 'the King of Sumer', a title not used in many years. Although there had been some references to a rebellion in other texts, this inscription gave great detail and was of high historical importance. When it was first being offered for something like USA $400,000 dollars, it had papers claiming it had been in a Swiss collection for years. Everyone who learned of the inscription knew that this was impossible, since a text of this importance would have been shown to a cuneiformist when it entered that collection so that there could be a publication for the scholar and an increase in value for the collector.

A year or so later, another dealer in the USA was said to be showing the pictures once again, but now the value was more like USA $40,000 and the papers said that it had been exported from Jordan with the permission of that country's Antiquities Department. Again, no one believed the provenance. Even at the reduced price, there was no buyer because the inscription was already readable in the photographs, and the value of the piece was greatly devalued because it was only a fragment of a statue and would not likely be displayed in a museum. It is not clear where the item is now, although I have heard a rumour that it is in an Italian private collection. Thus far, no one has published the text and no one seems to even mention its important revelations in an article, although many scholars know of its content. It is unfortunately the case that there is cooperation between scholars, mainly philologists and art historians, who authenticate and translate items for collectors and dealers. They do not look beyond the dealers to see the smugglers and looters who supply the traffic, but justify their actions by citing the loss of information for scholarship if they did not read the inscriptions or analyse the art works, and they say that if they did not record the items, they would go underground and never be seen again. Clearly, scholars are in an ethical dilemma here (Lawler 2005). Those who primarily identify themselves as archaeologists want to preserve objects in their original findspots, so that the invaluable information on context can give greater information on the meaning of the object, and the object can inform on the nature of the findspot.

Museum curators are in another kind of bind, because normally their museums have signed the 1970 UNESCO agreement and they are unable to buy items that have unsure provenance. This does not, however, prevent them from putting on show objects 'from the collection of Mr X or Mrs Y', thus authenticating them and giving them greater monetary value. Often the collectors are major donors to the museums, and this fact colours the judgment of curators and museum directors. In time, the donation by collectors of large sums to name a museum hall or a wing, or to subvent an archaeological excavation, and the anticipated donation of the collection to a museum are likely to erase memory of the acquisition trail and the destruction caused to cultural heritage by the suppliers of such an insatiable demand. Unfortunately, antiquities have long been a mark of sophistication and taste, and social status can be conferred by the accumulation of museum-quality objects. When collectors are also major donors to political campaigns, or have other levers of power, it is virtually impossible to prosecute them for their part in the criminal acts that lie behind their collections. A few smugglers, dealers, and curators may be prosecuted, and the poor farmers who do the digging just to make a living in very difficult times may be beaten, but the people at the root of the trade will escape. They excuse their actions by citing their superior appreciation of the objects, the greater safety of the objects in their possession or in the possession of a Western museum, rather than in the countries of origin. In fact, until the disruptions of two wars brought to Iraq by Western powers, Iraq had a better record of protecting its artefacts than most countries in the world. Artefacts are safest in the ground, awaiting their careful exposure by trained archaeologists, who can extract much greater information from them through knowledge of the context in which they resided.

The mechanisms of the illicit antiquities market are easy to see in the cleaned-up area of the trade: the antiquities shops on Madison Avenue in New York or other chic addresses in other cities. Usually conveniently located near the major museum of a city, these establishments have a symbiotic relationship with the art historians and philologists who authenticate objects, but with curators and collectors as well. Important to the entire trade are the well-illustrated catalogues of antiquities auctions, which have proliferated since 1990. These catalogues serve to advertise the goods and let the world, even rug dealers in Baghdad and Aleppo, know the going rate of ancient objects. Despite the fact that at present there are said to be virtually no Iraqi antiquities flowing into the USA because of a presidential decree against dealing in Iraqi cultural property, there is a plentiful supply abroad. The Gulf Emirates have become a new marketplace for antiquities from Iraq, often using the internet for sales, and some major new collections are being accumulated there. I have a suspicion that many of the objects are being held for dealers and collectors in warehouses in the Near East and Europe. Back in the 1990s, it was much easier and simpler. For instance, London dealers would send cylinder seals to at least one New York collector on approval, just like stamps. The buyer was to choose which of the dozens of seals he might want and send the rest back.

During the 1990s, when the looting began on a large scale, the no-fly zone in the south of Iraq was essential to the trade. Without helicopter surveillance, it was very

difficult for the Iraqi authorities to control the countryside. They could hold the towns, but they had limited ability to police the country, especially the desert areas which are difficult to access. Looters could see the dust from approaching convoys of vehicles and be gone from the site long before they arrived.

As it was clear that Umma was being very badly looted, since the market in London and the rest of Europe were flooded with many texts from that tell, I advised a photographer who was sent to Iraq in the mid-1990s by the *Natural History* magazine to ask to see Umma, to check on the situation. After much difficulty, she was escorted there and found the site badly damaged by looters. The Antiquities officials who accompanied her were able to use the information they gathered to gain emergency funding to conduct salvage excavations at Umma, Umm al-Aqarib, and several other sites, effectively putting an end to looting in that vicinity from 1998 until 2003. But the looters just shifted their operations to other sites. One badly looted site was Umm al-Hafriyat, a pottery-making centre that I had excavated in 1977. Cuneiform documents from this town were in European and American collections by at least the late 1990s, as I learned from one of the specialists in texts. The great city of Isin, which was the capital of Babylonia during two periods in the 2nd millennium BC and had been excavated by a German expedition in the 1970s, was also looted in the 1990s. That looting greatly intensified after the 2003 war.

In 2001, I visited Iraq for a conference and asked to see the salvage projects at Umma and the other sites. Dr Donny George took a small group from Baghdad on a one-day trip, taking only about two hours to reach the nearest town, given the excellent highways. But it took almost two hours more to travel the 15 kilometres through the desert to Umma and Umm al-Aqarib (Lawler 2001). It was clear from surface indications at these sites that although there had been extensive illicit digging at both, the areas affected were relatively concentrated. One very deep hole at Umma was probably the location of much of the looting from the late 19th and early 20th century. The pits from the 1990s were relatively shallow. The excavations by the State Board of Antiquities in the past two years had exposed astonishing architecture and had recovered many objects. In order to keep the looters from returning to the tells, the expedition had to work throughout the year, even in the heat of summer. At Umma, there were as many as 18 guards, an extraordinary number for a site being excavated. Those guards, and those at the other salvage operations in the vicinity, were to prove inadequate. The day the 2003 war started, more than 200 looters went to Umma and the other sites and drove away the guards and began digging once again (Lawler 2003a, 2003b). The guards at Nippur were equally powerless in May 2003, when armed men began to loot the north-western side of the West Mound. They dug for a month before police from the nearby town of Afak came out to drive them off.

By late 2002, it was clear that the USA was going to pursue a war with Iraq. I went with a small delegation to the Pentagon and the State Department on 24 January 2003, to try to emphasise the importance of Iraq as the most important centre of ancient culture. I pointed to the thousands of important sites and stressed their vulnerability, since they are

mounds, and being the highest points on the southern landscape, they would be seen as high ground to be taken and held. I also said that they were probably going to be looted if there was chaos following an invasion. I also emphasised the importance of the Iraq National Museum and said that it was likely to be looted. The Pentagon officials said that they were aware of the Museum. I took this to mean that it would not only not be bombed, but that it would be secured. I was mistaken on the second point. The Pentagon apparently thought of looting only in terms of its own soldiers carrying out the action. They were not thinking, as I was, about the probability of looting by Iraqis.

The worst that can happen to a museum occurred in Baghdad from 10 to 12 April 2003. The worst that can happen to an archaeological site is still occurring in southern Iraq, and there is no prospect of an end to the looting.

NOTES

1. For an account of early explorations in Iraq, see Hilprecht, 1903

Bibliography

Bernhardsson, M, 2005 *Reclaiming a Plundered Past: Archaeology and Nation Building in Modern Iraq*, University of Texas Press, Austin

Gibson, M, 2003 Fate of Iraqi Archaeology, *Science* 299, 1348–49

Hilprecht, H, 1903 *Explorations in Bible Lands During the 19th Century*, T. & T. Clark, Edinburgh

Lawler, A, 2001 Archaeology in Iraq, *Science* 293, 32–44

—— 2003a Mayhem in Mesopotamia, News Focus Special Report: A Museum Looted. *Science* 101, 582–588

—— 2003b Assyrian Gold Safe as Looters Threaten Southern Sites, *Science* 300: 1488

—— 2005 Looted Tablets Pose Scholar's Dilemma, Rencontre Assyriologique Internationale Meeting, *Science* 309, 869

The Market Background to the April 2003 Plunder of the Iraq National Museum

Neil Brodie

Saleable artefacts have been plundered from archaeological sites whenever there have been collectors willing to buy them, and for all their importance the sites of Iraq have not been spared. European and later North American collectors and museums started acquiring Iraqi artefacts soon after modern archaeological excavations began there in the 1840s; by the 1880s illegal digging was well established and large quantities of artefacts were being shipped out of the country (Foster *et al.* 2005, 214; Eisenberg 2004, 41). The price of artefacts on the Western market dropped during the first two decades of the 20th century, probably due to their increased availability (Eisenberg 2004, 41), and widespread illegal digging was still being reported in the 1920s, when a Department of Antiquities was established under the British Mandate and backed up by a new antiquities law, which together seem to have had an ameliorating effect (Bernhardsson 2005, 126, 156–7; Gibson 1997, 6). Iraq gained independence in 1932 and a stronger antiquities law was passed in 1974 which prohibited the export of any archaeological artefact except samples for scientific analysis (Foster *et al.* 2005, 217). From the 1960s through the 1980s increased revenue from oil sales allowed the expansion and generous support of the Department of Antiquities, which by the 1970s had become a fully professional organisation, employing alongside archaeologists and other specialists something like 1600 site guards. During this time, clandestine excavation and illegal trade are thought to have stopped almost entirely (Bernhardsson 2005, 179–80; Foster *et al.* 2005, 217; Gibson 2003, 1848; Lawler 2001, 33).

The situation began to deteriorate during the 1980s when the long Iran–Iraq war placed a heavy strain on the Iraqi economy, but worse was to follow in the turmoil that followed the 1991 Gulf War. Eleven regional museums were burgled and by 1995 there was widespread illegal digging. The economic collapse that followed the imposition of a trade embargo by United Nations Security Council Resolution (UNSCR) 661 exacerbated the situation still further, as it became impossible for the Department of Antiquities to maintain adequate staffing levels or to acquire and maintain necessary equipment and vehicles, and so site protection suffered accordingly (Lawler 2001, 34; Gibson 2003, 1848). At the same time, for the general population, real wages dropped and unemployment increased, so that for many people in rural areas archaeological sites

offered a ready source of income. The excavated artefacts found a market in the West, where no action was taken to prevent their illegal export and sale, even in the face of the UN trade embargo.

The market for Iraqi antiquities, 1990–2003

The UN trade embargo should have applied as much to antiquities as to any other class of material, but by 1994 artefacts were flowing out of Iraq onto the international market (Brodie 2006; Lawler 2001), and continued to do so until the Coalition invasion of 2003, and after. By 1994, notice of the UN trade embargo had been provided by the major London and New York auction houses in their relevant sales catalogues. For example, the following statement appeared in the London Christie's catalogue of their 12 December 1990 Fine Antiquities sale:

> A recently imposed United Nations trade embargo prohibits us from accepting bids from any person in
> Iraq and/or Kuwait (including any body controlled by Iraq or Kuwait residents or companies, wherever
> carrying on business), or from any other person where we have reasonable cause to believe (i) that the
> Lot(s) will be supplied or delivered to or to the order of a person in either Iraq or Kuwait or (ii) that the
> Lot(s) will be used for the purposes of any business carried on in, or operated from, Iraq or Kuwait.

Bonhams' first ever Antiquities sale catalogue of April 1991 contained a similar statement, and so too did comparable Sotheby's catalogues (for example, in the catalogue for the London December 1992 sale). What is remarkable about these statements, however, is that they are aimed very much at potential buyers. There is no mention of potential consignors, and no prohibition on consignments originating in Iraq, even though Article 3(a) of UNSCR 661 stated specifically that states should prevent 'The import into their territories of all commodities and products originating in Iraq or Kuwait exported therefrom after the date of the present resolution;'. It is not surprising then to find evidence suggesting that the auction houses continued to accept consignments of what was most probably material exported in contravention of UNSCR 661. They were able to do so because most material was being sold without provenance.

There have been a large number of Iraqi antiquities in circulation since the 19th century, and more were exported legally during the 20th century before the adoption of the strong 1974 antiquities law. While many of these antiquities are sold with provenance, many are not, and so the trade in these unprovenanced but still licit antiquities is able to provide cover for the entry onto the market of looted material, which is similarly sold without provenance. For example, in the decade leading up to the 1991 Gulf War, and after, most cylinder seals on the London market were traded without provenance, as shown by the numbers of cylinder seals offered for sale at the main London and New York auction houses over the period 1980–2005 (see Plates 2 and 3). The 1990 UN trade embargo made no impact whatsoever on the volume of this trade, which, if anything, increased through the 1990s and up to 2003. An unknown proportion of these unprovenanced seals might well have been acquired and taken out of Iraq illegally, though it would be difficult to prove illegal export for any one individual lot. Subsequent events, however, have confirmed that this was most probably the case.

In May 2003, UNSCR 1483 lifted trade sanctions on Iraq, except for those on weapons and cultural objects. Article 7 of UNSCR 1483 specifically stated that the trade in Iraqi cultural objects was prohibited when 'reasonable suspicion exists that they have been illegally removed' from Iraq since the adoption of UNSCR 661, and that the return of any cultural objects stolen from cultural institutions or other locations in Iraq since that time should be facilitated. UNSCR 1483 was implemented in the United Kingdom as Statutory Instrument 1519, The Iraq (United Nations Sanctions) Order (SI 1519). Article 8 of SI 1519 makes it a criminal offence to hold or to deal in any cultural object that has been removed illegally from Iraq since 6 August 1990 (the date of UNSCR 661), unless there is no knowledge or reasonable suspicion of its illegal export. Since the implementation of SI 1519, it is noticeable that unprovenanced cylinder seals have disappeared from the London auction market (Plate 2); this means that either the auction houses or their consignors feel that they do have reason to suppose that some if not all of the unprovenanced material they had been selling was removed illegally, but while they had not felt obliged under previously existing law to act upon that suspicion and stop the sales, the new criminal offence introduced by SI 1519 has proven to be a stronger deterrent. The explicit criminal offence introduced by SI 1519 has been criticised for not being human rights compliant (Chamberlain 2003), but it has focused minds on the possible consequences of selling unprovenanced material, and confirmed that many if not all cylinder seals most likely have a recent illegal origin.

THE SÎN-IDDINAM CUNEIFORM BARRELS

It might be argued that with the large numbers of cylinder seals already in circulation before 1990, there was no real reason during the 1990s to suppose that any had a recent illegal origin, and that the auction houses should therefore be given the benefit of the doubt. But during that time there were other types of artefact turning up on the market that, unlike cylinder seals, were not previously well known outside Iraq. The appearance of these objects should have raised questions about provenance, but did not.

In the late 1990s and early 2000s, for example, a series of Old Babylonian cuneiform-inscribed clay barrels appeared for sale at the major auction houses. Inscribed barrels of this sort, in the region of 11 to 15 cm high, are usually found in architectural foundation courses. These particular barrels each carry an identical cuneiform inscription recording Sîn-iddinam's achievement of dredging the river Tigris. Sîn-iddinam was king of Larsa (1905–1898 BC) at a time when the city's sovereignty extended over much of Sumer and Akkad in what is today southern Iraq.

The first of these barrels to appear was offered for sale at Sotheby's New York in May 1997. Fortuitously, Toronto's Royal Inscriptions of Mesopotamia project had published its corpus of all known Old Babylonian royal inscriptions only a few years earlier (Frayne 1990), and it was easy for Sotheby's to check their barrel against known comparanda. The relevant catalogue entry correctly states that at the time there were only three comparable pieces known, one each in the Louvre, the Ashmolean Museum, and Chicago's Oriental Institute. The fact that the Sotheby's barrel had apparently just 'surfaced' might have

raised questions about its provenance, but if it did, they were not enough to stop the sale. At the next Sotheby's New York auction, in December 1997, another barrel carrying the same inscription was offered for sale, and this time the catalogue listed four comparanda, including the barrel sold earlier that year, in May. At Christie's New York the same month, a third barrel appeared. Since then, more barrels have been offered for auction (Table 1), and at least two have turned up outside the auction market, one at Fortuna Fine Arts of New York in 2000,[1] the other at the Barakat Gallery of Beverly Hills and London in 2005 (item no. PF.5531). In total, since 1997, when the first one appeared at Sotheby's, at least 11 previously unknown barrels have appeared for sale, almost a four-fold increase in the size of the known corpus in less than ten years.

It is hardly credible that so many of these barrels should have lain dormant in old collections and hidden for decades from dedicated researchers, only to appear *en masse* at a time when there was widespread looting of archaeological sites in southern Iraq. A more parsimonious explanation for their sudden appearance is that, in fact, they *had* been plundered and removed illegally from Iraq. If this was the case, the due diligence procedures of the major auction houses in place during the 1990s and early 2000s were clearly inadequate. Yet this was a time when in the wake of allegations of misconduct in its London Antiquities Department (Watson 1997), Sotheby's claimed to have instituted a new code of conduct with the express purpose of guarding against the sale of illegally-acquired antiquities (Alberge & McGrory 1997).

The Aramaic incantation bowls

The Antiquities sales of the large auction houses attract a lot of critical attention, but this is due in part to the fact that the material offered for sale is published systematically and comprehensively – albeit without much information about provenance – in well-illustrated catalogues, and is therefore open to public scrutiny. Recent research, however, has pointed to the importance of the 'invisible market', where the large bulk of archaeological material, including the most valuable objects, is traded away from public view (Nørskov 2002, 270; Watson & Todeschini 2006, 312–14). This is as true for Iraqi material as it is for material originating elsewhere. For example, it was reported in the mid-1990s that illegally-removed pieces of relief sculpture from the Assyrian palaces of Nineveh were being offered for sale (Russell 1997), though these pieces have not publicly 'surfaced' on the market or in collections. Another large corpus of Iraqi material to pass through the invisible market during the 1990s comprised hundreds of Aramaic incantation bowls.

Aramaic incantation bowls are hemispherical or flat-based bowls with Aramaic inscriptions written in ink on their inner surfaces. Each inscription, usually spiralling out from the centre, records a magical incantation intended to ward off malevolent spirits. There are analogous bowls written in Mandaic and Syriac, though the Mandaic and Syriac bowls often adopt other arrangements of text (Hunter 2000a, 171). The bowls were first reported in an archaeological context by Layard (1853, 509, 524), who had discovered them in 1850 at Babylon and Nippur, though two had already been acquired by the British Museum in 1841 (Hunter 2000a, 163).

The best reported archaeological contexts are for bowls that have been excavated at Nippur. Exploratory work during the second University of Pennsylvania expedition to Nippur in 1889 exposed houses immediately below the surface. Each house contained one or more incantation bowls, together with more routine domestic artefacts such as pottery and grindstones (Peters 1897, 182, 194). One house was thought by the excavators to have been the residence of an apothecary or a doctor because of the discovery there of several ceramic containers filled with an unidentified substance and sealed with bitumen (Peters 1897, 183). In total, more than 150 whole or fragmentary inscribed bowls, including Aramaic examples, were recovered (Montgomery 1913, 14). The University of Chicago Oriental Institute's Nippur Expedition returned there for ten seasons between 1948 and 1967, recovering something like 50 whole or fragmentary bowls. Half were taken to the Iraq National Museum and half to Chicago (Kaufman 1973, 170). More bowls were discovered in 1989 (Hunter 1995), and are now in the Iraq National Museum. Outside Nippur, the University of Oxford/Chicago Field Museum excavations of 1923–33 at Kish discovered incantation bowls in the top one metre stratum of the Sasanian settlement (Moorey 1978, 122). On the basis of coins found in context at Nippur and Kish, the currency of the bowls is dated to the 7th and 8th centuries AD.

By 1990, less than a thousand Aramaic bowls were known. In addition to the 238 published examples listed in Table 2, Montgomery (1913, 21) referred to 69 bowls in the 'Berlin Museum' and there is also a collection in Istanbul from the first Nippur project. Thus there were perhaps something in the region of 300–500 bowls outside Iraq, and several hundred more in the Iraq National Museum (Hunter, pers comm). It was a surprise then when many hundreds of previously unknown incantation bowls began to appear in private collections during the 1990s.

In September 2004, a Norwegian Broadcasting Corporation (NRK) television documentary revealed that the Norwegian collector Martin Schøyen had acquired 650 bowls, and that since 1996 they had been held in University College London (UCL) for study and publication by scholars at the university's Institute of Jewish Studies (Lundén 2005, 6–7). Schøyen's representatives claimed that the bowls had been out of Iraq since the 1960s, but NRK counter-claimed to have evidence that the bowls had been discovered in Iraq by clandestine digging in 1992 and transported by road to Amman, and on to London, before being sold to Schøyen.

Mark Geller, who was Director of UCL's Institute of Jewish Studies at the time the bowls were received for study, wrote soon after the sack of the Iraq Museum in defence of his institution's possession of the bowls that 'Many of the sites in Iraq have Jewish Aramaic incantation bowls' and that 'Within the past decade [i.e. 1993–2003], hundreds of Aramaic incantation bowls have appeared on the antiquities market, collected from archaeological sites; there is no evidence that these objects have been stolen from a museum' (Geller 2003). Geller, while trying to convince his critics that the bowls are not stolen property, and were found by chance, seems in fact to have confirmed NRK's version of events.

On 10 October 2004, UCL announced that it had informed the Metropolitan Police of the incantation bowls in its possession and that it was to establish a committee charged with undertaking an investigation into the provenance and rightful ownership of the bowls and also into the university's future policy as regards the acquisition and study of such material. The question of Iraqi provenance was crucial to the UCL enquiry and to Schøyen's claim to good title. If incantation bowls are found only in Iraq, and Schøyen cannot document the history of his bowls back to before August 1990 (the date of UNSCR 661), then the bowls might be forfeit. If, on the other hand, a substantial proportion of the previously known corpus of bowls was found in countries other than Iraq, it would be easier for Schøyen to contend there is no reason to suspect an Iraqi origin for his own bowls.

Although prior to the recent appearance of hundreds of bowls something like 240 had been published, very few were recovered through archaeological excavation; most were acquired on the market (Table 2). Those that have been recovered through documented excavation have come from Iraq. There are several bowls that are said to have come from Iran, though none are known to have been recovered through a documented and published archaeological excavation. It seems possible that some might have been found in the Iranian province of Khuzestan, which geographically and culturally would have been an extension of Sassanian Mesopotamia, but none are confirmed. One Aramaic-inscribed vessel said to have been found at Susa and currently located in a Mumbai museum in India is actually a jug, not a bowl (Unvala 1953, pl. 21). There is also a bowl at the British Museum, said in the accessions register to have been found by Layard at Arban in Syria. Layard did excavate at Arban, in 1850, but he does not record finding an incantation bowl there (Layard 1853, 272–82), nor does he mention an Arban bowl in his conspectus (Layard 1853, 524). Thus, again, it is conceivable that a bowl was found at Arban, but not demonstrable. It remains the case that no Aramaic incantation bowl has been found outside Iraq in circumstances that today can be verified.

The UCL committee of enquiry into the Schøyen bowls submitted its report in July 2006, and a copy was made available to Schøyen, though at the time of writing (October 2007) the contents of the report had still not been made public. In March 2007, Schøyen initiated legal proceedings against UCL for the return of the bowls (Schøyen Collection 2007a), and in June 2007 a joint UCL/Schøyen press release announced that after 'investigation by an eminent panel of experts, and further enquiries of its own, UCL is pleased to announce that no claims adverse to the Schøyen Collection's right and title have been made or intimated', and that 'UCL has now returned the Bowls to the Schøyen Collection and has agreed to pay a sum in respect of its possession of them' (Schøyen Collection 2007b). The agreement for payment and return was made as part of an out-of-court settlement of the action initiated by the Schøyen Collection in March 2007. UCL has steadfastly refused to publish the report of the committee of enquiry or its conclusions and recommendations, and so it is believed that agreement not to publish the report was part of the same settlement.

In October 2007 some of the report's contents were leaked to the journal *Science* (Balter 2007). It was revealed that UCL's committee of enquiry had concluded that the

bowls had probably been removed illegally from Iraq sometime after August 1990, though Schøyen would not necessarily have been aware of that fact. *Science* also reported that the Iraqi authorities intended taking legal action of their own to recover the bowls.

In addition to the Schøyen bowls, there is an unspecified number of previously unknown bowls in the collection of Shlomo Moussaieff (Shanks 2007); 20 have recently been published (Levene 2003a). It is also rumoured that a large consignment of bowls reached the United States towards the end of the 1990s, although this rumour has been hard to confirm. Nevertheless, it is becoming increasingly common to find incantation bowls with the spiral inscriptions characteristic of Aramaic appearing for sale on the Internet. A search on 12 July 2006 discovered 11 examples (Table 3). More have appeared since. It is interesting to note that the findspot of bowls on the Internet is rarely given unequivocally as Iraq, except on the site Baghdad Market Place, which with disarming honesty claimed that:

> Our company has established relationships with Iraqi merchants whose families have been in the antiquities business for generations. During the period when Saddam Hussein was in power, no items of antiquity were allowed to be sold on the open market. During this period, these merchants continued to travel the deserts of Iraq buying and bargaining with the rural Bedouins, herders and farmers. Information about age and provenance for these items comes from the merchants themselves, in addition to research conducted by us.

Thus the Baghdad Market Place, by its own admission, is selling antiquities, including at least one incantation bowl, that were smuggled out of Iraq prior to 2003. It is not possible from the information and e-mail address provided on the site to ascertain its physical location, which is perhaps why it can afford to be so candid.

The information presented in Table 3 also offers an insight into the economic value of scholarly support for the trade. Most of the bowls offered on the Internet are for prices in the range US$ 350–900. The two bowls offered by the Barakat Gallery, however, are priced much higher. One is offered for US$ 6000, and for the other bowl the price is available only on request, and presumably therefore in excess of US$ 6000. Similarly, four bowls were offered at Christie's London in their May 2003 Antiquities sale with estimated prices in the region US$ 5000–9000. The apparent added value of the Barakat and Christie's bowls probably derives from the fact that they were accompanied by translations of their texts. The translations increase the interest of the bowls, but also, and more importantly perhaps, attest to their authenticity as Aramaic creations, and also to their magical potency – some bowls were originally inscribed with a nonsense pseudoscript, presumably either by an illiterate scribe or for an illiterate client. Thus scholarly intervention has increased the price of the bowls ten-fold.[2]

Incantation bowls with documented contexts normally have good associations and a secure stratigraphy. They are not 'collected' as Geller (2003) maintains. Presumably, the unrecorded extraction of hundreds of bowls will have caused a large amount of archaeological damage. It is possible from the published report of Hunter (1995, pers comm) to make an approximate quantification of the real extent of the damage. Hunter discusses some incantation bowls found during excavations at Nippur in 1989, where

three Aramaic bowls were found buried in a courtyard. The excavated area was 230m^2, thus one Aramaic bowl was found for every 77m^2. Extrapolating from this figure to the 650 bowls thought to constitute the Schøyen collection, they would have been derived from a minimum area of 50,000m^2, or 5 hectares (an area slightly larger than that of Trafalgar Square in London).

CONCLUSION

Matthew Bogdanos, who led the official US investigation into the National Museum thefts, has reported anecdotal evidence that professional antiquities thieves moved into Baghdad hotels in the run-up to war (BBC 2006), and he has also concluded from his investigation that some of the thefts were carried out by knowledgeable thieves and involved some degree of forward planning (Bogdanos 2005, 213–15). For higher quality items there might already have been buyers in place before the theft occurred (Bogdanos 2005, 215), while the transportable material stolen from the basement was most likely directed to a middleman buyer who would be able to arrange its transport out of Iraq for subsequent dispersal on the international market (Bogdanos 2005, 216). Thus Bogdanos believes that a well-organised criminal network was already in place before the 2003 Coalition invasion, waiting to take advantage of any breakdown in museum security that might ensue.

The facility with which material stolen from the Museum was transported out of the country confirms that mechanisms and routes for smuggling Iraqi archaeological objects had been tried and tested during the 1990s. Within three weeks of the National Museum thefts, stolen material had been moved out of Iraq to London, and then to the United States. On 30 April 2003, US customs officials at Newark Airport seized four FedEx boxes that had arrived from London addressed to a New York art dealer. The boxes contained 669 artefacts that had been stolen from the National Museum (Bogdanos 2005, 229; Bailey 2003, 1). And it is by no means certain that US customs intercepted the first or the only shipment.

The burgeoning export of artefacts during the 1990s was clearly in contravention of the 1974 domestic antiquities law, noted above, and though the relevant stolen property statutes of the United Kingdom and the United States might have been used to prosecute the trade, no prosecutions were forthcoming. International regulatory instruments offered another possible means to stem the trade, but their effectiveness was compromised because of poor subscription or for procedural reasons. Iraq had joined the 1970 UNESCO *Convention on the Means of Prohibiting and Preventing the Illicit Import, Export and Transfer of Ownership of Cultural Property* in 1973, but the United Kingdom did not follow the Iraqi example until 2002, and although the United States had partly implemented the Convention in 1983, and could have made a constructive response to an Iraqi request for US import control, in the absence of diplomatic relations between the two countries such a request was not possible (Foster *et al.* 2005, 270). The 1954 *Hague Convention for the Protection of Cultural Property in the Event of Armed Conflict* together with its 1954 First Protocol (and later 1999 Second Protocol) could also, in principle, have offered

some protection. Although the Convention itself is designed to protect cultural heritage from intentional military action and from removal or destruction by occupying powers, its First Protocol is concerned with the prevention of illegal trade and arrangement for the return of illegally-traded material. Iraq has been party to the Convention and its First Protocol since 1967, but during the 1990s neither the United States nor the United Kingdom had ratified the Convention (and still had not by the time of writing in 2007). Both countries had signed the Convention, which means that they should recognise its principles, though the sincerity of their commitment can be questioned (Foster *et al.* 2005, 255–6). Finally, there was the 1990 UNSCR 661 trade embargo. But although it was completely flouted by the ongoing export, the political action necessary to achieve its enforcement was not forthcoming.

In retrospect, it is all too easy to see that during the 1990s, political and ultimately academic and public apathy allowed the illegal trade in looted Iraqi antiquities to develop and prosper. Despite the best efforts of a small number of academics and journalists, most of academia and the media seem to have been unaware of what was happening. Those profiting from the trade, either commercially or academically, looked the other way. Politicians were under no pressure to ensure more effective law enforcement, although there was a range of regulatory laws at their disposal. The public outcry that followed the burglary of the Iraq National Museum finally forced the UK government to take decisive action against the trade, and in 2003 it implemented SI 1519 as noted above and also enacted the Dealing in Cultural Objects (Offences) Act, and in 2004 announced its intention to ratify the 1954 Hague Convention and its two Protocols. Arguably, if such action had been taken in the 1990s, and followed through with effective enforcement, the illegal trade in Iraqi antiquities might have been stopped from taking root. Then there would have been no point in robbing the National Museum in 2003, as there would have been no market for the stolen material.

ACKNOWLEDGEMENTS

I would like to thank Joan Oates and John Russell for their help on the Sîn-iddinam barrels and on Layard, and Erica Hunter for her help on the incantation bowls.

TABLE 1. SÎN-IDDINAM INSCRIBED CUNEIFORM BARRELS OFFERED FOR SALE AT AUCTION BETWEEN
1997 AND 2002

Sotheby's New York, May 1997, lot 165
Sotheby's New York, December 1997, lot 175
Christie's New York, December 1997, lot 30
Christie's London, April 1998, lot 71
Christie's New York, December 1998, lot 251
Sotheby's New York, December 1998, lot 210 (possibly the one offered at Christies New York in December
 1997)
Bonhams London, October 1999, lot 255
Christie's New York, December 1999, lot 512
Christie's New York, June 2001, lot 350
Bonhams London, November 2002, lot 209
Christie's New York, December 2002, lot 285 (the one sold at Christie's New York in December 1997).

TABLE 2. PREVIOUSLY KNOWN ARAMAIC INCANTATION BOWLS. ALL FINDSPOTS ARE IN IRAQ UNLESS
NOTED OTHERWISE.[3]

Reference	Bowls
Cook 1992	1 (Oriental Institute), excavated at Tell Khafaje.
Franco 1978–9	5 (Iraq National Museum), excavated at Ctesiphon.
Gawlikowski 1990	1 (? location), excavated at Bidjân.
Geller 1976	1 (private ownership), no findspot
Geller 1980	2 (private ownership), no findspots; 1 (private ownership), bought in Teheran; 1 (Gulbenkian Museum), no findspot.
Geller 1986	7 (private ownership), 1 said to be Iraq, remainder no findspots.
Gordon 1934	7 (Istanbul and Iraq National Museum), said to be from Iraq.
Gordon 1937	2 (private ownership), no findspots.
Gordon 1941	2 (Harvard Semitic Museum), no findspots; 2 (Jewish Theological Seminary), no findspots; 12 (Ashmolean Museum), excavated at Kish; 1 (Ashmolean Museum), said to be from Iran; 18 (Hilprecht Collection), probably excavated at Nippur; 1 (Metropolitan Museum), excavated at Ctesiphon; 9 (Louvre), no findspots.
Gordon 1951	1 (private ownership), no findspot.
Gordon 1984	2 (private ownership), no findspots.
Harviainen 1981	1 (private ownership), bought at Borsippa.
Hunter 1995	4 (Iraq National Museum), excavated at Nippur.
Hunter 1996	1 (Cambridge University), no findspot
Hunter 2000a	75 (British Museum), 4 excavated at Kutha, 2 excavated at Babylon, 1 excavated at Nineveh, 7 said to be from Babylon, 5 said to be from Babylon or Borsippa, 1 said to be from Sippar, 3 said to be from Nimrud, 1 said to be from Uruk, 1 said to be from Arban (Syria), 50 no findspots.
Hunter 2000b	2 (Iraq National Museum), said to be from Babylon.
Isbell 1976	1 (Chicago Oriental Institute), excavated at Nippur; 1 (private ownership), said to be Susa, Iran.
Hyvernaut 1885	1 (Musée Lycklama de Cannes), said to be found at Babylon.
Kaufman 1973	1 (Chicago Oriental Institute), excavated at Nippur.
Koldeway 1911	Numerous, excavated at Borsippa.

Lacau 1893 1 (private ownership), no findspot.
Levene 2003b 2 (Pergamon Museum), said to be from Iraq.
McCullough 1967 2 (Royal Ontario Museum), no findspots.
Montgomery 1913 30 (Pennsylvania University Museum), excavated at Nippur.
Moriggi 2001 1 (Museo Nazionale d'Arte Orientale), bought in Tehran, Iran.
Moriggi 2005 2 (private ownership), no findspots.
Müller-Kessler 1994 1 (Museum für Vor- und Frühgeschichte zu Berlin), no findspot; 1 (private
 ownership), no findspot.
Naveh & Shaked 1985 3 (Hebrew University of Jerusalem), no findspots; 4 (Israel Museum), no
 findspots; 1 (National and University Library, Jerusalem), no findspot; 1
 (Jewish Historical Museum of Belgrade), said to be from Iraq; 2 (private
 ownership), 1 said to be from area of Jerusalem, 1 no findspot.
Naveh & Shaked 1993 1 (Bible Lands Museum), no findspot; 1 (Smithsonian Institution), no
 findspot; 8 (private ownership), no findspots.
Obermann 1940 4 (Yale University), no findspots.
Schwab 1890 & 1891 1 (Musée Lycklama de Cannes), no findspot; 3 (Musée Dieulafoy), said to
 have been excavated at Susiana, Iran; 2 (Bibliothèque Nationale de Paris), no
 findspots; 1 (Musée de Winterthur), no findspot.
Smelik 1978 1 (Allard Pierson Museum), no findspot.
Wohlstein 1893 & 1894 5 (Königlichen Museums zu Berlin), no findspots.
Yamauchi 1965 1 (private ownership), said to be from Iran.

TABLE 3. ARAMAIC INCANTATION BOWLS FOUND FOR SALE ON THE INTERNET ON 12 JULY 2006.[4]

Vendor	Material description	Findspot	Asking price
Janus Antiquities (Akron, Ohio)	1 Judaic incantation bowl	Holy Land	$450
Windsor Antiquities (New York City)	3 Ancient Aramaic inscribed incantation bowls	Syria	$350;$300; $400
Barakat Gallery (Beverly Hills, California; London, UK)	1 terracotta demon bowl	Near East	On request
Barakat Gallery	1 Babylonian demon bowl	Iran/Iraq	$6000
Jerusalem Antiquities (Jerusalem, Israel)	2 Byzantine/Talmud incantation bowls	Israel	$500; $600
Ancient Creations	1 incantation bowl	Holy Land	$895
Baghdad Market Place (Location not known)	2 Babylonian incantation bowls	Southern Iraq	$600; $750

NOTES

1. I thank John Russell for drawing my attention to this barrel.
2. In the event, one month after the sack of the Iraq National Museum, the Christie's bowls did not sell.
3. Some bowls have been published more than once, with improved editions of their texts. This table avoids duplication by counting only the reference with the best provenance-related information. Thus some publications may refer to more bowls than are listed here. The table is intended to be an archaeological corpus of bowls, not a reference list of reproduced and translated texts.
4. The Internet addresses of the named dealers are: Ancient Creations: http://www.ancientcreations.com/index.asp – The Barakat Gallery: http://www.barakatgallery.com/ – Baghdad Market Place: http://www.baghdadmarketplace. com/page10.html – Janus Antiquities: http://www.trocadero.com/janus/ – Jerusalem Antiquities, on ebay at: http:// cgi3.ebay.com/ws/eBayISAPI.dll?ViewUserPage&userid=homesell – Windsor Antiquities: http://www.vcoins.com/ ancient/windsorantiquities/store/dynamicIndex.asp

BIBLIOGRAPHY

Alberge, D, and McGrory, D, 1997 Smuggled art clampdown by Sotheby's, *The Times*, 17 December

Bailey, M, 2003 Seized: over 600 objects looted from Iraq, *The Art Newspaper*, September, pp1, 3

Balter, M. 2007 University suppresses report on provenance of Iraqi antiquities *Science* 318, 554–5

BBC (2006) In Search of Iraq's Treasure. BBC Radio4, broadcast 6 September 2006

Bernhardsson, M T, 2005 *Reclaiming a Plundered Past: Archaeology and Nation Building in Modern Iraq*, University of Texas Press, Austin

Bogdanos, M, (with W Patrick) 2005 *Thieves of Baghdad*, Bloomsbury Publishing, New York

Brodie, N J, 2006 Iraq 1990-2004 and the London antiquities market, in (eds N J Brodie, M M Kersel, C Luke and K W Tubb), *Archaeology, Cultural Heritage, and the Trade in Antiquities*, 206–226, University Press of Florida, Gainesville

Chamberlain, K, 2003 The Iraq (United Nations Sanctions) Order 2003 – is it Human Rights Act compatible? *Art, Antiquity and Law* 8, 357–68

Cook, E M, 1992 An Aramaic incantation bowl from Khafaje, *Bulletin of the American School for Oriental Research* 285, 79–81

Foster, B R, Foster, K P and Gerstenblith, P, 2005 *Iraq Beyond the Headlines. History, Archaeology and War*, World Scientific, Singapore

Eisenberg, J M, 2004 The Mesopotamian antiquities trade and the looting of Iraq, *Minerva* 15(4), 41–44

Franco, F, 1978–9 Five Aramaic incantation bowls from Tell Baruda (Choche), *Mesopotamia* 13–14, 233–49

Frayne, D, 1990 *The Royal Inscriptions of Mesopotamia, Early Periods. Volume 4. Old Babylonian Period*, University of Toronto Press, Toronto

Gawlikowski, M, 1990 Une coupe araméenne, *Semitica* 38, 137–43

Geller, M J, 1976 Two incantation bowls inscribed in Syriac and Aramaic, *Bulletin of The Institute of Oriental and African Studies* 39, 422–7

—— 1980 Four Aramaic incantation bowls, in *The Bible World. Essays in Honor of Cyrus H. Gordon* (eds G

Rendsburg, R Adler, M Arfa and N H Winter), 47–60, Institute of Hebrew Culture and Education of New York University, New York

—— 1986 Eight incantation bowls, *Orientalia Lovaniensia Periodica* 17, 101–17

—— 2003 *Spies, thieves and cultural heritage*, available at: http://www.ucl.ac.uk/hebrew-jewish/ijs/news.htm. [15 July 2006]

Gibson, M, 1997 The loss of archaeological context and the illegal trade in Mesopotamian antiquities, *Culture Without Context*,1, 6–8

—— 2003 Fate of Iraqi archaeology, *Science* 299, 1848–49

Gordon, C H, 1934 Aramaic magical bowls in the Istanbul and Baghdad Museums, *Archiv Orientální* 6, 319–34, 466–74

—— 1937 Aramaic and Mandaic magical bowls, *Archiv Orientální* 9, 84–106

—— 1941 Aramaic incantation bowls, *Orientalia* 10, 116–41, 272–84, 339–60

—— 1951 Two magic bowls in Teheran, *Orientalia* 20, 306–15

—— 1984 Magic bowls in the Moriah collection, *Orientalia* 53, 220–41

Harviainen, T, 1981 An Aramaic incantation bowl from Borsippa, *Studia Orientalia* 51(14), 1–25

Hunter, E C D, 1995 Combat and conflict in incantation bowls: studies on two Aramiac specimens from Nippur, in *Studia Aramaica. New Sources and New Approaches*, (Journal of Semitic Studies Supplement 4), (eds M J Geller, J C Greenfield and M P Weitzman), 61–74

—— 1996 Incantation bowls: a Mesopotamian phenomenon, *Orientalia* 65, 220–33

—— 2000a The typology of the incantation bowls: physical features and decorative aspects, in (ed. J B Segal), *Aramaic and Mandaic Incantation Bowls in the British Museum*, 163–88, British Museum, London

—— 2000b Two incantation bowls from Babylon, *Iraq* 42, 139–47

Isbell, C D, 1976 Two new Aramaic incantation bowls, *Bulletin of the American School for Oriental Research* 223, 15–21

Kaufman, S A, 1973 A unique magic bowl from Nippur, *Journal of Near Eastern Studies* 32, 170–4

Koldeway, J C, 1911 *Die Tempel von Babylon und Borsippa*, J C Hinrich, Leipzig

Lacau, P, 1893 Une coupe d'incantation, *Revue D'Assyriologie* 3, 49–51

Lawler, A, 2001 Destruction in Mesopotamia, *Science* 293, 32–35

Layard, A H, 1853 *Discoveries in the Ruins of Nineveh and Babylon*, John Murray, London

Levene, D, 2003a *A Corpus of Magic Bowls. Incantation Texts in Jewish Aramaic from Late Antiquity*, Kegan Paul, London

—— 2003b Hear O'Israel: A pair of duplicate magic bowls from the Pergamon Museum in Berlin, *Journal of Jewish Studies* 54, 104–21

Lundén, S, 2005 TV review: NRK (Norway) Skriftsamleren [The Manuscript Collector], *Culture Without Context* 16, 3–11

McCullough, W S, 1967 *Jewish and Mandaean Incantion Bowls in the Royal Ontario Museum*, University of Toronto Press, Toronto

54

Montgomery, J A, 1913 *Aramaic Incantation Texts from Nippur*, University of Pennsylvania Museum, Philadelphia

Moorey, P R S, 1978 *Kish Excavations 1923–1933*, Clarendon Press, Oxford

Moriggi, M, 2001 Aramaean demons in Rome. Incantation bowls in the Museo Nazionale d'Arte Orientale, *East and West* 51, 205–28

—— 2005 Two new incantation bowls from Italy, *Aramaic Studies* 3, 43–58

Müller-Kessler, C, 1994 Eine aramäische Zauberschale im Museum für Vor- und Frühgeschichte zu Berlin, *Orientalia* 63, 5–9

Naveh, J and Shaked, S, 1985 *Amulets and Magic Bowls. Aramaic Incantations of Late Antiquity*, Magnes Press, Hebrew University of Jerusalem, Jerusalem

—— 1993 *Magic Spells and Formulae. Aramaic Incantations of Late Antiquity*, Magnes Press, Hebrew University of Jerusalem, Jerusalem

Nørskov, V, 2002 *Greek Vases in New Contexts*, Aarhus University Press, Aarhus

Obermann, J, 1940 Two magic bowls: new incantation texts from Mesopotamia, *American Journal of Semitic Languages and Literatures* 57, 1–31

Peters, J P, 1897 *Nippur, or Explorations and Adventures on the Euphrates. Volume 2. Second Campaign*, Putnam, London

Russell, J M, 1997 The modern sack of Nineveh and Nimrud, *Culture Without Context* 1, 8–20

Schøyen Collection 2007a. Schøyen Collection sues University College London for recovery of incantation bowls, available at: http://www.schoyencollection.com/news_articles/UCL-090307.htm. [31 October 2007]

Schøyen Collection 2007b. The Schøyen Collection of Aramaic incantation bowls, available at http://www.schoyencollection.com/news_articles/bowlsreturned-260607.htm. [31 October 2007]

Schwab, M, 1890 Les coupes magiques et l'hydromancie dans l'antiquité orientale, *Proceedings of the Society of Biblical Archaeology* 12, 292–342

—— 1891 Coupes à inscriptions magiques, *Proceedings of the Society of Biblical Archaeology* 13, 583–95

Shanks, H, 2007 Magic incantation bowls, *Biblical Archaeology Review* January/February, 62–5

Smelik, K A D, 1978 An Aramaic incantation bowl in the Allard Pierson Museum. *Bibliotheca Orientalis* 35, 174–7

Unvala, J M, 1953 An Aramaic incantation vase from Susa, in Gokhale, P B, *Indica. The Indian Historical Research Institute Silver Jubilee Commemoration Volume*, 413–14, St Xavier's College, Bombay

Watson, P, 1997 *Sotheby's. The Inside Story*, Bloomsbury, London

Watson, P, and Todeschini, C, 2006 *The Medici Conspiracy*, Public Affairs, New York

Wohlstein, J, 1893 Ueber einige aramäische Inschriften auf Thongefässen des Königlichen Museums zu Berlin, *Zeitschrift für Assyriologie* 8, 313–40

—— 1894 Ueber einige aramäische Inschriften auf Thongefässen des Königlichen Museums zu Berlin, *Zeitschrift für Assyriologie* 9, 11–41

Yamauchi, E M, 1965 Aramaic magic bowls, *Journal of the American Oriental Society* 85, 511–23

The Metropolitan Police's Art and Antiques Unit

Vernon Rapley

The UK, unlike most major European states (for example, Italy, France, Spain, Greece, Germany, and Belgium) does not have a national police force or unit dealing specifically with the illicit trade in antiquities. The unit in the UK that is effectively the only organisation in law enforcement dealing with the prevention of the illicit trade in antiquities in the UK is the Metropolitan Police's Art and Antiques Unit (AAU), based at Scotland Yard in London, and set up in 1969. The Unit is limited in its work for two main reasons: first as it is a branch of the Metropolitan Police it is therefore, in most of its work, confined to policing the country's capital city, and second, as its name suggests, the Unit covers much more than just the trade in illicit antiquities. At any one time the Unit will be involved in between 40 and 100 investigations. Of these only some 10 or 15 will relate to illicit antiquities: in other words the Unit is only able to spend between 20 and 25% of its time and resources dealing with illicit antiquities. The Unit is also small, only comprising four police detectives and two support staff.

Constraints

Given the above staffing levels and wide remit, the first fundamental issue in dealing with the trade in illicit antiquities, and in particular in the context of this chapter the material being illegally exported from Iraq at present, is therefore a lack of resources. A larger, better resourced, national police unit could obvious achieve more than the small team working from within the Metropolitan Police. However, at present, the creation of such a national unit does not appear likely, nor would it address the second fundamental issue in dealing with illicit antiquities – the necessary legal constraints under which any policing in this area has to work (see below).

The Unit's role has evolved over the years. Some years ago it was the only law enforcement team proactively addressing with the whole of the illicit antiquities trade; more recently a clearly defined relationship has been developed with a new specialist unit within Her Majesty's Revenue and Customs which, under the *Dealing in Cultural Objects (Offences) Act 2003*, now has the responsibility of actually preventing the illicit import

of goods into the United Kingdom. Under this legislation Customs will seize tainted cultural objects and prosecute persons who commit offences under the Act where such objects are discovered and there is sufficient evidence to prosecute. This leaves the AAU to police the London art market, the second largest in the world. It is the Unit's role to ensure that the arts, antiques, and antiquities trade does not engage in illicit activities involving material from anywhere in the world that is in breach of the law in both the UK and the country of origin (see below).

For the AAU to prosecute people for handling supposed illicit objects, the Unit has to know beyond all reasonable doubt that that object is in breach of the law and that that person has handled it or dealt with it in breach of the law. Many hundreds, if not thousands, of antiquities came out of Iraq quite lawfully, from the late 19th century onwards, and the sale of these objects in this country without provenances is quite legal. It is not a dealer's responsibility to show provenance, but rather it is the police's responsibility to show that any given object is illicit, and therein lies the problem between an academic belief that particular objects in a dealer's showroom have been illegally excavated in, and been smuggled out of, Iraq within the last few years and the constraints under which the police work. This is the reality of the situation: experts are almost certainly frequently correct in their assumptions that particular items are illicit and are understandably frustrated that the police cannot act on their academic judgement. However, the police have to work within the law.

Some, but by no means all, dealers are complying with the terms of the UN sanctions Order (2003 Statutory Instrument 2003 1519) that relates to antiquities coming out of Iraq and are voluntarily submitting a great deal of Iraqi material for diligence checks. For example, within the last few months, one dealer submitted approximately 150 objects, allowing the AAU to check them on its database and on the Interpol database to see if they had been reported as stolen. If the objects do not appear on these databases, or they do not have any other obvious identification that would prove they had been stolen (such as a museum catalogue number), they will be returned with a letter stating they do not appear on the databases. Of course, this does not mean that they are not looted or stolen, but simply that the AAU has no evidence to prove otherwise. The databases also, obviously, cannot list those items recently excavated illegally as no academic or museum curator will have ever seen them. However, by submitting the material for diligence checking, the dealer has done everything they can lawfully do to cleanse the objects and make sure that they are not acting unlawfully and will be quite within the law to continue with their open market sale. This is why it is so important that any objects that are known to have been looted or stolen are on these databases; the AAU can only do what is reasonable within its available resources and cannot spend a huge amount of time trying to prove a particular object has been looted simply on the belief – frequently correct – of an expert that the said item is an illicit antiquity. Even if an object appears on one of ICOM's Red Lists (see below) the onus is on the AAU to prove that the specific object has been stolen; no object can be seized or restrained purely because it appears on a Red List – although, of course, the AAU would inform the dealer that an object they had submitted for checking appeared on an ICOM Red List.

The above limitations are further complicated by the requirement that activity has to be in breach of law in two countries (the UK and the country of any object's origin). Before an object can been described as illegal under UK law it has to be identified as illegal under the law of the country of origin. The onus is on the police to show that any given object has been illegally removed from the country of origin before any action can be taken in the UK. In other words, in the case of archaeological antiquities, the Unit has to prove that an object has been stolen or illegally excavated since the date of appropriate legislation in that country. For example, in Afghanistan the key relevant legislation was passed in 1958, in Egypt the date is 1971. The AAU cannot, for these legal reasons, use the usual date of 1970, as identified by UNESCO in its 1970 *Convention on the Means of Prohibiting and Preventing the Illicit Import, Export and Transfer of Ownership of Cultural Property*, and as used by most museums as a cut-off point. By reference to the law of the country of origin in this way the AAU can testify in a UK court that any given object is considered to be stolen from the country of origin in accordance with its law. UK courts commonly require a lawyer from the country of origin to testify in court to the validity of its law in order to allow the UK judge to compare the two sets of legislation and satisfy themselves that the object under scrutiny is legally considered to be stolen within the terms of the law in both the UK and country of origin.

This requirement for cross-referencing of legislation is key and is the reason behind the frustration felt by many archaeologists who cannot understand why the police are not more proactive. Without such cross-referencing no criminal proceedings can be brought within the UK. It is also extremely difficult to achieve. For example, legislation in Afghanistan has not been updated since 1958, so when a lot of what archaeologists would refer to as looted antiquities came in from Afghanistan the AAU had to rely on Afghan legislation from 1958 to declare it stolen. Unfortunately, the Taliban regime in the interim period was deemed to have breached its own laws covering export of antiquities leaving open the argument that if a government has disregarded its own legislation then the laws breached cease to have legal standing. If this argument is accepted, and the Crown Prosecution Service sees the likelihood of conviction so remote that it is not in the public interest to pursue, then there has been no theft and the AAU cannot prosecute individuals in the UK. Luckily, the same problem does not exist with respect to Iraq where relevant legislation has been consistently updated. Rumours that members of the government gave items from antiquity away at various points may be true but would be, almost certainly, treated as isolated crimes at specific times under Iraqi law, and therefore would not constitute a total breach of the legislation.

Finally, the AAU also faces the problem that material has to be returned to the country from where it can be proved it came. This may not be the actual country of origin. Thus, despite the fact that AAU staff may be absolutely convinced by an academic argument that a particular piece originated in Iraq (frequently pinpointed to a particular region or site), it may, by law, have to be returned to, for example, Syria because that is where it can be proved to have entered the UK from. Syria may, with some justification, claim ownership and so the AAU is bound again by the law to do what is reasonable. In a case where material has no clear provenance in Iraq it is quite possible, although perhaps

unlikely, that 'obviously Iraqi' material may have been excavated and sold at almost any time in the past and that it has been sitting in modern Syria for hundreds of years. In this way, if the legal trail leads to a Syrian origin, the object effectively becomes Syrian cultural heritage as it can be proved to have come from there and the AAU has to return it there. The best answer to this situation is to stop material leaving Iraq in the first place and, after actual protection of sites, border control is the fundamental first step in the combating of illicit trade. At that point it is legally easy to ascertain that the material is coming out of Iraq. At the point the AAU see it, two or three steps down the line, it is extremely difficult to prove it has come out of Iraq, let alone when it has come out, or whether it has been illegally excavated or actually stolen.

The AAU does have success stories. Most of these are when, following an AAU investigation, a dealer or individual possessing items accepts that they are probably illicit. They may, probably did, not realise this when they purchased the material in good faith but, frequently because of AAU attention, a decision is made to return the objects via the Metropolitan Police to the country of origin. In this situation, the dealer or individual will lose their money, and the AAU will return the items to Iraq. There have been particular success stories for example, with respect to Iraq, the return of a manuscript by the famous Arab physician Ar-Razi dating from AD 1013, that had been stolen from the AwQaf Library in Mosul in 1977 and was intercepted in London in 2003 when it was attempted to be sold to a London auction house. The auction house contacted the AAU and, while there was insufficient evidence to obtain a conviction, the manuscript was disclaimed by

Fig 1. Detective Sergeant Vernon Rapley returning Peruvian head-dress

Photo: Metropolitan Police

the individual trying to sell it and the AAU was thus able to return the manuscript to Iraq. At the same time an incantation bowl, believed to have been illegally excavated from Iraq was also returned. The AAU received information that the bowl was being sold in Grays Mews Market in London and, again while there was insufficient evidence to bring a prosecution, the dealer opted to disclaim the object thus enabling the AAU to return it to Iraq.

However, the AAU's real impact on the trade in illicit antiquities has been an educational one. This falls into two elements: first, the real educational role of teaching dealers and collectors about the laws relating to illicit trade; and second, it is the fact that the AAU exists, that the market knows the AAU is policing them, which almost certainly prevents significantly more crime than takes place or is detected.

Remit and collaboration

While the AAU is restricted to working on crime relating to London this does, on occasion, mean that it can work outside the capital when criminal activity occurs in other parts of the country, or world, that affects London. As London has such a large international art market the stretch of the AAU tends to be much wider than much of the rest of the Metropolitan Police. For example, many fakes and forgeries of art works are, at the moment, created in the north of England. However, as these fakes and forgeries appear on the art market in London they start to cause real financial damage and this then becomes a concern for the AAU. The Unit is therefore able to work with forces elsewhere in the UK to stop this impact on the London art market. In the same way, very often antiquities, and forgeries and fakes, will come into London when they have been routed from somewhere else in the world or forged and faked somewhere else, but as they have an impact on the London market, the AAU has the remit to become involved and therefore has the ability to work with law enforcement agencies in other parts of the world.

In this way the AAU has built up very good relationships with a wide range of law enforcement agencies from all over the world, including with forces in many countries that are not generally perceived as having good links with the police or the UK. This is mainly because the UK is accepted as a 'market' country and therefore the AAU is seen to be helping other countries (in trying to return their stolen heritage) far more than actually asking for help. Compared to a significant number of countries – for example Iraq, Iran, Syria, Cambodia, Nigeria, or many countries in South America – the UK is not usually a victim or 'source' country as far as art, antiques, and antiquities are concerned. Neither does it lose fine art to the extent of countries such as Greece, Italy, or Egypt. The UK is, sadly, a country that handles the material that is stolen from elsewhere, and therefore its main role is to help these countries retrieve material they have lost. Thus the AAU has very good working relationships with countries such as Turkey, Iran, with Iraq to some extent, with South American countries, Colombia in particular, that perhaps policing has found difficult in other areas to bridge.

While staff in the AAU have good personal relationships in this way, there are some countries that do not share intelligence, and some that the AAU is, for various reasons,

effectively prohibited from working with, either because UK laws are so inconsistent with theirs, or where, for example, if the AAU provided information that led to a conviction the result would be the death penalty. Despite these few instances where collaboration is impossible, on the whole the AAU works very closely, and very effectively, with other police forces around the world.

In the same way the AAU has very good relations with Interpol that has a dedicated art team in Lyon, at its Headquarters. Interpol is the world's largest international police organisation, with 186 member countries. Created in 1923, it facilitates cross-border police cooperation, and supports and assists all organisations, authorities and services whose mission is to prevent or combat international crime. Its five priority crime areas are: drugs and criminal organisations; financial and high-tech crime; fugitives; public safety and terrorism; countering terrorism, which threatens public safety and world security; and trafficking in human beings. However, Interpol is not, *per se*, an international police force; it does not have an executive function, rather, it is an intelligence gathering and dissemination agency, and therefore it is very heavily reliant on the information that is fed to it by member, and other, countries. In the area of illicit antiquities Interpol has, for example, been trying to teach border patrols and border guards what to look for and how to handle and deal with objects when found. As ever, it has a very limited expertise in this area – its arts team consists of three detectives (French, German, and Italian), and one Spanish assistant – and so it has to rely very heavily on the expertise of member-state law enforcement agencies such as the Caribinieri and archaeologists and other experts willing to help (and see Zottin, chapter 24 for the work of the Caribinieri in Iraq). Thus while such training and activity is not done *by* Interpol it is done *through* Interpol.

Perhaps the most important function of Interpol has been the dissemination of intelligence, acting as a conduit between national police forces. The AAU receives, and feeds in, a lot of information in this way. Much of this information can be highly sensitive and by passing it through Interpol law enforcement agencies can protect their original sources. In situations where two countries may not have good relations, the sharing of information through Interpol may be the only way to apprehend criminals and confront the trade in illicit antiquities. Other countries may not regard the loss of heritage from Iraq as high on their agenda, but individual law enforcement officers in these countries may come across information that they realise will be useful and are willing to pass on information that can be shared through Interpol without causing 'national embarrassment'. It is a sad reflection of the world, that the Interpol arts team only comprises three detectives and that of these one is retired and back on his sixth extension, because no-one can be found to replace him, one has just had a one year extension put in place, while the third has only been there for less than a year. Just as with the AAU, there is a limited amount three officers can achieve, and of course combating the trade in illicit antiquities – and in particular the present Iraqi situation – is just one of their responsibilities as, just as the AAU, they are not an antiquities unit but deal with art, antiques, cultural property, shipwrecks and more. This said, Interpol's work, and the AAU's liaison with the Interpol arts team, has been extremely beneficial to both parties.

Interpol, and most law enforcement agencies it is fair to say, were caught slightly by surprise by the extent of the looting and illegal excavation that was happening in Afghanistan. As a result measures were put into place far more quickly with regard to the looting in Iraq. The AAU sits on most Interpol working groups, when staff are able to attend. In particular the AAU sits on Interpol's Tracking Task Force (Iraq) (ITTF), a group of law enforcement officials who work in close liaison through Interpol with an Expert Working Group (IEWG). The IEWG meets annually in Lyon and these meetings are preceded by two or three months by a meeting of the IEWG. The initial membership of the ITTF comprised the market countries (in this instance the USA, UK, Switzerland, France and Italy) and the victim country, Iraq. It quickly became clear that most of the material was not coming directly out of Iraq, but rather through what are known as 'transit' countries: Jordan, Syria, Iran, and the United Arab Emirates and so law enforcement officers from these countries were also invited to join the TTFI. However, attendance at these meetings in Lyon by colleagues from the Middle East was poor and so the TTFI met in Amman in Jordan where attendance was much higher and where, as a result, the meeting was far more useful. Unfortunately, Interpol does not have the resources to fund meetings on this topic in Amman on a regular basis and, understandably, national (or in the case of the AAU, city) police forces often do not prioritise such crime highly enough to fund their own officers to attend – either in Amman or Lyon. The TTFI has, however, been very helpful as it has allowed the police to receive information from archaeological experts. This means that police activity is not just guided by police intelligence, but that it works with information supplied by experts in the field. This liaison allows the AAU and other police forces to have an understanding of the type of material for which they should be alert.

This continuing relationship with experts has been crucial in the tracking and identification of material from Iraq as was the rapid production, in collaboration with Interpol, of ICOM's *Emergency Red List of Iraqi Antiquities at Risk* (http://icom.museum/redlist/irak/en/index.html: accessed 20 April 2007). This particular Red List has been the most useful of all Red Lists that have ever been produced, because it came out so quickly. Experience has shown, sadly, that when looting takes place, it takes place very rapidly, with a quick dispersal of materials throughout the world to the market and then to collectors, and the fact that three or four years later the most perfect Red List comes out, is a bit like closing a stable door long after a horse has bolted. Such information is far too late for law enforcement agencies. What the police would like to see is Red Lists coming out within two weeks of a major event such as the looting of the Iraq Museum but we realise this is, in most instances, an impossible aspiration. The Iraq Red List came out within a few months of the looting and was immediately handed out to police officers and customs officers in the relevant areas. This was exactly what is needed: a simplistic, generic guide to the sort of objects of which law enforcement officers should be suspicious. It has to be accepted that perhaps 99% of law enforcement officers, both police and customs, do (or at least did) not know what a cuneiform tablet looks like, but as soon as they were provided with a clear picture, and told that this was the sort of thing for which they should be looking, they were able to start to look for them, and start to find them.

Much police work is about trust and knowing people. Just as the AAU has good relations with other law enforcement agencies it is always open to developing other relationships with individuals or organisations that might help in combating crime. With respect to the looting of the Iraq Museum one extremely useful contact was Matthew Bogdanos and then successive members of the USA forces stationed at the Museum. This type of direct link into a war torn country was extremely unusual. When the AAU became aware of, or recovered, items in London that aroused their suspicion staff were able to email Colonel Bogdanos images and ask 'Do you know where they came from?' and he was able to email back and say 'I think they came from shelf B … row C and this is the curator who last saw them, and this is the curator who will give you a statement and have a look on the bottom and see if it's got this number on it'. Now that was a unique position, and it mattered not at all to the AAU whether he was a curator, a museum official or a USA Marine Corps colonel: the fact was the he could provide the information in a real time situation was an advantage that the unit had never had before. This relationship was built and has been retained. Colonel Bogdanos was also able to introduce AAU staff to various other members of his team, and to other people in Iraq who the AAU could immediately trust, and who could speak English, and he could provide communication with Iraq to facilitate such interaction. In a similar way the AAU has had limited contact with the UK military but because of the particular circumstances in relation to Iraq, this has not been anywhere near as useful as the link with the USA Marine team based in the Iraq Museum.

More broadly the AAU has benefited enormously from informal links with the *Illicit Antiquities Research Centre* (IARC) in Cambridge (and see Introduction, chapter 1). The IARC has become invaluable to the AAU and has developed as the AAU's first port of call for confidential, trusted, expert advice as it has a detailed understanding of the issues and understands how to work with the police and customs. Crucially, if the AAU needs an expert in a particular area, if the IARC does not possess the expertise within house, they will find the necessary expert for us, anywhere in the world. AAU staff can e-mail the IARC an image, and will get, usually within minutes, a very good idea of what they are dealing with. Such cooperation is vital as frequently police work has to be carried out very quickly. AAU staff may be suspicious of a dealer's collection, or a particular item, but while they may look at it and think that it could be Iraqi (or whatever), such guesswork does not provide the grounds for them to go and seize it. By sending the IARC an image or a drawing or by describing the item or collection the AAU frequently gets something back that provides the grounds for seizure – or, equally importantly, to realise they have been mistaken.

More generally, it is very difficult for the AAU to suddenly react to a problem in a new part of the world of which staff know little if anything about the antiquities. AAU staff will not know how to identify these new antiquities, and they will have to build up a new level of knowledge very quickly. By being able to rely on a unit like the IARC, invaluable support can be provided very quickly, the AAU can act more speedily and crime can be combated more efficiently. It is far quicker to use the expertise of the IARC to train AAU staff than it is for AAU staff to go out and start reading books about a new

area, which will take months instead of days: by which time, most of the looted material will have been lost to collectors, perhaps for good.

The potential, perhaps imminent, closure of the IARC will be very serious for the AAU. The Centre will be very hard to replace, because they have such a broad base of knowledge and they know so many people, and they can be trusted. While the AAU obviously has similar links with other institutions, for example the British Museum and the Victoria and Albert Museum, the loss of the IARC will be a devastating blow to combating the trade in illicit antiquities in the UK.

In an effort to supplement the AAU's relationship with the IARC and other agencies the *Art Beat* project was begun in November 2006. This project comprises the recruitment of Special Constables, with particular expertise and experience in the academic side of our work, who undergo basic police training and who then work one day a fortnight as fully qualified police officers for the Unit. These are senior staff, top experts in their field, who either give us their time for free or whose organisations pay their salary for the day they are working for us (an arrangement the AAU has for example with the Victoria and Albert Museum). By the summer of 2007 the AAU hopes to have 22 such expert Special Constables working one day a fortnight (with some additional hours) which effectively translates into having two additional constables a day. However, while this is a tremendous boost to the Unit's work the AAU still needs its relationship with the IARC and major museums to continue to steer it in the right direction: a special constable may be the world's leading authority on Saxon silver, but if the main problem of the moment is Mesopotamian antiquities or whatever, their expertise is limited.

CONCLUSION

It is ironic that at a time when the UK has recently significantly strengthened its legislation concerning dealing in illicit antiquities (see Gerstenblith, chapter 18), when the country is facing an unprecedented level of cultural property crime, given the increase in looting of antiquities across the world, and given the UK's position in the art market, that not only is the future of the IARC in doubt but so is the future of the AAU itself. The Unit has been told to find private sponsorship within two years or face closure. The AAU is to have a 50% cut in April 2008 and so has to find 50% of its funding from private sponsorship by April 2008, or it will lose half its team. In April 2009 the other 50% of internal funding is to be withdrawn. In other words, within two years the AAU has to be self-financing. This is not a reflection of any perceived failure on the part of the AAU, but rather reflects the conflicting priorities facing the Metropolitan Police. One could have hoped that the country would be putting more effort into this area of crime rather than less, but, sadly, it seems we are faced with exactly the opposite. Cultural property crime will not go away; it will only take another civil disturbance in an area of archaeological interest or another war and what has happened in Iraq and Afghanistan will be repeated elsewhere. Each new location, each new event, needs new understanding, careful policing, and enormous effort if our understanding of the world's cultural heritage is to be deepened. The AAU works to enable academics to research their areas of expertise and museums to display antiquities

for the benefit of both specialists and the general public. We believe our contribution is an effective and important one. A future without a unit such as the AAU will be one where the trade in illicit antiquities, and its corresponding loss of knowledge, will be allowed to flourish.

War, Cultural Property and the Blue Shield

SUE COLE

The 1954 Hague Convention on *The Protection of Cultural Property in the Event of Armed Conflict* arose out of the unprecedented destruction and looting of cultural property that took place during World War II and its immediate aftermath. The Convention takes a deliberately broad view of cultural property[1] both fixed and movable and 'irrespective of origin or ownership':

(a) Movable or immovable property of great importance to the cultural heritage of every people, such as monuments of architecture, art or history, whether religious or secular; archaeological sites; groups of buildings which, as a whole, are of historical or artistic interest; works of art; manuscripts, books and other objects of artistic, historical or archaeological interest; as well as scientific collections and important collections of books or archives or reproductions of the property defined above;

(b) Buildings whose main and effective purpose is to preserve or exhibit the movable cultural property defined in sub-paragraph (a) such as museums, large libraries and depositories of archives, and refuges intended to shelter, in the event of armed conflict, the movable cultural property defined in sub-paragraph (a);

(c) Centres containing a large amount of cultural property as defined in subparagraphs (a) and (b), to be known as 'centres containing monuments'.

The Convention identifies that State Parties (ie countries that have signed the Convention) should prepare in time of peace for the safeguarding of cultural properties in their own territory against the foreseeable effects of both international and non-international armed conflicts as they consider appropriate. State Parties are obliged to train civilians and armed forces in the need for protection of cultural property; to help identify the cultural property a special emblem, the Blue Shield, was created (Fig 1). A new war crime with regards to cultural property is required to be established on the statute books of each State Party with copies of the legislation provided with the list of cultural property put forward. The Convention also introduces responsibilities for invaders and those invaded alike with regards to cultural property, stipulating that cultural property should not be used for:

- Purposes which are likely to expose it to destruction or damage in the event of armed conflict; and by refraining from any act of hostility directed against such property; and

- The High Contracting Parties further undertake to prohibit, prevent and, if necessary, put a stop to any form of theft, pillage or misappropriation of, and any acts of vandalism directed against, cultural property. They shall refrain from requisitioning movable cultural property situated in the territory of another High Contracting Party; and

- They shall refrain from any act directed by way of reprisals against cultural property. (Article 4)

The Convention states that the State Party, as an occupying power must, where possible, support the competent national authorities of the occupied country in safeguarding and preserving its cultural heritage. In addition it must take any necessary protective measures where cultural property has been damaged by military operations and where the competent national authorities cannot remedy the situation. However, the Convention makes provision for military commanders to be able to attack cultural property in the event of 'imperative military necessity' that may be invoked by senior commanders in cases where cultural property is being used for military purposes, eg a sniper in a museum or fighter planes being stored on archaeological sites.[2] Under the Convention, cultural property can qualify for so-called 'special protection' when it is agreed that it is of 'great importance to the cultural heritage of every people' and where the State Party agrees that neither it nor its immediate surroundings will be used for military purposes or for any activity likely to expose it to damage or destruction in the event of armed conflict.

In 1996 the four main cultural property international non-governmental organisations (IGOs) – the International Federation of Library Associations and Institutions (IFLA), the International Council on Archives (ICA), the International Committee of Museums (ICOM), and the International Committee on Monuments and Sites (ICOMOS) – met together to look at how best to respond to the need to protect cultural property in the

FIG 1.

BLUE SHIELD DISPLAYED ON THE KUNSTHISTORISCHES MUSEUM, VIENNA, SUMMER 2007

CREDIT: CORINE WEGENER

event of disasters and armed conflict and this resulted in the setting up of the International Committee of the Blue Shield (ICBS). In September 2005, the Coordinating Council of Audiovisual Archives Associations (CCAAA) joined the ICBS to extend coverage to audio visual media. It is, relatively speaking, quite rare to find movable cultural property experts – on art, books, and digital data – in the same ICBS committee as those dealing with the immovable cultural property such as buildings and archaeology. ICBS has set up a series of National Committees that comprise, at a minimum, representatives from IFLA, ICOMOS, ICOM, ICA and CCAAA, together with representatives from government, emergency services, the military and others as appropriate. In October 2007 there were 12 National Committees and ten under construction. These National Committees agree to abide by certain requirements (see http://www.ifla.org/blueshield.htm for details). As a result, ICBS offers unrivalled worldwide independent professional networks covering the whole cultural property sphere and two of UNESCO's core areas. ICBS is able to widely distribute information and acted as a focal point in the wake of Hurricane Katrina; it is able to mobilise professional emergency assistance in the event of disaster through its National Committees, subject to resources, and it is able to advise on precautionary emergency provision in time of peace. ICBS is unfunded and depends on donations and monies from its constituent bodies although it is actively fundraising. This means that it has had to concentrate on lobbying, encouraging the formation of National Committees, information exchange, and providing capacity building training on emergency planning mainly through its constituent bodies.

One central area of activity for ICBS has been lobbying countries to sign up and ratify the 1954 Convention through its National Committees. Although many states signed the Convention in 1954, many failed, like the UK, to ratify the Convention citing reasons such as impracticality and imprecision and indeed only one site – the Vatican – had been granted 'special protection' (UNESCO 1994). To attempt to address these shortcomings, UNESCO commissioned Professor Patrick Boylan to review the effectiveness of the Convention and First Protocol and to identify any measures required for enhancement. This led to the development of the Second Protocol in 1999 which:

- Introduced a system of 'enhanced protection' for cultural property of the greatest importance to all mankind [sic]. The October 2007 *Guidelines for the Implementation of the 1999 Second Protocol to the Hague Convention of 1954 for the Protection of Cultural Property in the Event of Armed Conflict* envisages that State Parties will use 'enhanced protection' rather than 'special protection' as this offers greater clarity;

- Clarified the concept of imperative military necessity and sets out when cultural property can be legitimately attacked;

- Recognised the role of the expert non-governmental cultural property organisations such as the ICBS in advising the *UNESCO 1954 Second Protocol to the Hague Convention for the Protection of Cultural Property in the Event of Armed Conflict Committee*. This Committee, comprised of State Party delegates, is funded by UNESCO and secretariat functions are provided by staff from the World Heritage Centre.

The Second Protocol came into force in 2004 when Costa Rica ratified the Protocol. The Second Protocol Committee met for the first time in 2006 and it is hoped that this committee will enable progress to be made rapidly and UNESCO have said that it wants to make such progress a priority, though whether this will be supported by the necessary funding remains to be seen.

In the lead up to the Second Gulf War ICBS acted as a focal and information point lobbying the USA and UK regarding the protection of cultural property. In the UK it lobbied the Prime Minister and Secretary of State for Culture Media and Sport in a variety of ways and together with the United Kingdom and Ireland Blue Shield (UKIRB) it made sure that authorities and others were clear on what needed to be protected. In the wake of the destruction that took place, ICBS and its National Committees continued to lobby countries to ratify the Convention and continued to raise issues via political routes, through the cultural sector meeting with government, workshops, and through the press. In the UK this helped lead to the Government's decision to ratify the 1954 Convention and to the decision to enact UN sanction orders preventing dealing in looted artefacts (DCMS 2003) and legal action has resulted in several cases. A draft bill (Draft Cultural Property [Armed Conflicts] Bill) was published for consultation on the 7th of January 2008 which, when enacted, will make it illegal to damage or attack cultural property protected by the Convention and its Protocols; make it illegal to trade in cultural property illicitly removed from occupied territory; and to ensure that the Blue Shield emblem provides the equivalent protection as does the Red Cross emblem.

ICBS is helping UNESCO refine its draft guidelines for its Second Protocol Committee to make sure that these are fit for purpose and practical. It is hoped that the guidelines will be agreed by the Committee in December 2007. It is important that each State Party prepares a list of what it considers its greatest cultural property that it wants to protect. Great detail needs to be included in the list to enable ready identification of 'objects' (here meaning not only movable but immovable cultural property) if they are looted or damaged and it needs to be verified, in my own view, by an independent assessor appointed by UNESCO in much the same way that UNESCO appoints evaluators to evaluate candidate World Heritage Sites. This will require dedicated resources which may be problematic; at the moment there is only 0.5 person time dedicated to the Convention and this staffing needs to be dramatically increased if it is to be useful and enforceable.

A new association is being formed of Blue Shield National Committees (ANCBS), taking advantage of the offer of funding and premises by the City of The Hague and further funding opportunities, such as that offered by the European Community Solidarity Fund (set up to assist those affected by flooding and natural disasters following the floods in Central Europe in 2002). Other sponsors are being sought. The ANCBS will act as a nerve centre coordinating funding applications, lobbying campaigns, and information dispersal.

By 2006 nearly 100 countries (UNESCO 1999) had signed and ratified the Convention including Iraq, Syria, Kuwait and Oman. Many more, like the UK, are preparing for ratification, shocked by the horrific destruction of cultural property in

Credit: Jasenka Zuvela-Splivalo

Fig 2.

The World Heritage Site of Dubrovnik, specifically targeted during the war in former Yugoslavia

Iraq since 2003. Even the USA, which has staunchly resisted so far, now has a National Committee. But will this really make a difference?

In war it is often said that the first casualty is truth; anecdotally the second is often cultural property either because of inaccurate targeting, guerrilla or resistance activity, looting, or to raise money for food. This has been particularly true in Iraq (Breitkopf 2007) but this is repeating a pattern found elsewhere in earlier times: for example, the Pergamon Museum contains a temple 'liberated' from the Near East and the British Museum contains the Rosetta Stone which Nelson captured from Napoleon, who in turn took it from Egypt. In ancient times the library at Alexandria (Arab, n.d.) was fired as a result of armed conflict. In the Balkans conflict in the mid-1990s, the World Heritage Site of Dubrovnik was shelled (Fig 2). After the conflict this action was deemed, by a War Crimes Tribunal in The Hague, in part to be an attempt to destroy the cultural identify of the Croats. The general concerned was convicted of horrific war crimes for killing people but was also given a seven year sentence for cultural war crimes (UN 2007). In many other areas of Serbia and Croatia (Teijgeler 2006; Valencia 2002) there is anecdotal evidence being collected that buildings and monuments marked with the protective Blue Shield were deliberately used as target practice to help wipe out national identity.

It is possible that this pattern can be broken if countries ratify the 1954 Hague Convention and if States Parties put in place comprehensive peacetime emergency planning and training which can be effectively implemented in times of armed conflict. Joint forces – depending on the situation either as part of humanitarian relief actions or an invasion force – should also sign up to the Convention to avoid unnecessary damage. UN peacekeepers undertake to respect cultural property but it can be difficult to ensure this in reality with troops from many different countries. It is crucially important to ensure that national legislation be enacted to make damage to cultural property a war crime, that

measures are put in place to prevent dealing in illegally looted cultural property, and that perpetrators are caught and prosecuted. UNESCO will have a significant part to play in ensuring that countries do this effectively and adhere to their commitments. Finally, as with so much to do with the cultural sector, there needs to be a real injection of funds to enable proper assessment, analysis and capacity building. It is naïve to think that there will be no further damage to the world's heritage as a result of war. However it is our job to limit this as much as possible and to prevent such destruction from becoming a disaster.

NOTES

1. Cultural property and cultural heritage are considered as interchangeable terms for the purpose of this chapter although this has long been a bone of contention between those looking after immovable and movable items. It should be noted that landscape and maritime cultural assets are not covered in the convention which, with the benefit of 50 years' hindsight, is an unfortunate exclusion.
2. In the First Gulf War many newspapers such as *The Times* carried reports of Iraqi MIG fighter jets being positioned within archaeological sites such as Babylon.

Bibliography

Arab, S M, no date *The ancient library of Alexandria and the re-built of the modern one* [online] http://www.arabworldbooks.com/bibliothecaAlexandrina.htm [30 October 2007]

Breitkopf, S, 2007 *Lost: The Looting of Iraq's Antiquities* [online] http://www.aam-us.org/pubs/mn/MN_JF07_lost-iraq.cfm [30 October 2007]

DCMS, 2003 *Statement from the DCMS re Iraq's Cultural Heritage* [online] http://www.culture.gov.uk/Reference_library/Press_notices/archive_2003/statement_iraq.htm [30 October 2007]

Hague Convention, 1954. *On the Protection of Cultural Property in the Event of Armed Conflict*, see http://www.icomos.org/hague/Hague

Office of the Leader of the House of Commons, 2006 Cultural Property (Armed Conflict) Bill [online] http://www.commonsleader.gov.uk/output/page1785.asp [30 October 2007]

Teijgeler, R, 2006 Preserving cultural heritage in times of conflict, in *Preservation management for libraries, archives and museums* (eds G E Gorman and S J Shep), 133–165, Facet Publishing, London, available online at http://www.culture-and-development.info/issues/conflict.htm [30 October 2007]

United Nations News Centre, 2007 *UN war crimes tribunal issues seven-year jail term over shelling of Dubrovnik* [online] http://www.un.org/apps/news/story.asp?NewsID=10122&Cr=icty&Cr1 [30 October 2007]

UNESCO, 1994 *Information Note: International Register of Cultural Property under Special Protection Co-ordination of Implementation of Conventions Protecting the Cultural Heritage* [online] http://whc.unesco.org/archive/94-3-f12.htm [30 October 2007]

UNESCO, 1999 *Convention for the Protection of Cultural Property in the Event of Armed Conflict: Second Protocol to the Hague Convention for the Protection of Cultural Property in the Event of Armed Conflict* [online] http://www.unesco.org/culture/laws/hague/html_eng/protocol2.shtml [30 October 2007]

Valencia, M, 2002 Libraries, Nationalism and Armed Conflict in the Twentieth Century, *Libri* 52, 1–15 [online] http://www.librijournal.org/pdf/2002-1pp1-15.pdf [30 October 2007]

The Identification and Protection of Cultural Heritage during the Iraq Conflict: A Peculiarly English Tale

Peter G. Stone

In the early months of 2003 there was much anxiety concerning what the British Government was doing to avoid damage to archaeological sites in the expectation of conflict in Iraq. Questions were asked in Parliament, appeals made to various government departments, and letters published in the national press. As reported in *Antiquity*'s Editorial for June 2003 (221–225), scholars such as Lord Renfrew and Harriet Crawford and institutions such as the Archaeological Institute of America asked urgent questions of politicians, and made strong public statements, drawing attention to the imminent threat to the safety of Iraq's 25,000 archaeological sites and historic mosques, churches, forts, khans and treasures housed in museums and emphasising their duty of care. On 24 January the White House and the Pentagon had been given a prioritised list of almost 200 sensitive sites.

In Britain some formal acknowledgement was achieved by Lord Renfrew in response to his question tabled in the House of Lords on 24 February concerning what 'measures [the Government] plan to implement, in the event of military intervention in Iraq, to prevent the looting of archaeological sites and museums, and to safeguard the rich historic, archaeological and cultural heritage of Iraq.' The Minister for Defence Procurement, Lord Bach, assured him that 'very careful attention' was being applied to ensure that 'we minimise the risk of damage from any quarter to civilian populations and infrastructure, including sites of historic, archaeological, and cultural heritage' (PQ Ref No 1953N). In the House of Commons, veteran Labour backbencher Tam Dalyell (who has had a life-time interest in archaeology; *Antiquity* 76 (2002), 1050–4), was assured by the Prime Minister that the Government was not only fully committed to the protection of cultural property but that [quite correctly] it had obligations to protect sites under the Geneva Conventions. He ended his response by stating 'we will do everything we can to make sure that sites of cultural or religious significance are properly and fully protected' (Hansard 19 March 2003, Column 940).

The public expressions of anxiety by numerous institutions were not necessarily intended to add opposition to the war, but to offer advice and assistance in the business of protecting sites. A key agency was the International Committee of the Blue Shield (ICBS), the organisation established by International Charter (the 1954 Hague Convention) to protect cultural heritage by coordinating preventative measures to meet and respond to

emergency situations, both natural and man-made. Through the Second Protocol to The Hague Convention (adopted in 1999 though still not in force in March 2003 as the requisite 20 states had not ratified it) the ICBS has a particular and specialised role to advise the Convention's Committee for the Protection of Cultural Property in the Event of Armed Conflict. In its statement of 7 March, the ICBS, having urged all governments concerned in the potential conflict to 'work within the spirit of' the 1954 Hague Convention and to protect '…archives, libraries, monuments and sites, and museums', went on to offer technical assistance and coordination. It called upon 'all governments in a position to act to provide the necessary resources, human and financial, to assess the damage caused by the conflict to cultural heritage and to implement plans for the necessary repair and restoration. In the case of looting of cultural property, detailed plans by trained experts should be prepared for the repatriation or restitution of the property concerned, with the involvement of Iraqi scholars and heritage professionals.' The statement ended by calling upon all governments which had not yet become party to the Hague Convention and its two Protocols to do so. This statement was aimed, one assumes, directly at the USA and UK, as neither had signed. The Second Iraq War began on 20 March 2003. Public pressure concerning the identification and protection of the archaeological cultural heritage took second place to widespread concern over the possibility of the invasion provoking biological and/or chemical war. Such fears abated with the speed of the initial advance and archaeological attention soon returned to the sites and museums.

In the period during and after the build-up to war, in the shadow of these heavyweight public exchanges, I found myself to be a player in a peculiarly English sub-plot, one that has, however, had a direct bearing on the question of the fate of antiquities in war, and as it transpired, constituted the only actual direct dialogue on the subject between an archaeologist and the British military. The story does something to unravel the tangled and discontinuous thread of heritage in government, and sounds a warning for the future. This paper offers a sketch of the key events and the discussions that took place.

On Sunday 2 February 2003 I was approached by a friend, a serving officer in the Royal Navy, who was at the time working in the Ministry of Defence (MoD). He asked if I could provide some information on the major archaeological sites that might be threatened *if*, as anticipated, an American-led Coalition invaded Iraq. I was immediately interested (as any archaeologist would have been), but pointed out that I was the wrong person to ask, not being a specialist in Middle Eastern archaeology. My friend persisted that it would be very helpful if I were to front the delivery of information as I was known personally by him (and therefore implicitly trustworthy). He was also aware of my role as honorary Chief Executive Officer of the World Archaeological Congress (WAC) and surmised that if I did not have the necessary information myself then I would know where to find it.

Accordingly I contacted Roger Matthews, the most recent Director of the British School of Archaeology in Iraq, and Neil Brodie, a specialist in the illicit trade of antiquities. I had to ask both to keep our conversations and work confidential (although at no time were any of us asked to sign any confidentiality document, such as the Official Secrets

Act). On 4 February Roger Matthews who had already been in consultation with Iraqi colleagues over this matter, provided me with a selective list of 36 of the most important sites in Iraq, ranging from Neanderthal to Islamic. He also underlined the importance of the dedicated staff of the Iraqi Department of Antiquities who had often risked their lives to protect the archaeological cultural heritage. Both Matthews and Brodie stressed the vulnerability of Iraq's museums during and after any fighting, bearing in mind the disasters that had befallen many of Iraq's museums during the regional uprisings against Saddam Hussein in the spring of 1991, when thousands of artefacts had been looted and not yet recovered.

I forwarded the Matthews list to the MoD on 4 February, underlining the vulnerability of museums and sites. I also noted that, despite the fact that the UK had not signed the 1954 (Hague) *Convention for the Protection of Cultural Properties in the Event of Armed Conflict*, or the 1970 *UNESCO Convention on the Means of Prohibiting and Preventing the Illicit Import, Export and Transfer of Ownership of Cultural Property*, or the 1995 UNIDROIT *Convention on Stolen or Illegally Exported Cultural Objects*, it did nevertheless have responsibilities under Article 53 of the 1977 Additional Protocol, of the Geneva Conventions. Specifically that, as a signatory to the conventions the UK was 'prohibited to commit any acts of hostility directed against the historic monuments, works of art or places of worship which constitute the cultural or spiritual heritage of peoples'.

Finally, I reminded the MoD that the UK also had responsibilities under the terms of the 1972 *Convention Concerning the Protection of the World Cultural and Natural Heritage* (Article 6) to which Iraq was also a signatory 'not to take any deliberate measures which might damage directly or indirectly the cultural and natural heritage … situated on the territory of other States Parties to this Convention'. On 5 February I spoke with staff in UNESCO who confirmed that, although Iraq only had one site, the city of Hatra, inscribed on the World Heritage List, a further seven were on the Tentative List. It was one of my first frustrations that I was unable to ascertain which sites these were as such information was deemed to be confidential between UNESCO and the State Party. I was also informed that, while the Iraqi government had transmitted four volumes of documentation to UNESCO in October 1991 of items missing from a number of provincial museums as a result of the 1991 Gulf War, no request had yet been received requesting special protection under Article 8 of the Hague Convention with respect to the impending conflict.

I did learn, however, albeit unofficially, that the UNESCO Director General had recently written to Kofi Annan, Director General of the United Nations, asking him to raise the issue of protection of cultural heritage in Iraq with the UN Security Council, but that the letter was at present regarded as private correspondence. Finally, UNESCO staff agreed with earlier assessments that the most vulnerable time for the cultural heritage in Iraq would be immediately following the cessation of hostilities. I was asked informally to do all in my power to ensure that British and Coalition forces realised this and that they understood and accepted the full extent of their responsibilities under the various relevant International Conventions.

On Friday 7 February the MoD requested the itemisation of those sites on the Matthews list that were close to, or in, urban centres. We provided this information on Monday 10 February, also including those close to military installations. In summary we had, by this date, done three things: tried to identify the 'most important' sites in Iraq (an almost impossible task in itself); stressed the vulnerability of sites and museums immediately post-conflict; and stressed the Coalition's responsibilities under international conventions. As a result, it seems that all the sites on the Matthews list were added to British military maps being prepared for the conflict and that British Military Field Orders identified them as places to avoid. Moreover, the list was apparently drawn to the attention of the Attorney General, who, as the senior legal officer of the country, vets all places that the military wish to target during a conflict, and designates those that should not be targeted (with the inevitable proviso 'unless the military situation demanded otherwise'). This was probably the first time that archaeological sites were included in a list that is usually dominated by religious buildings, hospitals, and schools. All of this information, including our grave concerns for the museums and sites immediately following any conflict, was apparently shared with Coalition partners.

Once the war had begun, I was keen to 'go public' as soon as possible and on 31 March I requested that the MoD hold a briefing session with a small group of selected archaeologists and politicians at which we might finally explain what had been done so far. I hoped this would not only go some way to appease the – still growing – frustration of the archaeological community over their perception that no serious or detailed consideration had been given to their concerns, but would also allow those present to offer advice on what should be done post-conflict.

I augmented my request for a briefing by drawing the MoD's attention to the concern that was growing over the aims and role of the 'American Council for Cultural Property' (ACCP) which, on scratching its surface, revealed itself to be a loose, but potentially extremely influential, coalition of wealthy collectors and curators. The ACCP were actively lobbying to have the very strict Iraqi antiquities legislation relaxed to enable them to purchase archaeological material in a post-Saddam Iraq. The ACCP played on the publicly voiced (on both sides of the Atlantic) concerns regarding the risk of looting and claimed that its only concern was to protect the country's archaeological record from further loss and destruction. This showed the complexity and importance of the issues surrounding the cultural heritage, a matter I was able to impress on the staff of the MoD.

On 2 April, apologising for the delay, the MoD informed me that the idea for a briefing session was receiving 'serious consideration'. The MoD also confirmed that the American Operational Plan contained detailed instructions to Coalition forces on avoiding damage to sensitive places, including archaeological sites. The MoD then approached me on 7 April with the suggestion that I meet with a group from the MoD and the fledgling UK 'Iraq Secretariat' – a group working on the strategy for the administration of post-conflict Iraq prior to the hand-over of power. This meeting was scheduled for 9 April. I decided that if the MoD – understandably as they were in the midst of running a war – did not have the time to brief archaeologists about pre- (or post-) war planning I would take the

initiative and contact a number of people from whom I wanted advice in anticipation of this meeting. The MoD were aware that I was going to be talking to more colleagues and accepted the reality that people needed to know what had been done. Over the next few days I contacted Lord Redesdale, Harriet Crawford, George Lambrick (CBA), and Tom Hassall (ICOMOS). Between them these individuals, and others, raised a number of concerns that I was able to use on 9 April.

The three key points were that [1] Coalition forces must act immediately to ensure no looting took place; [2] Coalition forces needed to be made aware of who they should be liaising with from the Iraqi Department of Antiquities; and [3] the international archaeological community was ready to offer any support deemed necessary by the Iraqi Department of Antiquities but that any post-conflict assistance must be at the request of the Iraqis and be led by Iraqi archaeologists. All of these points were accepted by those present. I also noted international concern over Saddam's regime's plans for building a dam that threatened some 60 or more archaeological sites including the Assyrian city of Ashur and I again raised grave international concern over the aims and objectives of the ACCP.

During the meeting I suggested that the type of support it was envisaged the Iraqis might request was [1] immediate liaison with known and trusted international colleagues; [2] conservators; [3] conservation chemicals that had been outlawed by the UN embargo, and [4] structural engineers to ensure the safety not only of museum buildings but of some archaeological sites and the reconstructions at them. I indicated that, in the longer term, there might well be a need for international lawyers to help counter potential requests from the USA to relax Iraq's antiquities legislation and that assistance would probably be needed for the drafting of management plans and nomination documentation for inscription of sites onto UNESCO's World Heritage List.

I repeated my request for a briefing for key archaeologists and politicians, noting that the American military had held a major press conference in Kuwait on 5 April outlining its commitment to the protection of the cultural heritage. I stressed that the international archaeological community was sharply focused on the situation and that an opportunity existed in the forthcoming Fifth World Archaeological Congress (to be held in Washington DC in June 2003) for the whole issue to be discussed. I asked how the MoD might ensure that Iraqi colleagues could attend that meeting if they so wished. Finally, and in some respects most importantly, I stressed the need for a proper system to be put into place that would ensue that transparent, specialised archaeological and other advice be available to the UK military in the future.

I was reassured that all of my points would be carefully considered and acted upon where possible. The Office of Reconstruction and Humanitarian Affairs (ORHA) was being set up to administer Iraq immediately post-conflict, and had cultural heritage as a key priority. A suitable specialist would be appointed to liaise between ORHA and the Iraqi Department of Antiquities (eventually this was John Russell from the USA). I was then invited to a meeting at the Foreign and Commonwealth Office (FCO) on 14 April, organised by the Iraq Planning Unit (IPU) which appeared to have a similar strategic

role within the FCO to the MoD's Iraq Secretariat. A wide range of UK organisations involved in education and cultural heritage were due to meet to discuss the UK's future involvement in Iraq (the meeting was also attended by John Curtis and Christopher Walker of the British Museum).

And then, on 12 and 13 April, as American troops took control of Baghdad, came news of the looting of the museums, first in Baghdad on 11 April and Basra and then reports (initially unconfirmed) of looting at other regional museums. The looting of the museums of Iraq immediately became a major agenda item for the 14 April meeting and John Curtis outlined plans for assistance to be led by the 'five world museums' (identified as the British Museum, London; the Hermitage, St Petersburg; the Louvre, Paris; the State Museums, Berlin; and the Metropolitan, New York). Following that meeting I went back to the FCO on 16 April detailing four areas of concern that I had. First, and most urgent, was the pressing need for the Baghdad Museum to be sealed (according to the press and TV news it was still being looted). I emphasised again that the Coalition was responsible as an Occupying Force under the Geneva Conventions for the protection of the cultural heritage – a point acknowledged – finally – by US Secretary of State Colin Powell on 14 April. Second, I noted that we did not know what, if any, damage had been done to the archaeological sites either through fighting or looting, but argued strongly that protection of cultural heritage could not be seen as a museum-only issue. Third, I expressed concern over the self-appointment of the five so-called world museums. I stressed that in no way was I questioning the ethical or professional motives of any individual scholars involved but noted that all five museums had collections of dubiously provenanced material from the region. I felt obliged to make UK government sources aware that such a cabal might attract international criticism if not outright hostility. Finally, I repeated my request for a group of relevant archaeologists and politicians to be briefed by MoD and/or the IPU.

It soon became clear that many archaeological sites were being looted (and continue to be, as I write, in November 2004). Slightly later in June, the journalist Robert Fisk travelled to southern Iraq together with Joanne Farchakh Bajjaly, a Lebanese archaeologist and journalist, and reported to the world the destruction that they witnessed (see for example *The Independent Review* 3 June 2003; *Antiquity*, Editorial for June 2003, 77, 442–444). When Joanne asked villagers why they were looting many responded that since the collapse of the Saddam regime no-one purchased their crops and the only way they had of surviving was by providing the goods demanded by antiquity dealers. As the looting of museums and then sites began to be reported in April 2003 I asked the MoD to provide me with contact points for the American military who were involved in the protection of cultural heritage. I tried through the first half of April to make contact by phone and email. I had hoped that combined efforts might just have slightly more influence than working separately. I failed to get any response.

The looting of the museums has been the subject of much controversy as to what happened and when, with much claim and counter-claim as to who did or did not do what. This controversy is not a topic of this article. Whatever the process, it was clear very quickly that a number of museums had suffered considerable losses to their collections. In

the division of Iraq into 'Areas of Responsibility', the only major town, and therefore the only regional museum for which the British had responsibility was Basra. Once Basra was secured the British authorities launched an Arabic language newspaper, *Al Zamera*. I wrote a piece on the importance of the cultural heritage which, I believe, was printed alongside an offer of total amnesty for anyone returning anything that had been removed from the museum. In some respects the British authorities were lucky in that Basra Museum did not hold a major archaeological collection and therefore they were not subject to the enormous scrutiny and criticism that their American partners received over the looting of Baghdad Museum.

As soon as the initial fighting had calmed down there were meetings in Paris, organised by UNESCO, and London, organised by the British Museum, to try to assess the damage and losses to the cultural heritage in Iraq. I attended the meeting at the British Museum on 29 April with some feeling of unease: here was the primary museum in the UK positioning itself at the forefront of efforts to assist in the protection and conservation of the cultural heritage in Iraq when it was the – many believe unlawful – actions of the UK government that had put the cultural heritage at risk in the first place. This feeling of unease had been reinforced by a number of comments I had received from international colleagues questioning the motives and/or the sensitivity of the offered advice. I felt obliged to raise this at the meeting and was somewhat reassured to hear Donny George, Director of Research for the Iraqi Department of Antiquities (and who had been extracted from Iraq by John Curtis at significant personal risk to them both, to attend these meetings) that the BM was the obvious choice to spearhead an international response and that he was perfectly happy to work with the BM where he, and other Iraqi specialists, had long associations.

The meeting, however, raised two new concerns. The first regarded so-called 'leaking borders': there were numerous rumours circulating in the press that Jordanian border guards had amassed some 12 case loads of antiquities that had been waived across the border by American troops only interested in finding players from their infamous 'pack of cards'. The second concerned the behaviour of the military where there was a real worry over antiquities being smuggled out of the country as souvenirs. After the meeting I immediately contacted the MoD to request that UK personnel with border responsibilities be fully briefed to search for antiquities and to request that all UK personnel leaving Iraq be searched specifically for antiquities. Once again, the British came off quite lightly as the UK only had responsibility for a short part of the Iraq–Iran Border – which, I was assured, was so heavily mined that no-one in their right minds would try to smuggle anything across it. I *believe* that all UK personnel were – and continue to be – searched for antiquities.

The MoD eventually came back to me regarding my requests for a briefing meeting for key archaeologists and politicians by turning my request on its head and asking for a presentation from me to a cross-Whitehall audience on 'Archaeology, Heritage and War'. The argument ran that archaeologists and politicians now knew what had happened and that the most important issue was to put the 'cultural heritage side' to as wide an audience

of those who might be able to influence decision makers, as possible. There was a clear acceptance amongst those with whom I was dealing directly that things could have been managed much better and that they wanted to get it right 'next time'.

Accordingly on 17 July I made a presentation to staff of the MoD, FCO, DFID, and Department for Culture, Media and Sport (DCMS) in which I suggested that there were three levels of necessary action: immediate concerning Iraq; medium term concerning (mainly) Iraq; and, longer term, more generally. However, before I embarked on what was essentially a shopping list of aspirations, I suggested that I needed to place my concerns regarding the protection of the cultural heritage into a wider context, one that might resonate more clearly with my audience (and their elected masters). This suggestion came from a realisation that many of those to whom I had been talking over the previous months had no background in, or understanding of, the importance of cultural heritage. They had been told by numerous scholars that cultural heritage was important for all humankind, but such academic statements had failed to impact upon their own, impossibly busy, day-to-day work in the build up to war.

I attempted therefore to put cultural heritage into their worlds, to try to make it relevant and therefore important, *to them*. I used the examples of Nazi Germany, colonial Rhodesia, and the former Yugoslavia to show how the cultural heritage can be used and abused by governments in a variety of ways. I also gave an extremely basic overview of the trade in illicit antiquities and how damaging it is to so-called 'source countries'. I think I am correct in saying that very few, if any, of the audience had ever had the importance of the cultural heritage explained in these, rather pragmatic, terms before. From questions and follow-up email correspondence, it was clear that at least some of the audience had grasped the relevance of the cultural heritage to their work and to the role and responsibilities of the military. I then turned to my wish-list.

I pleaded that the following action was needed in Iraq *immediately*, that is within the next few weeks:

a] the UK must accept that as part of an Occupying Force under the Geneva Conventions it had (and continues to have) a responsibility to protect the cultural heritage of Iraq. I noted that it was difficult to see how the Government could claim that it was fulfilling this responsibility;

b] that ORHA must understand that this was not just a museums issue. A review was needed of what support for cultural heritage was required across Iraq and I noted that the most pressing concern was the protection of archaeological sites;

c] that ORHA must support Iraqi colleagues within the Department of Antiquities by arranging for salaries to be paid and for staff to be provided with the infrastructure necessary to carry out their work (I noted that all of the Department's cars had either been stolen or damaged beyond repair);

d] that Iraqi guards be deployed on 24 hour rotas – with the support of Coalition forces – in sufficient numbers to safeguard sites;

e] that Coalition forces should continue to

o provide amnesty for the return of objects

o check all military personnel leaving Iraq

o keep tight control on borders;

f] that more effective communication needed to be developed between different elements of Coalition forces, the embryonic Iraqi government, and the Iraqi Department of Antiquities;

g] that ORHA should reject the suggestion, apparently put forward by Cultural Heritage Ambassador Cordoni that new excavations should take place, because

o it was currently unsafe

o there was no archaeological infrastructure at present

o there was no mechanism for the conservation of finds;

h] that DFID undertake an immediate review of the purchasing of crops in Iraq;

i] that Government support the Richard Allen Private Members Bill that made it a criminal offence to deal in illicit antiquities in UK; and

j] that the UK support Iraq (UN sanctions) Order 2003 Statutory Instrument 2003 1519.

In the *medium term* I argued the UK should:

a] indicate support for the US Congress in its plans to pass HR 2009 and equivalent law in Senate that would help to protect any objects arriving illegally in the USA from Iraq;

b] start a public relations and education campaign with local Iraqi people as to the long-term economic value of their heritage to them;

and that the MoD should:

c] develop liaison with archaeologists *already* working within the Ministry. It had come as a total surprise to my contacts within the MoD that the Ministry actually employed four archaeologists within Defence Estates, the MoD agency which manages the Department's estate in the UK and overseas. These archaeologists had themselves been trying to raise the issue of identification and protection of sites and museums before the war but had, in the time-honoured civil service way, been unable to get their voices heard in a different part of the Ministry.

I finally asked that over the *longer term*:

a] DFID acknowledge value of, and put into place planning for, the development of cultural heritage tourism for local developing economies in Iraq (and that DFID should see this as a legitimate role for them more widely);

b] where reconstruction takes place in Iraq interim authority must ensure archaeological excavation precedes it;

c] the UK should sign and ratify the 1954 Hague Convention (and both its protocols), the 1970 UNESCO Convention and the 1995 UNIDROIT Convention;

d] consideration be given to planning for the protection of museums and the wider cultural heritage if the UK came under attack;

e] serious consideration be given to how the archaeological – and wider cultural heritage – community could and should liaise with the UK military in the future. I noted that such liaison falls into two parts: first, introduction of the importance of the cultural heritage into military, and customs, training at all levels (but especially at the Joint Training College for senior officers at Shrivenham); second, when conflict is imminent, co-ordination between the heritage community and military – and here I stressed the role of, and need for Government funding for, the UKIRB.

CONCLUSION

The 17 July presentation was the last major contribution I made regarding the identification and protection of the archaeological cultural heritage in Iraq. I was to have given evidence to a House of Commons Environmental Audit Committee meeting on 'Military Operations and Reconstruction: the Environment in Iraq' in the spring of 2004 but the inquiry was postponed on 29 April, reflecting the deterioration in the security situation in Iraq. (I was later informed that it was unlikely that the Committee would meet until after the UK election.) Partly as a result of the postponement of this inquiry, the UK's All Party Parliamentary Group for Archaeology held its own meeting on 19 May 2004. I made a verbal presentation outlining the extent of my role with the MoD. This is one of a number of presentations I have made since June 2003 in the USA, UK, Jordan, Australia and New Zealand regarding my experience. In these I have tried not only to show that something was done in the lead-up to war – however ineffective that action now appears to be – but that something far more must be done with respect to future conflicts.

Much has been written on the developing situation within the UK, within Iraq, and internationally (see for example, Bogdanos 2003; Cole 2004; Catling and Crawford 2004; Cruickshank 2003; Cruickshank and Vincent. 2003; Gaimster 2004a and 2004b; Phuong 2003; *The Independent Review* 3 June 2003). The UK has begun the process of signing and ratifying the 1954 Hague and 1970 UNESCO Conventions (but not, it seems, the 1995 UNIDROIT Convention) and now has the Dealing in Cultural Objects (Offences) Act. There is also a significantly greater awareness within certain levels of the MoD of the importance of the cultural heritage and the responsibilities of UK forces to protect it. This awareness must be built upon and the archaeological community needs to continue to lobby for dedicated training for all military personnel. While it is clutching at straws to find much good out of the events of 2003/4 – especially as it becomes increasingly and depressingly clear just how much has been lost from the museums and the extent of the continuing looting of archaeological sites – none of this legal enhancement would have happened without the recent conflict.

However, there is far more on the negative side. Despite assurances from within the MoD that they take protection of the archaeological cultural heritage seriously, widespread looting continues: Joanne Farchakh Bajjaly, recently returned from another visit to Iraq, estimates that over 100 archaeological sites have been damaged to such an extent that they are archaeologically almost worthless. There are also reports of significant damage being done to archaeological sites by Coalition forces at Babylon (see, for example, Zainab

Bahrani, Professor of Ancient Near Eastern Art History and Archaeology, from Columbia University, writing in *The Guardian*, 1 September 2004). In most instances, with the exception of Ur and one or two other sites where military installations sit alongside the site, archaeological sites are not being protected as Coalition forces do not have the capacity. As fighting escalates it is clearly impossible for them to protect isolated and remote sites. DFID have, to my knowledge, still declined to purchase crops from local producers in Iraq. No archaeologist or heritage manager has been asked to contribute to any military training at any senior or strategic level – although a senior civil servant (who attended my Whitehall presentation and who had been aware of my earlier work) does now mention this issue in his own lectures at Shrivenham – a small step in the right direction. The MoD's own archaeologists, who have introduced successful management and protection measures on the Department's own estate, do not appear to have been introduced into MoD planning teams. In short, not only does the sacking of one of the most important cultures in the world continue unabated but there seems no real move to improve the preparation of UK forces for any future conflict.

Part of the responsibility for this situation must lie with the cultural heritage community itself. In the presentations I have made in five different countries (one of which was to a multinational audience) it has stunned me to find *less than 5%* of audiences, made up of academic archaeologists and cultural heritage managers, had ever heard of the ICBS. Such a level of awareness of the ICBS offers no endorsement that we, as engaged professionals, take the protection of the cultural heritage particularly seriously.

I ended my 17 July presentation with the following words:

> I've tried to show that cultural heritage is important. I hope that together we can begin to develop the recognition of this importance. That we can begin to develop strategies that will attempt to protect it, to use it, to interpret it, in the most suitable fashion. Not for any specific nationalistic agenda but for the explicit agenda of making the world a better, safer, more harmonious, and more civilised place to live.

I can think of no better way of ending this essay other than perhaps sharing the sign photographed last year from above the door of Kabul museum: *A nation stays alive when its culture stays alive.* I believe anything that anyone can do to contribute to ensuring such life is time well spent.

Acknowledgements

I am very grateful to the following who responded to my request for advice before making
my presentation to MoD on 17 July 2003: Neil Brodie; John Curtis; Patrick Boylan;
Nicholas Postgate, (a member of the Council of the BSAI who had, with Eleanor Robson,
set up a website with an excellent catalogue of Iraqi sites, specifically as a means of putting
information into the public domain where it might be accessed by the military, or anyone
else with an interest; See: http://users.ox.ac.uk/~wolf0126/); and Niall Hammond, an
archaeologist working for Defence Estates, an agency of the MoD.

Bibliography

Antiquity, Editorials for June and September 2003, 77, 221–25; 442–444

Bogdanos, M, Update on the situation at the Iraq Museum 11 July 2003
 http://www.thebritishmuseum.ac.uk/ iraqcrisis/reports/Bogdanos11072003.doc

Cole, S, 2004 The United Kingdom and Ireland Blue Shield, *Alexandria* 16:3, 153–159

Catling, C, and Crawford, H, 2004 Protecting the past in times of war: some good news and bad, *The
 Archaeologist* 52, 20–21

Cruickshank, D, 2003 Return to Baghdad http://www.bbc.co.uk/history/war/iraq/iraq_after_the_war_
 01.shtml

Cruickshank, D, and Vincent, D, 2003 *Under Fire: People, Places and Treasures in Afganistan, Iraq and Israel*,
 BBC, London

Gaimster, D, 2004a Measures against the illicit trade in cultural objects: the emerging strategy in Britain,
 Antiquity 78: 301, 699–707

Gaimster, D, 2004b Protecting the past in times of war: UK progression towards accession to the 1954 Hague
 Convention, *The Institute of field Archaeologists Yearbook and Directory*, 35–36

Phuong, C, 2003 The Protection of Iraqi cultural property, *International and Comparative Law Quarterly* 53:
 985–998

The Independent Review 3 June 2003

Damage to Iraq's Wider Heritage

Usam Ghaidan

Iraq's building heritage

Iraq was the site of Islam's first new towns, the early 7th-century settlements of Basra and Kufa. Later in the same century, the Omayyads built the town of Wasit in central Iraq, west of the Tigris. Town building continued during the Abbasid period when the seat of the Caliphate moved from Syria to Iraq in AD 750. In that year, the first Abbasid Caliph, Abu-al-Abbas, built the town of Anbar near Fallujah on the banks of the Euphrates. His successor, Mansur, founded Baghdad on the western bank of the Tigris in AD 762. Twenty eight years later, Harun al-Rashid, the fifth Caliph, founded the city of Qadisiyya higher up the Tigris, about 110km north of Baghdad, and in 833 the eighth Caliph, Mu'tasim, left Baghdad and built an entirely new capital city in Samarra.

With the exception of the desert palace of Ukhaidir, which was built, probably in the 8th century, from rubble and brick masonry, hardly any pre-12th century structures have survived intact because the materials used in their construction, mud bricks and timber beams, were too fragile to withstand the harsh climate and the impact of frequent wars and floods. Among the remaining buildings in Baghdad are the Al-Mustansiriyya school, built in 1234, three 12th- and early 13th-century mausoleums with conical, muqarnas-supported domes, the 12th-century Abbasid Palace and a number of brick minarets also dating from the 12th century. Elsewhere in Iraq there are further minarets of a similar age, a famous example being the leaning minaret of Al-Nuri Mosque in Mosul (AD 1147). Also in Mosul, on the banks of the Tigris, are the mausoleum of the Prophet Jonas (Nabi Yunus) and the 13th-century sanctuary of Imam Yahya bin al-Hassan. There are three more conical mausoleums; one covers the tomb of the Prophet Ezekiel, the oldest existing Jewish shrine, in Kifil, 25km south of Babylon. The Citadel in the Kurdish city of Arbil is the oldest inhabited town in the world and in Kerbala, Shiite Islam's foremost holy city, are the shrines of Hussein and Abbas, the grandsons of the Prophet Muhammad. In Nejaf, the other holy city, is the shrine of their father, Imam Ali.

The Ottoman era

The Ottoman era, between 1534 and 1917, was a period of little building activity. A number of mosques were erected and some existing structures were restored and extended,

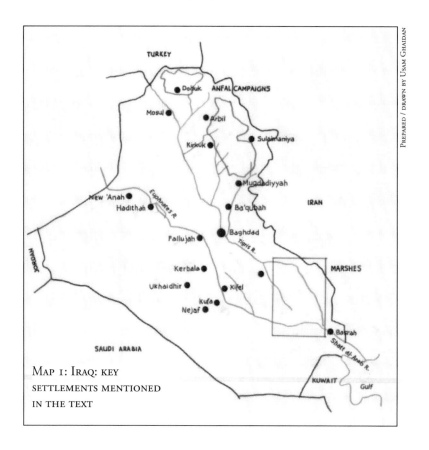

PREPARED / DRAWN BY USAM GHAIDAN

MAP 1: IRAQ: KEY
SETTLEMENTS MENTIONED
IN THE TEXT

such as the shrines of Abdul Qadir al-Gailani and Abu Hanifah, where new domes were
added in 1534 and 1681 respectively; the former was designed by the famous Ottoman
architect Sinan. In 1802 the Ottoman governor constructed the Saray building which
became the nucleus of the city's administrative centre. Fifty years later, another governor
added the Qushlah barracks adjacent to it. This building was extended in 1870 by a third
governor who added a second storey. He demolished a section of the early 11th-century
wall surrounding Baghdad to provide the building materials for the project. There had
been instances of destruction in Baghdad during wars and foreign invasions, such as the
burning of the suburbs surrounding the round city by Mamun in 806, the destruction
of the city's irrigation system and buildings by the Moguls in 1258 and 1393 and so on,
but breaking down the city's protective wall in peace time was an unmistakable act of
cultural vandalism. In the early years of the 20th century, the Ottoman administration
decided to tighten its control on the population by opening a street through the city's
traditional quarters to connect the administrative centre with the heart of the city. As a
result, hundreds of Baghdad's old houses were lost for ever.

THE HASHEMITE AND REPUBLICAN ERAS (1921–1963)

The above road-widening project, begun by the Ottomans for the purpose of control, was revived in the name of modernisation by the administrators of the city of Baghdad during the Hashemite period (1921–1958). This would have meant the further demolition and damage of more of the town's old fabric, however, Gertrude Bell (1869–1926), the newly appointed British Director of the Department of Antiquities, established in 1923, used her considerable influence to halt the project. Bell was an enthusiastic supporter of conserving the vernacular heritage buildings of Iraq. She would have been horrified to see the looting and burning of historic buildings in April 2003 and during the months that followed. After her death in July 1926, the road-widening project was resumed. More traditional houses were lost and two mosques, the 14th-century Marjan mosque and the 19th-century Haidarkhana mosque, were truncated. In the 1930s two similar streets were built west of this original development, causing the loss of yet more old buildings.

There were, however, positive developments as well. The new Antiquities Department was gaining strength and experience. The Department of Public Works was established and began designing and supervising the implementation of colleges, airports, railway stations, hospitals, and other projects needed by the modern state. The School of Antiquities and Archaeology was established within the College of Arts in 1951 and scholarship students were sent abroad to study architecture. In 1957 the Architects Collaborative, headed by the ex-Bauhaus director Gropius, were appointed architects to the new Baghdad University campus, and in 1960 Geo Ponti designed the headquarters of the Ministry of Planning, which was bombed during the US-led invasion in April 2003.

THE YEARS OF ADVERSITY

During the four decades between 1963 and 2003, Iraq endured two military coups; a Gulf war against Iran, which lasted eight years and cost USA $453 billion, (more than four times the oil revenues collected during the war period); a Second Gulf War, in which the armies of 26 countries destroyed Iraq's communication infrastructure and strategic industries; followed by 12 years of sanctions. The period began with a violent coup during which tanks and fighter planes partly destroyed two of the country's heritage icons, the Ministry of Defence in old Baghdad and the Rashid Military Camp to the south of the capital. During the first ten years, with the exception of a brief period in 1965–1966, the country was governed by army officers who paid no attention to cultural matters. The situation improved slightly during the oil boom years of the 1970s. A modern stadium, designed by Le Corbusier, was erected; the Antiquities Department, later named the State Board of Antiquities and Heritage (SBAH), established, with help from UNESCO, the 'Regional Centre for the Conservation of Cultural Property in the Arab Countries', which provided advice and training in matters related to building conservation. In 1980, at the start of the First Gulf War (against Iran), the Centre was closed down and SBAH lost a large proportion of its budget. Many of its employees were sent to the war front, others left the country and heritage protection dwindled.

Baghdad was a city which represented both the Hashemite and the Republican past. Both were anathema to the Ba'athists, so many old monuments and cultural vestiges were destroyed. In 1995 the traditional courtyard houses in west Baghdad were demolished and replaced by a line of 15-storey concrete apartments, copied from 1950s Europe, years after they had been condemned there as social failures. In Baghdad's main shopping area, scores of old shops were knocked down and replaced by a statue of a Ba'ath party member who had carried out an unsuccessful terrorist attack against the prime minister in 1995. Major planning decisions breaking fundamental taboos were taken arbitrarily and in direct contravention of agreed land-use patterns. Old buildings were torn down and replaced by large palaces for the ruling family and the senior members of the Ba'ath Party and were turned into no-go areas. The riverside cafés along Abu Nouas Street, which were among

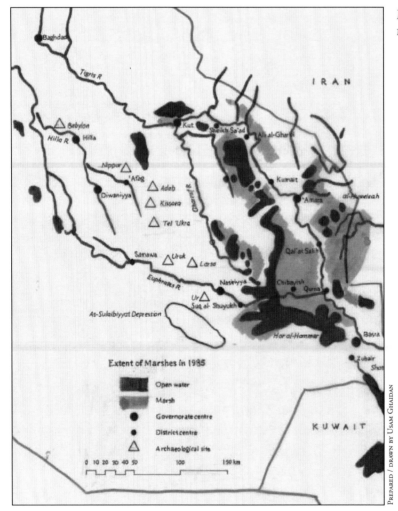

MAP 2: EXTENT OF MARSHES IN 1985

PREPARED / DRAWN BY USAM GHAIDAN

the Middle East's most famous leisure centres, specialising in the serving of traditional smoked Tigris carp, were closed down and hedges of water hyacinth (*eichhornia crassipes*), a thick, fast-growing bush were planted along the river bank, totally cutting off the view of the river from the street. The Unknown Soldier monument, designed by one of Iraq's foremost architects and built in 1959, was demolished and replaced by a presidential statue which itself was pulled down after the fall of Baghdad in April 2003. Perhaps the most heinous acts of cultural genocide were committed in the 1980s against two cultural assets; unique environments that embodied thousands of years of intertwinement of the works of nature and of humanity. Iraq's marshes, home to a Mesopotamian civilisation, where urban life had developed over 5000 years previously, were desiccated, and the fertile plains of Kurdistan, home to the first site of agriculture, were ravaged and burned.

MAP 3: EXTENT OF
MARSHES IN 2000

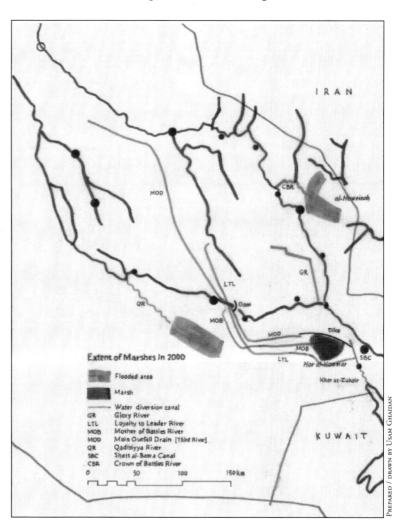

Extent of Marshes in 2000

Flooded area

Marsh

Water diversion canal
GR Glory River
LTL Loyalty to Leader River
MOB Mother of Battles River
MOD Main Outfall Drain [Third River]
QR Qadisiyya River
SBC Shatt al-Basra Canal
CBR Crown of Battles River

0 50 100 150 km

PREPARED / DRAWN BY USAM GHAIDAN

DRAINING THE MARSHLANDS

The marshlands of southern Iraq are located at the confluence of the Tigris and the Euphrates. They consisted of several permanent lakes and stretches of seasonal marshes interconnected with lagoons and water courses. Covering an area of up to 20,000 square kilometres during the flood season, they were the largest wetlands in the Middle East and among the most important in the world (see Map 2). The area's 400,000 inhabitants, mainly Shi'a Muslims, lived by fishing, keeping water buffalo and planting wheat, barley and rice. They lived in humped-back reed houses, supported on arches made of reed bundles covered with reed mats, a unique building method inherited from their Sumerian ancestors. Archaeologist Sir Leonard Woolley found remains of reed houses in Ur dating from before the Great Flood. He believes that the reed house was the forerunner of the arches and vaults used in ancient Iraq during the Sumerian, Babylonian and Sassanian periods. (Woolley 1961, Chapter III). Pictures depicting reed houses were used to decorate cylinder seals produced during the Uruk and the First Ur Dynasty periods.

The marshes acted as a natural habitat for rare mammals, way stations to migratory birds between Siberia and southern Africa and as a treatment system for the waters of the Gulf. They began to decline in the 1970s as dam building in Syria and Turkey attenuated the flow of the two rivers. The situation worsened in the 1990s when the Ataturk Dam, the first phase of the Southeast Anatolia Project in Turkey, was completed. In 1991 the Iraqi government, as part of its systematic targeting of internal opposition groups, began constructing an intricate system of diversionary canals, (see Map 3), to drain the life-giving waters in order to force the inhabitants to evacuate the area.

In 2000, the United Nations Environment Programme reported that 90% of the marshes had disappeared and studies presented at the Worldwide Forum three years later indicated that a third of the remaining 10% had also dried up. The immediate results were the displacement of around 300,000 people, loss of vital agricultural land, disappearance of endemic flora and fauna, contamination of rivers and intrusion of salt water into Shat al-Arab, causing disruption to fisheries in the Gulf. The central marsh has turned into a complete dust bowl and is covered by a salt crust, 60cm thick in places due to the rapid evaporation of brackish water. Hor al-Hammar, west of Shat al-Arab, still has some remaining lush areas and segments of marsh remain in al-Huweizah, east of the Tigris, where returnees have reintroduced their water buffalo. There are plans to make al-Huweizah a pilot project for restoring more areas of the lost marshes. The main restraining factor in this effort, however, is the scarcity of water. In early 2000, Iran started to impound its largest reservoir dam on the Karkhah, a main watercourse supplying al-Huweizah marshes. The Karkhah dam was inaugurated in April 2001. It has a capacity of 7.8 billion cubic metres and is intended to irrigate 320,000 hectares of land in the Khurdistan plains. It is going to be difficult to persuade Iraq's neighbours to heed the UN call to reconsider their water policies in order to avoid further damage. Also, with the looting and burning of the Ministry of Irrigation which occurred after the invasion, all the plans and blueprints of Iraq's dams, barrages, pumping stations and canals were destroyed.

The destruction of rural life in Iraqi Kurdistan

Iraqi Kurdistan covers an area of around 74,000 square kilometres or 15% of the area of Iraq; more than half of the area is made up of rural fertile plains. Its population is approximately four million, or just over 18% of the population of Iraq.

The relationship between the Kurds and the rulers of Iraq has been one of broken promises, neglect and repression. Since the 1940s, the Kurds have been struggling for self-determination. In 1970, the Iraqi government granted them a considerable degree of autonomy. Soon afterwards, it reneged on the covenant by evicting Kurdish farmers from the oil-producing areas of Kurdistan and replacing them with tribal Arab families. In March 1974, the Kurds rose up against the government and a full-scale war ensued. In 1975, the Algiers agreement between Iraq and Iran put an end to the uprising. The following year, the Iraqi government secured the approval of Turkey and Iran to create a *cordon sanitaire* which extended for 5km and was later increased to 30km along their borders. Between 1975 and 1978, 500 villages situated within the *cordon sanitaire* were destroyed and their occupants were given five days to gather up their possessions and leave their homes. When that deadline expired, the army demolition crews moved in. Deportees were relocated to concrete encampments built along the main highways in army-controlled areas. From 1982 onwards, more villages lying outside the *cordon sanitaire* were cleared. By the beginning of 1987 it was becoming evident that a sinister ethnic cleansing plan was being implemented. In its first phase, carried out between April and June of that year, 711 villages were burned and bulldozed. Subsequent phases took place months later under the code name of Anfal (Middle East Watch, 1993).

The Anfal campaigns

The first Anfal campaign began in February 1988 and the eighth and last was completed on 6 September of the same year. There were six target zones covering an area of over 45,000 square kilometres, more than half the total area of Iraqi Kurdistan. Every campaign began with air attacks, which were accompanied in five of the six zones by bombardments using chemical weapons, followed by ground troops and pro-government militias moving in to destroy residences, loot possessions and animals and set fire to homes before the demolition crews were called to blast large buildings such as schools, clinics, and similar structures. The Kurdish government officially estimates that 182,000 people perished between 1987 and 1990. According to a survey prepared by the Kurdistan Ministry of Reconstruction and Development, only 637 villages were still standing in Kurdistan after the Anfal and 4049 villages had been eradicated (Middle East Watch, 1993). Of those still standing, two thirds were in areas excluded from the Anfal. (Only larger villages are shown on Map 4.)

After the establishment of the safe haven in northern Iraq by the USA, UK, France and the Netherlands in April 1991, there were over 700,000 internally displaced persons waiting to be resettled and the numbers continued to grow with the eviction of Kurds from Kirkuk and other towns in southern Kurdistan. Now, 18 years after the Anfal campaigns, unmarked minefields continue to claim dozens of victims each year.

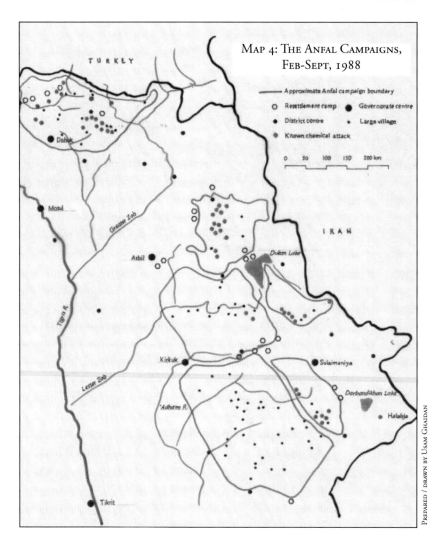

MAP 4: THE ANFAL CAMPAIGNS, FEB-SEPT, 1988

AFTERMATH OF THE 1991 UPRISING

The heavy loss of life and the destruction of people's ways of life described above reinforced the Shi'ites' and Kurds' perceptions of the Ba'ath regime as genocidal, hell-bent on their extinction and that of their culture. This view was reinforced by the brutal repression that followed the failure of the March 1991 uprising, when the Iraqi army was defeated and evicted from Kuwait. The rebels certainly acted, at a local scale, outside the norms of the Geneva conventions, but government forces responded with atrocities on a massive scale. In the holy city of Kerbala, the shrines of Hussein and Abbas were riddled with bullets, the dome of the former was damaged, the buildings lining the plaza between the two shrines were levelled and the palm groves outside the town decimated. A report which appeared

in *The New Yorker* on June 24 1991 described the devastation in Kerbala as follows:

> (It was) comparable to the levelling of cities in World War II, and the damage to the shrines was
> more serious than that which had been done to many European cathedrals. It seemed that no
> neighborhood had been spared. Big holes in walls indicated tank fire; smaller holes, and chunks
> taken out of concrete, were the signature of lighter automatic weapons. The wreckage suggested
> block-by-block, if not house-by-house, resistance, and many casualties. (Quoted in Human Rights
> Watch, 1992, p 49)

In Nejaf, the tomb of Imam Ali, the Prophet's cousin, was pounded with mortar
fire and stormed. In Kirkuk, an ethnically mixed city in northern Iraq which sits atop
one of the world's largest oil fields, the houses of Kurds who had fled the city following
the uprising were demolished or given to Arab families as part of what was essentially a
government ethnic cleansing policy to reduce the Kurdish population.

POST-INVASION IRAQ

'Stuff happens', Donald Rumsfeld is reported to have said, impatient at the indignation
over the theft from the Iraq National Museum of the 4th-millennium offerings vase
excavated at the Temple of Inanna in Warka in southern Iraq. Two years earlier, Mullah
Omar tried to justify the orgy of destruction by the Taliban towards the statues of the
Bamiyan Buddhas in Central Afghanistan. He said, 'all we are breaking are stones'. The two
men were making similar statements of intent. Mullah Omar was expressing intolerance
towards a religion and philosophy that played a central role in the spiritual, cultural and
social life of millions of people, and Mr Rumsfeld was showing total disrespect for the
history, identity and culture of the people his troops were claiming to liberate.

In August 2003, I visited Baghdad's old Administrative Complex on the eastern
bank of the Tigris. It consists of five buildings (see Plate 4). Three of them are 19th-
century Ottoman, the other two were erected during the Hashemite period in the 1930s.
Until March 2003, they were occupied by government departments. Nearby are other
structures representing almost every period of Iraq's past: the 12th-century Abbasid
Palace, the 16th-century Saray Mosque built by Sultan Suleiman the Magnificent, al-
Wazir Mosque named after the Ottoman governor who restored it in 1599, the Mandate
era Ministry of Defence, and the Hashemite Parliament House which the US bombed
in April 2003, as they did the adjacent research centre of Bayt al-Hikma. Here too is
Suq al-Sarai, the oldest book mart in the Islamic world, occupying a covered pedestrian
street which connects the Administrative Complex with the 14th-century Mustansiriyya
School. Between them these buildings chronicle every architectural style of Iraq's heritage
stock: courtyards, domes, vaults, iwans, and exposed brick walls, all of superior quality. A
number of them had been completely pillaged. From the rest, with the exception of the
mosques and the Abbasid Palace, gangs of looters had removed all furniture, doors and
windows and were pulling out the telephone and electricity cables from the ducts under
the pavements. They were assisted by children who were piling the loot onto donkey-
drawn trailers parked within the courtyards. The buildings fell under the jurisdiction of
the Ministry of Culture whose senior advisor, Ambassador Cordoni, had the previous

month announced that he intended to revive a 1990 project for the rehabilitation of some of the buildings of the complex. When I went to report the theft to him, I was told by his assistant, a colonel of the US Army 352nd Civil Affairs Command, that the Coalition Provisional Authority (CPA) had no intention of interfering. He stated specifically that 'it had ranked protecting cultural property as priority number three'.

When looters, who had pillaged shops, schools, universities and government offices, realised that the American troops were not going to protect cultural institutions and historic buildings, these too became fair game (see Plate 5). They moved into the Melodic School, the Heritage Teaching Institute, and the Museum of Modern Art. Eight thousand works of art were removed from the latter, of which 3000 were later recovered, but even these are under threat due to a lack of electricity and the absence of the controlled environment required to preserve them. In several cases, looting was accompanied by arson. This happened in Bayt al-Hikma, the research centre and repository of Ottoman and royal documents, the Post Office Headquarters and the Union of Industries building. In April 2005, the historic suq of Shorja in central Baghdad was destroyed by fire and 200 warehouses were burnt down. Although stories are in wide circulation that agent provocateurs of uncertain origin started these fires, no efforts are underway to investigate or dispel these reports.

Professional terror groups are embarking upon a campaign of bombardments targeting important cultural icons. The famous Malwiyya Minaret of the Great Mosque of Samarra, the first free-standing minaret in Muslim architecture, famous for its imposing external spiral staircase, was bombed in April 2006. Soon after, the 14th-century minaret of Ana was bombed. This minaret had been dismantled and transferred by SBAH to its present location when the town was drowned in the Qadisiyyah reservoir in 1986. The most criminal act of this kind took place in February 2006 when the dome of the 17th-century Askari mosque in Samarra was blown up, sparking a civil war which is still raging between fundamentalists from the two sects of Islam (see Plate 6).

The USA stands guilty of contravening three sets of treaties, namely the Hague Conventions of 1949 and 1907, the Geneva Convention of 1949 and the Hague Convention of 1954. The latter was invoked during the 1991 Gulf War and was successfully implemented by creating "no fire target lists" of places where cultural property was known to exist. Most of the Coalition states in that war were party to the Convention. The USA is a signatory to it but the treaty has not been ratified by the US Congress. In April 2003, the US military managed to protect the ministries of oil and the interior. They could have also protected Iraq's cultural properties, had there been a plan to do so.

CONCLUSIONS

Culture is the first collateral casualty of war and current international laws are unable to protect cultural property during and after military conflicts. Violent regime change creates a vacuum of authority and when this is coupled with the absence of civic responsibility and inadequate commitment and training on the part of the occupying forces, the result is disaster (Knuth, 2006).

Four years into the occupation, Baghdad and other cities are at war with themselves. The resulting lack of security and high cost of insurance are preventing international organisations from operating inside Iraq. This is also true of the Kurdish governorates, where security is not a problem. There, international help is now needed to carry out emergency exploratory excavations in some of the 3125 unexplored sites which are under threat of destruction from the planned expansion of the region's infrastructure. Lack of security is the most pernicious legacy of the invasion.

Prior to April 2003, Iraq was not a factor in the war on terror. Despite the brutal dictatorship, which until 1990 was shored up by the United States of America, whose annual subsidies to it had approached one billion dollars by 1988, the people of Iraq were struggling to remain a cohesive union of races, languages and religions. Under occupation this union is falling apart, and Iraq's culture, which was the main riveting power of the union, has become the latest victim of a global catastrophe that shows no sign of ending.

BIBLIOGRAPHY

Ghaidan, U, and Al-Dabbagh, N, 2005 in *Heritage at Risk, Icomos World Report 2004/2005 on monuments and sites in danger* (eds M Truscott, M Petzet and J Ziesemer), K.G. Saur, München

Human Rights Watch, 2002 *Endless Torment: The 1991 Uprising in Iraq and Its Aftermath*, Middle East Watch, USA

Knuth, R, 2006 *Burning Books and Leveling Libraries: Extremist Violence and Cultural Destruction*, Praeger Publishers, Westport, CT

Middle East Watch, 1993 *Genocide in Iraq: The Anfal Campaign Against the Kurds*, Middle East Watch, USA

Salih, K, 1995 Anfal: The Kurdish Genocide in Iraq, *Digest of Middle East Studies* Vol 4, no 2, Spring 1995, 24–39

UNEP, 2001 *The Mesopotamian Marshlands, Demise of an Ecosystem*, United Nations Environment Program

Woolley, L, 1961 *The Art of the Middle East*, Crown, New York

Woolley, L, 1980 *Art of the Middle East*, Crown, New York

The Looting of the Iraq National Museum

DONNY GEORGE

Roughly a year before the 2003 invasion of Iraq, I received information from a very reliable source that there were people in England, including some referred to as 'scholars', who were suggesting that the Iraqi people did not understand the value of the archaeological remains in Iraq, that they did not 'deserve' them, and that the obvious consequence of this was that the material should be removed – stolen – from Iraq and taken to England. It was reported to me that one person had commented, 'I'm waiting for the day that the American troops enter Baghdad, I will be with them and I will go to the Iraq Museum and take what I want.' This, in part, is what happened in April 2003.

With the escalation of tension in early 2003, we received orders from the Ministry of Culture to assemble teams of young people, men and women, in order to defend the whole National Museum complex. These teams, of between 23 and 25 individuals, were sub-divided into groups for first aid, fire prevention and control, messengers, and one group who were given AK-47 Kalashnikovs to defend the Museum compound, whatever happened. Rotas were set up to ensure that the Museum compound was protected by these teams, each under the command of one of the Director Generals of the State Board of Antiquities and Heritage, at all times of the day and night. At the same time, partially as a result of the intelligence reported above and partly given the experience of looting that had followed the previous invasion of 1991, Museum staff had been busy removing and storing the majority of objects on display in the National Museum. The only things left in the galleries were objects that were too large and/or heavy to move, and some replicas.

I was supposed to be in charge of the team protecting the Museum over the weekend of 5–6 April 2003. I had decided to move my family from our flat in the Jadiriah area of Baghdad to my parents' house in Dorah so we would be all together in one place. I could not get to the Museum on the Saturday as there was a fierce battle around the intersection of Hilla and Al-Dorah, where American troops were entering Baghdad coming from Babylon, and Hilla where troops were entering from the highway. On Sunday 6 April I managed to get to the Museum, passing through the remains of the battle that included burnt out Iraqi and American tanks, armoured vehicles, cannons, and a variety of other

vehicles: I hardly made it between those burnt vehicles, but managed to cross and reached Bayya', and then the Museum. Just over half my team also made it to the Museum. I had about ten missing, because by then there were roads blocked going into the centre of the city and people could not get through. We stayed overnight in the Museum and I slept in my room on the couch that I had there.

It is worth mentioning here that on the Sunday, Dr Nawala, the Director General of the Museum, had come to Dr Jaber's room where I was together with Dr Jaber, Mr Mohammed Nabeeh, and the late Rabee' al-Qaisi, where she said that her brother-in-law was waiting for her outside and that her parents had gone to Ba'qooba and the rest of her family were just waiting for her to leave. Dr Jaber asked her whether all the doors of the Museum were locked and she replied that they were. He repeated the question and again she responded that all of the doors to the Museum were locked. Dr Nawala gave the Museum keys to Dr Jaber and his final words to her were 'May God be with you'.

The next day, Monday, my team's duty was finished but I stayed at the Museum until after 2pm. I then tried to get back to my parents' house, although we could hear fierce fighting all around Baghdad. Leaving my large Nissan Patrol car in the back yard of the Museum I took a small car, a Mitsubishi pick up, and tried to reach home. I tried to reach the same intersection where there had been a battle the previous Saturday but when I got close to the intersection I could see that American troops had returned and occupied the main road, and I could therefore not cross that intersection to get back to my family. As it was about 5.30pm I decided to go back to the Museum. I arrived there and met Dr Dakhel Majhool, Director General of the Heritage Department, whose team was on duty. We were told that the Minister, Hamed Youssef Hammadi, had just arrived and together we went to meet him at the front door of the Museum. I asked the Minister whether he wanted to go inside but he declined so we sat together at the main entrance of the building of the State Board of Antiquities and Heritage. We talked for about 15 minutes and he told us that the Americans had bombed the Al-Sa'a Restaurant. I did not know at this time why this was so important, but afterwards I learnt that it appeared that Saddam and a good number of his senior officers had been meeting there and that he had escaped only a few minutes before the bombing. Other senior staff were also present, including Dr Jaber Khalil, the Chairman of the State Board of Antiquities and Heritage, the late Rabee' al-Qaisi, then Director General of Restoration, Mr Mohammed Nabeeh Abdul Fattah, the Director General of Administration, and Captain Jasem, who was in charge of security in the Museum.

The Minister left, and that evening I stayed at the Museum with not more than about 10 or 15 young men from the Museum. I slept in my room again but the next morning I was woken up at about 5am by the sound of huge blasts all over the area, very close to us. Most of the blasts came from the left side of the Museum, where we learnt that the American troops had arrived and captured the building of the Ministry of Information and, next door to it, the building of the radio and television station. That building is not more than 400 or 500 metres from the Museum. Then we started hearing fighting on the right side of the Museum where there's a large bus stop.

I was told that Dr Jaber wanted to see me. I went to his room where all the senior staff mentioned above had congregated, except for Dr Nawala, who had left Baghdad on Sunday 6 April. Dr Jaber asked me what I was going to do – would I leave the building or stay? I responded that we should make a collective decision. I was pressed for my personal opinion and I responded saying that I would stay with the Museum, that I could not leave it in such difficult times. The group asked if this was my final decision and I reiterated that it was – 100%. I was confident that as soon as the Americans occupied the whole area, the first thing they would do was to protect the Museum. The meeting ended and within a few minutes Rabee' al-Qaisi, Mohammed Nabeeh Abdul Fattah and Captain Jasem vanished, and went away. They just left the building, while fighting was going on all over the area, and as we started to hear helicopter gun ships above us. They slipped from the back doors of the Museum and went away.

Dr Jaber had decided to stay with me, as did Qasim al-Basri, whose family lived in Basra and who lived within the Museum compound, along with one driver. Everyone else had left. We had food and water to survive. We decided that as Dr Jaber had the keys, we should go down to the cellars of the Museum, and stay there, lock all the doors and wait and see what would happen. As we were preparing to go into the Museum, I went back to my room to collect some biscuits that I had there. When I returned Dr Jaber said that we had to leave the building quickly. Looking out of one of the windows, he pointed out, and I saw myself, about four or five militants, Iraqi militants with RPG-7s on their shoulders, and they were firing towards the left side of the Museum against the American tanks. So this made the Museum compound a very, very hot spot. It was clear that the Museum could be caught in the cross-fire of a battle which is why Dr Jaber made the decision that we should leave immediately. We checked that the Museum gate and door were blocked and locked and that the main door of the State Board of Antiquities building was chained and locked and the four of us, me, Dr Jaber, the driver and Qasim al-Basri, left through a back door, which we locked, and we took the car I had used previously and we went to the eastern side of the River Tigris, with the intention of returning to the Museum as soon as possible when everything had calmed down.

At about 3pm the four of us decided to go back to the Museum. We started crossing the river at 17 July (or Medical City) Bridge but as we reached the middle we met people and some cars coming from the other side, from the western side, shouting and preventing us from crossing the bridge because they said the Americans had occupied the whole area, and nobody could move on that side. So we returned to the eastern side of the river again and went to the house of Rashid Ali al-Qailani, which was being used as an ethnographic museum.

We debated what to do: it was clear that it was impossible to get back to the Museum, so I told Dr Jaber that he should go home. This was impossible as he lives in part of Baghdad close to the Dorah area which we knew to be completely occupied by American troops, so he decided instead to go to his brother-in-law's house. I suggested that he took the car as he wanted to check his family were safe and then return. We agreed this was pointless as there was nothing we could do. After an hour the driver came back to me

and said that he had witnessed a battle very close to Dr Jaber's brother-in-law's house: in fact the house next to Dr Jaber's brother-in-law had been hit by a missile and almost completely destroyed. I was unsure where to go myself as it was clear I could not get back to my family in Dorah. I decided to go to my aunt's house, on the eastern side of the River Tigris, and asked the driver to take me there. He then went home himself. Qasim al-Basri stayed in the ethnographic museum, since he had nowhere else to go. I stayed at my aunt's, for all of Tuesday, Wednesday and Thursday, listening to the news, trying to follow what was happening. On Friday I managed to see a friend of mine who had a car, and he took me back home to Dorah where some sense of calm had arrived. By this time it was about six days that I had been away from home.

The next day, Saturday, my first day back home, I was listening to the evening news when I heard that the Iraqi Museum had been looted. I immediately decided to go the next morning to the American headquarters which we knew from news reports was in the Palestine Hotel. That Saturday evening I called Dr Jaber and we agreed to go together. The next morning I took my car, collected Dr Jaber and we went to the Palestine Hotel. Normally it would only take half an hour from where I used to live to the Palestine Hotel. On Sunday 13 April it took us about three hours to reach not even the Hotel, but something close to a kilometre away from it. I parked the car as close as we appeared to be able to get and we started walking. As we finally reached the hotel, we went to the main perimeter checkpoint, introduced ourselves and explained who we were, and requested to see somebody senior. They checked our IDs, they checked us, searched us completely, and then let us through.

When we reached the hotel entrance we were stopped and checked again, we again explained who we were and that we wanted to see someone senior and we were told to wait. We waited there for about two hours until we were sent for. We were escorted to meet a Colonel Zarcone from the American Marines. I asked him for help to protect the Iraq Museum. He asked me what I though was a very strange question – whether there was anything left in the Museum to protect. I responded that there was and that we wanted him to organise its immediate protection. He accepted this was an American responsibility and he showed us a map and asked me to show him where the Museum was on the map. I was surprised that these American troops that had come to Baghdad did not know the location of the National Museum. Despite this surprise, we showed him the Museum on the map; he took the coordinates, and told us that he would immediately send some troops to protect it. He asked us whether we were going back home or to the Museum, and when we said we were going to the Museum he gave us a letter for the checkpoints, so that they would allow us to get to the Museum compound.

When we got back to the Museum, we found two of our employees at the main entrance. One of them was Mohsen, one of our staff who lives in the Museum compound, the other one was Al'a Hussein. With them there were two or three other volunteers, who I did not know, but they were there to protect the Museum. When I started going towards my office in the Department, Al'a asked me not to go. I insisted and three or four times he shouted, 'Please Doctor, don't go to your room'. I anticipated what I was going to find

there: my room was an example of what had happened to all of the rooms in the building of the State Board of Antiquities and Heritage. All of the doors had been smashed, they had holes in them, all the rooms were devastated. In my room all the drawers had been emptied, all my books, all my reports and paperwork were on the floor. I had about two feet of papers on my floor. My desk was dismantled and in three or four pieces, my computer was gone, my safe, in which I had stored eight cameras, was destroyed completely and my cameras were gone. Even my coffee machine was taken away. Exactly the same thing had happened to all of the offices in the Department.

After that I returned to the main gate, and Dr Jaber and I went into the Museum as we wanted to see what had happened to the galleries. Of course there was no electricity, but we walked into the parts of the Museum lit by daylight. Our first discovery was that the looters had broken through a window that we had blocked some years before. In one of the halls I found four glass cutters which the looters had brought with them and left behind. We walked on and went to the Sumerian Gallery. I saw the showcase for the Warka Vase smashed on the floor and I realised that one of the masterpieces of the Museum was missing. Of course my heart at that time was pounding; because we had three very, very important pieces in that room: the Sumerian Stela of Lion Hunting, the Warka Vase, and the beautiful mask of the Warka Lady. At that moment I did not know anything about the Warka Lady, but I realised the Warka Vase was gone, but the Sumerian Stela of Lion Hunting was still there because it was made of basalt on a steel base, which was too heavy to move easily. We went through the Museum and we saw a lot of damage everywhere. We discovered that the statue of Basitki from the Akkadian Gallery was gone; at the end of the Babylonian Gallery a number of terracotta lion statues had been smashed, and in the Grand Assyrian Gallery I noticed that the statue of the Assyrian king Shalmanessar III was gone, another great loss. In the Hatra Galleries we found more tragedy: three important marble statues had been smashed and their heads removed; and the bronze head of Nike, the deity of victory, had also been taken.

After this brief tour of the galleries, we decided to immediately block, with bricks and gypsum, the holes the looters had made through the first window we had seen and another small window between an Assyrian Gallery and the Babylonian Gallery in the new part of the Museum. Then we went to the Hatrian Gallery, where we realised that the looters had got into the cellars, to the store rooms on the lower floor. They had gone through a small door from the Hatrian Gallery which I myself had not known about.

According to Mohsen, who had been at the Museum all the time, by midday on Thursday 10 April, there had been about 300–400 people gathered at the front of the Museum compound, outside on the street. They were all armed with a variety of hammers, crow-bars, sticks, Kalashnikovs, daggers, and bayonets. He realised that they intended to enter the Museum. So he went to an American tank very close to the right side of the Museum, where, through an interpreter who he said looked like one of the Arabs from the Gulf States, he begged the Americans to come and move their tanks in front of the Museum to protect it. The Americans in the tank radioed to somewhere and said that they were sorry but that they did not have permission to move. Then the looters started

entering the compound and then the Museum building, smashing the doors. First they came through one of the back doors, and then they opened a small door at the front, and then people were inside the Department building, coming and going from the back door, and from the front door, taking anything they wanted.

This looting continued for three days, Thursday 10, Friday 11, and Saturday 12 April. On Sunday 13 I went with Dr Jaber to the American headquarters and then returned to the Museum. Sunday 13, Monday 14, and Tuesday 15 were very, very hard days for us, as we had to stand guard in front of the Museum with sticks and clubs in our hands, trying to protect what was left inside. And we could see looters going around, roaming around the premises waiting to loot again. On one occasion, one of them waved a Kalashnikov at us, and we were afraid of another large wave of looters. Our most pressing concern was that we were afraid that the mob would set fire to the whole building, as had happened to many other government buildings.

One development that helped us greatly was that, on Sunday 13, at about midday, the media started to arrive and over the next few days press from all over the world descended on us once the news spread about the looting of the Museum. I believe the media generally did an excellent job by exposing what had happened to the Museum, and by bringing to the attention of the whole world the humanitarian and cultural tragedy that had taken place. What we had in the Museum, and in the archaeological sites across Iraq, was not only the Iraqi heritage, but rather the heritage of humankind that we held here in trust. It was this global heritage that was looted and disturbed and smashed, and that is a great loss to all humankind. While the media generally did an excellent job, there were some misunderstandings. The biggest of these was, in one of those early days, one of the reporters, I cannot recall who, asked me about the amount of material in the Iraq Museum. I said we had over 170,000 objects. Then this number was taken as over 170,000 objects that were *missing* from the Museum, a significant error and misunderstanding. However, everybody wanted to know how much had been looted from the Museum. During those early days, of course, we could not give any precise numbers because we had to check through the storerooms, through all the shelves and in all of the boxes (and see Bogdanos, chapter 11). However, after a few months, we were able to estimate with some degree of certainty that over 15,000 objects were missing from the Museum.

On Tuesday 15 April, people from the UK's Channel 4 visited for a second time and asked me whether I wanted to talk to John Curtis, curator of the Near Eastern Department of the British Museum. I said 'of course' but had no idea how it would be possible. They had a satellite phone with them, something I had never seen before, so they contacted John immediately and I talked to him, and I told him what had happened to the Museum and of my fears that there would be another wave of looting, and of my biggest fear that the mob would set fire to the Museum (and see Curtis, chapter 20). I told him that we would do everything we could in Baghdad but I pleaded with him to do something, and he said he would do everything he could. The next morning, Wednesday 16 at 7.30am, a group of American tanks surrounded the whole Museum compound and allayed any fears we had about further looting, vandalism, or arson.

I learned later, when I went to London for a meeting on 29 April, that immediately after I had talked to John he had gone to Neil MacGregor, the Director of the British Museum, and repeated to him what I said. Immediately Neil MacGregor telephoned Tessa Jowell, the British Minister of Culture. She, apparently, immediately contacted 10 Downing Street and asked Tony Blair to do something at once for the Iraq Museum. I learned that they had contacted the American Pentagon and the American State Department, and that there were immediate orders given to deploy forces to protect the Museum.

Once the Museum was protected, we were able to take stock and it became clear very quickly that many of the looters had come from the area immediately surrounding the Museum. So we went to the mosques in the area and asked them to start preaching to the people about the looted antiquities, explaining that they were the heritage of all Iraqis, that they should not have been stolen in this way, and that they should be returned to the Museum. Within a few days people started bringing objects to these mosques, and the people from these mosques started bringing the objects to us. It was a wonderful thing to have objects being returned so very soon after the looting. Among these returned objects were some very important ivories.

One day, in the period after the looting but before the Museum was protected by the American military, two young Iraqi men asked to speak with Dr Jaber and myself. When we met them they asked to speak to us in private. They told us that they had been in the Museum during the looting, and they felt very sorry about what was happening, but they could not do anything because most of the looters were armed. So they decided to take objects from the Museum, and to take them to their houses, to protect them, and to return them as soon as possible. They told us not to ask for their names or addresses, but rather to depend on their word of honour, and promised to return the items they had removed as soon as they saw that the Museum had been secured. We thanked them, accepted their word of honour and they left. A few days later, when we had American troops living within the Museum compound, someone came to me and said that there were people outside at the main gate, who wanted to deliver antiquities. When I went out there I saw the same young men who had come and told us about the antiquities they had removed. I let their car into the compound and they returned nine very important objects that they had taken from the galleries of the Museum. Among them was the statue of the Assyrian king Shalmanesser III. They said it had been knocked down from its base onto the floor, that it had been broken into five pieces, that they had collected all of the pieces and taken them to their house and were now returning them. There was one piece, one relief made of bronze, which had been originally found in Tell Al-Ubaid, from the Sumerian Early Dynastic period, in the southern part of the country. They returned these and some other very important pieces that they had removed for safe keeping during the looting.

These young men epitomised the very positive side of the Iraqi people. When they brought the antiquities back to the Museum, I began to feel that, since there were such honest people around, everything would turn out alright; that we would have many of

the stolen objects returned. I was fearful that some of the objects had already been taken out of the country, and these fears have been realised. But we have had a lot of objects returned, more than 4000 objects from the ones that were looted from the Museum, and we have more than 17,000 objects handed in that have been looted from archaeological sites.

In the weeks and months that followed the looting, we had a lot of help from all over the world including additional checking at airports and known crossing points and at official borders. There is now good information that the American authorities have recovered over 2000 objects from within the USA and that the Jordanian authorities have recovered over 2000 objects in Jordan and along the border that are now in the safe-keeping of the Jordanian Department of Antiquities. Arrangements to have them returned to the Iraq Museum were underway when I left Iraq but these are still to be returned. Also we have information on what has been seized officially in Kuwait, Saudi Arabia, and Syria. Unfortunately we have had no information about whether or not the other countries with borders with Iraq have seized any antiquities: nothing from Iran, or Turkey. More positively, from outside the region, I understand that 250 objects have been found in Switzerland and over 100 clay tablets have been recovered by the Italian Carabinieri, in Genoa. More recently we received information that a good number of clay tablets have also been seized in Spain. I hope all of the above will be returned as quickly as possible to the Iraq Museum, as soon as the security situation permits.

The Iraq Museum holds a very important place within Iraqi culture, because it is receiving such huge support from all over the world. From the USA, private donors, institutions, and the State Department, are all helping the Museum to get back to where it was, or even better. UNESCO is coordinating a huge number of projects with the money coming from donors from European countries and Japan; individual countries are helping the Museum so much. Much of this relates to physical infrastructure – for example, the replacement of the Museum's lighting system, special cupboards for storing clay tablets, and the donation of books – but much support has come in the form of opportunities for educating and training our staff. Twenty-three of our young archaeologists are going to the USA for short courses and another 15 to France. Germany did arrange for the provision of four PhD scholarships, from Heidelberg, although this has since been cancelled. Six have been offered places to study for their masters in New York (and see Cox, chapter 26 for specialised training offered in the UK). In all it has been estimated that around 300 of the staff of the Iraqi State Board of Antiquities and Heritage were trained outside the country in 2004, and over 360 in 2005.

I believe that the Iraq Museum had never had such a level of support in its whole life. We do thank all these people, we do thank all these countries and institutions for their support, and I am sure that the time will come when the generosity shown will be able to be repaid when the Iraq Museum becomes one of the best museums in the world, where people can come and visit and wonder.

Looters ... Governments ... Who is Responsible?

But who were the people who looted the Iraq and other museums in 2003 and who looted, and who continues to loot, archaeological sites across the country as I write in 2007? What follows is mostly from my personal experience of 30 years of working in the field and in the headquarters of the State Board of Antiquities and Heritage in Iraq. It is not my intention or role to blame the foreign forces that occupied Iraq after April 2003, nor do I blame the dealers outside the country, in Europe or the USA, and nor do I blame Iraq's neighbouring countries. The roles of all these are already known. Rather I delve into the economical, educational, and the political systems of Iraq, to search for the reasons that led to the large scale looting of the museums and archaeological sites.

Politics

Since World War II, Iraq has gone through many changes in politics, the economy, and education, all affected by wider changes in the system used to rule the country, from monarchy, to republic, to dictatorship: some of these followed Western ideas; others, Eastern ones. From the first revolution of 1958, then again in 1963, then again in 1968, each of the recent revolutions introduced different ideas and ideologies and then imposed these onto the Iraqi people: Communism, Arab Nationalism, and then the particular Arab Ba'athist ideology. All of these, and others, were imposed by the successive governments on the Iraqi people, in a dictatorial way, without taking into consideration the real needs, thoughts, or ambitions of the Iraqi people. The Iraqi population was always taught and told that its wealth was for the Arab Nation first, second for those who governed and their families, then the military, and that last in line were the people. This political hierarchy was accepted by the population while government was strong. However, the awareness that the people came last in the minds of the governing elite, that the general population was the last to be taken care of, led to an understanding that it was acceptable, when possible, for the population to take things from the government: in other words it was regarded as socially acceptable for people to steal from government properties. No-one was educated that what the government had was, in fact, the wealth of the people, administered and protected on their behalf. In this way, what was in the museums and in the archaeological sites, especially those that were protected by guards paid by the government, was considered the property of the government, just as were the contents of any other government office or building, and consequently it was considered that it was completely reasonable to take it, just as people were taking – looting – from other government institutions and offices.

Education

The educational system in Iraq comprises 12 years of study in three stages, starting with elementary (six years), then intermediate (three years), and finally secondary (three years); then some young people go on to university. Most children start the elementary stage at age six. Within this system Iraqi pupils start to study history in the fifth year of the elementary stage, ie when they are ten years old, and they continue to have history courses

until they finish high school; in other words, most Iraqi pupils completing schooling will have had eight years of studying history. The history syllabus is centrally controlled and pupils start their study of the past with the history of the Arabs before Islam, followed by the history of Islam. This content is then enlarged, expanded, and repeated in following years. One year is dedicated to European history (mainly German and Italian) and one year, the first year of the intermediate stage, is dedicated to ancient Mesopotamian history, which means that children study Mesopotamian history when they are 12 years old. This is the *only* opportunity that pupils have to study ancient Mesopotamian history. Imagine, children of 12 being stuffed with all the new information on ancient Mesopotamia: new name of sites and cities, kings, and a few pictures of antiquities and sites. Everything is completely new to them, as if this is the history of a civilisation that comes from outer space. They are taught about it, just for one year, then it all stops, and most pupils forget about it completely, because they just study it to pass the end of year examination. If you ask pupils the next year about ancient Mesopotamian history, they have forgotten everything. Even more problematic is that even this part of the syllabus was only added in the last 20 years. Before then there was almost no reference to ancient Mesopotamia in the school curriculum at all.

As people working in the field of Mesopotamian history and archaeology, in the State Board of Antiquities and Heritage and in the universities, we worked very hard for many years with the Ministry of Education, in an effort to expand the study of Mesopotamian history and archaeology to continue through at least the three years of the intermediate stage, so that pupils would be taught about this past more gradually and over a longer time, in an attempt to produce pupils who would be more open-minded when they finished the intermediate stage, aged 15. All this effort – talking to individuals, working through special joint committees, always at our request – served for nothing and our suggestions were never accepted by the Ministry of Education.

As a result of our efforts we did manage to have pupils come to both the National Museum in Baghdad and to the regional museums in the major provincial cities in large numbers. In this way many children in Iraq were exposed to real antiquities as only two provinces, Kerbala' and Samawa, had no museum. Our main aim in all this was to educate pupils ourselves as an additional support to the very limited exposure to the material they received at school. However, these visits could only ever achieve very little as pupils only visited once and never returned with their families.

ECONOMY

Iraq, with its oil and other mineral resources, water, and fertile land, and large working population, is one of the richest countries in the world. But, as noted above, only a fraction of that was ever allocated for the welfare of the general population. Taking the example of oil, most oil revenue was spent on the military, the palaces and the family of the president. It has been suggested that less than 5% of oil revenue ever reached the people of Iraq. This meant fewer initiatives in education, health, or agriculture. Given that the majority of the Iraqi population depend on farming to support their families,

the failure to supply regular, safe and secure water for arable and pasture agriculture was critical, especially for those communities in the southern parts of the country.

This economic failure produced something that was impossible to imagine in such a rich country: a very high level of acute poverty and starvation. As one example, on our excavation at Um Al-Agareb near Al-Rifai', I noticed one day that one of our workers was very slow and that he could hardly move himself. After checking with the foreman, I found out that this man, together with his wife and three children, had had nothing to eat for four days as he had nothing to plant, no money and no supplies left at home. This family was lucky as we were able to help them.

Now imagine this man in such a situation, living beside an archaeological tell, with no excavation team there to help him feed his family. It would be only natural that he would go and dig and sell whatever he could find in order to feed his family, especially given the lack of education as described above. But this was not the case of one family only, but hundreds of families in the southern parts of the country, and when they found out it was, and is, easy to sell the things they find and that they get easy money to feed their families, it is not surprising they continue to dig on sites, especially when there is no protection for these sites.

Now if we start to consider the issues mentioned above: the huge gap between the people and the government; the extreme lack of awareness of the importance and cultural value of the ancient Mesopotamian past on the part of the majority of the people, especially in the southern part of the country, the impossible individual economic situation and the grinding poverty of the whole community, these factors combine to create a very volatile situation. In such a situation it is perfectly understandable that large scale looting can happen at any time, unless the country is controlled by a very strong police force, although even this can never be enough – or the solution – for a country like Iraq with over 12,000 archaeological sites.

Given this context, it must be asked where the real and major blame lies for the mass looting of the museums and archaeological sites in Iraq? I do not present excuses for the people of Iraq who did all the looting, but provide the real reasons that led the people to do what they did.

Thieves of Baghdad[1]

Matthew Bogdanos

1 The Looting of the Iraq Museum

As word of the Iraq Museum's fate spread like wildfire throughout the world, USA forces took a lot of heat. The 'Why didn't you prevent the looting?' question had emerged right from the start, during the period that British columnist David Aaronovitch had summed up with 'You cannot say anything too bad about the Yanks and not be believed.' (Aaronovitch 2003).

So why had the USA not 'done more' to protect the Museum? After hundreds of interviews on the ground of eyewitnesses, and countless hours of forensic examinations of the entire museum compound - inside and out - I learned a great deal in 2003 about what actually occurred at the Museum, and what USA forces could be expected to have done, faced with the situation on the ground. The following describes those findings in detail.

Two months before the war began, in January 2003, a group of scholars, museum directors, and antiquities dealers met with Pentagon officials to discuss their fears about the threat to the Museum's collection. McGuire Gibson of the University of Chicago's Oriental Institute went back twice more, and he and his colleagues continued to barrage defence department officials with e-mail reminders. They could not have done more.

Gibson and his colleagues were heard. But only partly. The Pentagon ordered the Iraq Museum placed on the coalition's no-strike list, and US Central Command obliged, listing it as number 3 on the list. But the planners had no idea of the extent to which the average Iraqi viewed the Museum not as housing the priceless cultural heritage of their country, but as Saddam Hussein's gift shop - their words, not mine. This was not surprising given that the Museum had been closed for 20 of the previous 24 years - open only once (on Saddam Hussein's birthday in 2000) and then closed again shortly thereafter. Planners did not understand that many Iraqis would equate stealing from the Museum with stealing from Saddam and not from themselves. Even museum officials, who brought in sandbags and foam-rubber padding against possible bomb damage, were caught by surprise. The extraordinary Dr Donny George Youkhanna, who was, at the time, the Museum's Director of Antiquities and Research, told the *Wall Street Journal*, 'We thought there would be some sort of bombing at the Museum. We never thought it could be looted.' (*Wall Street Journal* 2003a). Dr Ahmed Kamel, the Museum's Deputy Director, shared his surprise: 'we didn't think anybody would come here and steal things because it has never happened before' (*Peninsula* 2004).

Turning to the Museum's protection by Coalition forces, it is clear that the law of armed conflict holds that cultural property should be protected against any act of hostility.[2] But the same international agreements that protect cultural property *absolutely prohibit* the military use of cultural sites, specifying that such sites lose their protections when so used.

In clear violation of those provisions, the Iraqi Army had turned the Museum and the surrounding eleven-acre compound into a fortress. Saddam Hussein's elite Special Republican Guard was stationed across the street. A firing position at the Children's Museum was aimed toward a traffic circle, offering an unobstructed field of fire on the high-speed avenue of approach that ran in front of the compound. That street, running between the Museum and the Special Republican Guard facility, led to the strategically important al-Ahrar Bridge across the Tigris, 900 metres away. A sniper's position in the aboveground storage room provided a perfect flanking shot on any USA forces moving

FIG 1. Sketch of the 11-acre compound of the Iraq Museum prepared by Colonel Bogdanos and Senior Master Sergeant Roberto Pineiro

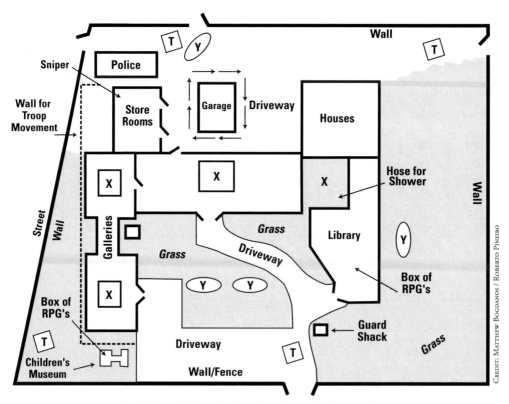

Y = Fighting Position T = American Tanks X = Courtyard

through the marketplace to reinforce any battle in front of the Museum. The sniper's window also overlooked the ten-foot wall that protected soldiers running from the battle position in the back to the battle positions in the front courtyard. Each of those fighting holes, equipped with dirt ramparts and aiming sticks, provided interlocking fire. All of this was run from the makeshift command post that had been set up in the back of the eleven-acre Museum compound. (Fig 1)

On the morning of 8 April, armed Iraqi soldiers took up their previously prepared firing positions in the Museum compound. The Museum staff, including all museum guards, had already left, decamping when Coalition forces hit the outskirts of the city on 5 April. The only exceptions were Dr Jaber Ibrahim al-Tikriti, the Chairman of Iraq's State Board of Antiquities and Donny George, along with a driver and an elderly archaeologist who lived in the rear of the Museum compound. Bravely, they had planned to stay throughout the invasion, but decided to leave when they realised the level of violence that was imminent (and see George, chapter 10).

The violence in question was, in fact, part of a campaign to attack Baghdad from the inside out. With all the Iraqi defences facing the perimeter, General Tommy Franks at the time, Commander of US Central Command had opted for 'thunder runs' into the centre of the city with tanks and mechanised infantry. Crumbling from the inside out, Baghdad fell in days instead of months. One of these 'thunder runs' ran directly in front of the Museum. And the intensity of the fighting in the vicinity of the Museum and the Special Republican Guard compound opposite it was directly proportional to this area's strategic importance.

At approximately eleven am on 8 April, after ensuring that all of the doors to the Museum and the storage rooms were locked, the four museum staffers left through the rear exit, locking it behind them. They then crossed the Tigris into eastern Baghdad, hoping to return later the same day. As they left, the nearest Coalition forces were about 1500 metres west of the Museum, receiving heavy mortar fire as they proceeded in the direction of the Museum. When Donny and his colleagues from the Museum tried to come back several hours later, heavy fighting pinned them down on the other side of the river.

On 9 April, a tank company from Task Force 1-64, the only Coalition military unit in that part of Baghdad, moved to an intersection about 500 metres west and slightly south of the Museum. Their orders were to keep that crossroads open as a lifeline to support Coalition military forces engaged in combat in the northern part of the city. Throughout that day, they took fire from the Children's Museum, the main building, the library, and the building to the rear of the Museum that had previously been used as a police station. The tank company commander on the scene, US Army captain Jason Conroy, reported that approximately one hundred to one hundred fifty enemy fighters were within the Museum compound firing on Coalition military forces. Some of these fighters were dressed in Special Republican Guard uniforms and some in civilian clothes. They were carrying RPGs (Soviet-designed, Iraqi-Army-issued rocket-propelled grenades[3]) or AK-47s.[4]

Later, many neighbourhood residents told renowned combat journalist Roger Atwood (who interviewed approximately 30 neighbourhood residents in addition to the Museum staff for his exceptionally well researched, first-hand reporting) that 'the Americans had come under attack from inside the Museum grounds and that fighting in the area was heavy.' (*Wall Street Journal* 2003b). The neighbourhood residents told me the same story, but they were merely confirming what the Museum grounds and its countless spent shell casings and dozens of RPGs had already told me: This was a fiercely contested battleground. Indeed, the fighting was so heavy that for 48 hours, between 8 and 10 April, some USA soldiers in Task Force 1-64's C Company never left the inside of their tanks.

According to several accounts from nearby residents, it was during this time - on the ninth - that two Iraqi Army vehicles drove up to the back of the Museum (near where the impromptu command post had been) and spent several hours loading boxes from the Museum onto the vehicles before they left. Selma al-Radi, an Iraqi-born archaeologist and tour de force of brilliance, energy, and spunk, arrived less than a month later and interviewed several neighbourhood residents who told her that on 9 April two Iraqi army vehicles drove up to the back of the Museum (Al-Radi 2003).

On the following day, 10 April, Second Lieutenant Erik Balascik's platoon received word of looting 'in the area of the museum and the hospital.' They passed this information up to the Task Force 1-64 commander, Lieutenant Colonel Eric Schwartz, who ordered them to move closer to investigate. As soon as they did so, they began receiving intense fire from the compound. This forced one of the tanks to fire a single round in return from its 120 mm main gun, which took out the RPG position, put a hole in the Children's Museum, captured the world's attention, and inflamed critics throughout the world. Indeed, when I first saw the infamous hole in the façade of the Children's Museum, I was furious and began to understand the world-wide condemnation.

Then I saw the evidence. The tank gunner had fired only after someone had fired an RPG at him from that building. On the roof, we found a stash of RPGs and, inside, blood splatter whose pattern suggested that at least two shooters had been on the third floor when the round hit its mark(s).

Because the Iraqi army had fortified this cultural site and people were firing at them from it, Lieutenant Balascik would have been justified under international law in taking any steps necessary to eliminate the threat to human life. But even if his unit had simply stood their ground and fought back with ground-based supporting fire, there would have been nothing left of the Museum either to save or to loot. Instead of conducting such an assault to 'save' the Museum, the moment that Schwartz - a former high school teacher - was informed of the situation, he made the militarily wrong but culturally brilliant decision to pull back those tanks from the Museum. This was the only way to avoid the Hobson's choice between endangering his men and destroying the institution. It took real courage to pull back.

Because of that fire, and because, from their position to the west, the Children's Museum blocked their view into the main compound, they never advanced close enough

to determine what was actually going on within the compound, let alone within the galleries and the storage areas of the Museum itself.

One of the residents we interviewed said that the looters - estimated by some witnesses to number between three or four hundred at their height - first appeared at the Museum on the evening of 10 April, entering through the back of the compound. If this single source was accurate, his account strongly suggests that the original fighters had left the Museum by that date - 10 April. There was, however, still intense fighting around the Museum on the morning of the 11th. It was on that day, at the intersection directly in front of the museum compound, that a Coalition tank company destroyed an Iraqi Army truck and a Soviet-built armoured fighting vehicle. This fighting in the front of the compound on the 11th prevented Coalition forces from either approaching the Museum or determining that enemy forces no longer occupied the Museum itself. The 11th was, however, the last day that fighting was reported near the Museum.

On the afternoon of the 12th, the Museum staff came back, courageously chasing looters from the Museum, a moment famously captured by a German film crew. The Iraqi soldiers had already left. But when? It is entirely possible, especially considering all the uniforms we found lying throughout the compound, that some of the looters carrying out antiquities had been in uniform and carrying AK-47s only hours - or even minutes - earlier. We simply do not know. Regardless of when this retreat took place, however, it cannot be overstated how difficult it was for Coalition forces on the ground to have known when the last fighter left, and whether it was safe to enter without a battle that would destroy the Museum. I rarely knew what was happening one hundred meters away - let alone on the other side of an eleven-acre compound.

Some critics have contended that if journalists were able to get into the Museum on the 12th, military forces should have been able to do the same on that day or even on the 11th. With rare exceptions, however, journalists are not shot at simply because of who they are. Putting on a military uniform makes anyone a lawful target. Journalists, protected - officially at least - by their 'non-combatant' status, are generally able to move more freely on the battlefield in order to report on the conflict. This is not to suggest that journalists are not vulnerable to random fire, or that being a combat journalist does not take guts, or that journalists are never targeted illegally. Rather, it is to point out that neither journalists nor uniformed combatants should be judged by the distinct restrictions placed on, or the distinct freedoms enjoyed by, the other.

The only way uniformed military could have entered a compound the size of the Museum's was as part of a properly planned assault complete with supporting arms - tanks, mortars, and crew-served weapons - or by a 'reconnaissance in force'. This means having troops advance without supporting arms in the hope that they do not get shot. If no one shoots at them, it suggests that the buildings are clear. Either that or it is an ambush - with the risk that the football-field-sized open area between the compound wall and the buildings would become a killing ground.

By 12 April, the fighting in Baghdad had subsided, and the damage to the Museum and its holdings was done. Once the staff was back on-site to guard the Museum, there

was no more looting. On the afternoon of the 12th and then again on the 13th, with the compound no longer a battlefield, Donny George and others approached Task Force 1-64, the Army tank unit, and asked for help. So why did USA forces not just move a tank closer to the Museum at that point? All it would have required, the Monday morning field marshals said, was a single tank.[5]

Not exactly. First, you cannot just hail a tank the way you hail a taxi. Unless you are requesting a suicide mission, you need a tank platoon. What those who have never been in combat do not understand is that a stationary tank is a death trap. While intimidating to look at, tanks are far from invulnerable - one well-placed round from an antitank weapon and you would need to use dog tags to identify the charred remains of the four men inside. The only way a tank can survive in combat, especially urban combat, is by virtue of speed and manoeuvrability, and by the firepower provided by other tanks. You have to have, at the least, tanks in pairs. You also need a squad of infantry alongside them, because tanks have blind spots. But mostly, once you draw fire, you have to return fire until you have eliminated the threat - right down to the plumbing in the basement - if that is what it takes to save the lives of those in your charge.

Okay, so it is not as simple as sending in a tank. Then why not send in some ground troops instead? Committing 'just' ground troops would have been criminally irresponsible on the part of the commander, whose obligation is to protect the lives of the men under his command. A proper military assault would have required supporting arms. And this once again brings us back to the spectre of the museum reduced to rubble.[6]

Moreover, if the mere presence of uniformed military had not dispersed the crowd, what would these ground troops have done, anyway - shoot the looters? Perhaps the critics would like to have been there with an M16, mowing down the local residents swarming through the Museum. But people who know the law of war know that deadly force can only be used in response to a hostile act or a demonstration of hostile intent. Shooting unarmed looters in civilian clothes who were not presenting a risk to human life would have been a violation of the law of armed conflict and prosecutable for murder under Article 118 of the Uniform Code of Military Justice.[7]

Well, couldn't they have just fired some itsy-bitsy warning shots? Here we see the influence of movies on assumptions about what is possible in a law enforcement or military engagement. A warning shot only works if you are a member of the Screen Actors Guild. In real life, firing a weapon merely escalates the situation, usually causing unarmed participants to arm themselves, which once again means drawing return fire. Moreover, the bullets fired from the muzzle of a weapon - be they 'warning shots' or shots aimed at centre mass - do not just disappear into the ether. Eventually, they come back to earth and hit something - often with fatal effect - which happens all the time when revellers fire celebratory shots into the air during holidays and weddings.[8] For this reason, among others, the rules of engagement in effect in 2003 specifically instructed soldiers that if they must fire, they must 'fire only aimed shots. NO WARNING SHOTS' (capitals in original). Doubtless in recognition of the deteriorating security situation, by 2005, the rules had changed to permit warning shots to be fired as a last resort.

The bottom line here is that any suggestion that Coalition forces could have done more than they did to secure the Museum before the 12th is based on wishful thinking or political ideology rather than on any rational appreciation of military tactics, the reality of the conflict on the ground, the law of war, or the laws of physics. 'If I'd raced up from south Baghdad to the Museum, I'd have had a lot of dead soldiers outside the Museum,' the tank commander for this sector, Lieutenant Colonel Eric Schwartz, told the BBC. 'It wasn't the Museum anymore - it was a fighting position' (quoted in Cruickshank and Vincent 2003).

The blame for the looting must lie squarely on the looters. But the blame for creating chaos at the Museum from the 8th through the 11th that allowed the looting to occur must lie with the Iraqi Army. It was they who chose to take up fighting positions within the Museum, they who chose to fire on the American tanks, and they who kept American forces from investigating the reports they had received of looting 'in the area of the Museum'. After the 11th, however, the blame clearly shifts to Coalition forces.

The US Army showed up to secure the compound at ten am on the morning of 16 April. If critics want to question the military reaction, the delay between the 12th to the 16th is fair game. I will go one step further: this delay was inexcusable. Although nothing was taken during this period, that does not make the indictment any less valid - because American military forces had no way of knowing that looters would not come back. You can thank the Museum staff for guarding the compound for those four days.

This leaves us with the more pointed question - the one that is never asked: Before the battle, why was no unit assigned the specific mission of moving in to protect the museum the moment Baghdad was secure?

There are two basic kinds of orders in the military. The first is the standard type that directs a unit to achieve a specific objective at a specific time. 'At 0800 tomorrow, you will seize the beachhead and advance to the cliff wall.' Then there are the kinds of orders that warn a unit that they will be expected to achieve a specific objective at a time yet to be determined. This is a 'be-prepared-to-execute' order, telling that unit to get ready to execute that mission, thereby enabling the commander on the ground to conduct proper reconnaissance, develop a tactical plan, and identify personnel and resources needed for the mission when it is ordered.

No such be-prepared-to-execute order was issued for the Museum, and therefore no unit was either assigned or prepared to be assigned to secure it until the tank platoon showed up on the morning of 16 April. Why was no such order issued? Why was there such a delay in responding to repeated requests for assistance on 12 and 13 April? The answer is the same for both questions - and it is neither complicated nor entirely satisfactory.

Ultimately, the same 'catastrophic success' on the battlefield that outstripped the ability of the conventional Iraqi uniformed military forces to react also outstripped the ability of Coalition planners to anticipate – and be prepared for – the overwhelming security needs when Baghdad fell months sooner than originally expected. In the case of the Museum, this was coupled with a lack of a sense of urgency on the part of military planners - which, in turn, was grounded in a failure to recognise the extent to which Iraqis

identified the Museum with the former regime. Thus, despite the prior warnings, planners simply did not believe that the Museum - unlike the presidential palaces and governmental buildings that were more overt manifestations of the regime - would be looted. To put it another way, planners naively thought that the recognition of the Iraqi people in their extraordinary heritage would deter them from looting the Museum. Even if Coalition forces had properly planned for the Museum, however, given the lack of sufficient forces in country, there would have been no spare units to assign anyway: As I said, not entirely satisfactory. But not sinister or callous either - just human error exacerbated by the speed of the fall of Baghdad and not enough boots on the ground.

Returning, then, to the investigation itself, once I had the timeline for the fighting worked out, I began to use it as a template to sort through the rest of what had happened. I needed this structure to help explain the unfolding of the three distinctly different crimes: the thefts in the public galleries and restoration area, in the aboveground storage area, and in the basement storage area.

In Baghdad, we did not have access to the kind of judicial and governmental apparatus that would have allowed us to determine precisely how many missing antiquities had been stolen in the years or even decades before the war - though several sources told us the number was high. Because the Museum had been open to the public only once since 1991 - on 28 April, 2000, Saddam Hussein's birthday - and closed again shortly thereafter, we could not even turn to Museum visitors for independent verification as to what was in the Museum just prior to the arrival of Coalition forces. So even when we were able to determine what was missing, we were not always able to determine - independent of what the staff told us - when it was *first* missing. This did not affect our day-to-day operations, however, because our primary job was simply to get the stuff back.

In order to do *that*, though, we had to come up with three different investigative approaches to begin tracking down three different types of thieves - professionals, people off the street, and insiders. These three different categories of crooks had taken three different kinds of loot - marquee items from the galleries, random artefacts from the storage area, and high-value smaller pieces from the basement.

From the 28 galleries and landings on two floors, and from the nearby restoration room, thieves stole 40 of the Museum's most treasured pieces. All evidence suggests that these marquee items were carefully chosen, implying that the thefts were professional. Whether or not these thieves were assisted by Museum staff, the selection and removal of these items showed the mark of a professional. Likewise, the underworld connections necessary to move and sell these items required a level of professionalism beyond that of a low-level staff member or neighbourhood looter. Indeed, we had been told that professionals had come in just before the war - possibly through Jordan - waiting for the fog of war and the opportunity of a lifetime. One of the most telling clues to the professional eye of these thieves was that they passed right by the unmarked copies and lesser pieces and went straight for the highest-ticket items (and see Introduction p1). There was one exhibit in particular that had 27 cuneiform bricks running from Sumerian through Akkadian and Old Babylonian to New Babylonian.[9] The nine most

exquisite bricks were taken - selected from each time period - and all the others were left behind. That kind of selectivity happened repeatedly, also implying some measure of organisation.

Of course, some observers have given credit where it was not due, citing, for instance, the fact that the stela containing Hammurabi's code was untouched. But it would not have required a master thief to read the large sign next to the display telling anyone in Arabic and English that this is a copy, and that the original is in the Louvre.

Others used the discovery of a pair of glass cutters as further evidence of professionalism and the advance planning that goes with it. But this tool was a rusty relic that should have been junked long ago, and it was never used on any of the glass inside the Museum.[10] Moreover, why would a professional thief bother bringing along such a tool to a museum with neither a security system nor guards on the scene?

To me, the rusty glass cutters argued just the opposite - that while the professionals went about their business, they no doubt had to put up with any number of bumbling amateurs getting in their way. Would-be looters in off the street knocked over statues and, unsuccessfully, tried to drag them away on their foam-rubber padding. We could trace every single heavy piece that did leave the Museum by following the trail of skid marks left in the floor. It is safe to say that these guys had never done this sort of thing before and had no idea what they were getting into. This is not to say that some random bumblers in the gallery area did not get lucky. The guys who walked off with the Sacred Vase of Warka, for example, were average Joes, not an experienced gang of thieves imported for the occasion.

Altogether, in the galleries, corridors, and nearby restoration room, 25 pieces or exhibits were damaged by this sort of activity, including eight clay pots, four statues, three sarcophagi, three ivory reliefs, two rosettes, and what remained of the Golden Harp of Ur. (Fortunately, the golden bull's head that was stolen from the harp while it lay in the restoration room was a modern replica. Unbeknownst to most of the staff, the original had been removed to the Central Bank of Iraq before the 1991 Gulf War.) Sadly, one of the damaged statues was a two-foot-high terra-cotta lion from Tell Harmal dating from the Old Babylonian period of approximately 1800 BC.

It is also safe to say that some of the thievery in the galleries had been carried out by a third category of persons. That so many pieces originally missing from the galleries 'miraculously' showed up on the restoration-room floor during the weeks and months we lived in the Museum strongly suggests that they had been lifted by sticky-fingered staff who later chose to take advantage of our amnesty by returning many dozens of antiquities to the room we had repeatedly announced we would search last. Moreover, seven of the most precious items from the Museum appear to have been collected and left in the restoration room prior to the looting: the Golden Harp of Ur, the Mask of Warka, the Lioness Attacking a Nubian, two plates inlaid with shell depicting ritual scenes from the royal tombs of Ur (2600–2500 BC), a large ninth-century BC Assyrian ivory-relief headboard, and a ninth-century BC wheeled wooden firebox from Nimrud. Although the room itself had two small safes that could have housed the Mask, the Lioness, and the

plates, none of the objects were secured. Instead, everything was left on a table and stolen, except for the wooden body of the harp, a reproduction that was severely damaged, the fragments of its intricate ivory inlay left scattered across the room.

From the two aboveground storage rooms, 3138 excavation-site pieces (jars, vessels, pottery shards, etc) were stolen - though I knew that number would surely grow by another one to two thousand when inventories were finally completed.[11] Valuable in their own right, they were of significantly less value than the signature pieces that had been in the public galleries. This was largely the work of random looters - indiscriminate, or at least undiscerning. This is where we saw traces in the dust where an arm had swept across an entire shelf, dragging anything and everything into a sack - and then dumping out the contents of the sack a few aisles away as if they had found something they liked better. Somebody took an entire shelf of fakes, leaving untouched an adjacent shelf containing pieces of infinitely greater value.

But these rookie mistakes do not rule out the possibility that our other bad actors made the amateur heist a lot easier. Neither of the two storage rooms that were looted showed any signs of forced entry on their exterior steel doors. One of the looted rooms was on the first floor, and the other was on the second, and both were connected by an interior stairwell - meaning that entry to one automatically enabled entry to the other. The second-floor room was where the sniper team had been located during the battle for Baghdad that raged around the Museum. So our best judgment was that the looters gained access to both rooms when the sniper team decamped, leaving the door open behind them. But it was also possible that either the professionals who stole the high-end artefacts or the insider(s) with the keys to the basement may have left the doors open - intentionally. Crowds destroy evidence and help cover tracks.

As for the underground storage area, this is the theft that saddens me the most: individuals with an intimate insider's knowledge of the Museum and its storage practices breached a wall blocking entrance to the basement and walked past room upon room of tens of thousands of priceless antiquities until they got to the farthest corner of the farthest room of the most remote recesses of the sealed basement to steal - our best count to date - 5144 cylinder seals, as well as 5542 pins, glass bottles, beads, amulets, and other small items of jewellery. They knew how to get in, they knew where to find the keys, and they knew what they were looking for.

Given this level of preparation, the material they took was more likely to have a middleman buyer and make its way into the hands of organised smugglers able to move it out of Iraq and into the international market. My plan to recover those big-ticket items once they had left the country, then, would depend on monitoring a rarefied group of known buyers and on developing confidential sources within the art community, most of whom would be museum employees and university professors. But because potential whistle-blowers risked losing their jobs, the challenge was, first, to find them, and, second, to protect their identities. The plan also including persuading Coalition forces to tighten borders in the hopes of interdicting the loot before it got to the collector.

Similarly, the most likely way of recovering material stolen by the more sophisticated thieves, especially when the items in question were small and easily hidden, was at border crossings, where law and custom allow inspection of baggage on less than probable cause. As a result of Iraq's neighbours having increased the effectiveness of their border security and inspections to thwart terrorists, they were also intercepting many antiquities that would otherwise have slipped through. While relevant borders were far from airtight, and antiquities smuggling had become a quasi cottage industry in many regions, the increased effectiveness of border inspections had probably discouraged many less experienced smugglers from even making the attempt. Old hands, of course, would simply increase their patience and resourcefulness.

But increasing inspection rates is never enough to stop the traffic. A law enforcement official must be able to articulate a rationale in order to seize an item in transit, and at a glance these smaller artefacts were not necessarily recognisable as contraband. The key strategy, going forward then, would be to educate law enforcement authorities so that they could immediately recognise illicit antiquities and therefore be justified in seizing what they found.

As a result, the plan I developed was to treat recoveries inside Iraq and interdiction at the borders not as separate approaches, but as two prongs of the same pincer designed to work together to put the squeeze on the bad guys. Increased border inspections increase the risk of trying to move stolen goods out of the country, which keeps them in Iraq, which makes them more likely to be seized through raids based on good intelligence inside the country. But the pressure of seizures inside Iraq pushes smugglers to risk export, which makes them more susceptible to interdiction at a border with improved inspections and better-educated guards. These actions would be further enhanced by the increased scrutiny and investigative resources that would result from heightened public interest and improved public awareness.

In summing up our investigation, I can offer some - albeit tentative - answers to the most basic questions: Of the 40 objects stolen from the public galleries and restoration rooms, 16 have been recovered, including six of the finest pieces the Museum possessed: the Sacred Vase of Warka, the Mask of Warka, the Bassetki Statue, one of two Ninhursag Bulls, a ninth-century BC Assyrian ivory headboard from Nimrud, and a headless inscribed limestone statue from Lagash. The amnesty programme we had established throughout Iraq with the assistance of sheikhs, imams, and local officials netted two pieces (the Ninhursag bull was returned as a walk-in, and the vase after New York City Police Captain John Durkin's skilled negotiation), while seizures accounted for the other four - two inside Iraq (the Warka mask and the Bassetki Statue) and two outside Iraq by Jordanian customs (the ivory headboard) and US Customs (the headless statue). These numbers are accurate as of the summer of 2006 with the revealing recovery of the headless inscribed limestone statue from Lagash, from approximately 2450 BC. I write 'revealing,' because before it was seized by US customs, it had gone from Baghdad to Damascus to Beirut to Geneva.

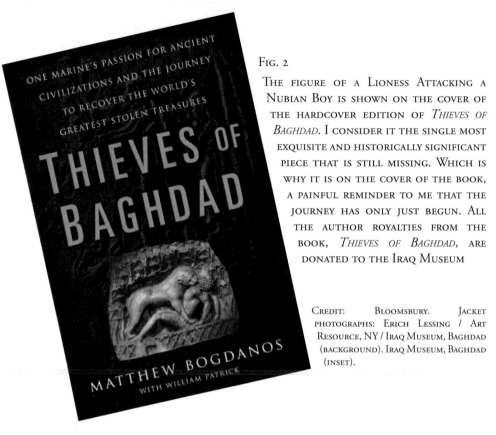

FIG. 2

THE FIGURE OF A LIONESS ATTACKING A
NUBIAN BOY IS SHOWN ON THE COVER OF
THE HARDCOVER EDITION OF *THIEVES OF
BAGHDAD*. I CONSIDER IT THE SINGLE MOST
EXQUISITE AND HISTORICALLY SIGNIFICANT
PIECE THAT IS STILL MISSING. WHICH IS
WHY IT IS ON THE COVER OF THE BOOK,
A PAINFUL REMINDER TO ME THAT THE
JOURNEY HAS ONLY JUST BEGUN. ALL
THE AUTHOR ROYALTIES FROM THE
BOOK, *THIEVES OF BAGHDAD*, ARE
DONATED TO THE IRAQ MUSEUM

CREDIT: BLOOMSBURY. JACKET
PHOTOGRAPHS: ERICH LESSING / ART
RESOURCE, NY / IRAQ MUSEUM, BAGHDAD
(BACKGROUND). IRAQ MUSEUM, BAGHDAD
(INSET).

We know that at least 3138 pieces were stolen from the aboveground storage rooms - though this number is still likely to go up by as much as one to two thousand as excavation catalogues are checked and inventories completed. Of these, 3037 have been recovered. Roughly 1924 of the recoveries were via the amnesty programme, and 1113 through seizures. Since I compiled these numbers in December 2003, there have been other recoveries (through both amnesty and seizures) of excavation-site objects, but I have not personally confirmed those more recent recoveries and do not list them here.

Our efforts to recover antiquities stolen from the basement have not proven so successful. Slightly more than ten thousand cylinder seals remained safe in the Museum, but of the 10,686 objects stolen from underground only 2307 have been recovered. (As with the storage rooms, the numbers of objects stolen from the basement are accurate as of the last time I personally verified the losses and recoveries in December 2003. Altogether, the Museum had approximately 15,000 cylinder seals in its collection in four different locations. One-third, then, was stolen by the insiders.) Part of the problem is that the entire haul from the basement could fit in one backpack. Looking at the recoveries of items stolen from the basement another way, 911 were recovered inside Iraq, and 1396 internationally.[12]

As of December 2003, then, approximately 5400 objects had been recovered - roughly 1950 via amnesty and 3450 via seizures.[13] Moreover, another 62,000 pieces were 'found' in other locations in Baghdad. These include 8366 display-case items found in a top-secret vault within the Museum that a select group of museum staff had referred to as 'the secret place', 39,453 ancient manuscripts found in a bomb shelter in Western Baghdad, the collection of Iraq's royal family in the Central Bank's old building (6744), and the burial goods from the royal tombs of Ur and Nimrud in the Central Bank's new building (the last two totalling approximately 7360 pieces altogether). Sadly, though, at least 8500 pieces - many of them truly priceless - were still missing. These include nine Sumerian, Akkadian, and Babylonian cuneiform bricks, a Babylonian boundary stone, and five heads from Hatra: a copper head of winged victory, a stone head of a female deity, and marble heads of Apollo, Poseidon, and Eros.[14] The list of missing pieces also includes the one that breaks my heart. It is the piece that is on the cover of *Thieves of Baghdad*, the Lioness Attacking a Nubian Boy, an extraordinary eighth century BC chryselephantine ivory plaque inlaid with lapis and carnelian and overlaid with gold (see Fig 2). It is in my view the single most exquisite and historically significant piece that is still missing. This is why it is on the cover of my book, a painful reminder to me – and now, I hope, to you - that the journey has only just begun.

2 Combating Global Traffic in Stolen Iraqi Antiquities

As the head of the investigation into one of the greatest art crimes in recent memory, I have spent more than four years attempting to recover and return to the Iraqi people their priceless heritage. I have spent almost as much time, however, attempting to correct the almost universal misconceptions about what happened at the Museum in those fateful days in April 2003, to increase awareness of the continuing cultural catastrophe that is represented by the illegal trade in stolen antiquities, and to highlight the need for the concerted and cooperative efforts of the international community to preserve, protect, and recover the shared cultural heritage of all humanity.

Indeed, in more than 175 speeches in more than one hundred cities in 12 countries - in venues ranging from universities, museums, and governmental organisations to law-enforcement agencies, INTERPOL (the International Criminal Police Organisation) and both houses of the British Parliament - I have urged a more active role for governments, international organisations, cultural organisations and foundations, and the art community.

I have not been very successful. Most governments have their hands full combating terrorism, with few resources left to spare for tracking down stolen artefacts. Most international organisations are content to issue proclamations, preferring to hit the conference centre rather than the streets. Many cultural organisations and foundations are equally content to issue a call for papers rather than a call to action. As for the art community, some members wash their hands of unpleasant realities and argue that, while technically illegal, the market in purloined antiquities is benign - victimless - as long as it brings the art to those who can properly protect it and appreciate it (namely, themselves).

And as the investigation continues, much has happened to reinforce the core lesson we learned in the back alleys of Baghdad: that the genteel patina covering the world of antiquities rests atop a solid base of criminal activity. Witness the events taking place in the USA since 2003. In New York, the Metropolitan Museum accepted what amounted to a plea bargain with Italian authorities - agreeing to (eventually) return 21 separate antiquities the Italian government says were stolen, including one of the Met's most prized items: the Euphronios krater, a sixth century BC Greek vase. In Missouri, the St Louis Art Museum broke off negotiations with Egypt over the museum's possession of a thirteenth century BC pharaonic mask that Egyptian authorities claim was stolen and smuggled illegally out of their country. In California, the Director of the J. Paul Getty Museum agreed to recommend to its trustees that the Getty return antiquities the Greek government says were stolen - while the Getty's long-time curator for ancient art resigned and is currently on trial in Rome on charges of conspiracy to receive a completely different set of stolen artefacts. More trials are sure to follow.

I am delighted that nations are moving to reclaim their patrimony. I am also delighted to see media attention beginning to illuminate certain well-appointed shadows where money changes hands and legitimate - but inconvenient - questions of the provenance (origin) of the object are too frequently considered outré.

But shadows remain. In March 2006, for example, private collector Shelby White donated $200 million to New York University to establish an ancient studies institute, prompting one of the university's professors to resign in protest over what he considered the questionable acquisition practices of the donor. Ms White and her late husband Leon Levy have generated considerable debate since at least 1990, when the Met (of which Ms White is a Trustee) presented a major exhibition of 200 of their artefacts from Greece, Rome, and the Near East. The Met did so despite the fact that a study later published in the *American Journal of Archaeology* determined that more than 90 percent of those artefacts had no known provenance whatsoever (Chippindale and Gill 2000). As with the Euphronios crater, Italian authorities have consistently maintained that they can prove many of the antiquities in the Levy-White collection were illegally excavated (aka stolen) and smuggled out of their country.

Not only did the Met proudly display that collection, dubious provenance notwithstanding, but it also (coincidentally?) celebrated the opening of its new Leon Levy and Shelby White Court for Hellenistic and Roman antiquities on 15 April, 2007. Other institutions continue to hold out one hand while covering their eyes with the other. In 2000, Cornell University accepted a gift from well-known collector Jonathan Rosen of 1,679 cuneiform tablets from Ur. They said, 'Thank you very much,' despite reports of widespread looting at Ur after the 1991 Persian Gulf War, and despite the fact that the provenance of 10 percent of the tablets consisted of the phrase 'uncertain sites'. Harvard University has done equally well in neglecting to ask awkward questions - witness its Shelby White-Leon Levy Programme for Archaeological Publications.

But this is nothing new. In 1994, a decade before its current imbroglio, the Getty displayed a major exhibition of classical antiquities owned by Lawrence and Barbara

Fleischman. Like the Met, the Getty proudly held this exhibit despite the fact that 92% of the objects in the Fleischman collection had no provenance whatsoever, and the remaining 8% had questionable provenance at best (Chippindale and Gill 2000). To put it in starker terms, of 295 catalogued entries, not a single object had a declared archaeological find spot and only three (1%) were even described as coming from a specific location.

Sometimes, however, the questionable practices extend beyond merely wilful ignorance. Consider the following. Prior to the exhibition in 1994, the Fleischman collection had never been published. Thus, the first catalogue for, and hence first publication of, the Fleischman exhibit was the Getty's - of which Ms Fleischman was a trustee. Fewer than two years later, the Getty purchased part of that collection for $20 million. But the Getty had a stated policy of not purchasing objects unless they have been previously displayed in published collections. How, then, could they possibly have justified the acquisition? Easy: the Getty was quick to point out that the collection had been published just two years earlier...by themselves.

Further sweetening the deal, while the collection had been purchased originally at a much lower price, it was valued at $80 million at the time of the sale to the museum. Tax laws use the fair market value at the time of the sale rather than the original purchase price in determining the value of a bequest. As a result, the difference between the 1996 valuation of $80 million and the $20 million sale price to the Getty would be deemed a gift of $60 million - affording a $60 million tax deduction for the Fleischmans. Under these terms, the gift to the Getty, therefore, was actually financed by USA taxpayers. Enron's accounting team could not have done a better job.

In many respects, then, we have advanced very little since the imperial 19th century, when Lord Elgin could haul away the Parthenon Marbles (now in the British Museum and commonly referred to as the 'Elgin Marbles') and Henry Layard could haul away the Nineveh reliefs (now in the Met). Despite the hue and cry of the last several years, the Met's current policy is to require documentation covering only the last ten years of an object's history. This, even though most institutions view 1970 - the year of the landmark UNESCO Convention to regulate the transfer of antiquities - as the cut-off date for requiring proof that an antiquity was not illegally looted.

The imposition of a firm date (here, 1970) is crucial in stopping the trade in illegal antiquities. As each year passes, it becomes less and less likely that a previously unpublished (and hence unknown) antiquity can appear on the market and be legal - either in the sense of having come from a properly sanctioned excavation or from some ancient collection that was assembled before the imposition of any requirement of documentation. To put it another way, as each year passes, it becomes increasingly certain that previously unpublished items are stolen.

Thus, the Met's policy of requiring documentation covering only the last ten years of an object's history becomes more unsupportable as each year passes. For example, in May of 2013, the Met could begin to buy items stolen from the Iraq Museum in April 2003 without violating its stated policy. All it need do is not ask where it comes from before the ten-year window. As if to flaunt the Met's policy of 'see no evil,' Philippe de Montebello,

the museum's director, told the *New York Times* in February 2006 that the context in which an artefact is found is virtually meaningless; in his opinion, it accounts for less than two percent of what we can learn from antiquity. His position is as absurd as the equally unreasonable view of some purists that context is everything.

But far from this world of museum receptions and limos waiting at the curb, however, there has been an even more troubling development. In June 2005, US Marines in northwest Iraq arrested five insurgents holed up in underground bunkers filled with automatic weapons, ammunition stockpiles, black uniforms, ski masks, and night-vision goggles. Along with these tools of their trade, were 30 vases, cylinder seals, and statuettes that had been stolen from the Iraq Museum. Since then, the scenario has been repeated many times. It does not take a counterterrorism expert to detect the sinister adjustment that has taken place. In 2003, when pursuing leads to recover antiquities, we usually came across weapons and links to violent groups. Now, as security forces pursue leads for weapons and insurgents, they find antiquities. In a modern-day version of the old 'molasses to rum to slaves' triangle trade of pious New England ship captains and owners who sang hymns and offered prayers while getting rich off human misery, the cosy cabal of academics, dealers, and collectors who turn a blind eye to the illicit side of the trade is, in effect, supporting the insurgents who are killing our troops in Iraq.

This is not surprising. As the *National Commission on Terrorist Attacks upon the United States* (9-11 Commission) noted, international law enforcement has aggressively attacked traditional means of terrorist financing by freezing assets and neutralising charities that had previously served as fronts for jihadists. But terrorists are nothing if not adaptive. In late 2005, the German newspaper *Der Spiegel* reported that 9/11 conspirator Mohammed Atta had approached a professor at the University of Gottingen trying to sell Afghan antiquities to raise money to buy an aeroplane. While nothing came of that inquiry, times have changed. Like the Taliban in Afghanistan who have learned to finance their activities through opium, insurgents in Iraq have discovered a new source of income in Iraq's cash crop: antiquities. We do not have hard numbers - the traffic in art for arms is still too recent a phenomenon, and some of the investigations remain classified because of the connection to terrorists. But this illicit trade has become a growing source of revenue for the insurgents; ranking just below kidnappings for ransom and 'protection' money from local residents and merchants. Iraq is a war zone, but it is also the cradle of civilisation, with 10,000 poorly guarded archaeological sites. Among the most prized items from those sites are cylinder seals, intricately carved pieces of stone about the size of a piece of chalk, that can sell for $250,000, enabling an insurgent to smuggle millions of dollars in his pocket. Given this almost limitless supply of antiquities, the insurgency appears to have found an income stream sufficiently secure to make any chief financial officer sleep well at night. As a result, the desert night is filled with the roar of bulldozers ripping into the ancient mounds of clay that were once thriving cities.

All the while, the situation in Iraq has deteriorated dramatically, seemingly descending into chaos - with a majority of the USA electorate increasingly reluctant to risk American blood to save Iraqi lives. So it is a pretty tough sell to ask people to care about bunch

of old rocks with funny writing. Finding the political will to divert resources to saving cultural artefacts, no matter how precious, seems like cutting funding for police and fire in order to expand the public library. There might be a case for it, but when? After all, looting has always been a cottage industry in Iraq, the region that gave birth not just to agriculture, cities, the wheel, and pottery, but to war and conquest as well.

The argument for protecting artefacts takes on added strength when we recognise that we are where we are today, not just because of our failure to provide sufficient security to overcome the long-festering tribal and religious animosities, but also because of our continuing failure to appreciate the importance Iraqis place on the preservation of their history. This failure to protect a rich heritage going back to the dawn of civilisation has convinced many in Iraq and the Middle East that we do not care about any culture other than our own. And their belief is continually reinforced: four years after the initial looting - and despite having recovered almost 6000 antiquities since then - we cannot keep pace with the artefacts that are being looted every day.

3 PROTECT ARCHAEOLOGICAL SITES

Based on my experience in both counterterrorism and law enforcement - and as a result of the time I have spent in Iraq and throughout the world in tracking down the stolen antiquities - I submit that the first order of business in addressing this catastrophe must be to protect the archaeological sites. Some of these, such as Babylon and Nimrud, require several hundred guards and support staff for protection around the clock. The maths is daunting: country-wide more than 50,000 personnel are required, along with the necessary vehicles, radios, weapons, and logistical needs. But there is an immediate solution.

In other contexts, the United Nations (UN) and the North Atlantic Treaty Organisation (NATO) have acted to address catastrophic situations. In Bosnia, Cyprus, and Afghanistan, for example, many countries have provided contingents for specific missions under UN or NATO auspices. But not in Iraq. The reasons are much-argued, and I will not revisit them here. Recalling Voltaire's observation that 'everyone is guilty of the good he didn't do,' I will focus instead on what we can do now.

So who might act? In the past, most archaeological digs in Iraq have had foreign sponsorship - the Germans at Babylon and Uruk, the British at Ur and Nimrud, the French at Kish and Lagash, the Italians at Hatra and Nimrud, the Americans at Nippur and Ur. Leveraging this history, I propose that these (and eventually other) countries provide forces to protect Iraq's archaeological sites until a professional Iraqi security force dedicated to the sites can be recruited, equipped, and trained. Under this proposal, and with the permission of the Iraqi government, facilitated by the American military, and under the authority of the UN or NATO, each country would 'adopt' a site. After sending an assessment team to the assigned sites to determine the precise numbers and type of personnel and equipment required, each donor nation would then draft and sign bilateral status of forces agreements with Iraq, outlining the rules of engagement, funding, billeting, and the standard logistical issues. Then, each country would deploy its

security forces (military, police, private contractors, or a combination of all three) to the agreed-upon archaeological sites around the perimeter and around the clock.

Upon arrival, each country's contingent would also be assigned a group of Iraqi recruits (who would live and work with them) to train at their chosen site. Once those Iraqi security forces were fully trained – a process that ordinarily takes six months - the donor nation would recall (or reassign) its forces on a site-by-site basis. In half a year, every archaeological site of consequence in Iraq could be completely protected from the looters. Mesopotamia's cultural patrimony would be safe, al-Jezeera would have to find other ways to show Western indifference to Arab culture, and the terrorists would have to find another income source.

Unfortunately, neither NATO nor the UN has such plans in the works. NATO opened a training centre in Iraq in 2005, but has trained only 1500 Iraqi security personnel, none of whom have been assigned to archaeological sites. The UN has never trained guards for the sites. Even the UN's cultural arm, UNESCO, has failed to act, claiming it has no such mandate from its member nations. Assuming that to be true, UNESCO ought to convince its member nations to support such an initiative. It is time for the UN to seize the mantle of international leadership and convince its members to support such a plan. As our best hope, UNESCO ought to step into the vacuum of international leadership, seize the bully pulpit, and become relevant again. 'Man should share the action and passion of his time', former United States Supreme Court justice Oliver Wendell Holmes once noted, 'at peril of being judged never to have lived'.

Individual countries are also slow to respond. Only the Italians, Danes, Dutch, and Poles have joined the Americans and British in protecting these sites - and the Danes, Dutch, and Italians have already left. Other countries have argued that the level of violence does not permit deployment of their forces. The circular nature of this rationalisation is underscored by the fact that it is the failure to protect these sites that is partly funding those who are creating the unsafe environment. 'If you were to take account of everything that could go wrong,' Herodotus advised long ago, 'you would never act.' Of course there is risk. I know this first-hand. But the risks of the failure to act are far worse: more money for the insurgents, more propaganda for al-Jezeera, and the loss of these extraordinary testaments to our common beginnings.

Equally risky are the politics: most elected officials view involvement in Iraq as political suicide. But an internationally coordinated contribution of personnel would not be a statement about the war or the Bush administration's policies in Iraq. It would be a humanitarian effort to protect a cultural heritage rich with a common ancestry that transcends the current violence. Real leaders should have no difficulty convincing their electorate of the distinction between politics and culture. It is, of course, the very definition of leadership to educate, inform, and motivate into action those who might otherwise be inclined to do nothing.

4 THE NEXT STEPS: A FIVE-POINT ACTION PLAN

The incomparable works of art unearthed in the land between the rivers predate the split

between Sunni and Shiite. They predate the three competing traditions that have brought so much bloodshed to the Middle East - Islam, Christianity, and Judaism. Attending to this cultural heritage from the very dawn of civilisation reminds us of our common humanity, our common aspiration to make sense of life on this planet. I have seen these pieces of alabaster, and limestone with funny writing on them, work their magic through a language that is both immediate and universal, visceral and transcendent.

While protecting the archaeological sites in Iraq is a vital beginning, much more needs to be done. To stop the rampant looting and the black market that funnels money into terrorist hands, we must adopt a comprehensive global strategy using all of the elements of international power. Toward this end, I propose a five-step plan of action to combat the global traffic in antiquities.

I MOUNT A PUBLIC RELATIONS CAMPAIGN FOR MAINSTREAM SOCIETY

The cornerstone to any comprehensive approach must take into account that real, measurable, and lasting progress in stopping the illegal trade depends on increasing public awareness of the importance of cultural property and of the magnitude of the current crisis. First, then, we must develop and communicate a message that resonates with mainstream society - not just with academics. We must create a climate of universal condemnation, rather than sophisticated indulgence, for trafficking in undocumented antiquities.

But this calls to arms needs to avoid the sky-is-falling quotes so beloved by the media, while steering clear of the debilitating rhetoric of red state versus blue state politics. It also has to keep the discussion of the illegal trade separate from broader issues such as repatriation of objects acquired prior to 1970 and whether there should be any trade in antiquities at all. The Parthenon Marbles are in the British Museum, but their return is a diplomatic or public relations issue, not a matter for the criminal courts. Similarly, there is a legal trade in antiquities that is completely fair, regulated, and above board. And it is simply unproven (and unfair) to argue that the legal trade somehow encourages an illegal trade. Most dealers and museums scrupulously do avoid trading in antiquities with a murky origin. Repatriation for pre-1970 transfers and the question of whether all trade in antiquities should be banned are legitimate issues, but they are not my issues. Every time the discussion about stopping the illegal trade in antiquities veers off into these broader realms we lose focus, we lose the attention of mainstream society, and it makes the job of recovering stolen antiquities that much harder.

II PROVIDE FUNDING TO ESTABLISH OR UPGRADE ANTIQUITIES TASK FORCES

Second, although several countries - including the United States, Britain, Italy, and Japan - have pledged millions of dollars to upgrade the Iraq Museum, to improve its conservation capacity, and enhance the training of the Iraq State Board of Antiquities and Heritage's archaeological staff, not a single government, international organisation, or private foundation anywhere in the world has provided additional funding for investigative purposes. Reluctant to be seen cooperating with police and military forces, many cultural

leaders and organisations seem oblivious to the fact that a stolen artefact cannot be restored until it has been recovered. To put it more clearly: money for conservators is pointless without first providing the money to track down the missing objects to be conserved.

This ivory-tower distortion of priorities affects investigative efforts worldwide. INTERPOL can afford to assign only two officers to its Iraqi Antiquities Tracking Task Force - and both have other responsibilities as well. Scotland Yard's art and antiquities squad has four officers covering the entire world - and in January of 2007, their budget was slashed in half (and see Rapley, chapter 6). The Federal Bureau of Investigation's (FBI) Rapid Deployment National Art Crime Team has eight people. Regardless of the exceptional dedication and talent of personnel such as Scotland yard's Vernon Rapley and the FBI's Robert Whitman, no law-enforcement agency can operate effectively at such levels.

Thus, as a second component, all countries - but most especially the countries of origin, transit, and destination - must establish robust, specialised art and antiquities task forces, with particular attention paid to the borders and the ports of entry. Where such forces already exist, we must increase their size and scope, with cultural foundations providing art-theft squads with vehicles, computers, communications equipment, and training.

III Create a Coordinated International Law-Enforcement Response

Among the many dirty secrets of the looted antiquities market is that 'open' borders are as profitable as they are dangerous. Many countries, especially those with free ports or free-trade zones, generate sizeable customs and excise fees from shipping and - despite their public protestations to the contrary - are not eager to impose any increase in inspection rates that might reduce such revenue. Even if willing, the sheer tonnage passing through certain international ports and free-trade zones makes 100% inspection rates impossible. Nor does the improved technology installed as a result of September 11 solve the problem: devices that detect weapons and explosives do not detect alabaster, lapis lazuli, and carnelian. Further exacerbating the problem, most high-end smugglers are simply too sophisticated, and the questionable acquisition practices of some dealers, collectors, and museums, too entrenched to be defeated by improved border inspections and heightened public consciousness alone.

The *sine qua non* for effective interdiction, then, is an organised, systematised, and seamlessly collaborative law-enforcement effort by the entire international community. We need coordinated simultaneous investigations of smugglers, sellers, and buyers in different countries. And - just as important - prosecution and incarceration need to be credible threats. Thus, as a third component, the UN, through UNESCO, should establish a commission to continue the Iraq Museum investigation, expanding it to include other pillaged countries as well. INTERPOL must also become more active, entering into agreements with its 191 member nations stipulating that each country forward to them immediately, along a secure network (that already exists), a digital photograph and the particulars (who, what, when, and where) of all antiquities encountered by law

enforcement or military forces anywhere in the world - including those items that were seized, as well as those that were inspected and not seized because there was insufficient evidence of criminality at the time of the inspection.

The global criminal enterprise that is antiquities smuggling must be defeated globally through international cooperation (promoted by UNESCO) and real-time dissemination of information, (enabled by INTERPOL). The consequent ability to conduct monitored deliveries of illegal shipments to their destinations (a tactic long used against drug smugglers) would enable legal authorities to incriminate and thereafter prosecute each culpable party along the trail. It would also serve as a deterrent to those collectors or curators who could never be sure that the next shipment was not being monitored by law-enforcement officials.

IV ESTABLISH A CODE OF CONDUCT FOR TRADING IN ANTIQUITIES

Fourth, museums, archaeologists, and dealers should establish a strict and uniform code of conduct. Similar to ethics rules for lawyers and doctors, this code of conduct would clarify the documentation and diligence required for an artefact to change hands legally. If they refuse such self-regulation, then Congress should impose regulation. Although many argue that the interests of dealers, collectors, museums, and archaeologists differ from each other so dramatically that any single code of conduct acceptable to all is impossible, I point out that the differences within the art world are no greater than those existing between prosecutors and criminal defence attorneys. Yet, the American Bar Association has adopted and actively enforces a single Code of Ethics applicable to every attorney admitted to the bar in the United States. Until then, I continue to urge academics, curators, and dealers to abandon their self-serving complacency about - if not complicity in - irregularities of documentation.

V INCREASE COOPERATION BETWEEN THE CULTURAL HERITAGE COMMUNITY AND LAW ENFORCEMENT

Finally, the art community must break down barriers and assist investigators by serving as law enforcement's eyes and ears. We need scholars and knowledgeable dealers as on-call experts to identify and authenticate intercepted shipments, and to provide crucial in-court expert testimony. They should also request appropriate law-enforcement personnel (depending on country and focus) to provide detailed, factual briefings at every conference purporting to address art or antiquities smuggling. The call for up-to-date investigative facts should become as standard as the call for papers.

But the education and information exchange should run in both directions. In 2004, Dr C Brian Rose, then First Vice-President of the Archaeological Institute of America (now its President), developed and conducted cultural-awareness training in half-a-dozen pilot locations around the country for military personnel scheduled to deploy to Iraq or Afghanistan. The programme should be expanded to include every unit deploying overseas. A similar programme should be offered to the FBI and the Department of Homeland Security on a regular basis (and to similar organisations in other countries

as well). Such cooperation between the art and archaeological communities and the law enforcement and military presents a real chance of winning a fight we cannot afford to lose.

5 FUTURE MILITARY CONFLICTS

The United States military has lessons to be learned as well. Looking to the future, we must never again cede the moral high ground on issues of cultural sensitivity and national patrimony. Thus, before the military takes action in any country, all commanders must clearly articulate the recognition of that country's proud cultural heritage and the intent to protect such property, to the extent possible, during the conflict and post-conflict stage. Not just the message, but the actions that flow from it, must convince the world that the United States and, in particular, its military forces are committed to honouring and preserving the heritage of all nations and religious traditions.

To do so, military leaders must plan before any action for the protection of cultural property in the proposed area of operations. This protection must go beyond merely putting the site on the no-strike list. It must include the securing of significant sites (as identified by members of the archaeological community) and the immediate deployment, if needed, of on-call security forces (identified in advance of the operation) upon reports of looting. Where such forces already exist, military forces should assist by providing them with vehicles, radios, and training. Where no such forces exist, the American military must protect the sites until trained forces are available. Such preparation would enable planners to identify shortfalls and - where appropriate - attempt to fill such needs from international organisations or Coalition countries before the conflict.

Diverting resources to save cultural artefacts during a time of war may seem trivial considering the human cost of war. But some wise soldiers before us have seen the wisdom. 'Inevitably, in the path of our advance will be found historical monuments and cultural centres which symbolize to the world all that we are fighting to preserve,' said General Dwight Eisenhower, just before D-Day during the deadliest war of the last one hundred years, one that threatened the very existence of democracy. 'It is the responsibility of every commander to protect and respect these symbols whenever possible.'

CONCLUSION

Antiquities trafficking will never merit the same attention or resources as terrorism, drugs, human trafficking, or violent street crime. But, at the very least, it deserves to be on the same list. From government corridors, precinct headquarters, and media newsrooms to faculty lounges, museum boardrooms, and galleries on Madison Avenue, this cultural catastrophe must be confronted and debated fairly, honestly, and without rancour or bias. We must expose those who engage in the illegal trade for what they are: criminals.

On my first tour in Iraq, our mission was to track down illegal arms and terrorist networks. My decision to expand our mission to include investigating the looting of the Iraq Museum and tracking down the stolen artefacts was characterised by many as a distraction. I regret that I did not pursue that distraction even more.

NOTES

1. This chapter is excerpted and adapted from *Thieves of Baghdad: One Marine's Passion to Recover the World's Greatest Stolen Treasures* (Bloomsbury 2005). Copyright © 2005 by Matthew Bogdanos. Reprinted by permission of Bloomsbury USA. For a more exhaustive treatment and a more complete list of notes and works cited, see M. Bogdanos, 'The Casualties of War: The Truth About the Iraq Museum,' in the *American Journal of Archaeology* 109 (2005), 477–526 (also available from ajaonline.org).

2. See the Protocol Additional to the Geneva Conventions of 12 August, 1949 (Protocol I), 8 June, 1977; Protocol Additional to the Geneva Conventions of 12 August, 1949 (Protocol II), 8 June, 1977; Convention for the Protection of Cultural Property in the Event of Armed Conflict, The Hague, 14 May, 1954; Protocol for the Protection of Cultural Property in the Event of Armed Conflict (Protocol I), The Hague, 14 May, 1954; Second Protocol to the Hague Convention of 1954 for the Protection of Cultural Property in the Event of Armed Conflict (Protocol II), The Hague, 26 March, 1999.

3. An RPG, or rocket-propelled grenade, is an extremely effective shoulder-fired weapon, using an 85-mm armour-piercing shaped warhead that is capable of penetrating up to 35 cm of armour. The ubiquitous Soviet-introduced RPG-7 weighs 8.5 kg with its warhead and is devastatingly effective up to 500m against a stationary target and 300m against a moving target. An RPG-7 can penetrate a Bradley armoured personnel carrier, and although it cannot penetrate the heavily armoured portions of the US Army's main battle tank, the M1A1 Abrams, there are areas of the tank that are vulnerable as well.

4. An AK-47, or Automat Kalashnikova Model 1947, is an assault rifle capable of firing up to six hundred rounds per minute at the cyclic rate in its automatic fire mode. Its 7.62-by-39-mm bullet can penetrate USA body armour and is lethal to 300m.

5. 'All it would have taken was a tank parked at the gate,' said Jane Waldbaum, president of the American Institute of Archaeology. *USA Today*, 14 April, 2003. From these requests for assistance, an urban legend grew up, the Legend of the Heartless Tank Crew. The legend began in the *New York Times* with the account of an archaeologist named Raid Abdul Ridhar Muhammad, who supposedly 'went into the street in the Karkh district, a short distance from the eastern bank of the Tigris, about 1 pm on Thursday [10 April] to find American troops to quell the looting . . . Mr Muhammad said that he had found an American Abrams tank in Museum Square, about 300 yards away, and that five Marines had followed him back into the museum and opened fire above the looters' heads. That drove several thousand of the marauders out of the museum complex in minutes, he said, but when the tank crew men left about 30 minutes later, the looters returned.' ['Pillagers Strip Iraqi Museum of Its Treasure,' *New York Times*, 13 April, 2003; the same report erroneously reported 'at least 170,000 artefacts [were] carried away by looters' in 'only 48 hours.'] It made for a sensational story that justified its front-page placement, but the account is geographically impossible and internally inconsistent. To put it more bluntly, the evidence strongly suggests that it never happened. *The Times* report had Muhammad going 'a short distance from the eastern bank of the Tigris . . . to find American troops.' However, the Iraq Museum is not on the eastern bank of the Tigris, but 900 metres *west* of the river. Assuming that 'Muhammad' existed at all and did what he said he did, he had to have been talking about some other museum. The only one possible is the Baghdad Museum (containing 20th century artefacts), on Mamoun Street, which is, in fact, 'a short distance from the eastern bank of the Tigris.' Any reporter working in Baghdad in April 2003 knew, or at least should have known, the difference between the Iraq Museum in Baghdad's al-Karkh district, on the western side of the Tigris, and the Baghdad Museum in Baghdad's al-Rusafa district, on the eastern side of the Tigris. This obvious error in geography helps to explain many other problems with the story. Despite Muhammad's claim to having found five Marines '300 yards away,' there were no Marines near the Iraq Museum on 10 April - it was not their sector. There were, however, Marines assigned to the eastern side of the Tigris, where the Baghdad Museum is located. The sector in which the Iraq Museum is located was assigned to Captain Conroy's tank company. They were the only unit in the vicinity of the museum on 10 April and were still engaged in combat on that day. They did report that an unknown Iraqi approached them - on 10 April - and told them of looting 'in the vicinity of the hospital and the Museum.' Immediately thereafter, a second Iraqi approached the same tank crew and told them to shoot the first Iraqi because he was *fedayeen*. Then both men ran away. When the crew reported this slightly surreal encounter - the fog of war in all its glory - they were ordered to advance toward the Museum to investigate. That is when they drew fire from the Children's Museum, fired the single round in response, and then pulled back. But there are other flaws in the Muhammad story that appear obvious to anyone who knows the first thing about the military. Military personnel follow orders. They do not wander off on their own just

to see what is going on down the block. No soldier or Marine would ever - as the article claims - have left his battle position, during combat, to follow an unknown informant into a potential ambush. Even the number of 'Marines' alleged to have followed him (five) rings false: a fire team (the smallest tactical unit), like a tank crew, has four men. Finally, *The Times* description of 'thousands of men, women, and children' in the crowd contradicts every other witness we ever interviewed about the looting, every one of whom numbered the crowd at fewer than four hundred. There have never been any reports of children, and although some of the looters appear to have had rifles (former fighters?), not a single other witness ever reported seeing the colourful 'rifles, pistols, axes, knives and clubs.' But the legend was already born, and legends spawn sequels, and the details change with each telling. In the *New York Times*, the request for assistance came on 10 April, but the *Guardian* soon shifted it to 11 April: 'The Americans returned with tanks at one point on Friday [11 April] and sent the looters fleeing, but as soon as the tanks rumbled away, the gangs came back to finish the job.' ['Museum's Treasures Left to the Mercy of the Looters,' *Guardian* (London), 14 April, 2003.] Then it became 12 April: '[A] single tank crew responded . . . for about 30 minutes on 12 April.' [Poudrier, A. 2003, July - August. 'Alas, Babylon! How the Bush Administration Allowed the Sack of Iraq's Antiquities.' *Humanist.*] Then, as in a kids' 'choose your own adventure' game, the assistance seeker became a 'shape-shifter'. In the *New York Times*, he was Muhammad. Then he became 'Muhsin, the guard [who] tried to convince the American tank crew positioned nearby to come and protect the museum - they came once and drove off the looters but refused to remain.' Eventually, he became 'museum staff and journalists in Baghdad [who] repeatedly urged American tank crews to go and protect the museum until they finally went for half an hour to chase away looters.' [Elich, G. 3 January 2004. 'Spoils of War: The Antiquities Trade and the Looting of Iraq.' *Centre for Research on Globalisation.*] In other accounts, the tank crew never even moved at all: 'One tank crew was within 50 yards of the building . . . but its commanders refused emotional pleas from museum staff to move any closer'. [See, eg, F. Gibbons, 'Experts Mourn the Lion of Nimrud, Looted as Troops Stand By,' *Guardian* (London), 30 April, 2003.] Like the earlier needless controversy over the number of looted items, the 'Legend of the Heartless Tank Crew' says far more about the quality of the early reporting than it does about what really happened at the Museum.

6. In a similar vein, some ill-informed critics complained about how coalition forces protected the oil ministry, but not the Museum. What those critics failed to take into account is that to 'secure' a building in combat, you usually have to physically occupy it, at least temporarily. If the building is fortified, that means a battle. In this comparison, there are three facts that such critics blithely ignored. First, the 'securing' of the oil ministry began with coalition air strikes on 9 April. It was a lawful target, and they dropped a bomb on it. They were not going to bomb the Museum. Second, the oil ministry did not contain soldiers - it had not been turned into a fortress that housed people who were trying to kill Coalition forces. The Museum was filled with Republican Guards shooting at Americans with automatic weapons and tank-killer rocket-propelled grenades. Finally, the oil ministry is just one building - the Coalition 'secured' it in less than an hour. The Museum was an eleven-acre complex of interconnecting and overlapping buildings and courtyards. Securing it would have required a serious fire-fight that would likely have reduced the place to expensive rubble. Comparing the Museum with the oil ministry, then, is more politics-based than fact-based.

7. Although the use of non-lethal measures such as tear gas might have satisfied legal standards, several factors would have argued against their employment. First, even 'non-lethal' measures sometimes result in death, particularly among the elderly and children. Second, there is the question of effectiveness. Non-lethal measures would have dispersed the looters (and have caused them to drop larger items). But most of the looted items were the smaller excavation-site pieces, and the use of tear gas, for example, would not necessarily have caused the looters to empty their pockets or drop their bags as they ran away. Finally, while it is easy to judge these events with the benefit of hindsight, any argument that coalition military should have used force, non-lethal or otherwise, to disperse a crowd at the museum, must first consider the extraordinarily negative reaction it would have been expected to cause among a people that in April 2003 believed that such governmental sponsored violence had ended with the fall of the Saddam Hussein regime.

8. Both of the standard-issue rifles for USA forces, the full-size M16A2 as well as the smaller M4 carbine, fire a NATO bullet that measures 5.56mm in diameter and 45mm in length, weighs 3.95 g, and leaves the muzzle at a velocity of 905.5 (M4) or 974.1 (M16A2) m per second. The bullets return to the ground at lethal terminal velocity.

9. On one of the second-floor landings was a group of 27 bricks with royal inscriptions placed in chronological order from the cuneiform tablets of Eannatum I (ruler of Lagash, c.2470 BC), Naram-Sin (king of Akkad, c.2250 BC), and Hammurabi (king of Babylonia, 1792–1750 BC) to Assurnasirpal (ruler of Assyria, 885–858 BC), Nebuchadnezzar (king of Babylon, 605–562 BC), and - the most recent - a Latin-inscribed brick from a Roman barracks of the first century BC. The nine that were stolen were carefully selected.

10. 'Glass cutters left behind at the scene are viewed as another indication of professionals at work alongside the mob' (Rose, M. 2003, 15 April - 11July. 'Taking Stock in Baghdad.' *Archaeology*.). Another popular claim is that these professionals 'even brought equipment to lift some of the heavier pieces' (F. Deblauwe, quoted in Elich, G. 2004, January 3. 'Spoils of War: The Antiquities Trade and the Looting of Iraq.' *Center for Research on Globalisation*). No-one brought any such equipment to the Museum. At least, no one used any such equipment. In the case of the Bassetki Statue, we followed the cracks in the floor made by thieves who dropped it several times, and who certainly had no equipment at hand to assist them.

11. In the absence of any master inventory, the numbers of missing items are based on the Museum's staff's hand counting - shelf by shelf, aisle by aisle, room by room - those items still present and comparing those objects with the excavation catalogue for the particular site represented by that shelf and then writing out in longhand a list of the missing items by designation. Thus, the numbers will change as each shelf and box in each aisle in each room is inventoried and is likely to take many years.

12. Neighbouring countries report having recovered a total of approximately 1866 Iraqi antiquities altogether (Jordan 1450 items; Syria 360; Kuwait 38; and Saudi Arabia 18). Donny George believes that approximately 700 came from the Museum and the rest from archaeological sites. No antiquities have been seized (or, to be more precise, acknowledged to have been seized) by the other two border nations, Turkey and Iran.

13. Although Italian authorities have seized another 300 artefacts that they believe came from the Museum, they are not included this number because neither Donny George nor I have yet verified that the items are from the Museum.

14. The female deity was the only statue whose head the thieves cut off. Discovered in a Hatrene temple dedicated to the worship of Hercules, it may, therefore, represent his wife (Basmachi, F. 1975–76. *Treasures of Iraq Museum*. Baghdad: al-Jamahiriya Press, 309). The three heads of Poseidon, Apollo, and Eros were exquisite Roman copies of c AD 160 after Greek originals of the fourth century BC.

Bibliography

1. Al-Gailani Werr, L. 2005. "A Museum Is Born." in *The Looting of the Iraq Museum, Baghdad*, edited by M. Polk and A. Schuster, 27–33. New York: Abrams.

2. Al-Radi, S. 2003a, October. "War and Cultural Heritage:Lessons from Lebanon, Kuwait, and Iraq." *The Power of Culture*. http://www.powerofculture.nl/uk/articles/war_and_cultural_heritage.html (13 March 2005).

3. ———. 2003b. "The Destruction of the Iraq National Museum." *Museum International* 55(3–4).

4. ———. 2005. "The Ravages of War and the Challenge of Reconstruction." in *The Looting of the Iraq Museum, Baghdad*, edited by M. Polk and A. Schuster, 207–11. New York: Abrams.

5. Aaronovitch, D. 2003. "Lost from the Baghdad Museum: Truth," *Guardian* London, June 10, 2003

6. Atwood, R. 2004. *Stealing History: Tomb Raiders, Smugglers,and the Looting of the Ancient World*. New York: St. Martin's Press.

7. Bahrani, Z. 2003–2004. "Cultural Heritage in Post-war Iraq." *International Foundation for Art Research* 6(4).

8. Basmachi, F. 1975–1976. *Treasures of the Iraq Museum*. Baghdad: al-Jumhuriya Press.

9. Brodie, N., J. Doole, and C. Renfrew, eds. 2001. *Trade in Illicit Antiquities*. Cambridge: McDonald Institute.

10. Chippindale, C. and DWJ Gill. 2000. "Material consequences of contemporary classical collecting," *American Journal of Archaeology* 104, no. 3 (July 2000): 463–511

11. Cruickshank, D., and D. Vincent. 2003. *People, Places,and Treasures Under Fire in Afghanistan, Iraq and Israel*.London: BBC Books.

12. Damerji, Muayad S.B. 1999. *Graber Assyrischer Koniginnen aus Nimrud*. Mainz: Verlag des Romisch-Germanischen Zentralmuseums.

13. Deblauwe, F. 2003, 17 October. "Melee at the Museum." *National Catholic Reporter*. http://www.natcath.com/NCR_Online/archives2/2003d/101703/101703n.htm (12 March 2005).

14. Elich, G. 2004, 3 January. "Spoils of War: The Antiquities Trade and the Looting of Iraq." *Center for Research on Globalisation*. http://globalresearch.ca/articles/ELI401A.html (12 March 2005).

15. Gibson, M. 1997, Autumn. "The Loss of Archaeological Context and the Illegal Trade in Mesopotamian Antiquities." *Culture without Context: The Newsletter of the Illicit Antiquities Research Centre* 1 (1997). http://www.mcdonald.cam.ac.uk/IARC/cwoc/issue1/Loss Context.htm (20 February 2004).

16. ———. 2003. "Cultural Tragedy in Iraq: A Report on the Looting of Museums, Archives and Sites." *InternationalFoundation for Art Research*. http://www.ifar.org/tragedy.htm (12 March 2005).

17. Hussein, M., and A. Suleiman. 1999–2000. *Nimrud: A City of Golden Treasures*. Baghdad: Republic of Iraq, Ministry of Culture and Information, Directorate of Antiquities and Heritage; al-Huriyah Printing House.

18. Joffe, A.H. 2004. "Museum Madness in Baghdad." *Middle East Quarterly* 11(2). http://www.meforum.org/article/609 (13 March 2005).

19. Lawler, A. 2003. "Mayhem in Mesopotamia." *Science Magazine* (August 2003).

20. Nordhausen, F. 2003. "Jede Nacht gibt es Raubgrabungen: Der Marburger Orientalist Walter Sommerfeld untersucht derzeit die Plünderungen im Irak." *Berliner Zeitung*, 3 May 2003.

21. Oates, J. 2001. *Nimrud: An Assyrian Imperial City Revealed*. London: British School of Archaeology in Iraq.

22. *Peninsula* Qatar, "Iraq Museum Still Counting the Cost of Invasion,", July 1, 2004

23. Renfrew, C. 2000. *Loot, Legitimacy, and Ownership*. London: Duckworth.

24. Rose, M. 2003, 15 April–11 July. "Taking Stock in Baghdad." *Archaeology*. http://www.archaeology.org/online/news/iraq3.html (12 March 2005).

25. Russell, J. 1997, Autumn. "The Modern Sack of Nineveh and Nimrud." *Culture without Context: The Newsletter of the Illicit Antiquities Research Centre* 1 (1997). http://www.mcdonald.cam.ac.uk/IARC/cwoc/issue1/nineveh.htm (7 June 2005).

26. *Wall Street Journal*, 2003a. "Iraqis Say Museum Looting Wasn't as Bad as Feared,",17 April, 2003.

27. *Wall Street Journal*, 2003b "Inside Iraq's National Museum", 17 July, 2003.

Will Mesopotamia Survive the War?
The Continuous Destruction of Iraq's Archaeological Sites

Joanne Farchakh Bajjaly

For archaeologists Mesopotamia is the 'cradle of civilisation'; it provides the context for much of the story of humankind, it broke history's enigmas. But since the invasion of Iraq in 2003, Mesopotamia has, for others, become 'the promised land', a paradise for looters of archaeological sites. Today, still, they descend in numbers on Sumerian and Assyrian capitals and on Babylonian cities where they dig, unearth objects and sell them for a few American dollars. They even arrange loans from the dealers to secure their livelihoods before finding an object. For the looters, the archaeological sites are a kind of 'Treasure Island', where some piece to sell can always be found. Here, looting is a profession – free of any ethical judgment.

Five years ago, as the American troops were pressing toward Baghdad, looters were invading Iraq's archaeological sites, which are spread all over the country. Profiting from the confusion created by the war, the looters sought to benefit as much as possible. Their working strategy was well known long before the war. In 1991, after the First Gulf War, 13 provincial Iraqi museums were ransacked and their objects were sold around the globe. For archaeologists and professionals working on saving heritage in times of war, the scenario of the looting of the archaeological sites was foreseen long before the war. Many attempts were made to alert the American[1] and British military authorities regarding the danger that lay ahead (see Stone, chapter 8). The warnings fell on deaf ears. Archaeology and heritage were not a priority for the military establishment of the occupying powers.

The result of this indifferent attitude was clearly felt on the country's major archaeological sites. In May 2003, two months after the fall of Baghdad, I toured some of Iraq's main sites, to assess any damage (Farchakh 2003) and then went back there in February 2004 to do a report a year after the looting of Baghdad museum (Farchakh 2004). From the north to the south, the situation was dramatic and depressing. The country's past was being ravaged. In 1991, after the revolution against Saddam Hussein's regime, looters invaded Sennacherib's palace in Nineveh and smashed down the marble reliefs which they later sold in pieces on the antiquities market. Returning to Nineveh in 2003 there were no guards and no-one responsible for stopping the looters, as they smashed the only Sennacherib wall that had survived the 1991 destruction. In Nimrud, a gun battle took place between guards at the archaeological site and looters as the latter

tried to break up marble reliefs in an effort to remove them for sale. On the smaller sites located in northern Iraq, such as the palace of King Karatukulti Ninurta, the situation was no better: looters had broken coloured mud brick tiles to sell them in the local market. Inspecting the archaeological sites one after the other showed the extent of the damage caused by the looting. But the real, widespread looting was taking place in the southern part of the country.

Di Qar district, in southern Iraq, whose principal city is Nassiryah, was in 2003, and still is in 2007, under the total control of the looters and antiquities dealers. Heavily armed, they controlled the main roads leading to the biggest archaeological sites thereby providing security for their 'employees'. These were hundreds of farmers who had left behind their families to actually live on the sites and search for antiquities for the dealers. Their days started before sunrise for a few hours, and then the heat would force them to stop until late in the afternoon when a second shift would begin, continuing until late into the night. They were well equipped: they carried shovels and hammers, and they had made their own lamps run off car batteries. They did not spare one metre of these Sumerian capitals that have been buried under the sand for thousands of years. They systematically destroyed the remains of this civilisation in their tireless search for sellable artefacts: ancient cities, covering an estimated surface area of 20 square kilometres, which, if properly excavated, could have provided extensive new information concerning the development of the human race. Humankind is losing its past for a cuneiform tablet or a sculpture or piece of jewellery that the dealer buys and pays for in cash in a country devastated by war. Humankind is losing its history for the pleasure of private collectors living safely in their luxurious house and ordering specific objects for their collection.

The Sumerian capitals of Umma, Larsa and Jokha looked like the surface of the moon. Hills and piles of broken pottery, craters and mounds of sand, mixed with mud brick tiles. The walls of the temples had been broken into pieces because some of these mud brick tiles had the stamps of the Sumerian kings engraved in them – thus becoming a sought after and valuable object for the market. Iraq's archaeological sites are simply becoming providers of beautiful and valuable objects.

It is common practice to blame the looters for all this damage and destruction, but are they singularly to be blamed? They do hold the shovel and dig, but what are their motives? Are they destroying these cities for the pleasure of it? Or is their driving force a basic need (and see George, chapter 10)?

Iraq's rural societies are very different to our own. Their conception of ancient civilisations and heritage does not match the standards set by our scholars of social sciences. For them, history is a people's own past. History is limited to the stories and glories of your direct ancestors and your tribe.

So, for them, the 'cradle of civilisation' is nothing more than desert land with 'fields' of pottery that they have the right to take advantage of because, after all, they are the lords of this land, and as a direct result, the owners of all its possessions. In the same way, if they had been able, these people would not have hesitated to take control of the oil fields, because this is 'their land'. Their concept of the world is limited to their

own surroundings and direct family, and neighbours. Because life in the desert is hard and because they have been 'forgotten' by all of the governments, their 'revenge' for this reality is to monitor, and take, every single money-making opportunity. Ahmad, one of the looters working at Jokha, explained his point of view on digging for artefacts while smoking a 'Sumer' cigarette:

> These are fields full of pottery that we come and dig up whenever we are broke. Sometimes we find a plate or a bowl that is broken, and then we cannot sell them. But perhaps, we will find something with some writings on it, and it's still intact, and that will be sold very fast for USA dollars. (Farchakh 2003)

A cylinder seal or a cuneiform tablet earns US$ 50, and that's half the monthly salary of an average government employee in Iraq. The looters know, as told by the traders, that if an object is worth anything at all, it must have an inscription on it. A cylinder seal, a sculpture or a cuneiform tablet can bring in hard cash. In the West, looting is considered dangerous work, badly paid. In Iraq, the farmers consider their Western-termed 'looting' activities to be part of a normal working day. To them there is not much difference between working in the field as a farmer and digging a site as a looter; it's all work. With some luck, the site is much more rewarding than the field.

For the Director of Antiquities in Di Qar province, the archaeologist Abdulamir Hamdani, the looting of these archaeological sites is a:

> disaster that we are all witnessing and observing, but which we can do little to prevent. In 2006, we recruited 200 police officers as we are trying to stop the looting by patrolling the sites as often as possible. Our equipment was not enough for this mission because we only had 8 cars, some guns and weapons and a few radio transmitters for the entire province where 800 archaeological sites have been inventoried. Of course, this is not enough but we were trying to establish some order until money restrictions within the government meant that we could no longer pay for the fuel to patrol the sites ... So we ended up in our offices trying to fight the looting with our social contacts but that was also before the religious parties took over southern Iraq and showed support for some of these tribes (and see Hamdani, chapter 14).

In fact, the religious parties are gaining influence in all Iraqi provinces with each day that passes. Hamdani hints at this development. In 2006, the antiquities department in Di Qar province received notice from the local district, approving the creation of new mud brick factories in the areas surrounding Sumerian archaeological sites. The factory owners intended to buy the land from the Iraqi government, but on closer inspection, the land under question covered several Sumerian capitals and other smaller archaeological sites. This meant that the new landlord would 'dig' the archaeological site, dissolve the 'old mud brick' to form the new one for the market, and of course sell the unearthed finds to antiquity traders. The landlord would also only pay his employees the regular worker's fee and not the higher fee for professional diggers of archaeological sites. Such an arrangement would have meant the complete destruction of thousands of archaeological sites. So Abdulamir Hamdani refused to sign the dossier. His rejection had rapid consequences. The religious parties controlling Nassiryah sent the police to see him with

orders to jail him on corruption charges. He was imprisoned for three months, awaiting trial. The State Board of Antiquities and Heritage in Iraq defended him during his trial and international and national supporters played their role, as did his powerful tribe. He was released and regained his position. The mud brick factories are for the time being 'frozen projects' in Di Qar district but reports have surfaced of a similar strategy being employed in other cities and in nearby archaeological sites such as the Aqaraquf Ziggurat near Baghdad (Al-Akhbar 2006). For how long can Iraqi archaeologists maintain order? This is a question that only Iraqi politicians affiliated to the different religious parties can answer, since they approve these projects.

Alongside the religious parties, the antiquities traders have developed a well-organised support structure for their work. In rural Iraq, they have managed to win the support of the tribe leaders who control southern Iraq to a considerable degree, to the extent that the current Iraqi government is considering supplying them with weapons to confront the so-called insurgency (Al-Jazeera 2007). The wealth of Iraqi tribes and the well-being of many villages depend on black market artefact-generated revenues. Artefact hunters will not hesitate to kill in order to protect their income when no other options are available. In 2005, the Iraqi customs arrested, with the support of the Coalition forces, a few antiquities dealers in the town of Al Fajr, near Al Nassiryah. They seized hundreds of artefacts and decided to take them inland all the way to the Iraqi National Museum in Baghdad. The convoy was stopped a few kilometres away from Baghdad, eight customs agents were killed and their bodies burned and thrown into the desert. The objects disappeared. This was a clear message being sent out from the antiquities dealers to the world: the chain is long and efficient. In the desert and small towns the dealers have the support of the tribes and in the cities they have the political links that guarantee them the liberty of their action. In a country ravaged by war where basic human necessities are no longer safeguarded and where prices are increasing by the day, the antiquities dealers present themselves as an alternative solution in this desperate situation. Working with them is not particularly dangerous, it is comparatively well paid, and they hire people from different factions and communities. So, for the politicians they bring in badly needed cash for their people and they never hesitate to bribe every tribe or political power in every part of Iraq, because in Iraq at present, every area is ruled by the community living there and what generates income is protection money.

The tribal leaders give the antiquities dealers full support because they see in this an economic benefit for their community. At present, and since the Coalition authorities are not buying any of the farmers' agricultural products, preventing people from looting archaeological sites will mean condemning them to starvation. Besides, for these people, excavating an archaeological site is not a crime. Even in local police records they are not classed as thieves, but rather as 'peasants farming by mistake on archaeological sites', because, in a tribal society, to be called a thief is a huge insult. All of these people respond to their own value ratings that the dealers and assassins are taking full advantage of; therefore, they have the freedom to vandalise and destroy the first cities of humankind. These black market artefact dealers are living in the farmers' villages, encouraging looters to go and dig. They buy any antiquity discovered and extend loans to needy farmers to

keep them working on sites. Claims that these dealers are part of a worldwide organised network that had planned the looting of Iraq's archaeological sites and that is profiting from the war and the resulting chaos seem increasingly plausible.

On a regional level, the traffic in Mesopotamian antiquities is well structured in the five countries bordering Iraq. Trucks, cars, planes and boats are used to transport artefacts to Europe, the USA, the Arab Emirates or Japan, where private collectors are eager to purchase them. Millions of dollars and, it is claimed, very powerful people within Iraq and its neighbouring countries are involved in this trade. Because the antiquities market generates money, and, unlike arms trafficking, in the eyes of all 'military officers' ruling the Middle East it does not represent a threat to any of the existing regimes, it is 'allowed' to take place. An ever-growing number of internet sites now offer Mesopotamian artefacts – objects anywhere up to 7000 years old. Doubtless, there are more fake objects advertised on the web than authentic ones, but the mere existence of this market has fuelled the looting of archaeological sites in southern Iraq.

There will be no end to the destruction of Iraq's heritage, unless the country's leaders start considering archaeology a priority. To start with, the ring of artefact dealers in Baghdad has to be broken, looting in the south has to be effectively confronted and Coalition forces have to be prevented from setting up base on archaeological sites. The longer Iraq finds itself in a state of war, the more the cradle of civilisation is threatened. It may not even last long enough for our grandchildren to learn from it.

So, how would it be possible to save the history of the world from the hands of the looters? Is it still possible to save Mesopotamia? If the political decision to save Iraq's history is taken as late as today in the summer of 2007, it would still be possible to save Mesopotamia from irretrievable 'collateral damage'. But it is no longer clear this could be achieved as the farmers have become, effectively, professional looters of archaeological sites. By now, they know how to outline the walls of buried buildings and are able to break directly into rooms and tombs where the objects, so prized on the world's antiquities markets, are to be found. They have been trained in how to rob the world of its past and they have been making significant profit from it; they know the value of each object and it is difficult to see why would they stop looting now or what would make them stop. Strict laws, economic alternatives and political approval and cooperation from the tribal leaders provide the only possible solution to this dilemma.

None of these approaches could or will work in isolation, and if deployed separately, no effective results will be forthcoming. Iraq's antiquities law sees the looting of archaeological sites as punishable by death and long-term imprisonment. Not that I advocate the death penalty, but if imprisonment was to be applied rigorously, perhaps this would begin to restrict looters and dealers in their activities. They would know that there is no way out if caught.

Still more important is that there should be an economic alternative for the locals who, given the present state of emergency in Iraq, are unable to work legitimately with archaeologists on excavating the Sumerian capitals, as has been the case since the late 1990s. At that time, after the First Gulf War, in order to stop the looting of archaeological

sites in southern Iraq, groups of archaeologists went to the area and started excavating the sites; they hired the former looters as workers and assured them salaries paid by the government. They could not stop their missions because this income was the only alternative to looting and, when reduced, the farmers would revert to looting, this time as professionals. These techniques worked as long as the archaeologists were on the sites but it was one of the main reasons for the destruction of the Sumerian sites following the invasion. People knew how to excavate and what to expect.

The latest USAid report (USAid 2007) on farming in Iraq stated that the country has a huge potential and that this sector can generate more than a third of national income if developed properly. Farming could provide a solution, particularly given that the great majority of looters are themselves farmers. It is possible that the organisation of farming and industrial dairy products might replace the illicit excavation of antiquities as the major source of income for much of the rural population in Iraq. But someone needs to organise and manage such activity.

Even more important is to identify looters as what they are in police records, whenever captured on a site, because according to the traditional 'honour laws' of Iraq, looters are viewed in a very poor light by society. If the law is applied and these people are listed as 'thieves' they may no longer retain the support of their tribe leaders, especially if these leaders have agreed to opt for the economic alternative of farming instead of looting archaeological sites, then things will start to change.

Even if it were possible, which it is not at present, rejuvenating Iraq's rural economy must not be linked to employment on archaeological sites. People have to be driven away from this option. They have to forget about this experience and find alternatives and better income solutions. Then, and only then, can one start hoping to save Mesopotamia. If none of the above-mentioned suggestions are given consideration, the very real fear is that the Sumerian civilisation that has survived, in the archaeological record, all of its successors may not survive its worst enemies of all time: the antiquities market, the ignorance of politicians and the silence of witnesses. Each of us who knows about this massacre of civilisation is a silent witness who, by ignoring it, is helping it to grow.

NOTES

1. Letter from the Society of American Archaeology: http://www.saa.org/goverment/Iraq.html, Archaeological Institute of America (AIA) petitioning US government for cultural resource management in Iraq, 1/15/04.

BIBLIOGRAPHY

Al-Akhbar newspaper, Beirut, November 2006

Al-Jazeera English, 2007 Maliki supports arming Sunni tribes, in *Al-Jazeera.net* 23/6/07 [online] http://
english.aljazeera.net/NR/exeres/B45078CF-5028-4374-836E-72683227E861.htm[25 October 2007]

Farchakh, J, 2003 Le massacre du patrimoine irakien, in *Archéologia*, July/August, 402, 12–35

Farchakh, J, Témoignage d'une archéologie héroïque, in *Archéologia*, May, 411, 14–27

USAid, 2007 Agriculture, in *USAid.gov* 16/5/07 [online] http://www.usaid.gov/iraq/accomplishments/agri.
html [25 October 2007]

The Damages Sustained to the Ancient City of Babel as a Consequence of the Military Presence of Coalition Forces in 2003

Mariam Umran Moussa

The city of Babel lies 90km to the south of the Iraqi capital Baghdad, within the limits of the city of Hillah. Geographically it sits in the middle of a group of ancient cities including Kish, Borseppa, Kotha, and the tomb of the prophet *Thou Al Kifl*. Babel is mentioned in numerous cuneiform inscriptions, the holy books of the Koran and Bible, and the books of travellers and orientalists.

The name of the city appeared for the first time in the Akkadian period, 2371–2230 BC, as 'Ka-dingir-ra' in the Sumerian language and 'Bab-ili' or 'Bab-ilani' in the Babylonian Semitic language, meaning 'the door of god' or 'the door of the gods/goddesses'. This name is associated with King Hammurabi, the great lawmaker (1792–1750 BC) and King Nebuchadnezzar II (604–562 BC), in whose reign Babel became the biggest city in the ancient world. Alexander the Great even considered adopting it as his capital because of its special status and the importance it enjoyed among the cities of the ancient world.

The first archaeological excavation of the city was undertaken between 1899 and 1917 by a German expedition under the leadership of Robert Koldewey. This early work was followed by some short projects of excavation by Professor Schmidt in the ziggurat area, then some Iraqi projects in the 1960s and then the major Iraqi programme begun in 1977, during which the Italians also carried out some excavations in the southern parts of the city. However, while significant parts of the city have been revealed, much of its area remains unexcavated, and because of the high level of the ground water in the city, no-one has been able to reach the levels of the old Babylonian period as yet. The archaeological programme that started in 1977 was part of a larger initiative entitled 'The Project for reviving the City of Babel' (hereafter 'Babel Project'). This later included the annual 'International Babel Festival', which began in 1987, which took place mainly in the Greek theatre, the throne hall, and the temple of Nin-Makh (the great lady). The archaeological work included major consolidation work relating to the majority of the ancient buildings exposed during the excavations of the earlier German expedition. It

should be noted, however, that much of this consolidation work was not of a suitable standard, nor did it faithfully restore the archaeological remains. In addition, new buildings and other structures appeared across different parts of the ancient city.

During the 2003 invasion, the ancient city was subjected to acts of vandalism and destruction and in particular the Nebuchadnezzar and Hammurabi Museums were vandalised and looted. Fortunately, the artefacts damaged in, and stolen from, both museums were not originals but gypsum copies. Some pieces of these were found broken and scattered on the floors of the two museums; the rest had gone. The museums' administration offices and the offices of the Babel Project were also ransacked. What could not be stolen was burned so badly that everything in the library and archives including reports, maps, excavation and restoration records from the Babel Project, have been lost forever.

The Ancient City became a Coalition camp (Camp Alpha) in April 2003 and remained in the control of Coalition forces until 22 December 2004. The use of the city as a military camp was a major affront towards this world-renowned archaeological site, and during their occupation Coalition military forces caused significant, direct, and undisputed damage to the archaeological city, by their activities relating to the defence and fortification of their camp, that included digging, cutting, scraping, levelling, and the creation of earth barriers. In addition, their presence caused other, indirect, damage to the archaeological remains.

DIRECT DAMAGE

DIGGING

Coalition forces dug several trenches in different parts of the city with varying distances between them. Some of these were in known, important, areas of the city. However, bearing in mind that the whole of the landscape of Babel, whether mounds or level land, is archaeologically sensitive, all of these trenches are archaeologically intrusive. Described below are some of the most conspicuous areas in which digging with heavy machinery was carried out:

a) All along the inner wall of the city on the eastern side, in what is known as the Humairah area, to the north-east of the theatre, where three trenches were dug with different distances between them.

– The first trench: 30m long x 2–3m wide x 1.15–2m deep.

– The second trench: 13m long x 2–3m wide x 1.15m deep.

– The third trench: 14m long x 2m wide x 2m deep.

It should be noted that the soil extracted from these trenches was used to construct a barrier, which contains fragments of pottery of varying sizes and functions on some of which is cuneiform script representing the stamp of the seal of the Babylonian King Nebuchadnezzar II.

b) A fourth trench 30m long, 2m wide and 0.25–1m deep, was dug to the west of the gate of Mardoukh and to the left of the main entrance to the city.

c) A fifth trench, 18m long, 2m wide and 1.15m deep, was dug to the north of the Presidential Palace and to the left of Shatt-Al-Hilla in the area that provides the northern entrance to the city.

d) A sixth trench: 25m long, 2–3m wide and 1.15m deep, was also dug on the right side of the northern entrance. The excavated soil from these two trenches contains fragments of ancient pottery.

e) The seventh trench, 62m long, 2–3m wide and 2.5m deep, is the most damaging because it was dug at the entrance of the north-eastern corner of the ziggurat area (Tower of Babel): This is a major transgression against not only the city but the tower itself, which is referred to in a cuneiform inscription as the *E-Temen-an-Ki*, and which is specifically referred to by Greek and Roman writers and which numerous Renaissance artists have tried to depict. The excavated earth from this trench has been spread along its sides and, once again, contains varied fragments of ancient pottery.

f) An eighth trench, 162m long (one of the longest trenches dug in the city), 1–1.5m wide, 2m deep, was dug within the religious area of the city, situated to the north of the seventh trench. From its eastern side, another trench measuring 10m in length branches out of it. Again, the excavated earth from these trenches contains fragments of ancient pottery of different sizes, on some of which are cuneiform inscriptions carrying the stamp of the seal of the Babylonian king Nebuchadnezzar. The most recognisable artefact is a small cup, a part of which is missing. Another is a glazed vase, part of which is missing and which was found in the western part of the trench. These trenches are placed roughly at the extremities of the camp area extending from the eastern to the western and to the northern sides of the camp and are encircled with barbed wire.

g) In the southern part of the city, on the road leading to the village of Jumjumah, on the western side – which links the ancient city of Babel with the village of Jumjumah and the city of Hillah, there are two almost circular holes, the first with a diameter of 7m and a depth of 5.2m and the second with a diameter of 10m and a depth of 2m. The earth excavated from these fields, which included known archaeological sites, was put into bags or containers and used for constructing barriers.

EXCAVATION WORK

(Non-archaeological) excavation work took place in different areas of the city including the mounds located in the south, the middle and the north of the city, and in its northern and eastern sections.

a) The first excavation, dimensions 8 x 7 x 6m, was carried out to the north-east of the Greek theatre, within the hills extending alongside the main road between Baghdad and Hilla (the region of Humairah), which begins approximately in the north-eastern corner of the inner wall. It should be kept in mind that the results of the German excavations indicated that much of the earth in this area had been brought from the area surrounding

the Tower of Babel: in the wake of Alexander the Great's attempt to rebuild the tower after it had been subjected to acts of destruction several times. Alexander's men must have cleared the area and transferred its debris to this district which means that the earth here will almost certainly contain a lot of artefacts from the destruction layers of the Tower.

b) A second excavation to the south of the first excavation is larger with an area of 30 x 19 x 7m.

c) A third excavation to the south of the second excavation measuring 23 x 24 x 5m.

d) A fourth excavation measuring 12 x 16 x 5m.

e) A fifth excavation, measuring 38 x 6 x 3m, is located in the southern section of the city, to the west of the street which links the city with the village of Jumjumah. The purpose of this excavation was to provide material to build an earth barrier for protection; most of the earth barriers in this section containing fragments of ancient pottery.

f) A sixth excavation, measuring 30 x 1.8 x 6m, took place on the eastern side of the city, which also contained fragments of ancient pottery.

g) A seventh excavation, measuring 60 x 3 x 3m, sits to the north of the fifth and the sixth excavations and on the western side of the road near the Koura (brick kiln) area, and to the south of the southern airport which was also built by Coalition forces. The purpose of this excavation was to provide material to build a road to allow the passage of cars through to newly constructed residential areas and to enable the passage of heavy vehicles transporting equipment and foodstuffs.

h) An eighth excavation, measuring some 600 square metres, took place to the south of Koura. Once again, this excavation also contained fragments of ancient pottery.

i) A ninth excavation, on the eastern side of the Koura, with a length of 100m, was carried out to provide earth to make 'Hesco'[1] barriers. This required the removal of parts of the archaeological mounds located at the side of the road. This is clear from the presence of fragments of ancient earthenware in the 'Hesco' containers.

j) A tenth excavation, some 30m in length, was situated to the south of the southern palace. The excavated earth was used as a barrier after it had been mixed with sand brought from outside Babel.

k) An eleventh excavation, measuring 3 x 2 x 3m, took place to the east of the temple of Ishtar, the goddess of fertility, love, and war near the watch tower.

l) A twelfth excavation, some 50m long, was situated to the north of the 'Babylonian house'; once again here parts of the archaeological mounds were removed.

m) A thirteenth excavation, some 180m long, was situated in the northern section of the helipad.

n) A fourteenth excavation, measuring 12 x 13 x 1–2m, was situated to the east of the Babylonian house and west of the Greek theatre. Fragments of ancient pottery were evident until the excavation reached walls built with sun dried bricks which could be clearly seen at the position where the digging was stopped.

SCRAPING AND LEVELLING

Part of the damage caused by the Coalition forces in Babel was the scraping and levelling of archaeologically sensitive areas and mounds and the covering of the flattened areas with sand and gravel. Such activity encompassed vast areas of Babel and necessitated the use of heavy machinery for compacting the earth, which results in the destruction of every artefact buried within it.

a) Before the 2003 invasion there was a small, unpaved, car park to the south of the theatre and the Babylonian house. The Coalition forces enlarged the car park to an area of 2075 square metres, levelled the larger area and covered it with sand and gravel. The new larger car park was encircled with 'Hesco' barriers and used to park heavy trucks and heavy equipment. Finally a new road was built to join this car park to the new developments in the temple area of the city. It should be remembered that this area of the city has not been excavated and is situated within the boundaries of the ancient city centre. In addition to the expansion of this car park a second area, measuring 2000 square metres, was levelled and covered with gravel to be used as another car park.

b) Levelling and covering with gravel and sand were carried out around the Babylonian house and the Museum of Hammurabi in the area which was the headquarters of the American construction and security company KBR. This section of the city, especially the area to the south-east of the Babylonian house, was used for parking military equipment of all shapes and sizes in addition to accommodation caravans across an area of 1000 square metres. Finally, on the western side of the Babylonian house, an area contiguous with archaeological excavations, carried out in 1999, was levelled and rolled flat for use. Ancient pottery fragments are spread across the surface of this area.

c) The region situated to the north of the Babylonian house was used by the Coalition forces as a helipad. An old car park was enlarged. The area that was levelled and rolled, with the exclusion of the old park, was 30,000 square metres.

d) From the south of the asphalted street to the north of the Babylonian house, some archaeological mounds were flattened and the area levelled and spread with large gravel and used as living quarters.

e) The area situated to the north of the Presidential Palace, situated on the north-western side of the north-eastern side of the city, was levelled and spread with large gravel (an area of 70 x 80m).

f) The area to the south of the archaeological city near the Jumjumah gate was also subject to levelling, covering with gravel and being turned into a helipad and as a space for accommodation caravans.

g) The area to the south of the temple of Nin-Makh was covered with sand and used as a dwelling area and car park. The area, estimated at the time at about 3300 square metres, was encircled with barbed wire.

h) To the north of the first helipad a road, 130m long and 8–10m wide, was built which leads to the control tower north of the helipad and to one of the mounds of the region. A further area, measuring 1300 square metres, was levelled and covered with

gravel and bounded with concrete blocks. In addition two other stretches of road, 400m and 300m respectively, were constructed.

EARTH BARRIERS

Coalition forces built earth barriers at the northern and south-eastern entrances to the city, and in various places inside the city. These barriers took two different forms: the first being piles of excavated earth heaped up in long barriers and the second being constructed of so-called 'Hesco' bags which are material containers 1.5m high and 1.10m wide.

BARRIERS OF EXCAVATED EARTH

To the north-east of the theatre there are three earth barriers, of 30m, 29m, and 21m respectively, forming parallel lines. The earth excavated from ditch number one forms one of these blockades.

To the east of the theatre there is an earth barrier 35m long which contains ancient earthenware fragments. It can be seen to the right of the road leading to the centre of the city and was built from earth from the land next to the road. To the west of the Greek theatre there is an area surrounded by earth barriers divided into seven parts in the form of squares, designed for storing fuel. The earth of these barriers contains ancient earthenware and ceramic fragments, upon some of which are cuneiform inscriptions, which indicate that the earth is originally from Babylon itself. The movement of this earth makes it, and the area to which it has been moved, archaeologically contaminated and effectively useless. The area covers 1200 square metres and to the south a further area of approximately 1300 square metres was covered with gravel, on which the traces of heavy equipment wheels are apparent. To the north-west of the Presidential Palace, there are barriers, with a total length of 138m, most of which contain ancient ceramics with inscriptions in cuneiform and carrying the stamp of the seal of Nebuchadnezzar II.

'HESCO' BARRIERS

All along Jumjumah Street, inside the boundaries of the city of Babel, there are barriers formed by 'Hesco' bags filled with earth from within the city containing fragments of ancient pottery. These run on the left side of the road for 380m and on the right side for 250m. All along both sides of the northern entrance of the city to the north of the Presidential Palace for a length of 200m there are 'Hesco' bags filled with earth. Some of these contain earthenware and ceramic fragments.

BARBED WIRE AND IRON PEGS

When setting up the camp, Coalition forces protected its boundaries with a barbed wire fence held in position by iron pegs. These iron pegs have damaged the archaeological remains into which they have been driven and have, in all probability, damaged below ground archaeology.

Concrete blocks

Concrete blocks of different shapes and sizes, but all providing a different type of barrier, were distributed at key points across the city and at its gates.

Direct damages to ancient buildings

a) The Ishtar Gate: The Ishtar Gate is considered one of the most important and prominent ancient buildings in the city and can be regarded as one of the famous monuments from antiquity. The gate has been damaged by the removal of nine of the animal bodies which adorned it and which represent the mythical dragon emblem of the god Mardoukh, god of the city of Babel.

b) Procession Street. This is the main street of the city. The street took its name from the religious processions that moved along it between the Esagila temple (the temple of the head of the gods) and the Bet-Akitu (the house of religious celebrations). The southern part of the street was uncovered during excavations carried out in 1979. Extensive damage has occurred in the street. In the temple of Nabushakhari the imprints of the wheels of heavy equipment are apparent; the passage of heavy transport has caused the street's paving to break up in a number of places; and three rows of concrete blocks have been placed directly on the ancient paving undoubtedly damaging the surface below. The placing of concrete blocks weighing approximately 2 tons each in the middle of the street is, in itself, a transgression, not to mention the method of their transportation to the spot by means of heavy transporters. This led us to insist that, in order to avoid further damage to the street, they were removed by helicopter when the Coalition forces were decommissioning the camp in late November 2004.

Finally a row of 'Hesco' bags filled with earth from the eastern wall of the holy region was placed, together with barbed wire fixed with iron pegs, in the middle of the street. A ditch was also dug into the eastern wall itself, 2.5m long, 1.5m high and 50cm deep.

INDIRECT DAMAGE

Ancient buildings

Most of the ancient buildings were subject to extensive indirect damage. The present state of these buildings, with cracks, splits and fissures in their walls, is primarily the result of the presence of the Coalition forces in Babylon, which isolated these buildings from the normal planned maintenance work and prevented us from performing such maintenance as previously took place on an annual (and/or 'as necessary') basis.

Modern buildings

The modern buildings on site were also badly damaged during or after the war. These comprise the Presidential Palace and its associated buildings; other buildings in the city such as restaurants around the lake to the north of the theatre; the buildings in the 'parasol' area; the Babel Project offices; the administration offices; and the museums. We

were unable to assess the full level of damage in 2003 because of the commandeering of the site by Coalition forces, which made use of these buildings after establishing their camp in the city. In 2007 only the shells of these buildings exist and most are without doors, windows, or electricity.

NOTES

1. 'HESCO Container is a prefabricated, multi-cellular system, made of galvanized coated steel welded mesh and lined with non-woven polypropylene geotextile. It is delivered flat-packed on standard timber skids or pallets. Units can be extended and joined using the provided joining pins and filled with available material using minimal manpower and commonly available equipment. HESCO Containers can be installed in various configurations to provide effective and economical structures tailored to the specific threat and level of protection required. It is used extensively in the protection of personnel, vehicles, equipment and facilities in military, peacekeeping, humanitarian and civilian operations.' Quoted from the Hesco company website http://www.hesco.com/enter.html accessed 6 October 2007.

The Damage Sustained to the Ancient City of Ur

Abdulamir Hamdani

IMPORTANCE AND GLOBAL VALUE

The Sumerian City of Ur is considered by many to hold a central position in the development of human history, playing a crucial role in consolidating the emergence and components of civilisation resulting from the interaction between nature and humankind. Ur is mentioned in the Old Testament and was almost certainly known to the prophet Abraham. Arab historians and geographers also refer to it as Qamrinah (city of the Moon), and Thi-Qar, a reference to the extensive use of tar in its buildings (Fig 1).

The results of Leonard Woolley's excavations consolidated Ur's claim to fame by demonstrating the grandeur of Sumerian achievements in the field of construction, examples of which can be seen in the ziggurat and the building of temples and palaces, as well as the standard attained in sculpture and ceramic manufacture, and also the clay tablets which show the degree of progress and development of Sumerian thought in literature, science, astrology and mathematics.

Ur was considered a regional religious centre, where important gods such as Nannar (god of the moon), Anu (god of the heavens), En-ki (god of earth) and the goddess Nin-Gal (wife of Nannar) were worshipped. It was in the early period of occupation, c 4000 BC that the early Sumerians established the principles of irrigation, developed agriculture and made use of metals, particularly copper. Later, in the second, or pre-dynastic or flood period, that of Jamdat-Nasr c 2900 BC, achievements included the emergence of writing, and a heightened understanding of architecture. After a period of decline, the final period of Ur's history was the dynastic period (2800–2400 BC) which started with the first Dynasty of Ur which ruled for 177 years, with five kings, the most famous of whom was Miss-Ani-Padda.

The second Ur Dynasty ruled for 108 years and saw the reign of four kings. Ur regained its position among the cities of the region with the rise of the third Ur Dynasty (2113–2006 BC), under the leadership of its founder Ur-Nammu (2113–2096 BC), who is famous for strengthening Ur as a regional power. Four kings succeeded him; his son Shulgi (2096–2048 BC), his son Amar-Sin (2047–2039 BC), his brother Shu-Sin

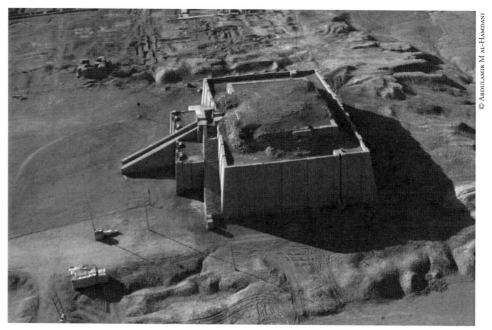

FIG 1: AERIAL PHOTO OF UR ZIGGURAT AND TEMPLES QUARTER

(2038–2030 BC) and his son Abbi-Sin (2029–2006 BC). This is considered the golden age in which Ur reached the height of its splendour in every aspect of art and technology – such as the architectural developments of the arch and vault (which are evident in the temple of E-Dub-lal-makh– and the Royal tomb of King Shulgi) as well as in sculpture, gold work, marquetry and the production of intricately designed cylindrical seals. The Sumerian language was considered the language of governance and literature. Its authority spread to include southern and middle Iraq, the country of Elam and the shores of the Arab Gulf. Finally the city fell into the hands of the Elamites who took Abbi-Sin, last king of the third dynasty, as a prisoner to Elam. This ended the regional influence of Ur.

THE ARCHAEOLOGICAL REMAINS

The city of Ur is situated 380km south-east of Baghdad near the main highway linking Kuwait, Iraq and Jordan. It has several notable landmarks, amongst which is a three-floor decorated ziggurat built by King Ur-Nammu and completed by his son Shulgi for the worship of god Nannar (Sin), god of the moon. At present, two floors remain at a height of 17.25m. There are also several temples scattered across the site, the largest of which, measuring 95 x 50m, is the Gig-Par-Ku temple which dates back to King Amarsen. The E-Dub-Lal-Makh is another temple which holds above one of its doors the oldest example of a brick-built arch in Mesopotamia. Other temples at the city of Ur built during the third dynasty are the Temple of E-En-Ki and the Temple of E-Nun-Makh. The latter was dedicated to the worship of the god Nannar during the Assyrian period.

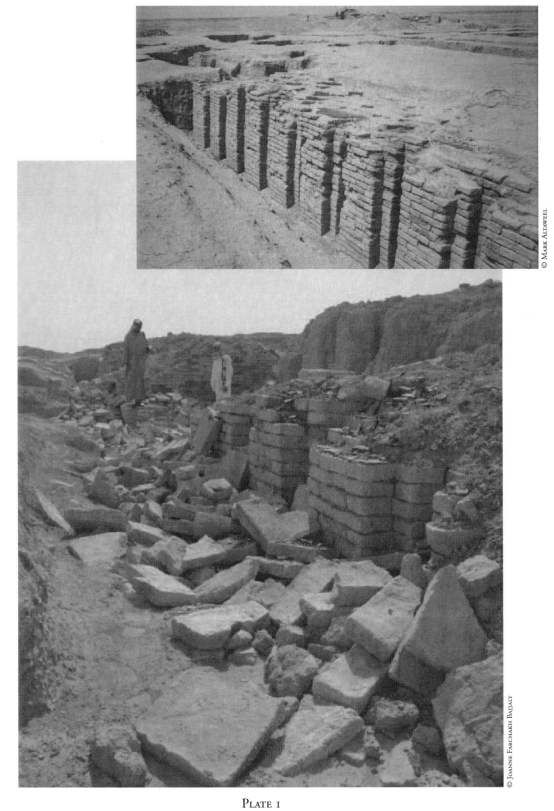

© MARK ALTAWEEL

© JOANNE FARCHAKH BAJJALY

PLATE 1

The after picture of the façade of the Shara Temple at Umma, with looters in the background, May 2003.
Inset: Façade of Ur III Shara Temple at Umma as exposed by Iraqi archaeologists, 2001

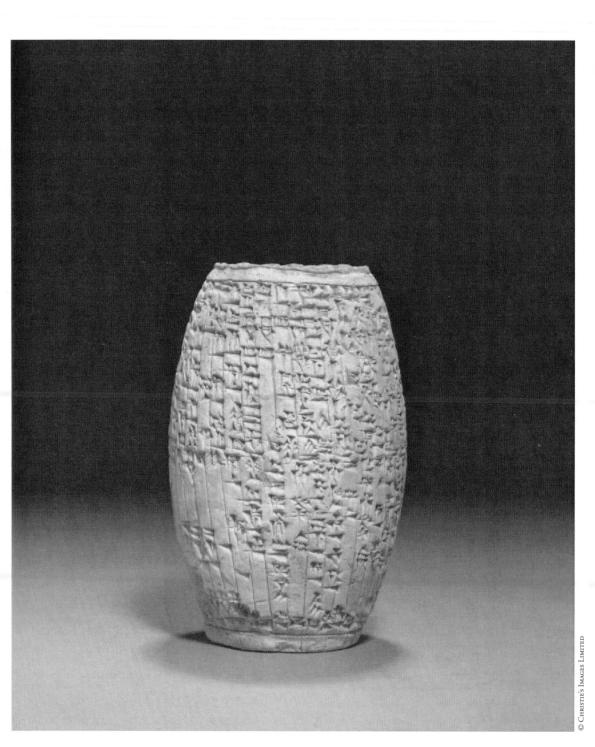

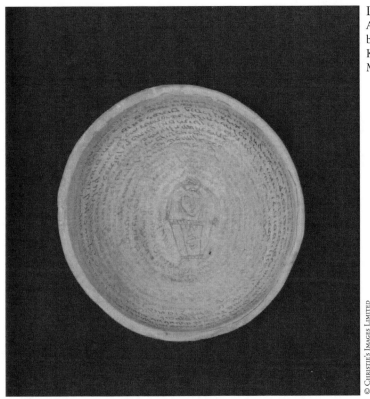

LEFT: PLATE 3
Aramaic pottery incantation bowl. Christie's South Kensington, Antiquities, 13 May 2003, page 29, lot 43

OPPOSITE: PLATE 2
An old Babylonian terracotta cuneiform barrel. Christie's New York Antiquites Sale, 8 June 2001, Reign of Sîn-Iddinam, 1849–1843 BC. The hollow barrel biconical in form with a flat base, encircled with an inscription that reads, 'I am Sîn-Iddinam, mighty man, provider for Ur, King of Larsa, King of Sumer and Akkad, the king who built the Ebabbar – the temple of Utu, and who restored the ordinances of the temples of the gods. When An, Enlil, Nanna and Utu granted me a pleasant reign of justice whose days were long, by my wide-ranging wisdom which was brought to perfection and which excels, in order to provide clean water for my city and country, to extol my ways, and to glorify publicly my heroism for time to come, I prayed intently to An and Enlil. When they had accepted my firm petition, they commissioned me with their unchanging word to dredge the Tigris and restore it, thereby making a name for myself for many days to come. Then at the command of An and Inanna by the good work of Enlil and Ninlil. with the help of my god Ishkur, and by the exalted strength of Nanna and Utu, I magnificently dredged the Tigris, the well-supplied river of Utu, in my great achievement. I directed its flow to the border, the line I had chosen, and regularized its might to the swamp, thus supplying uninterrupted water, an increasing source of prosperity for Larsa and for my country. After I had dredged the Tigris, the great river, the wages of a man were: 1 gur of barley, 2 sila of bread, 4 sila of beer, 2 shekels of oil; this is what they received each day. I let no man have either less or more. With the labor of my land I finished that task. By the command and decision of the Great Gods I restored the Tigris, the broad river, and established by name for far off distant days.'
5¾ in. (14.6 cm) high

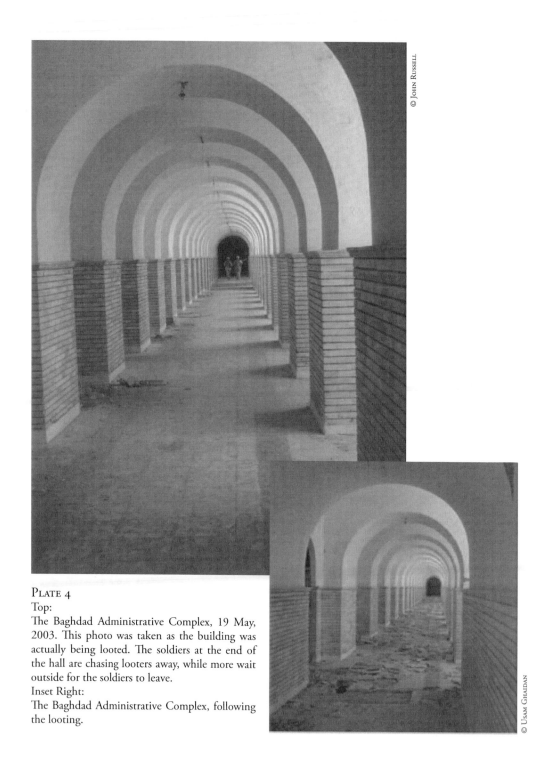

PLATE 4

Top:

The Baghdad Administrative Complex, 19 May, 2003. This photo was taken as the building was actually being looted. The soldiers at the end of the hall are chasing looters away, while more wait outside for the soldiers to leave.

Inset Right:

The Baghdad Administrative Complex, following the looting.

Plate 5: Destruction in the Public Library, Basrah

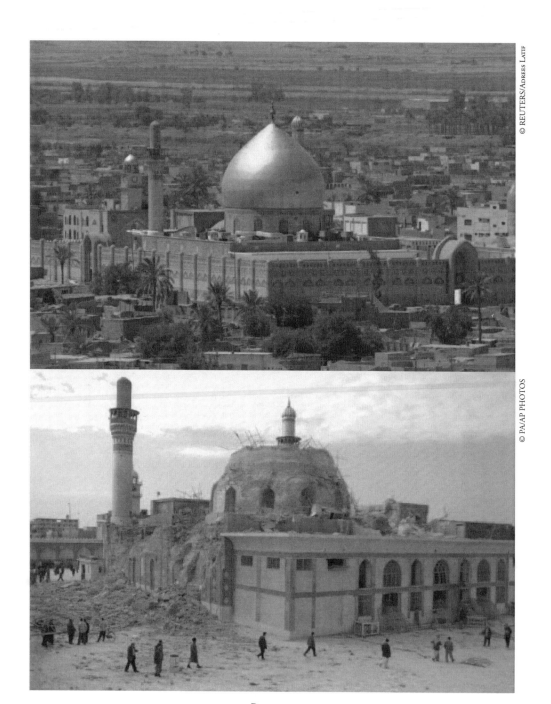

PLATE 6
Al-Askari Mosque in Samarra before and after attack

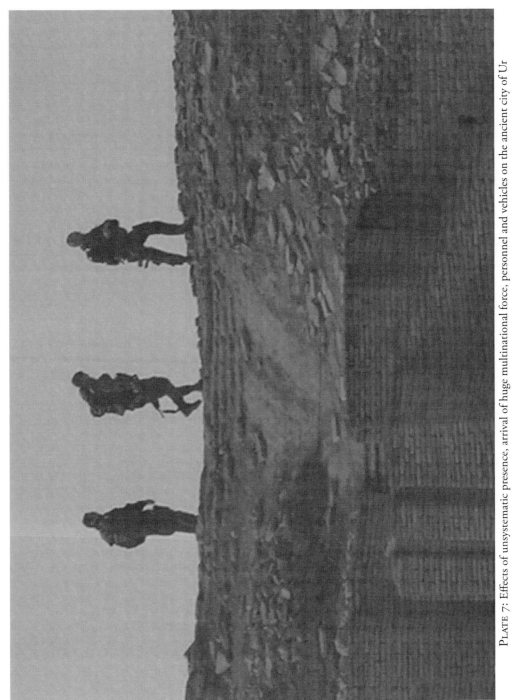

PLATE 7: Effects of unsystematic presence, arrival of huge multinational force, personnel and vehicles on the ancient city of Ur

PLATE 8

Top: View of reconstructed Nebuchadnezzar palace with military vehicles and installations to the right, in the heart of the inner city

Bottom: Troops walking near ancient walls, area of Ishtar Gate, Babylon

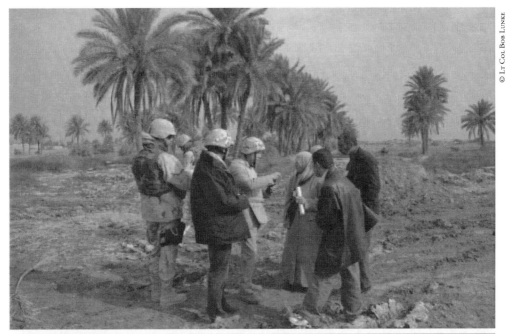

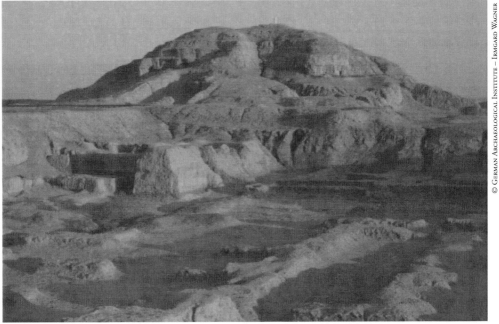

PLATE 9
Top: Part of the Babylon audit team at the site (December 2004)
Bottom: Uruk-Warka. The Eanna ziggurat, sanctuary of Ishtar/Inanna,
built by Urnammu (22nd century BC)

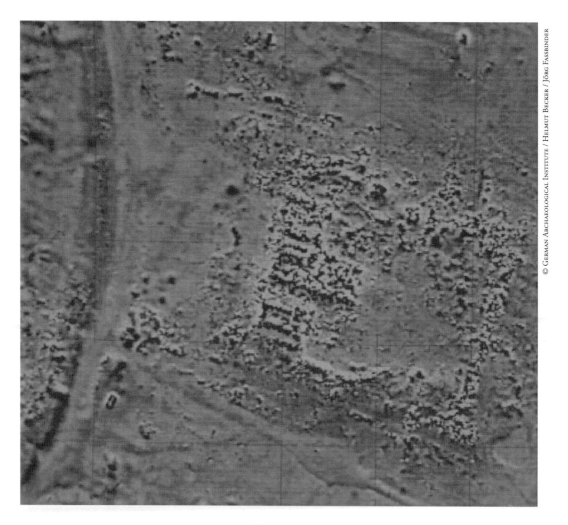

PLATE 10
Uruk-Warka. Magnetogram of the south-western area of the city

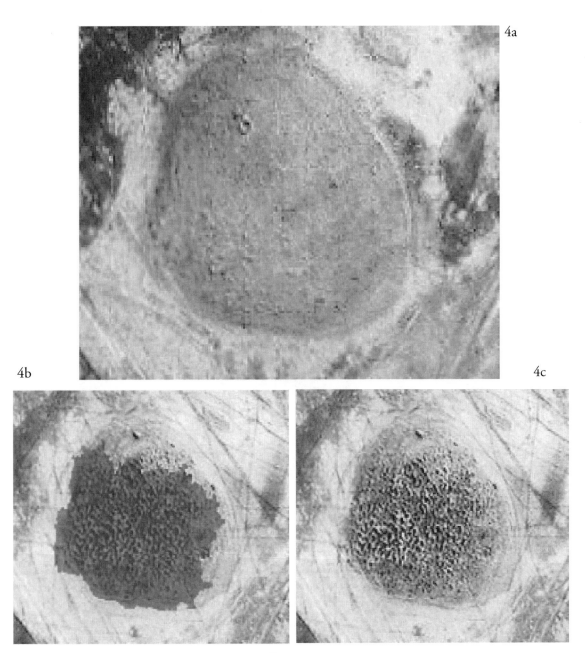

4a

4b

4c

PLATE 11
Archaeological site in 2001 (fig .4a) and in 2005 (fig .4b and .4c) with the individual looting sites and the detected looted area.

Photo: European Space Imaging, EUSI Munich / German Archaeological Institute – Orient Department / German Aerospace Center, DLR-DFD

Oberpfaffenhofen / Definiens AG Munich / Helmut Becker / Jörg Fassbinder

B.R.I.L.A.
Bureau for Recovering and Investigating Iraqi Looted Antiquities

Scheda reperto

CLASSE	Terracotta
N. INVENTARIO.	75083
OGGETTO	Lamp
MUSEO	Basra
DATA - PERIODO	Parthian
MISURE (H,W,L)	14 x 14,3 cm
MATERIALI -TECNICHE	Terracotta
STATO DI CONSERVAZIONE	Complete
DESCRIZIONE	Lamp in a shape of bearded man (Sylen as handle) wearing a mantle, with seven spouts (two lateral); on circular base.
PROVENIENZA	Seleucia
ANNO SPEDIZIONE	1971 Centro Ricerche Archeologiche e Scavi di Torino
RIFERIMENTI	

IMMAGINE - DISEGNO im_075083.jpg

INVEN.	IM 075083 - excav. N 791 S8		DATA	March 2001

PLATE 12

Example of a page from the Centro Ricerche Archeologiche e Scavi di Torino/BRILA website

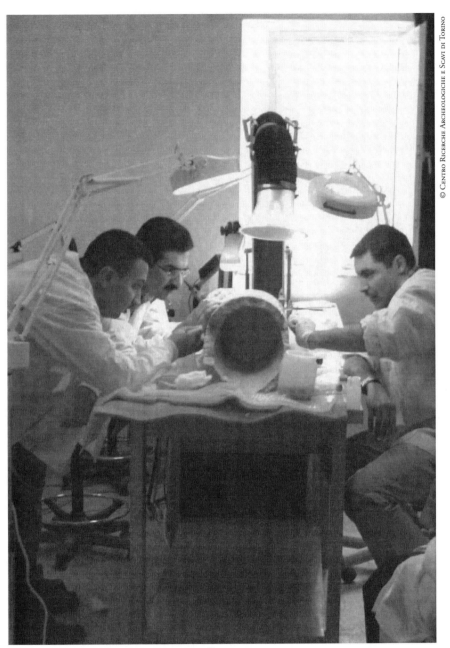

PLATE 13
Iraqi restorers at work in the new restoration lab

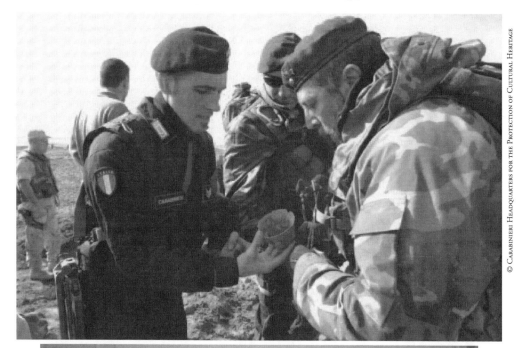

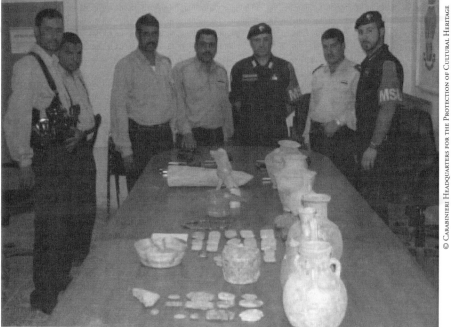

Plate 14

Top: Carabinieri TPC (Tutela Patrimonio Culturale) officer by the looted site of Tel Lam, showing a pot to an officer of the Italian Army

Bottom: Objects recovered together with Iraqi police in Al Fajr, following raids conducted in the area

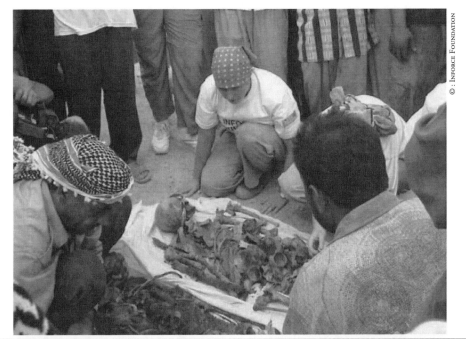

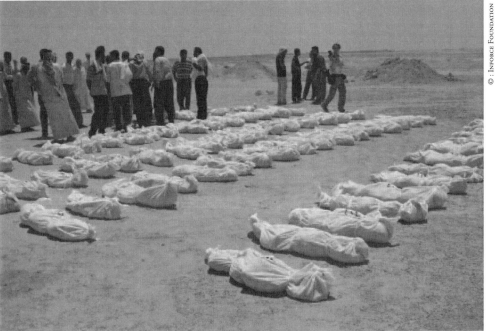

PLATE 15
Top: Inforce anthropologists working with members of a local community in Iraq in 2003 to help to ensure that all remains were recovered and examined
Bottom: Scenes following exhumation by a local community in Iraq in 2003. These scenes show a systematic and respectful approach to the work taken by the community. Examination of some of the remains by us demonstrated co-mingling and incomplete recovery

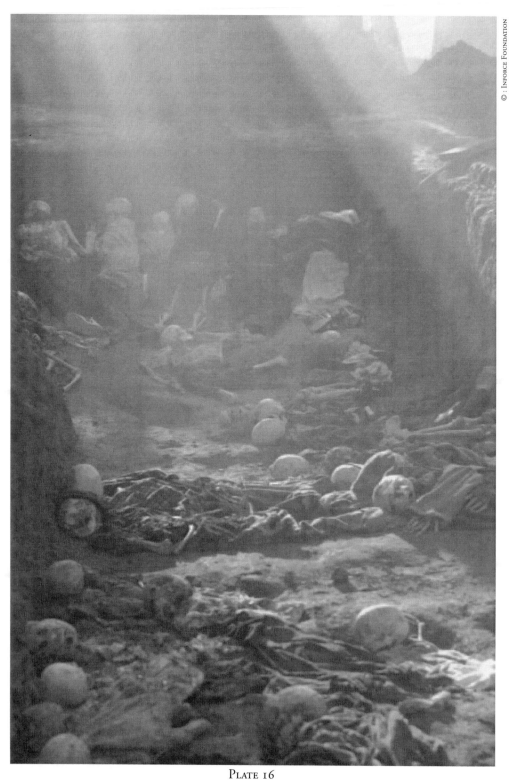

PLATE 16

A simulated mass grave located and excavated by Iraqi forensic archaeologists and scene of crime officers in Dorset, UK (2005) as a component of a capacity building programme

In addition to temples, the city of Ur contains royal palaces, such as the Palace of Shulgi E-Kur-Sag and the Palace of Nabunaid. Ur also has the royal burial site in which the tombs of the two kings Shulgi and Amar-Sen have been uncovered.

Dwellings from the period of Isin-Larsa and the Babylonian period are another significant feature found in Ur. Evidence of a unique Mesopotamian urban design is notable in the arrangement of these dwellings separated by alleyways that lead to a central point. Babylonian dwellings were built using tiles while the foundations of the Isin-Larsa houses were built out of adobe and clay and the upper part out of bricks, tiles and clay.

CONSERVATION OF THE REMAINS

These startling remains have been neglected for the past four decades. The last major maintenance work was carried out in 1961 and the extant ruins are in desperate need of conservation and restoration. This is especially true of the royal tombs which may collapse at any time. Much of this maintenance is required to deal with natural phenomena, such as rainwater run-off and wind. Other problems have been caused by conservation work carried out in the 1920s where, for example, concrete laid by the excavation expedition on top of the walls to protect them from the rain, has exerted pressure on the walls and foundations that has led to the formation of cavities inside the walls which, in turn, have caused them to buckle and tilt (Fig 2). The site is in dire need of a temporary protective roof to mitigate the worst of these problems.

While the Saddam regime neglected the conservation of the archaeological site, a number of intrusive asphalt roads were built in and around the ancient city. These appear to have been constructed for political reasons – for example a road that led to a building controversially attributed to the prophet Abraham, that was built for a Papal visit that never took place.

FIG 2: DAMAGE DUE TO UNSCIENTIFIC MAINTENANCE, AND USING EXTRANEOUS MATERIAL IN MAINTENANCE SUCH AS CEMENT, GRAVEL, AND MODERN BRICKS

© ABDULAMIR M AL-HAMDANI

THE IMPACT OF THE MILITARY

Significant damage has occurred at Ur over the last few decades as a result of military activity. The first major problem has been caused by the establishment, under the Saddam regime, of a military air base with army barracks and the deployment of military units in the vicinity of the archaeological site. The air base, still in use by Coalition forces, is approximately 3km south west of Ur, where, for the last three decades, the continuous activity of military fighters, helicopters and freight aircraft whose activities and noise produce vibrations, have caused fissions and cracking in the walls and roofs of the archaeological remains.

Such damage has occurred in the walls of the ziggurat, in the remaining parts of its third floor, and in the E-Dub-lal-makh temple nearby, as well as in the walls and roofs of the royal tomb. Saddam's Iraqi army had constructed its military barracks from bricks and roofed them with reinforced concrete, inside and around the archaeological city where it deployed a battalion for anti-aircraft air defence at a distance of only 400m to the north-east of the ziggurat in places not previously excavated.

The city became an area for military training in which was built a garage and a workshop for the repair of tyres and military equipment. In addition to the above, another vast building was constructed to store chemicals, with a room for chemical decontamination. Heavy and medium armour such as cannons, anti-aircraft batteries, radar units, Russian SAM missiles and self-propelled missiles were deployed around the ziggurat and in the vicinity of the Temple quarter, in order to attack the US/UK Alliance's aircraft during their raids and sorties in the period between 1991 and 2003. The city was damaged in February 1991 during a night-time air raid by American planes in response to one of them being hit by Iraqi anti-aircraft fire. The damage from this incident can still be seen on the southern side of the ziggurat, on the middle staircase, and on the two side towers. The American fire also hit and damaged the Temple quarter and the royal palace.

Since 2003, the presence of the multinational Coalition forces (American, Italian, Romanian and others) deployed in both the former Iraqi bases and newly constructed bases near the archaeological remains has caused further damage. Coalition troops frequently visit the archaeological remains without any restraint and their presence, driving heavy military vehicles across the site and wearing heavy boots as they trespass on the buildings, has actually changed parts of the landscape and has, almost certainly, destroyed or damaged yet unexcavated artefacts and buildings – usually, lest we forget, made only of baked or unbaked clay, and still buried under the soil (see Plate 7).

Damage can be seen on the ziggurat stairs and on the remains of its third floor, as well as on the stairs of the royal tomb and some of its walls made from tiles or clay blocks. In addition, American forces continued the construction of significant new facilities between the archaeological remains of the city and Daqdaqa Hill, which being only 1500m to its south is practically a part of it, and which may have been the old river bed of the Euphrates. The remains of this part of the old city and its immediate environs have

been lost forever as the construction of inspection points, road blocks and watch towers has damaged and changed the land irretrievably.

It should also be noted that the presence of Coalition forces leaves the airbase open to constant exposure of attack by mortar shells, which are usually fired from the northern side of the archaeological city. This undoubtedly causes further damage. In many instances, these shells stray or may have a shorter range than expected and fall in the proximity or actually inside the archaeological city or near the houses of the guards employed to protect the site. For example, on 1 September 2006, when I was at the site collecting information for this chapter, the site was hit by several shells, two of which fell between the ziggurat and the site guard's house.

The presence of military units, whatever their nationality, and their associated buildings in the vicinity of, or actually within, archaeological sites impacts negatively on these sites and is not commensurate with the sites' status as educational cultural sites that ought to be protected, respected and cared for. Such care is precisely what the military does not deliver, as its agenda simply does not cater for such considerations. If military aims and objectives, during and after wars, fail to take into consideration the protection of archaeological sites, then the military will ignore and sacrifice the latter with nonchalance and without a second thought.

In addition, the deployment of military units near to and within archaeological sites deprives the local population, and those with a specialist interest in the archaeology of the area, of the chance to visit, view and work with the culture of past ages. Such military presence also makes it impossible to excavate at the site or to engage with the preservation or restoration of the sites, let alone denying the opportunity to develop the sites as tourist venues. Under these circumstances, given the significant military deployment in the area, it could be understandable that UNESCO's World Heritage Committee hesitate to inscribe Ur on the World Heritage List.

Recent events of 2007

The bombardment on the Tallil air base, located behind the ziggurat at Ur, by armed groups, has intensified from about one attack per month to one per week, and the number of mortar shells launched every attack has increased from two to six. Some of these mortar shells hit the ancient city, as happened in January 2007, when shelling damaged an excavated area within the site, 100m south east of the ziggurat, affecting an area of around 50m^2, in the area surrounding the temples. There are fears that shelling will hit the royal cemetery – already in a precarious state and close to collapse due to natural phenomena and the lack of protective conservation – which is very susceptible to damage because of its fragile nature.

There is now an official and popular campaign in place, calling for Coalition forces to be redeployed away from the archaeologically sensitive areas of the Ur site, to facilitate the arrival of archaeological and other specialist staff to provide the desperately needed archaeological and architectural conservation required.

Inside the CPA

John Russell

For nine months, from 20 September 2003 until 20 June 2004, I was the Coalition Provisional Authority (CPA) Deputy Senior Adviser, and eventually Senior Adviser, to the Iraqi Ministry of Culture. Working with the Senior Adviser, Ambassador Mario Bondioli Osio, in coordination with Iraqi Minister of Culture Mufeed al-Jazairi, my principal efforts were focused on renovating the Iraq Museum, organising and equipping a guard force to protect archaeological sites from looters, preventing archaeological sites from being damaged by Coalition forces and reconstruction projects, securing a new building for the Iraq National Library and Archives, and preserving the waterlogged Iraq National Archives. While there, I kept a daily journal of my activities. The following excerpts, edited slightly for continuity, give some sense of what it was like to work for the CPA.

Saturday, 27 September, 2003

This has to be one of the most bizarre places on earth, but I'm getting accustomed to it so quickly that I should probably try to say why it's unusual. Our office is in Saddam's main palace, which has been completely taken over by the CPA. There's a big rotunda in the centre where Ambassador Bremer has his office, the dining room is in a huge banquet room, and other offices and ministries are spread out everywhere else. The office of the Senior Adviser for Culture is on the ground floor in a small wing that projects north-west from the south-west corner of the palace. It's in what I take to be one of the guest bedrooms, with a similar room next door and a bathroom in between, directly accessible from both rooms. All the rooms are ornate, with wood and stone door frames, stone paved floors, elaborate ceiling mouldings, painted or inlaid coloured patterns on the ceilings, and elaborate chandeliers. We've furnished it with some tables with computers and some nice upholstered chairs and a sofa. The office can be quiet or bustling during the day, depending on who's out, but in the evening it's all mine if I want it.

The CPA is billed as a civilian administration, but it is largely soldiers. Our office seems to have two senior civilians (the Senior Adviser and me), plus a couple of Italians I haven't met yet, and at least seven civil affairs soldiers, who work on a variety of culture-related projects, and drive and provide security when we go out. Most of them have been here since April or May, and will be here a full year. They are not free to leave Iraq at any

time as I am. When you walk around the building, four out of five people are soldiers, I'd say, so of course there are guns everywhere. I'm living in a trailer in what used to be an open area just north of the palace. The trailers are basic but comfortable, provided with powerful air conditioning, a communal bathroom with plenty of hot water, and two 2-person bedrooms with beds, metal wardrobes, and bedside table. The food, which is provided by KBR, is good, but a bit unimaginative, like eating diner food every meal. The people who have been here a while say it's much better than it was. They say the same thing about the office, which is air conditioned now, but apparently wasn't earlier in the summer.

MONDAY, 27 OCTOBER, 2003

Today there were six successful car bombings in Baghdad – the Red Cross, three police stations, the Oil Ministry, and the Mineral Resources Ministry – and two unsuccessful ones, one of which was at the new Baghdad Police Station. According to the *NY Times*, Iraq's police chief and deputy interior minister, Ahmad Ibrahim, said at a news conference that 34 people had been killed and 224 had been wounded in the attacks. He said 26 of the dead were civilians and 8 were police officers; 65 police officers and 159 civilians were wounded.'

Up until today, whenever I heard an explosion, my first thought was sonic boom, or backfire, or thunder. I first thought yesterday morning's rocket attack on the Rashid Hotel was thunder, but yesterday evening when I heard three more mortar rounds fall somewhere not too far away, I knew they were explosions. (I'm told we're out of the effective range of mortars here in the palace, though I'm prepared for surprises.) This morning we had three bombs in an hour, and each time I worry about what that one means. The car bomb at the Red Cross at 8:35 this morning shook our windows and people across the hall ran out into the hall and lay on the floor. I must confess that for me, the bombing of the Red Cross using an ambulance reaches a new low in the annals of terrorism. I can't think of parallels, though my knowledge isn't wide. I hope the Iraqis are able to get the message that this sort of thing isn't the Coalition's fault, nor is it the fault of foreign terrorists – they need to confront and root out the lingering terror in their own midst.

SUNDAY, 16 NOVEMBER, 2003

Fall is really here. It is quite cool in the early morning – I saw my breath today – and warms up to around 70° F [21° C] or so during the day. This morning I went to the Museum with Major Cori Wegener, the Minneapolis Institute of Arts curator, to discuss progress on the renovation work. The contracting officer from the State Department is arriving on Wednesday to start writing contracts for the museum renovation, and our US$ 700,000 in State Department reconstruction funds is on its way as well, so it's important to get these project plans finalised. I continued working on the Photoshop plan of the Museum this evening. I was so absorbed in this that I missed hearing the alerts for two separate rocket attacks, and so worked through them while everyone else

was going back and forth to the basement. Anyway, this is a very solid building and by the time you hear the first blast the best course is to head for the windowless bathroom a few paces away, not walk past dozens of windows on the way to the basement steps, which are a couple of hundred yards away.

THURSDAY, 27 NOVEMBER, 2003, THANKSGIVING

This is my second Thanksgiving in Iraq – the first one was in 1981 at Nippur. I slept rather late, until 7 or so, then got up and mopped up all the water on the floor around my bed and closet (it poured very hard around 6am, and the leak in my trailer roof continues and has even expanded to a small drip directly above my bedside table). It was rainy and grey all day again. At 10am, I went to the Thanksgiving Day Service in the tent that is now being used as the chapel, ever since the chapel in the palace was turned into a dorm with 150 beds. It was a very good service. The homily was that to avoid anxiety, you 'fake it till you make it,' that is, act the way you want to be until you become that way. There was a testimony time near the end and people said what they were thankful for. Many said family, friends, and phone and e-mail to bring them closer to loved ones when they're far away. One person, a civilian, said she was thankful for the army, and another civilian said he was thankful to be here. That last one took me by surprise – I realised I'm very thankful to be here too.

SUNDAY, 14 DECEMBER, 2003

In the afternoon I went out to BIAP [Baghdad International Airport] to meet the Iraq National Symphony, returning from their very successful concert in Washington, DC. At about 2pm, while I was waiting, we received the news of Saddam's capture. When the symphony's planes landed and they learned the news, they began cheering. There was lots of celebratory gunfire all evening, and we were warned to stay in the palace and wear our protective gear if we had to go out. I worked late and headed home to my trailer about midnight. The gunfire had pretty well subsided, but I wore my armour and helmet just in case. I walked into my trailer and turned on the light, and noticed that something had changed since this morning. Next to the head of my bed is the bottom half of a plastic water bottle placed under one of the leaks in my trailer roof. That container, which had been upright this morning when I left, was now overturned onto its side and there was an AK-47 bullet in it. Looking up, I saw a new hole in my roof where it had come through, landing in the water bottle. That's the second fallen AK round I've picked up, but the first to be delivered right to my home. A couple of us were speculating that much of the 'celebratory' fire must have been directed toward the Green Zone. I decided to sleep in my armour, the second time I've done that. I also tried to sleep in my helmet, but that doesn't work. Nothing further came through the roof.

THURSDAY, 8 JANUARY, 2004

Nahla, our translator, was killed today by an IED (improvised explosive device) targeted at our convoy, while I was on holiday leave in the USA. They were leaving the Ministry of

Culture when the bomb was set off, sending a piece of shrapnel into the back of her head, killing her almost instantly. She was dead by the time they got to the hospital. Apparently no-one else was hurt. I can't remember how much I've written before about Nahla. She was a wonderful young woman, drop-dead beautiful, very smart, and full of hope for the future of Iraq, exactly the sort of citizen the new Iraq desperately needs. I counted her as a close friend almost from the moment I got here. On one Friday soon after I arrived, she was the only other person in the office early in the morning, so we started talking about her perception of what the Iraqis thought of us Americans. She divided the Iraqis into three groups: those who really like us, those who want us to succeed and leave as soon as possible after that, and those who do not like us at all and want us to fail. She said the last group was small and did not represent the aspirations of Iraqis generally.

Nahla was definitely in the first group – she even defiantly wore a small American flag pin on her necklace. She told me that she liked the Americans because they gave her opportunities that she was denied under Saddam. Although her English was perfect, under Saddam she was not allowed to have a job as an interpreter because she was not a party supporter. Not only was she an excellent interpreter, but she was naturally trusted by everyone who encountered her. She often was the last one to leave the ministry, having been asked by the minister or someone else to stay behind to solve some problem. She was very religious, trusting God and following Muslim customs rigorously. She always wore a head scarf, so that we joked that she didn't have ears or hair, but as far as I could tell, she was without flaw.

THURSDAY, 15 JANUARY, 2004

Today was our helicopter reconnaissance trip of archaeological sites in the south. We flew in a pair of Blackhawks, and I sat by the open door and wore the headset linked to the pilot. He had programmed the sites I wanted to see into the navigation computer and told me as we approached each one. We flew to Babylon to refuel, and then flew over one site after another – Mashkan-Shapir, Nippur, Drehem, Isin, and Fara. Mashkan-Shapir, where Elizabeth Stone and Paul Zimansky worked before the 1991 war, is absolutely obliterated, as are Isin and Fara. At Isin we saw several fairly expensive cars parked and about 50 looters hard at work on what remains of the site. This is the site I first learned was being looted in mid-May 2003, when I was in Baghdad with UNESCO. In late May, a *NY Times* reporter visited Isin and reported dozens of looters at work, a story that made the front page. A month later, [journalist] Micah Garen, who was with us today, visited the site with some Marines and found the same thing going on. He said he thought surely something would have been done about the problem by now.

THURSDAY, 19 FEBRUARY, 2004

At 5pm I went to the Convention Palace for the first public concert by the Iraq National Symphony Orchestra since their concert in Washington in December. This concert was the first with their new Steinway grand piano, donated by Steinway, and with all new brass and woodwind instruments, donated by Yamaha. One of the first events I attended

upon my arrival here in September was a concert by this group for Assistant Secretary of State Patricia Harrison, who was here to arrange the Washington tour, among other things. The group was pretty pathetic then, playing dilapidated instruments and out of practice. Tonight they played brilliantly. The piano was showcased by Beethoven's First Piano Concerto, played with precision and brilliant sound quality by pianist Natasha Al-Rhadi. I spoke with Hisham Sharaf, the orchestra manager, before the concert, and he said that Al-Rhadi had played often with the orchestra over the years, and always complained about the quality of the pianos they had. Tonight, I said, she wouldn't have that excuse, and she rose fully to the occasion. The final piece, Grieg's *Hall of the Mountain King*, was especially successful at showing off the new wind instruments, which the ensemble played almost flawlessly. The orchestra had played this same piece in September, sounding like a mediocre high school band. Tonight it was played as well, and with as much enthusiasm, as I've ever heard it played by anyone. Everyone loved it, and they played that movement again as an encore, even better than the previous time. I hurried up afterward to Hisham and told him how excited and impressed I was by the orchestra, and he embraced me and absolutely beamed. I felt like I was witnessing a phoenix rising from the ashes. If this group could improve so much in five months and develop this much professionalism and obvious confidence, I think there's a lot of reason for optimism about the new Iraq.

WEDNESDAY, 17 MARCH, 2004

There's been a lot of bickering about who has the authority to write the State Department contract to purchase trucks in Kuwait for the archaeological site protection guard force. Late this evening a message came in from a DC contracting officer saying that we should send the money back to Washington, which would take weeks, and start all over. I lost my temper and replied to all the recipients: 'I'm sure this will be counterproductive and brand me as unreasonable, but this is one of the most frustrating exchanges I've encountered since I've been here, and that's saying a lot. We're trying to respond to an emergency here under very difficult conditions (turn on your TVs) and rather than the remotest hint of assistance, all I get are explanations of why nobody is able to do anything. Our donor told me he wanted his funds to make a difference in Iraq, and that's where they're needed – are there any emergency provisions that would allow the money to do what it's supposed to do rather than endlessly travelling around the globe looking for someone with the ability to spend it? A lot depends on the arrival of these trucks, and more and more of our archaeological heritage is being destroyed by looters while we debate how to get them here.' (We finally received 20 trucks in early June 2004.)

THURSDAY, 8 APRIL, 2004

The Green Zone was hit with two rockets at 4pm, shaking the windows in our office. There was another explosion or two not so close later in the evening. We've been warned to stay in for the next few days because of the religious processions. I really need to get to the ministry and meet with the minister, and had scheduled a meeting for Saturday morning, but after debating it all afternoon I decided to cancel until after the current

2

holiday is over. It's Arbaeen (Forty), the holiday 40 days after Ashura, and millions of Shia pilgrims are expected to march to Najaf and Kerbala to mark the end of the period of mourning for Imam Hussein. Once again, this is one of those holiday activities that was restricted under Saddam, so they have the hated American infidels to thank for the fact that they can do it freely this year. They're thanking us by joining al-Sadr's army to drive us out. We've all been watching the evolving security situation closely, but it's difficult to assess. I'm pretty sure most Iraqis don't want the chaos and repression that would result from military rule by Sunni or Shia extremists – they've already seen what that is like for the last 24 years. The problem is the same one we've had from the beginning, namely that the majority is intimidated by the minority into staying quiet or pretending support, hoping just to be left alone.

TUESDAY, 4 MAY, 2004

Our ministry transitioned to sovereignty today. In one sense this is the culmination of all my work here with the ministry, but don't ask me what it means in practical terms – probably not a great deal in terms of the sort of assistance we provide day-to-day. Ambassador Bremer was there – he, the minister, and I spoke briefly. We had been under considerable pressure from Bremer to transition, as he rightly wanted to be able to show that Iraqis were making progress towards self-determination, and Culture is one of those soft ministries that are not critical to the functioning of the country. Despite reservations I had expressed frequently about the ability of the ministry's bureaucracy to function effectively (a problem with all the Iraqi ministries), I had finally decided that this was less important than having a vision that was being implemented, and I believe the minister has that.

SATURDAY, 22 MAY, 2004

This morning United States Marshals from the Ministry of Justice arrived at the new National Library building to take it over. This caused much confusion, including threats from the library guards to the marshals and vice versa, which was resolved after the fact when the CPA property office gave me the Termination of Authority letter. I think the property office deliberately delayed giving the letter to us so the Ministry of Justice takeover would have the element of surprise. The leader of the marshals came by in the afternoon to complain about having our library guards' guns pointed at him, but he didn't get any sympathy from us. I told him the guards were doing their jobs. This attitude irritated him, but I'm tired of United States forces thinking they can walk over Iraqi security forces for any reason. We eventually parted amicably, but without apologies on either side.

THURSDAY, 10 JUNE, 2004

At 5pm Zainab [Bahrani – my successor] and I met Micah Garen and Marie-Hélène Carleton, at the Green Zone Café, which I've never been to. It looks like a diner and was a great place for beer and snacks. They are filming a documentary on archaeological issues in Iraq today. They're a very nice couple and we had a good chat, including talking about

what they are trying to do with their documentary. Micah said that since the problems facing antiquities in Iraq are insurmountable at present, what they were really interested in documenting were the people who fight to solve the problems against impossible odds, instead of doing nothing. I was really touched by that, as more and more, I realise we're not winning here, no matter how hard we try. This brought back a small thing that bothered me a few days ago, without being able to put my finger on why at the time. In a message to DC about other things, I noted 'I'm having trouble letting go'. The reply was: 'I think you need a ceremony (press event, party, whatever ...) so you can officially declare victory and go home.' It was a nice sentiment, but didn't seem right. Now I know why. The right thing to do is declare defeat and exhaustion, and be grateful I had the opportunity to be part of the fight.

The Battle for Babylon

Zainab Bahrani

Colonialism is not satisfied with merely holding a people in its grip and emptying the native's brain of all form and content. By a kind of perverted logic, it turns to the past of the oppressed people, and distorts, disfigures, and destroys it. (Fanon 1963, 210)

It has been more than two years since I left Iraq. The last time I was there was in 2004 when I spent several months as an advisor to the former Iraqi Minister of Culture. At that time, the Coalition Provisional Authority (CPA) had handed 'full authority' of the ministry back to Iraq and to the State Board of Antiquities and Heritage (SBAH), but the truth was that this was merely a charade. As soon as I left, I was bombarded by requests for interviews from various international newspapers and popular journals. Yet only two or three of the journalists who contacted me wanted to know anything about the condition of archaeological sites, museums or cultural heritage in Iraq. The others wanted to do a personal profile, complete with portrait photo. They seemed mostly interested in my education (was it Western or Iraqi?), ethnicity (are you Kurd or Arab?) and religious background (are you Shiite or Sunni?). I contacted some prominent newspapers in the USA and in Britain in an attempt to give them my first hand account of the damage to monuments, libraries and historical sites, but only *The Guardian* expressed any interest in this issue ('Days of Plunder' *The Guardian*, August 31 2004). In the end, I gave interviews only to those who would allow me to speak about the damage I had observed at Babylon, the occupation of other heritage sites, and the general destruction that has occurred under the occupation. Now, yet again, rather than being asked to write an essay on the destruction of history, I am asked to write an essay on my experience as an archaeologist in the line of fire and frankly, I feel that I have nothing to say on the matter. I could write a theoretical paper on the implications of war for the hypothetical universal archaeologist or scholar working on cultural monuments or institutions; I could write on the question of military archaeologists in war based on my personal observations over four months (I am not in favour), but I have had no inclination so far to write on the subject of what it meant for me personally to live and work in Iraq in the days of the so-called transfer of authority from the CPA to the Iraqi Government.

It is not acceptable practice for an academic writing in a scholarly volume to take a stance on war, but for me writing about this issue was a political act from the start. In April of 2003, when the news of the looting of the Iraq Museum broke, I sat down and wrote an article for *The Nation* in which I laid the blame on the Bush Administration, pointing out that what had happened under their command was in opposition to both the Hague Convention and the principles of the Geneva Convention (Bahrani 2003). As a result I, like anyone who opposed the war at that time, was branded as anti-American by the press in the USA and the UK, as if any criticism of the actions of the Bush Administration meant that one must hate democracy, Hollywood cinema, apple pie or rhythm and blues. Little did I know when I wrote on the morning after the looting that the destruction of the museums and libraries in 2003 would be only the tip of the iceberg of an immense historical annihilation that was to come, the processes which I would have the unfortunate privilege of seeing for myself in 2004.

Inside Iraq in the summer of 2004, it had all seemed like a fiasco. The dividing line between the newly designated 'Green Zone' and 'Red Zone' was in the process of being made more emphatic by the erection of a series of massive concrete blocks like those that form the wall between Israel and the Palestinian territory. The Green Zone was in the process of becoming a fortification of foreign rule in the very heart of the city of Baghdad. The hostility and aggression of the Coalition forces toward the local population of Iraq was becoming increasingly violent. On the streets one could see the abusive behaviour of soldiers and mercenaries, as if the entire population were prisoners of war in an extensive detention camp. This is the experience I can attest to because I merged as a local and experienced for myself what other Iraqis went through simply by walking on the street or approaching a checkpoint. I usually went around Baghdad in a local car, or flagged the

FIG 1. IMAGE OF HELICOPTER LANDING OVER BULLDOZED REMAINS AND CONSTRUCTION AREA

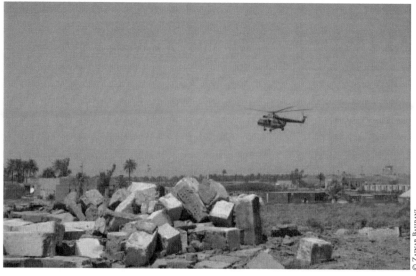

occasional taxi, and sometimes, I walked over the streets in the so-called Red Zone (all of Iraq outside US bases) on foot and so I have had the unpleasant experience of armed US soldiers at a checkpoint aiming directly for my head, with that 'shoot first, ask questions later' look on their faces, on more than one occasion. One is completely helpless in that situation. Yet the idea that I should write an essay on myself as 'an archaeologist in the line of fire' (as requested here) seems ludicrous to me given the horrors of that time and even more so in the face of the current massacres and destruction that have become the day-to-day existence of the average Iraqi. Archaeology and libraries have received some attention by various NGOs and government ministries, more so than the civilian death count or the contaminated drinking water or the hospitals full of dying children.

Since the first news of the looting of the Iraq Museum broke in the press, there has been a barrage of reports, of sound-bites from self-styled experts on Iraq's history or cultural heritage, reports from journalists who sat in the Rashid or Palestine Hotels in Baghdad while their Iraqi employees went out on the streets, reports of Coalition government representatives who minimise the effects of the damage or shift the blame to the previous regime, and reports of representatives from various governments, each claiming to have done the most, or making a pledge to do the most, for the rescue of cultural heritage in Iraq while they remain silent about the civilian deaths that the US government refuses to count as if they were not those of sentient beings. Living in Iraq itself, one saw precious few of the projects that have been announced as the valiant rescue of Iraq's heritage. These are mostly paper promises. Worse yet, some of the projects and funding agencies appear to be geared more for the benefit of European and North American consumption rather than being of much use to heritage in Iraq itself. In a country taken over by violence one can expect no more.

In reality, only a handful of scholars or cultural preservationists made the dangerous journey into Iraq in the first years after the fall of Baghdad, and even fewer have spent more than a few days there, or attempted to venture outside the Green Zone without a convoy of armoured SUVs, flak jackets, helmets and the now proverbial South African body guard. After the United Nations building collapsed in a 2003 bombing, the UN pulled out of Iraq and other NGOs followed suit, stating that it was simply too dangerous for their employees to remain. A number of institutions began working on projects to reconstruct the museums and libraries or to train Iraqi scholars from the safety of the distance provided by Amman, London or New York. In addition, some of the accounts that I have read on cultural heritage issues in Iraq are more in the genre of sensationalising narratives that set out to portray the western protagonist as an heroic figure and give either little or no credit to the Iraqi archaeologists and scholars who have been doing all the work inside Iraq. As a result of some of these accounts, one might say that the destruction of cultural heritage in Iraq becomes salvaged into a narrative of rescue and reconstruction where in fact there is nothing but catastrophic loss. This appropriation of the very narrative of the events, of the historical account of what has happened to historical sites and cultural institutions and who has been working to rescue and preserve these is a facet that I could not foresee in March and April of 2003. Cultural heritage is a pawn in this game of war in more ways than one.

In 2003 I went to Iraq with two colleagues, Elizabeth Stone and Paul Zimansky, driving the long road from Amman to Baghdad. This trip was a personal rather than a professional journey, even if it was aimed at providing equipment and assistance to the Iraq Museum. In the same way, returning to Iraq alone in 2004 was a decision taken out of personal anguish. I felt compelled to act in the face of the unceasing destruction of the cultural heritage of my own country, its ancient civilisations, its magnificent golden domed and turquoise mosques, its cruciform and box-like churches like ancient reliquaries, its remarkable tradition of early bold and linear modernist arts and architecture, its libraries filled with scrolls and codices, and its centuries and millennia of historical archives. It was only after I had gone and returned that I ever thought of danger, and even then it was only because others, outside Iraq, became rather vocal in pointing it out to me. It is only now that I can see that I acted without being consciously aware of any potential dangers or consequences, let alone caring about them so I did not see or experience my time there as an act of bravery.

In academia, the general stance has been that notions of cultural heritage and history, the relation of people to monuments, well, that is not to be universalised like the human subject, whose rights we fight for; that attitudes to history are culturally constructed, which is perhaps an obvious point. But furthermore, the currently favoured view in archaeology is that this kind of a relation of people to the past is a Western one, and as such it is part of a Western order that we impose on others. My own scholarly view diverges from these current positions and the Iraq war has only made this clearer to me. The appropriation of the notion of historical consciousness for the West, currently favoured by certain camps in the discipline of archaeology, is simply a continuation of past colonial attitudes under a new liberal guise. The historical accounts of antiquity make clear that the relationship of people to monuments, to natural and constructed landscapes, and to historical narrative itself is a very ancient one, certainly as old as the Early Dynastic Mesopotamian cities of the 3rd millennium BC.

In my view, having lived in the midst of this war and seen its violence on a daily basis, the horror of war is not the horror of body counts alone. Wars and occupation cause damage to the living that cannot be quantified. One of the forms of violence that Iraqis continue to endure is the destruction of their rich history. Psychologically, the loss of history can and does have a devastating effect on people. That is why such destruction is calculated into the strategies of war and is discussed quite openly as an aspect of military strategy known as a 'psy-op'. This is why iconoclasm and destruction and relocation of monuments have occurred as deliberate acts of war throughout recorded world history, why ethnic cleansing works through the annihilation of people by means of eradicating any trace of their past. This is why international legal conventions were written in opposition to such acts, especially after World War II.

In 2004 I had been Senior Advisor to the former Minister of Culture, Mufeed al Jazairi, a member of the communist party who had opposed the Saddam regime. Being opposed to the war, I was reluctant to go, but I had naïvely hoped that the ministry would become independent of the occupation authority. It soon became clear me that the US

forces held authority over use of land and public buildings, including heritage sites. In a number of publications I have attempted to explain how the occupation, demolition and construction of ancient sites and historical urban centres have become instruments of war. A case in point is Babylon, occupied as a US military base in the summer of 2003. By way of conclusion I will explain why, for me, the occupation of Babylon is emblematic of the entire US war and occupation of Iraq. It is perhaps for that reason that I focused all my energies, in 2004, on the removal of the military base from this archaeological site (see Plate 8).

In late 2006, Colonel John Coleman, speaking to the BBC, insisted that anything the military had done at Babylon was carried out in close consultation with the SBAH (BBC News 2006). He explained that before setting up camp, they (the US command) had 'made an analysis' and had come to the conclusion that it would be best for the site, because it would protect it from looters. In fact, during the dozens of meetings that I had with US officers on the matter of Babylon, in 2004, there was no-one who could answer the question of who it was that had taken the decision to occupy Babylon, or why. There was no-one who had any information about a decision, a plan or a strategy. Later, after we had exposed the story through the press, the idea of 'protection' emerged. This excuse of 'protection' is now being invoked in various contexts across occupied Iraq. In fact, the damage done to Babylon is both extensive and irreparable, and even if US forces had wanted to protect it, placing guards around the site would have been far more sensible than bulldozing it and setting up the largest Coalition military headquarters in the region.

The idea that the military occupation of Babylon was for its own protection simply beggars belief. The USA did nothing to guard any heritage site, museum or monument in the country in April of 2003. In fact, while the air strikes left historical monuments undamaged, the occupation has resulted in a tremendous destruction of history, well beyond the museums and libraries looted and destroyed at the fall of Baghdad. While Babylon is the most famous site that was occupied as a military base, it is certainly not the only one. At least seven or eight historical sites have been used in this way by US and Coalition forces since April 2003, one of them being the historical heart of Samarra, where the Askari shrine built by Nasr al Din Shah was bombed in 2006.

The use of heritage sites as military bases is a breach of the Hague Convention and Protocol of 1954, chapter 1, article 5 of which covers periods of occupation. While the United States has not ratified the Convention, a number of the Coalition countries (Italy, Poland, Australia, the Netherlands) and Iraq are contracting parties. Since 'sovereignty' was returned to Iraq on the first of July 2004, the United States has been in the country at the invitation of the Iraqi government, and may be subject to the Hague Convention as well as to the Iraqi Antiquities and Heritage law, which forbids any construction or use of a heritage site without prior permission of the SBAH. But across the country, the US and Coalition forces disregarded Iraqi antiquities and heritage laws, and the pleas of both the SBAH and international archaeologists and historians.

In 2004, I was a witness to much of this disregard of antiquities laws. During that time, my Iraqi colleague Dr Mariam Moussa and I made the preliminary archaeological assessment of damage to Babylon that became the basis of the SBAH report. We surveyed the damage at the site and documented it over several months, so that the continuing construction by KBR (the American contractors that provide all logistical services for the military) and the Coalition command can be seen in our archive of dated photographs http://www.guardian.co.uk/comment/story/0,,1293931,00.html. The observations that Mariam Moussa and I had made at Babylon were later corroborated by John Curtis, who went to Babylon for a three day inspection in December of the same year (and see Curtis, chapter 20) http://www.thebritishmuseum.ac.uk/news/babylon.html; http://www.guardian.co.uk/Iraq/Story/0,2763,1391042,00.html.

If Babylon had been occupied for its own good, the military commanders would certainly have listened to the repeated requests that Mariam Moussa and I personally made that they stop construction and put an immediate end to helicopter flights. But for 18 months, they dug their heels in and refused. I recall the surreal situation of standing in front of the commander of the base and being told that no damage had been done, while behind his head one could see a crane or a bulldozer working away into the Babylonian temple precinct. It reminded me of the PR methods of the former Iraqi minister of information, al Sahhaf, who while Baghdad was burning in March and April of 2003 continued to claim that there were no US troops anywhere near the city. This method was nicely summed up by Groucho Marx when he asked, 'who are you going to believe, me or your own eyes?'

It was only after a long and arduous campaign, that the US and Coalition commanders agreed to work on a schedule for the removal of the base known as Camp Alpha or 'the Ruins' in military jargon. 'The Ruins' was no small base. It was the South Central Headquarters of the Multi-National Forces. We had made numerous complaints and Mariam Moussa wrote letters to the commanders stating in no uncertain terms that she refused permission for any kind of construction, the use of helicopters, or the use of the site as a military base. The officers we spoke to consistently stated that the site was needed for military reasons. For me, the battle for Babylon is a metaphor for the occupation of Iraq. The idea that the USA took Babylon for its own protection is perhaps similar to the idea that the USA invaded Iraq to bring it freedom. If you believe in the second statement, you are likely to believe the first.

Bibliography

Bahrani, Z, 2003 Looting and Conquest, *The Nation*, May 14, [online] available at http://www.thenation. com/doc/20030526/bahrani [24 October 2007]

Bahrani, Z, 2004 Days of Plunder, *The Guardian*, August 31, [online] available at http://www.guardian. co.uk/comment/story/0,,1293931,00.html [24 October 2007]

BBC News, 2006 *US Marines offer Babylon apology*, [online] available at http://news.bbc.co.uk/1/hi/world/ middle_east/4908940.stm [24 October 2007]

Fanon, F, 1963 *The Wretched of the Earth*, Grove Press, New York (Reprint edition 2005)

Embedded Archaeology: An Exercise in Self-Reflection

RENÉ TEIJGELER

A year and a half has passed since I boarded a Dutch military plane to return to the Netherlands following a seven month tour in Baghdad. Since that day I have shared my experiences with many and compared them to conservation activity actions undertaken during other armed conflicts (Teijgeler 2005 and 2006). It is clear that much can be done to protect heritage in times of conflict *before* the hostilities begin (the *pre-conflict phase*), and that possibly more can be done after the hostilities cease (the *post-conflict phase*), but that during the fighting (the *peri-conflict phase*), the possibilities of preventing damage are very limited. In this peri-conflict phase it is usually the staff of the heritage institution itself who, often risking their lives, try to do their utmost to save whatever possible. In a violent situation practically all non-government organisations (NGOs) and international organisations (IOs) will have left the country. This is particularly the case in the repeatedly recurrent intra-state conflicts where traditionally neutral humanitarian aid organisations are not spared the assaults of the warring parties (Nanda 1993). The developments in Iraq during the operation Iraqi Freedom are no exception to that rule. The Canal Hotel bombings in 2003, the United Nations (UN) headquarters in Iraq since 1991, led to the withdrawal of some 600 UN international staff from Baghdad, along with employees of other aid agencies. The need to protect cultural heritage, however, only increases as the armed conflict continues. In spite of the relevant international conventions, combatants hardly seem able to protect the cultural heritage and again Iraq is no exception. Under these circumstances, ie the mere absence of NGOs and IOs as well as the increasing need for protection, I came to the conclusion that a civil-military cultural affairs officer could make a difference. When I held the position of senior advisor for the Ministry of Culture at the Iraqi Reconstruction Management Office (IRMO) at the US embassy I wanted to believe that I prevented the Coalition forces from causing further harm to Iraq's heritage and indeed I was successful on a few occasions. Nevertheless, ever since my return, I have begun to question the notion that my presence in Iraq did make a difference. I kept wondering if my so-called success in Iraq was as effective as I thought it to be and I wondered if I could have done more from the *outside* than on the *inside*? In reconsidering my position, I began to compare myself with 'embedded journalists', a term first used during the 2003 invasion of Iraq.

EMBEDDED ARCHAEOLOGY

The idea of comparing 'embedded journalism' with my position in Iraq came to me after reading a very thorough study that examined the impact of embedded versus non-embedded news coverage during the US invasion and occupation of Iraq (Haigh *et al.* 2006). The results show that the embedded reporters were significantly more positive toward the military, and conveyed greater trust in them, than non-embedded reporters. This made me wonder. The questions raised about the 'embeds' could perhaps be held true for my position. Was I too sympathetic to the American side of the war and did I become part of a system that Danny Schlechter has called 'weapons of mass deception' (Schlechter 2003)?

An embedded reporter is defined as a media representative remaining with a unit on an extended basis (Secretary of Defense [SECDEF], 2003). The program director, Victoria Clarke, defined the process as 'living, eating, moving in combat with the unit that [the journalist is] attached to' (Department of Defense [DoD] News Transcript 2003). The embedded journalists went where and when the military command dictated. To what extent did my position in Baghdad correspond to that of an embedded reporter?

In one sense I was also attached to a unit. My unit was the US embassy and in particular IRMO. Several of my IRMO colleagues were, like me, officers or former officers. For lodging, food, protection and transportation I was dependent on the embassy and consequently subject to their rules. Of course, as an officer I did not need a period of boot camp-style training before being allowed into the combat zone, as some of the embedded journalists had to undergo. As the embedded journalist, my employment was on a fully voluntary basis.[1] At the beginning of my tour in July 2004 the main hostilities were still outside the Green Zone.[2] Gradually the fighting reached the Green Zone and even the embassy itself. Especially during Ramadan that year, October 14–November 14, the embassy building itself was bombarded daily. In the same period the Green Zone café and the Haji market were bombed.[3] After nightly attacks were reported embassy personnel were not allowed to leave the premises after dark.

Of course, there are many differences. But still, the comparison between the position of a senior adviser for the Ministry of Culture at the US embassy and a reporter embedded in the military might have some validity. As one of my major tasks turned out to be the protection of Iraq's archaeology, it can be argued that I was possibly an 'embedded archaeologist' during the operation Iraqi Freedom.

SOCIAL PENETRATION THEORY

The Haigh study (2006) offers an explanation of the impact of the embedding of journalists on news coverage of US military operations. It cites the Social Penetration Theory developed by Taylor and Altman in 1975. It explains 'the range of interpersonal behaviours that occur in growing interpersonal relationships … can be quantified in terms of amount of information exchange (breadth), intimacy level of information exchange (depth), and amount of time spent talking' (Taylor and Altman 1975, quoted in Haigh *et*

al. 2006, 143). Taylor and Altman distinguish four stages of relationships:

– the orientation phase, ie getting to know each other

– the exploratory affective exchange, ie partners reveal more details about aspects of their personalities that they guarded earlier

– the affective exchange phase, ie interaction at outer layers of personality is open, and there is heightened activity at intermediate layers of personality

– the stable exchange phase, ie continuous openness, as well as richness across all layers of personality.

Taylor and Altman explain that close contact with another makes self-disclosure more constant and this leads to more affection. Others (Soeters 2000; Meyerson *et al.* 1995; Wheelus and Grotz 1977) found that these stages are accelerated when military units engage in combat operations and when uncertainty levels are high and the circumstances are dangerous, such as in times of war. In these circumstances, accelerated trust bonds are formed. This 'swift trust' bond can alter a person's judgment.

The process described in Social Penetration Theory was not exactly unfamiliar to me. That 'embeddedness' will lead to the development of interpersonal relations and in the end will bias the end result of the professional is a phenomenon that is also recognised in ethnographical research as one of the pitfalls of fieldwork. In the terminology of an ethnographer, the event is described as 'going native' (see Ashcroft 1998). The anthropologist's sexual orientation and gender, as well as their age, class, race, ethnicity, nationality, and other aspects of their personality and individuality are of course relevant in their experiences in the field. When an ethnographer 'goes native' he gets too submerged in the cultural entity under study. He forgets to keep his distance and is bound to take sides, which will undeniably affect his data and bias his results. That is why I always kept a certain distance to the subjects in my ethnographic research. It can be questioned, however, if I could maintain that attitude in a non-ethnographic situation. Today this 'positivistic' view is much in debate, especially by humanistic anthropology – an anthropology that is lived and written in a personal voice (see Behar 1997).

Despite my experiences in field work was I, as an 'embedded archaeologist', one of the professionals who became 'imbedded' instead of 'embedded'? How dependent was I?

LIVING CONDITIONS

My office was in the embassy building and I was living, eating and sleeping on the embassy premises. It was all pre-arranged and I had no control over these arrangements. Usually I took my meals in the cafeteria and sometimes I was joined by my colleagues. While the conversations were very friendly, we never saw much of each other afterwards. Sometimes I had a drink with colleagues or I would attend a party at the back of the embassy. This 'socialising' was part of the job too, as during the meals and drinks I gathered valuable information and made many useful contacts. In the beginning I shared a trailer with an Iraqi-American colleague but we had very little in common. As my regular working hours

were from early in the morning until late in the evening, my trailer was just a place to get some sleep. After I was attacked in my trailer by a drunken bodyguard, I managed to get transferred to a trailer of my own.

Inside the Green Zone I drove around in my own armoured car but for my travels outside the zone I was subject to the strict transportation security rules of the embassy. For every trip, I had to apply for a convoy and that hampered my work tremendously as there was a constant shortage of security vehicles. Still, it was for my own protection. It didn't take long before I took up my Iraqi friends' offer to pick me up at one of the gates surrounding the Green Zone. Driving around Baghdad in a US military convoy was not risk-free. The convoys were often hit by roadside bombs and on more than one occasion they even became lost and we drove around Baghdad without arriving at our destination. However, when my colleague, the senior adviser for the Ministry of Education was killed[4] because he was travelling without guards, I changed my methods of transportation and complied with the embassy security rules. Also, many trips I planned such as those to Najaf, Samarra and al-Hatra were cancelled for security or political reasons. That was very frustrating. Then once again the convoy to al-Hatra that I was to join was attacked. Travelling with either military or private guards, I learned to appreciate the dangers they were exposed to more than ever. Nevertheless, we had many heated discussions: for example, once, whilst on our way to an appointment in the city, one of my bodyguards threatened a young Iraqi boy selling newspapers at a traffic light which led to an argument between me and my bodyguard.

Did my living conditions influence my judgment? I associated with many people at the embassy on a daily basis and did gain better insight into some of their activities. Yet, our casual relations never went beyond a professional basis. From the perspective of Social Penetration Theory, my daily contacts were in the orientation phase.

IRMO COLLEAGUES

Unlike my colleagues from other countries, I received no instructions from the Dutch military command or from the Dutch government regarding how to fulfil my duties. I had no agenda whatsoever, I was my own boss and the only person I had to answer to was Ambassador Bill Taylor, the Director of IRMO, with whom I had very good relations. He never interfered with my job. As a senior member of the embassy staff and an officer I could move around freely.

During the two weeks of briefing which every Dutch soldier underwent before leaving for Iraq, we attended a number of classes on how to survive a war mentally. We learned about the signs of Post Trauma Stress Syndrome (PTSS) and the importance of the 'buddy-system' to relieve the pressure that is inherent to the job. The theory was: first find a buddy you feel comfortable with and watch over each other's mental well-being. In one colleague, a retired colonel from the US marines, I found a good friend and we spent a great deal of our limited spare time together and while we did not agree on much personally we got along fine. The violent death of our education colleague came as a shock to us all and intensified our bond. In spring 2006 my buddy passed through Amsterdam.

After a couple of days spent reminiscing, it was clear that our relationship as friends could only thrive under the exceptional circumstances of an armed conflict.

At one particular time I had regular contact with a colleague from the Ministry of Sports. I copied a programme of his that was very successful. For almost one thousand employees attached to the ministry, he organised classes in computer literacy, English, management, book-keeping and so forth at the American University in Beirut. I hoped that from his experience we could learn a lot, for the development of the Culture Ministry. Unfortunately, the programme never materialised due to political problems and lack of funds. After that, the regular contact with this colleague disappeared. For a short time I had more personal contact with four other co-workers at IRMO. We were united in our criticism of the Iraqi Freedom campaign and appreciated each other's company as there were so few of us with this political view. These relationships only lasted for two or three months when these colleagues returned home. I met some of them again at the end of November 2005 in the USA but, as with my buddy, our relationships proved to work only under the extreme pressures of the Green Zone.

Apart from daily early morning meetings, I did not see much of my other IRMO colleagues. Most of them considered me an oddity, being much too independent, liberal and engaged in a very minor task. In terms of Social Penetration Theory I did not have any effective exchanges with them. With my retired colonel buddy and my critical co-workers I did establish good contact in breadth and depth, ie the amount of information exchange and the intimacy level of exchange was extensive. With the exception of my buddy friend, however, we did not spend much time together, simply because we did not find the time. According to Taylor and Altman, the relationship with my retired colonel friend was one of 'affective exchange', and with my four co-workers the 'affective exchange' never exceeded the 'exploratory phase'.

Other embassy staff

Fortunately not all staff lacked appreciation of my work. The Embassy Counsellor for Public Affairs and his staff recognised the importance of Iraq's heritage as a symbol for the people and a material culture that was at the heart of their identity. Of course they were acting on a very practical level as well, as any damage to Iraq's monuments and sites was equally harmful to the image of the USA and the Coalition forces. The Public Affairs Office was continually monitoring the news – and the papers were incensed more than once at the incompetence of the US authorities to protect Iraq's heritage. The picture in the *Washington Post* of a sniper on top of the minaret in Samarra cried out for an immediate response on behalf of the embassy. Also the negative press on the military occupation of Babylon was endless. To find out if such allegations could be substantiated, my office was often called in. On a couple of occasions the support of the Public Affairs Office was instrumental in convincing senior staff or the military command to take action. I must admit that I was astonished to see the impact of publicity on policy making.

On one occasion, Public Affairs asked me to join them in an interview with a reporter from the *Christian Science Monitor*. Hesitantly I agreed, in spite of the fact that soon

after the onset of my tour I had decided not to make any public statements. Firstly, this was because making public statements could have serious consequences for my position as a negotiator (I could lose my 'neutrality') and secondly, and perhaps even more crucially, it could endanger my own safety. Nevertheless, in this instance I became a US official quoted in a much-too-positive article on the protection of Iraq's heritage by the Coalition forces (LaFranchi 2004). Looking back I have to confess that my interpersonal relationships with the Public Affairs Office led to bias in that it had an impact on the tone used in the *Christian Science Monitor* story. To reference Taylor and Altman (1975), our relationship was one of 'affective exchange'. My contact with other embassy departments was incidental and was mainly confined to very practical matters; it never was more than an orientation, if that.

THE MILITARY

Some of the senior advisers were military but most were civilians. The job did not require a military background but it certainly did help when in contact with the military. Whilst I was a major in the Dutch army, my position at IRMO was the equivalent of a two-star general. For one that meant that getting a helicopter was not too difficult. Also, I could easily sit in on military meetings and that was certainly an advantage in the case of Babylon as I often travelled to Camp Victory, the Coalition headquarters, to comment on the military planning of the clearance of the base (see Plate 9). I was fully accepted and my views were heard, and I spoke their language. Occasionally I even pulled rank. In the case of the occupation of the Malwiya minaret in Samarra, I used my military rank to put a military liaison officer in a helicopter to fly over the minaret and take pictures. The minaret, dating back to AD 852, was occupied by a US sniper in the autumn of 2004. In January the insurgents shot at the soldiers on top of the tower, causing serious damage. Those pictures finally convinced a general at the embassy and he signed the order to remove the snipers' nest from the minaret. Military convoys also helped me to get UNESCO pick-up trucks from the airport to the museum, to transport some of Saddam's material legacy to the museum and to facilitate the transport of the Ottoman Archive to the National Library.

It was clear to me that my work at the embassy 'should [in principle] not violate operational security', just as embedded press coverage should not (Paul *et al.* 2004). But that my job could be of direct importance to a military operation, I could never have guessed. One night I was sent for by a colonel who explained to me in secret that, the following morning, several units were to conduct a coordinated search of an entire neighbourhood in Baghdad in pursuit of terrorists. In order to coordinate the action from the air he wanted the ministers' permission to use a monument from Saddam's era. We discussed the necessity of the use of this particular building and after making some calls I agreed that there was no real alternative in the surrounding area. I drafted a Memorandum of Agreement that stipulated the maximum time of occupation, the necessity of the local guards' full cooperation, the need to maintain an extremely low profile and full compensation for any damage caused by this intervention, either directly or indirectly.

Very early the next morning, both the minister and the colonel signed the memorandum. The monument was not damaged, the action was successful and the military kept to the agreement. First of all I was glad that the colonel came to me and asked permission. He could have easily just occupied the building and chased everybody out; it would not have been the first time.[5] Besides, he could always have referred to the Hague Convention (1954) in which an exception is made for local commanders to occupy a monument for strategic reasons.[6] Still, I am aware of the fact that this action touched on a very sensitive issue: do we place people over heritage or heritage over people?

The Civil Military Affairs unit was another office I often frequented. The general was a kind man and had a keen interest in history. It was with his help that I finally got to the office of the general commander of the Coalition forces, to sign the final order to move the military base from Babylon. He was also instrumental in getting senior commanders to Babylon to force the Polish commander of Babylon to give up his fight against the moving of the camp. Once in a while a civil affairs officer in the field contacted me to ask for advice. As a rule I referred them to the State Board of Antiquities and Heritage, always pressing them to ask the Iraqi authorities first, whatever they were planning. On one occasion, a civil affairs officer took up the matter of the ammunition depot in al-Hatra with me.[7] That was the beginning of a good relationship. I worked from my end at the embassy and he was the man in the field. We managed to cut the force of the explosions by half and set up a monitoring system on al-Hatra with the help of the University of Mosul.

I always realised that the military were part of the problem in that they were responsible, at least in part, for the destruction of Iraq's heritage. But the way I defined my job was to facilitate my Iraqi colleagues whenever I could, from within the system and with the help of the military. The contacts with the military never exceeded the 'exploratory affective stage'. As I stated earlier, my appreciation for the tough job the military faced grew in our daily contact, yet our contact always stayed professional. However, my growing appreciation may well have influenced my willingness to collaborate in putting a monument at the disposal of the Coalition forces.

Conclusion

Several archaeologists refused to go to Iraq after Iraqi Freedom started in March 2003. For the record I would like it to be known that I do not blame them at all; it was a dangerous exercise and it only grew worse. Of course, others stayed at home because they were totally against the invasion of Iraq. Against my own political views, I chose to go and work from the inside in order to contain, as much as possible, the damage to Iraq's cultural heritage. Also, because I believe that once the NGOs and IOs leave the country, the only possible way of getting things done was and is under the protection of the Coalition forces. But now, 22 months after my return from what I consider the most difficult position I have ever held, it is time to review how independent I was and whether or not 'embedded archaeology' leads to bias.

Notwithstanding my dependency on food, lodging and secure transportation, I was free to do my job in whichever way I pleased. In that sense I was not troubled with any restrictions. Yet, I realise that my agenda was partly set by the enquiries by the Public Affairs Office and, to a lesser extent, by the military. Still, the questions were genuine and within the remit of my job description. It was precisely in those two departments that I reached the limits of sound judgment. In at least two cases it can be argued that close contact with these departments lead to a deeper relationship and that this subsequently influenced my decisions and conclusions.

In time I also learned to appreciate the dangers to which the military and private guards, who protected me outside the Green Zone, were exposed. I realise now that that was probably caused by a 'swift trust' bond. Yet, I cannot find examples of this bond influencing my opinion in other matters concerning them. These short information exchanges were based on humanitarian and utilitarian principles. That also applies for the rest of my interpersonal relationships with most of my colleagues in the embassy. I associated with colleagues in a polite manner and sometimes in the search for additional information.

My surroundings were very sympathetic to the American side of the war but I often took the liberty of disagreeing and never disguised my feelings, not even with my buddy. On the contrary, we had many heated discussions perhaps precisely because of the frequent affective exchange of information. After my mission at the US embassy ended I did not change my opinion on operation Iraqi Freedom. I was able to see many sides of the story and must, somewhat sadly, conclude that the whole story is not always conveyed.

Notwithstanding the conclusions drawn above, I believe it is necessary to further examine the position of an 'embedded archaeologist' working in a peri-conflict phase. A Code of Conduct should without a doubt help those archaeologists who choose to work from the inside in future intrastate conflicts.

NOTES

1. Unlike an American reserve officer, an officer in the Dutch reserves can in principle refuse to join a mission. It goes without saying that when he refuses a couple of times his contract will not be extended.

2. According to Global Security the Green Zone (today known as the International Zone) is the heavily guarded diplomatic /government area of closed-off streets in central Baghdad where US occupation authorities live and work. The Green Zone in the central city includes the main palaces of former President Saddam Hussein. The area houses the civilian ruling authority run by the Americans and British, and the offices of major US consulting companies (see http://www. globalsecurity.org/military/world/iraq/baghdad-green-zone.htm, accessed December 18 2006).

3. The Green Zone Café was a restaurant in the northeast corner of the Green Zone. The restaurant was housed in a fabric and metal-frame building established in the parking lot of a former gas station. It was a popular and successful business, primarily serving the Western inhabitants of the Green Zone and featuring a Middle-Eastern cuisine. On 14 October 2004, the restaurant was destroyed, one patron was killed and five wounded by a backpack bomb (see http:// en.wikipedia.org/wiki/Green_Zone_Cafe). The Iraqi Bazaar, popularly called the Haji market, and not far from the café is visited by many foreign personnel. It was hit the same day by a suicide bomber (see http://www.womeninleadership. com/jan_1,2005.htm).

4. Jim Mollen, the senior advisor for the Ministry of Education and the Ministry of Higher Education at IRMO, was killed on 24 November 2004 on his way back from the Ministry of Higher Education, three days before his tour of duty was due to end.

5. In October 2004 a US patrol entered the Baghdad University compound in Qadisiya in search of insurgents. They occupied the first building they saw, evacuated all the occupants and started to arrest students left and right (personal communication Jim Mollen, senior advisor for the Ministry of Higher Education, 10 October 2004).

6. For more on the Hague Convention see http://portal.UNESCO.org/culture/en/ev.php-URL_ID=8450& URL_ D0=D0_TOPIC&URL_SECTION=201.html

7. Al-Hatra, a World Heritage site, was severely threatened by a detonation programme of the coalition forces by the end of 2004. Five kilometres away Saddam built the largest ammunition depot that had to be dismantled and cleared. For this a five year programme was designed. At regular intervals large amounts of ammunition were detonated after being buried in the ground. It turned out that the vibrations were causing damage to the ruins. After long negotiations with the military I managed to lower the force of the detonations by half and agreed with them to monitor the site to see if further damage had been done to the ruins.

BIBLIOGRAPHY

Ashcroft, B (ed), 1998 *Key Concepts in post-colonial studies*, Routledge, London

Behar, R, 1997 *The Vulnerable Observer: anthropology that breaks your heart*, Beacon Press, Boston, MA

Department of Defense [DoD] News Transcript, 2003 *ASD PA Clarke Meeting With Bureau Chiefs*, January 14, 2003, DoD Defense News Transcripts via Defenselink, available from: http://www.defenselink. mil/transcripts/2003/t01152003_t0114bc.html [22 December 2006]

Haigh, M M, Pfau, M, Danesi, J, Tallmon, R, Bunko, T, Nyberg, S, Thompson, B, Babin, C, Cardella, S, Mink, M, and Temple, B, 2006 A comparison of embedded and nonembedded print coverage of the US invasion and occupation of Iraq, in *The Harvard International Journal Press/Politics* 2006 (11/2), 139–53

LaFranchi, H, 2004 Iraq's looted heritage makes a steady – if slow – comeback, in *The Christian Science Monitor*, October 14

Meyerson, D, Weick, K, and Kramer, R, 1995 Swift trust and temporary groups, in *Trust Organizations: Frontiers of Theory and Research* (eds R M Kramer and T R Tyler), 166–95, Sage, Thousand Oaks, CA

Nanda, V, 1993 Dealing with the shift from interstate to intrastate confrontation, in *Conflict Research Consortium*, Working Paper 93-32, October 25, 1993(1), University of Denver

Paul, C, and Kim, J J, 2004 *Reporters on the Battlefield: The Embedded Press System in Historical Context*, Rand National Security Research Division, RAND Corporation, Arlington, VA

Secretary of Defense (SECDEF). 2003 Unclassified message-Subject: *Public Affairs Guidance on Embedding Media during Possible Future Operations/Deployment in the U.S. Central Command's Area of Responsibility*, Feb 10, US Department of Defense, Washington, DC

Schlechter, D, 2003 *Embedded: Weapons of Mass Deception. How the media failed to cover the war on Iraq*, Prometheus, Amherst, NY

Soeters, J, 2000 Culture and uniformed organizations, in *Handbook of Organizational Culture & Climate* (eds N M Ashkanay, C Wilerom and M Peterson), 465–81, Sage, Thousand Oaks, CA

Taylor, D, and Altman, I, 1975 Self-Disclosure as a function of reward-cost outcome, *Sociometry* 38(1), 18

Taylor, D, and Altman, I, 1987 Communication in interpersonal relationships: social penetration processes, in *Interpersonal Processes: New Directions in Communication research* (eds M E Roloff and G R Miller), 257–77, Sage, Newbury Park, CA

Teijgeler, R, 2006, Preserving cultural heritage in times of conflict, in *Preservation Management for Libraries, Archives & Museums* (eds G E Gorman and S J Shep), 133–65, Facet, London

Teijgeler, R, 2005 *So Yesterday Was the Burning of Books – Wartime in Iraq*, Lecture held at Responsible Stewardship Towards Cultural Heritage Materials, Preconference of the IFLA Rare Book and Manuscript Section, Copenhagen, The Royal Library, 11 August 2005, available from: http://iwa.univie.ac.at/ teijgeler.html [25 October 2007]

Wheelus, L, R, and Grotz, J, 1977 The measurement of trust and its relationship to self-disclosure, in *Human Communication Research* 3, 250-57

Change in the Legal Regime Protecting Cultural Heritage in the Aftermath of the War in Iraq

Patty Gerstenblith

International and national law concerned with the protection of cultural heritage has developed along two distinct lines. The first of these focuses on the protection of cultural heritage during warfare and aims to restrain military acts targeted against cultural sites, monuments and repositories. The second focuses on the operation of the international art market, primarily in terms of the illegal removal of cultural objects from their original context contrary to the laws of the nation of origin. This bifurcation of the international legal system has caused an inadequate response in the protection of cultural sites, monuments and objects, and no experience in recent times better illustrates this failure than the ongoing situation in Iraq, which has been devastating to its cultural heritage.

I. INTERNATIONAL LAW

A. The 1954 Hague Convention

The basic principle that cultural, scientific and artistic works and repositories were to be protected during warfare, and should not serve as war booty, was first codified in the Lieber Code, written for the Union Army during the American Civil War in 1863, and was later adopted in the first international instruments to regulate the conduct of warfare, namely the Hague Conventions of 1899 and 1907. The 1954 (Hague) *Convention on the Protection of Cultural Property in the Event of Armed Conflict* was adopted in the wake of the cultural devastations of World War II and builds on this earlier law of the conduct of war. Although the United States of America and the United Kingdom both signed the Convention soon after its writing, neither nation was a Party at the time of the Second Gulf War. The Convention's effectiveness was therefore very much circumscribed.

The United States of America (USA) accepts many of the principles of the Hague Convention as part of customary international law. However, this leaves considerable doubt as to precisely which provisions the USA accepts and which it does not. The USA

is bound to the two earlier Conventions of 1899 and 1907, but their provisions are not as suitable for dealing with the nature of modern warfare and, in particular, fail to incorporate contemporary understanding of the mandate to preserve and protect cultural property during hostilities and occupation.

The 1954 Convention consists of three parts: the main Convention and its two Protocols. Article 1 of the main convention defines 'cultural property' broadly as:

> movable or immovable property of great importance to the cultural heritage of every people, such as monuments of architecture, art or history, whether religious or secular; archaeological sites; …works of art; manuscripts, books and other objects of artistic, historical or archaeological interest; as well as scientific collections and important collections of books or archives … ; buildings whose main and effective purpose is to preserve or exhibit the movable cultural property … such as museums, large libraries and depositories of archives

The main Convention addresses the conduct of warfare during active hostilities and the conduct of an occupying power with respect to cultural heritage located in occupied territory. The first obligation of Parties to the Convention is to 'prepare in time of peace for the safeguarding of cultural property situated within their own territory' from the effects of warfare (Article 3). During warfare, Parties to the Convention must refrain from using cultural property and the nearby area for strategic or military purposes if this would expose the cultural property to harm (Article 4). In addition, Parties must not target cultural sites and monuments, although there is an exception for 'cases where military necessity imperatively requires such a waiver'.

Article 4 also imposes an obligation on a Party to the Convention to 'undertake to prohibit, prevent and, if necessary, put a stop to any form of theft, pillage or misappropriation of, and any acts of vandalism directed against, cultural property'. This provision is probably limited to requiring that a nation prevent looting by its own military rather than extending to the prevention of looting by the local population, as occurred in Iraq. However, other international legal instruments may impose such an obligation inherent in the requirement to maintain security for the civilian population.

Article 5 turns to the conduct of an occupying power and imposes several obligations. This provision clearly contemplates that the occupying power will work with the national authorities of the occupied country, to the fullest extent possible, in preserving the occupied nation's cultural property. The primary obligation placed on the occupying power is to 'take the most necessary measures' to preserve cultural property that was damaged by military operations and only if the national authorities are not able to do so. Probably the most significant drawback to this provision is that it is limited to the preservation of cultural property damaged during hostilities. There is thus no obligation to carry out preservation or conservation measures for cultural property that is damaged by some other means, such as through looting and vandalism. The Hague Convention seems most concerned with preventing an occupying power from interfering with the cultural, historical and religious record of occupied territory and therefore requires preservation only under these narrow circumstances.

The First Protocol, which was also written in 1954, is concerned primarily with the status of movable cultural objects and imposes four obligations. First, an occupying power is obliged to prevent the export from occupied territory of any movable cultural property. Second, any nation that is a Party to the Convention must take into its custody any illegally exported cultural property that is imported either directly from the occupied territory or indirectly through another nation. Third, at the close of hostilities, any nation that is Party to the Convention must return illegally exported cultural property to the competent authorities of the formerly occupied nation. Finally, any cultural property taken into custody during hostilities must be returned at the end of hostilities.

The Second Protocol is not relevant to the conduct of the Iraq war because it only came into effect in 2004 and none of the main combatants is, as yet, Party to this Protocol. Its relevance would be found only to the extent that it incorporates customary international law, which would be binding on all nation states, and because it reflects an updating of the main Convention after the Balkan wars. Article 9 of the Second Protocol prohibits the carrying out of any archaeological excavation, 'save where this is strictly required to safeguard, record or preserve cultural property,' and also prohibits 'any alteration to, or change of use of, cultural property which is intended to conceal or destroy cultural, historical or scientific evidence'. Article 9 thus broadens the circumstances in which archaeological excavation may be conducted because it permits such activity even where the cultural property was not damaged during hostilities. Thus, it would be consistent with the Convention for an occupying power to carry out survey and salvage excavations if necessary to preserve the archaeological record during construction activities. However, neither the main Convention nor the Second Protocol truly incorporates modern understandings of cultural resource management.

B. THE 1970 UNESCO CONVENTION

The 1970 UNESCO *Convention on the Means of Prohibiting and Preventing the Illicit Import, Export and Transfer of Ownership of Cultural Property* was written in response to the growth of the international art market in the years of prosperity following World War II and the market's contribution to the theft and illegal export of cultural property, the looting of archaeological sites, and the dismemberment of cultural monuments. While its principles can apply during wartime, its focus is on the operation and problems of the market. At this time, over one hundred nations are party to this 1970 UNESCO Convention. The USA was one of the first market nations to ratify it, but today most of the significant market nations are also party to the Convention.

The USA's own implementing legislation, the *Convention on Cultural Property Implementation Act* (CPIA), adopted only two provisions of the Convention. The first of these, Article 7(b), calls on nations 'to prohibit the import of cultural property stolen from a museum or a religious or secular public monument or similar institution in another State Party ..., provided that such property is documented as appertaining to the inventory of that institution'. The second provision, Article 9, calls on nations to assist others, whose 'cultural patrimony is in jeopardy from pillage of archaeological or ethnological materials,'

by imposing trade, particularly import, restrictions on illegally exported archaeological and ethnological objects. Article 9 also requires that nations take temporary measures, even in the absence of multilateral agreement, in emergency situations.

With the exception of the USA, most nations that ratified the 1970 UNESCO Convention prohibit the import into their country of any cultural objects illegally exported or stolen from their country of origin if the latter country is a party to the convention. In contrast, the USA established a cumbersome mechanism by which nations that are party to the UNESCO Convention must submit a formal request for import restrictions. The US President can impose restrictions on the import of designated categories of archaeological and ethnographic objects pursuant to either a 'bilateral agreement', which is negotiated between the USA and the other country, or an 'emergency action', in cases of crisis threats to the other country's cultural patrimony. For a bilateral agreement to be implemented, four criteria must be satisfied. First, the other country's cultural patrimony must be in jeopardy from pillage of archaeological or ethnologic objects. Second, the requesting nation must have taken internal steps consistent with the 1970 UNESCO Convention. Third, the USA's action will be taken as part of a concerted or multilateral effort (although there is also a statutory exception to this criterion). Fourth, it should be clear that imposing import restrictions would further the public interest in international exchange of cultural materials for scientific and educational purposes. The CPIA process thus imposes a significant additional burden on requesting nations, and a nation that does not have diplomatic relations with the USA cannot make a request, as was the situation with Iraq until after the Second Gulf War.

II. US DOMESTIC LAW AND THE INTERNATIONAL ART MARKET

In addition to the international conventions, the domestic law of market nations has an impact on the operation of the international art market. The domestic laws of the USA will be used to illustrate this. There are three aspects: recovery of property stolen from collections (public or private), archaeological theft, and illegal import or smuggling.

A. Recovery of stolen property

In countries that follow the common law of property (the USA, UK,[1] Canada, Australia and New Zealand), a thief can never convey title to stolen property, although the original owner may be barred from recovering the property by a statute of limitations or an equitable defence. In contrast, civil law nations, such as those on the European continent, accept some variant of the good faith purchaser doctrine by which a thief can transfer title if the goods are sold to a good faith purchaser. If stolen property is transferred in a civil law nation, then the title can be 'laundered' so that when the property is taken to a common law country, the current possessor can claim to rely on having acquired title in the civil law nation. Several cases have occurred in the USA where the defendant has relied on such a claim, but only rarely has this argument been successful.

B. Archaeological theft

While cultural objects may be stolen from museums and private collections, archaeological objects may also be looted directly from the ground. Such objects are particularly appealing to the international art market because their existence is undocumented and there is no record of their theft. It is therefore extremely difficult to trace such objects through normal law enforcement methods and to establish their true origin.

To combat such looting, many nations have enacted laws that vest ownership of undiscovered archaeological objects in the nation. These ownership laws apply to any objects discovered after the effective date of the statute. If an object is recovered after this date and removed from the country without permission, then the object is stolen property and it retains this characterisation even after it is brought to the USA. Anyone who knowingly transports stolen property in interstate or international commerce, or intends to do so, violates the USA's *National Stolen Property Act*. Depending on the factual circumstances and the proof available to the government, the stolen property may be seized and forfeited and the individual may be subject to criminal prosecution. This doctrine was most recently upheld in the 2002 conviction of the prominent New York antiquities dealer, Frederick Schultz, who until shortly before his indictment, was President of the National Association of Dealers in Ancient, Oriental and Primitive Art. Schultz's co-conspirator, Jonathan Tokeley-Parry, was similarly convicted in the United Kingdom and so this doctrine applies there as well.

C. Illegal import/smuggling

The third type of illegal activity is illegal import or smuggling. While goods that have been illegally exported from one country are not generally regarded as contraband once they enter another country, illegal import renders the goods subject to seizure and forfeiture under Customs laws. The USA's *Customs Statute* prohibits the entry into the USA of goods imported contrary to law, such as the *National Stolen Property Act* (in the case of stolen property) and statutes that require truthful declaration of the country of origin and value of the goods to be imported.

III. CHANGES IN CULTURAL HERITAGE LAW IN THE AFTERMATH OF THE SECOND GULF WAR

A. Immovable Cultural Property

The cultural heritage of Iraq has suffered significantly since the beginning of hostilities in March 2003. The looting of the Iraq Museum in Baghdad and other cultural repositories received widespread media attention. The looting of archaeological sites, which destroys archaeological context and our ability to reconstruct and understand the past, has received less media attention. The construction of military installations at historical sites, including a berm encircling Samarra, may have caused damage but needs more complete assessment to determine the extent. The construction of a military base directly over the

site of Babylon, including use of part of the site as a helicopter landing pad and other alterations and damage to the site (Curtis 2004; Bahrani 2005, 214–16), seems to be a clear violation of the principles of the 1954 Hague Convention (Gerstenblith 2006, 311–16). The use of the spiral minaret (or Malwiya) at the 9th-century al-Mutawakkil mosque in Samarra as a sniper position exposed a religious and historic monument to danger, but, so far as we know, it has not been damaged to any significant degree (and the use may be excused under the military necessity waiver) (Gerstenblith 2006, 307–308; and see Teijgeler, chapter 17).

Perhaps the most significant change in international law subsequent to the 2003 war in Iraq is the announcement by the United Kingdom that it intends to ratify the 1954 Hague Convention and both Protocols and is now moving toward ratification. It is as yet unclear, however, how much the ratification process will focus on the protection of historic and cultural sites within the UK in case of attack and how much will focus on planning and training of the UK military for circumstances in which it is engaged in combat in other nations. In February 2007, the US Department of State listed the Hague Convention among those international instruments pertaining to the law of warfare that it wished to see ratified by the Senate, but no action has yet been taken by the Senate and in 2007 the USA and UK remain the only major world military powers not to have ratified the Convention.

B. Movable Cultural Property

The example of Iraq demonstrates both the difficulties of applying legal rules to deter looting of institutions and sites and the uniqueness of the situation in Iraq because of the significant public attention that it has attracted and the existence of UN-mandated sanctions on the import of goods from Iraq since August 1990. In the USA, these sanctions were implemented through a *Presidential Executive Order* and were administrated through the Treasury Department's Office of Foreign Asset Controls (OFAC). Archaeological and other cultural objects that were exported from Iraq after August 1990 were therefore already prohibited entry into the USA even before the 2003 Gulf War began.

The artefacts looted from the Iraq Museum and other repositories clearly constitute stolen property and as such implicate numerous legal doctrines previously discussed. However, because the documentation of the museum holdings was impaired during the looting, it is not clear whether these objects can be clearly documented as part of the inventory of the museum. If they are so documented, then their import into the USA is prohibited under the *Cultural Property Implementation Act*, the *OFAC sanctions*, the *Customs statutes*, and the *National Stolen Property Act*, if their value exceeds USA $5000. Anyone who knowingly receives, transports, or deals in any of these objects is liable to criminal prosecution.

Restitution of artefacts looted from archaeological sites raises different legal questions. As previously explained, the USA and Iraq did not have a bilateral agreement under the CPIA and so the import of illegally exported archaeological materials was not prohibited under this mechanism. On the other hand, Iraq has had a national ownership law in effect

since 1936 and so any archaeological objects removed without permission after this date are stolen property. The knowing import of such materials would violate the *National Stolen Property Act*. However, the burden of proof and the elements required under the *National Stolen Property Act* are more difficult for the government to establish than those required under the *Cultural Property Implementation Act*.

The considerable media attention that focused on the looting of Iraqi cultural institutions led to the enactment of several provisions unique to the Iraq situation. In anticipation of the lifting of the general trade sanctions, on 22 May 2003, the United Nations Security Council passed a resolution (UNSCR 1483) that included a specific provision (paragraph 7) for dealing with the cultural materials of Iraq. This provision states that the Security Council:

> Decides that all Member States shall take appropriate steps to facilitate the safe return to Iraqi institutions of Iraqi cultural property and other items of archaeological, historical, cultural, rare scientific, and religious importance illegally removed from the Iraq National Museum, the National Library, and other locations in Iraq since the adoption of resolution 661 (1990) of 6 August 1990, including by establishing a prohibition on trade in or transfer of such items and items with respect to which reasonable suspicion exists that they have been illegally removed

Several of the market nations undertook particular legislative or administrative actions to implement this Security Council Resolution, as they are required to do under the United Nations Charter. The European Union enacted Council Regulation No. 1210/2003, which, in paragraph 3, prohibits the import, export or dealing in Iraqi cultural materials largely as defined in the UN Security Council Resolution if there is reasonable suspicion that the goods were 'removed in breach of Iraq's laws and regulations'. The UK enacted Statutory Instrument 2003 No. 1519, which prohibits the import or export of any illegally removed Iraqi cultural property. The dealing in any such items constitutes a criminal offence unless the individual 'proves that he did not know and had no reason to suppose that the item in question was illegally removed Iraqi cultural property'. The Swiss Federal Council enacted the *Ordinance on Economic Measures* of 28 May 2003, which imposed a ban that 'covers importation, exportation and transit, as well as selling, marketing, dealing in, acquiring or otherwise transferring Iraqi cultural assets stolen in Iraq since 2 August 1990, removed against the will of the owner, or taken out of Iraq illegally'. It includes cultural assets acquired through illegal excavations. Such assets are presumed to have been exported illegally if they can be proved to have been in the Republic of Iraq after 2 August 1990.

The USA has continuously maintained a prohibition on import of, or other transactions involving, Iraqi cultural materials as described in the UN Security Council Resolution. In addition, the *Emergency Protection for Iraqi Cultural Antiquities Act* allows the President to exercise his authority under the *Cultural Property Implementation Act* to impose import restrictions on any cultural materials illegally removed from Iraq after August 1990. The statute defines 'cultural materials' in accord with the UN Security Council Resolution and more broadly than the CPIA defines archaeological and ethnological materials. This legislation will ensure that there are no gaps in the import restrictions protecting Iraq's

cultural heritage by eliminating the need for Iraq to bring a formal request for import restrictions and eliminating review of the request by the Cultural Property Advisory Committee. However, the President has not yet exercised this authority, and the import restriction on Iraqi cultural materials remains in place under Executive Order, thereby continuing the original sanctions.

Another, more subtle change in the law occurred as a result of the 2003 Gulf War. In 2002 and 2003, several new market nations, including the UK, Japan, Denmark, and Switzerland, ratified the 1970 UNESCO Convention. Implementing legislation had been languishing in the UK and Switzerland, and the looting in Iraq provided the impetus needed for both legislatures to take action.

The British legislation, the *Dealing in Cultural Objects (Offences) Act 2003*, created a new criminal offence for dealing in 'tainted cultural objects'. The offence consists of 'dishonestly deal[ing] in a cultural object that is tainted, knowing or believing that the object is tainted'. A cultural object is tainted if it was excavated or removed from '…a building or structure of historical, architectural or archaeological interest' or from an excavation, and the removal constituted an offence under local law in either the UK or in another country. Switzerland enacted the *Federal Act on the International Transfer of Cultural Property*, which permits the Swiss Federal Council to enter into agreements with other nations that are party to the 1970 UNESCO Convention to protect 'cultural and foreign affairs interests and to secure cultural heritage'. The Federal Council can also take additional measures when a 'state's cultural heritage [is] jeopardised by exceptional events'. In 2007, Germany enacted implementing legislation for the 1970 UNESCO Convention and the First Protocol to the Hague Convention, and it will become a party to the UNESCO Convention by the beginning of 2008. The impetus provided through the media attention to the looting in Iraq may encourage other market nations to ratify and implement the UNESCO Convention as well.

IV. CONCLUSION

The international and national legal regimes have changed in response to the damage done to Iraq's cultural heritage, but weaknesses remain. At the international level, the outdated approach of the Hague Convention to such issues as the conduct of modern warfare and of cultural resource management during occupation and the failure of the USA to ratify the Convention remain impediments to its effectiveness. Ratification and implementation of the 1970 UNESCO Convention have met with greater success in recent years.

Progress in the law that protects cultural heritage has resulted from both incremental changes, which had been in process for many years, and sudden changes that resulted from the public reaction to the events in Iraq. While many of these legal provisions are unique to the situation in Iraq, the rapid and relatively widespread implementation of these provisions demonstrates that the legal system can respond when there is sufficient public attention and pressure brought to the issue of archaeological looting. However, the changes that are necessary for effective deterrence of looting require a long period of time,

and this may not be available as the looting of sites goes on at a rapid pace, particularly in countries that, like Iraq, are the victim of domestic chaos.

NOTES

1. The UK's constituent countries have different legal frameworks with that in Scotland being, on occasion, significantly different to the rest of the UK. For simplicity this chapter refers to the UK but readers should be aware that there may be legal differences between the countries in the UK. In this particular instance, while there may be variances, all of the UK follows the common law of property.

BIBLIOGRAPHY

Bahrani, Z, 2005 A Museum is Born, in *The Looting of the Iraq Museum, Baghdad: The Lost Legacy of Ancient Mesopotamia* (eds M Polk and A M H Schuster), Harry N. Abrams Inc, New York

Curtis, J E, 2004 Report on Meeting at Babylon, 11–13 December 2004, available from: www.thebritishmuseum.ac.uk/the_museum/news_and_debate/debate/iraq_war/summary_of_activity_2005-6.aspx [26 October 2007]

Gerstenblith, P, 2006 From Bamiyan to Baghdad: Warfare and the Preservation of Cultural Heritage at the Beginning of the 21st Century, *Georgetown Journal of International Law* 37, 245–351

'May the Holy River Karun Mourn You'
(Gilgamesh viii, 18):
UNESCO's Post-Conflict Strategies for Safeguarding Cultural Heritage

Philippe Delanghe[1]

Literature can capture, summarise and inspire.

'It was on the edge of the Marshes that human history began. Far back in the darkness of time a people, already socially and culturally advanced, moved down from the plateau of Iran and settled in the Euphrates delta, where, in the fifth millennium BC, they built reed houses, made boats and harpooned and netted fish.' (Thesiger 2000, 79)

'The Garden of Eden is the name given to the "earthly paradise" where Adam and Eve are thought to have lived before their fall (Genesis 2 and 3). From the exact details recorded, it would seem that the writer of the Biblical story conceives of the Garden of Eden as an actual locality on earth … Since the discovery of ancient civilizations in Iraq scholars have leaned toward the sites of Southern Sumer (the Marshes). Indeed it is conceivable that the word "Eden" is derived from the Sumerian word "edinu" which meant field, plain, or depression.' (Ochsenschlager 2004, 1–2)

In *Baghdad Diary*, Nuha al Radi, an Iraqi artist, portrays the living conditions of ordinary Iraqis in Baghdad and her personal reflections, from the start of the Gulf War in 1991 to the events of 2003 (al Radi 2003). The book starts with an accurate, but rather cynical view on the 42-day-long assault on the capital in 1991. Life without electricity or running water, the stench of unfrozen freezers and rotting food, the constant pounding, but also the new friendships of her dog Salvador Dali, the happy Baghdad street cats and the importance of her garden and plants. Page after page, one becomes more and more drawn into wartime daily life which shows how often we take simple things for granted. The writer then moves on to the embargo period, her own exile in Lebanon and the beginning of the second conflict. Today's result? As a UN colleague put it: 'The situation in Iraq has never been worse.'

The contrast between the first two quotations and the following summary of UNESCO's work is shocking but real; what was once the fertile land where cultures flourished is now a land where civilisation suffers.

Culture can be viewed as a summary of what we are, what we have carried from the past to the present. Culture shaped and shapes identities, values and ways of life. Culture is a basis for social cohesion; the roots on which societies are built, thrive, and by which they can be identified through their tangible and intangible achievements. These achievements in Iraq are magnificent. Yet, very often, culture is forgotten by politics and is considered an unimportant component when it comes to national and international development assistance. This is especially so when a society is in crisis and the economy and other vital arteries falter.

At first sight of course, in having to cope with a terribly difficult situation in Iraq, it is far more important to deliver basic goods such as food, infrastructure, and health care than it is to 'waste' time and resources on funding cultural activities. But culture is there, running through everybody's veins, an identity to refer to: an identity to which individuals feel they belong. That identity can get lost and when opportunities are not seized, when culture is disregarded and not used as a positive force for development, differences can help fuel conflicts rather than solve them.

UNESCO was the first international organisation to try to seize the opportunity to try to use Iraq's cultural heritage as a means to help stabilise Iraqi society. In May and June 2003, following the looting of the Iraq Museum in Baghdad, UNESCO embarked on a campaign to protect and secure the country's immeasurable cultural treasures – held in sites, in museums, cultural institutions and within the people themselves. The campaign involved, in the first instance, two 'expert missions' to Iraq, lead by former Assistant Director General for Culture, Mr Mounir Bouchenaki, that attempted to get some sense of the extent of the damage to the Iraqi cultural heritage. This approach was then formalised through the establishment of an International Coordination Committee (ICC), which met for the first time in Paris in May 2004. It was intended that the ICC would meet on an annual basis and a second meeting took place in Paris, in June 2005. Both meetings ended with the development of a strategy with recommendations for project implementation in the course of the following year. (See http://portal.unesco.org/culture/en/ev.php-URL_ID=17417&URL_DO=DO_TOPIC&URL_SECTION=201.html)

The key recommendations of the ICC (2004-2005) can be summarised as:

1 To ensure support for institutional reform, capacity-building and training in the field of cultural policy and the safeguarding of the cultural heritage of Iraq in order to empower the Ministry of Culture with respect to the protection, conservation and rehabilitation of the cultural heritage;

2 To assist Iraqi museums to devise comprehensive conservation plans as well as a museum programme to enhance national capacities of Iraq regarding the research, study, documentation and conservation of Iraqi cultural heritage;

3 To assist the Ministry of Culture of Iraq to devise a cooperation mechanism and network of

international partners and stakeholders regarding the rehabilitation of the National Library and Archives;

4 To assist the Ministry of Culture of Iraq to devise a national programme for recording, documenting, assessing the condition of, and mapping archaeological sites and elements of the built heritage, with a view to establishing an official national registry and a plan for their protection and conservation;

5 To assist the Iraqi Ministries of Culture, Education, and Higher Education to raise awareness about the importance of cultural heritage and to promote associated educational activities;

6 To assist the Ministry of Culture of Iraq to develop a national registry of Iraqi living heritage;

7 To assist the Ministry of Culture of Iraq to strengthen capacity building in the field of museum studies;

8 To mandate the ICC to monitor the implementation of the recommendations adopted by ICC at its first and second sessions and for it to continue to play a coordinating role with respect to these recommendations.

Through activities flowing from these recommendations, UNESCO has relentlessly pursued targets, identified and agreed under these recommendations with Iraqi colleagues, in an increasingly difficult environment through the support of the United Nations Development Group Iraq Trust Fund (UNDGITF) and many other international bilateral donors. This broad network of assistance has contributed to projects as diverse as: protection of intangible heritage, cultural policy development, intercultural dialogue, rehabilitation of cultural institutions, site protection, and World Heritage. All of this work has taken place in close collaboration with the Iraqi Ministry for Culture, the Iraqi Ministry of Tourism and Antiquities, the Iraqi State Board of Antiquities and Heritage, and the Jordanian Government, which has been of great help and assistance.

Intangible cultural heritage, as defined in the 2003 *Convention for the Safeguarding of the Intangible Cultural Heritage*, means in the first place the practices, representations, and expressions, as well as the associated knowledge and necessary skills, that communities, groups, and in some cases individuals, recognise as part of their cultural heritage. UNESCO has undertaken to proclaim 150 'Masterpieces of the Oral and Intangible Heritage of Humanity' before the end of 2007. In 2003, the Iraqi traditional *Maqam* was inscribed on this list, being widely recognised as a genre of classical traditional music that provides significant insight into the history of Arab music and its continuing trans-border function and importance.

In terms of cultural policy development and cultural diversity, UNESCO organised a 'Cultural Forum' at its Headquarters in Paris in May 2004. The Forum served as a platform for both Iraqi intellectuals in exile and those living in Iraq to discuss a future cultural policy for their country. The recommendations that were formulated mainly stressed the importance of the conservation and protection of the wider cultural heritage. In view of its success, there was a clear will to continue the exercise and a second Cultural Forum was organised in Baghdad in April 2005 in close collaboration with the Ministry of Culture. The importance of that event is clearly illustrated by the fact that almost

1000, mainly Iraqi, individuals participated. The participants were organised in different discussion groups around themes directly or indirectly related to culture such as plastic arts, translation, theatre, science, intangible heritage, architecture, women, legislation, public libraries, children, heritage and antiquities, folklore, author rights, music and cinema. It is hoped that the recommendations from this meeting will help to form the context within which future Iraqi policy regarding culture can be formulated.

A beginning has also been made regarding the rehabilitation of cultural institutions such as the Iraq National Museum in Baghdad, the National Library and Archives, the Children's Museum, the National Heritage Institute, the Melodic Institute and the Regional Centre for Conservation. Special emphasis was given to the Iraq Museum, where different initiatives were organised under the UNESCO umbrella to help rehabilitate what had been ransacked during the looting in 2003. For example, a large financial contribution from the Japanese government helped with the rehabilitation of the conservation laboratories and the training of staff in the utilisation of new equipment, while the Swiss government funded the installation of a database system for the Museum's large collection (and see George, chapter 10; van Ess, chapter 21; and Zottin, chapter 24).

In view of the enormous problems Iraq is facing in relation to archaeological site protection, a training course was organised in Amman, Jordan by UNESCO and the Italian Carabinieri for site guards and border patrols in 2004 (and see Zottin, chapter 24). Specially equipped vehicles for patrolling were procured and a database for archaeological

Fig 1. Conservation work at the newly rehabilitated and newly equipped conservation laboratories of the Iraq Museum

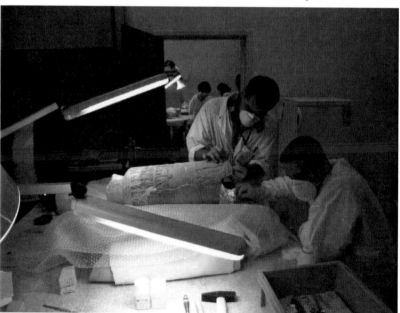

Photo: Donny George

site management is being set up in close collaboration with the World Monument Fund (WMF) and the Getty Conservation Institute (GCI) (and see Agnew and Palumbo 2005).

UNESCO's longstanding interest in tangible cultural heritage protection and conservation also led to initiatives in relation to the 1972 World Heritage Convention. Before 2003, only one site in Iraq, the archaeological city of Hatra, had been inscribed on the World Heritage List (1987). The site had first been surveyed in 1907 by the German archaeologist Walter Andrae. The first real excavations started in 1951, led by the Iraqi Antiquity Service under the direction of the Iraqi archaeologist Fuad Safar. Since then the unveiling of the mystery surrounding the origin and the character of Hatra's culture has been almost continuous. Excavations only stopped due to the war in 2003. The origin of Hatra is to be found, most likely, in a small settlement from the 5th century BC, located 115km south-west of Mosul. By the end of the first century AD, Hatra was fortified, encompassing 3 square kilometres, and was flourishing as an independent trading and sacred city within the Parthian Empire. Columns, capitals, architectural decoration, statues – all carved in limestone and on a monumental scale – make Hatra's temples some of the most spectacular complexes of the ancient world.

In the immediate aftermath of the 2003 invasion, the Assyrian site of Ashur was inscribed on the World Heritage List, but at the same time inscribed on the World Heritage List in Danger, because of its dire need for conservation and protection. Ashur was the first Assyrian capital and is situated approximately 100km south of Mosul. The founding of the city dates back to the beginning of the second millennium BC and the oldest building discovered so far is the temple of Ishtar. The city is very well known for its huge ramparts with fortification towers and palaces build by the first Assyrian Princes. During 2005 major emphasis was put on the preparation of the World Heritage nomination file for the site of Samarra. This documentation was finally submitted to the World Heritage Centre on 1 February 2006 for concurrent nomination to the World Heritage List and the World Heritage List in Danger. Samarra was inscribed on both Lists at the World Heritage Committee meeting in 2007.

More recently Samarra has, unfortunately, become famous for other things. Until very recently, Samarra was revered as a place for religious tolerance, where the mostly Sunni Muslim population welcomed each year millions of Shia'a Muslim pilgrims to the holy sepulchers of Imams Ali Al-Hadi and Al-Hassan Al-Askari at the Al-Askari Shrine. The bombing of the Al-Askari Shrine, which is not part of the World Heritage Site, in February 2005 however contributed to an explosion of sectarian violence and civil war in Iraq and turned the city into a symbol of religious extremism. The deterioration of the security situation may therefore cause irreversible damage to the city as a whole. It is very much hoped that UNESCO's inscription of the city as a World Heritage Site may contribute to Samarra's revival as a universal symbol of peace, and tolerance.

All these efforts are to be applauded, but to claim 'success' as an overall assessment for the work facilitated by UNESCO since 2003 is questionable and the task ahead immeasurable. It is clear that in the course of the past year – and even more the last six

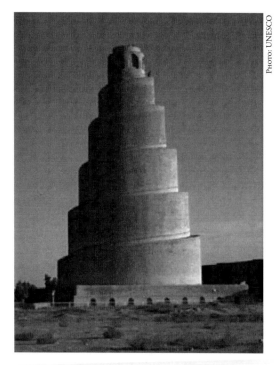

PHOTO: UNESCO

FIG 2.

SURRA MAN RA'A – 'DELIGHTED IS HE
WHO SEES IT'. DESPITE ITS VERY SHORT
HISTORY OF ONLY 58 YEARS – 836 TO 892
AD – SAMARRA'S ARTISTIC, LITERARY, AND
SCIENTIFIC SPLENDOURS HAVE REMAINED
A LEGEND IN ARAB AND ISLAMIC HISTORY.
SEVERAL OUTSTANDING FEATURES,
SUCH AS ITS SUMERIAN RELICS AND THE
MINARETS OF THE AL-MALWIYA AND
ABU DULAF MOSQUES, MAKE SAMARRA A
UNIQUE TREASURE IN THE WORLD. THIS
PICTURE SHOWS THE MINARET OF THE
AL-MALWIYA MOSQUE IN SAMARRA.

months – donor priorities have changed as did the situation in Iraq. In early 2006 the Iraq Museum in Baghdad was completely closed down because of the deteriorating situation in the capital and more recently, UNESCO was informed of the closure of the National Library and Archives after it had been bombed three times in three weeks and subjected to sniper fire with the loss of one life. Important components of UNESCO's activities under the UNDGITF stay unfinished and lay unattended such as the Melodic Institute and the Regional Centre for Conservation. Some specially equipped vehicles for archaeological site protection were stolen at the border with Jordan on Iraqi territory during delivery. Although the bulk of the vehicles were finally delivered to the Iraq Museum in Baghdad, they have not yet been distributed to the archaeological sites for which they were procured because of the very dangerous situation on the ground.

The only activity that continues under UNDGITF at present is the creation of the archaeological site database in close cooperation with WMF and GCI. This work, however, is only made possible through a generous financial contribution by UNESCO. However, with this project as with all others, the situation in the field is hampering the operational elements of the project. Some of the sophisticated equipment remains in the UNESCO Office in Amman, Jordan for further training, but most has been sent to Baghdad where staff often keep it in their private houses, afraid to use it outside or even take it to the office. Other projects funded on a bilateral level continue as well, but at a much slower pace and with a lot more uncertainty then before.

These few examples may illustrate the need for the reorientation of programming and a better balance between external and operational actions in the difficult and risky environment of Iraq. Such a realignment of activity may be necessary given that UNESCO has very limited experience of, and resources for, conflict situations. This issue becomes even more critical given the enormous number of violations against culture property that take place on an almost daily basis in Iraq at present (and see Farchakh Bajjaly, chapter 12; and George, chapter 10).

Facts and numbers vary, but the unfortunate truth is, what is happening at the moment, right across the country on archaeological sites and in museums, is only being recorded haphazardly. Looting and illegal digging have been observed by patrolling and satellite photography across the country but especially in the Southern Sumerian city states of Isin, Abad, Zabalam, Shuruppak and Umma where sites have been very badly damaged. Worrisome rumours also reached UNESCO from regional museums and many problems are known to have occurred at Hatra, Ctesiphon and Babylon. Documentation however, is very scarce and special efforts by the international community have been limited to Babylon (see Curtis, chapter 20; Moussa, chapter 13). Two international meetings, organised in 2005 under the auspices of UNESCO in Paris and Berlin, stressed the need for serious monitoring and reporting to better reflect the status of Babylon after the invasion of 2003. As a result, two comprehensive reports have been produced by Iraqi and American teams. Eventually both reports should be integrated with additional contributions to be presented at the 3rd ICC, scheduled for 13–14 November 2007. Their as yet unpublished content illustrates the graveness of the situation.

During the events of 2003, Babylon suffered significant damage. The Nebuchadnezzar and Hammurabi museums were robbed – fortunately the exhibited pieces were gypsum copies – and the administrative offices and study centre were burned down, damaging the Babylon library that housed reports, maps and valuable research records from excavation and maintenance works. On site, the Hellenistic theatre was badly damaged, and then in April 2003 Coalition forces arrived and established a military camp. By the time the military left, on 22 December 2004, outstanding archaeological remains such as the interior enclosure, Ishtar Gate, Procession Street, Ninmakh temple, Ishtar temple, Nadu Shekhery temple, Royal palaces, Babylonian houses and the Hellenistic theatre had suffered further damage (and see Curtis, chapter 20; Moussa, chapter 13).

Although the situation is depressing, the work carried out in Babylon is proof that the international community can do work in Iraq, and can provide useful analysis and evaluation. As little as it may seem under the circumstances, this is also part of the reconstruction and reconciliation process. It is therefore very much hoped that this exercise can be repeated for other sites. The loss of intangible heritage, while infrastructure is missing, is even more difficult to measure. UNESCO can only do what circumstances permit. We must continue to do the utmost to safeguard or record what constitutes a vital part of the education and formation of future Iraqi generations.

NOTES

1. I would like to dedicate this article to the memory of Prof Dr Baron Leon De Meyer, who worked for over 35 years on Iraqi archaeology and collaborated with UNESCO on Iraqi programmes.

BIBLIOGRAPHY

Agnew, N and Palumbo, G, 2005 *Protecting Iraq's Sites and Monuments: Support for a Nation's Keepers of Cultural Heritage*, Getty Conservation Newsletter, 20:3 Fall, 2005. http://www.getty.edu/conservation/publications/newsletters/20_3/news_in_cons1.html

Al Radi, N, 2003 *Baghdad Diary*, Saqi Books, London

Ochsenschlager, E L, 2004 *Iraq's Marsh Arabs in the Garden of Eden*, University of Pennsylvania Museum, Philadelphia

Polk, M and Schuster, A M H (eds), 2005 *The Looting of the Iraq Museum, Baghdad: The Lost Legacy of Ancient Mesopotamia*, Harry N. Abrams Inc, New York

Thesiger, W, 2000 *The Marsh Arabs*, HarperCollins, London

The Role of the British Museum in the Protection of the Iraqi Cultural Heritage

JOHN CURTIS

Much has already been written about damage to the Iraqi cultural heritage as a direct result of the Second Gulf War and its aftermath, and there is no doubt that much will be written in the future. Apart from the Iraqis themselves, whose testimonials we eagerly await, many foreign organisations and individuals have been involved, directly or indirectly, in what has happened. The problem is multi-faceted. It is not just about the looting of the major museums, particularly Baghdad and Mosul, but the destruction of libraries and archives, the damage to historic buildings, the extensive looting of archaeological sites, the illicit trade in antiquities, and now the undermining of the higher education system. It is still much too early to produce a coherent account of what has happened and what is happening. These are subjects that will occupy the attention of many people for a long time. In the meantime, it is important that those who have had some involvement, however peripheral it may seem, should set down what they know, so that in due course an accurate and reliable picture may be built up. The present article is about the work of just one institution, the British Museum, hereafter the BM.

Rather than attempting to write a synthetical account, I have presented below the work of the BM as a series of bullet points, believing this to be the clearest way of indicating the level and extent of our engagement.

(1) In the build-up to the war, the BM was not consulted by the British Ministry of Defence, even though we had extensive knowledge about the Iraq Museum and its collections and the real risk of looting, as seen after the First Gulf War. (For an account of the preparations made by the MoD to safeguard the Iraqi cultural heritage, see Stone, chapter 8.)

(2) I was, however, contacted by somebody collecting information for the USA Defense Department who wanted a list of sites in Iraq. I was reluctant to provide this on the grounds that 'Iraq is a vast archaeological site', and it seemed to me that highlighting

particular sites might put at risk many smaller or unexcavated sites of equal or potentially equal interest.

(3) On 28 February 2003, I wrote a joint letter (with Professor Robert Springborg of the London Middle East Institute of the School of Oriental and African Studies) to Geoff Hoon, then Minister of Defence, warning him of the potential danger to the cultural heritage of military action in Iraq. We wrote: 'In the event of war there will inevitably be some damage (to the Iraqi cultural heritage) and it is imperative that the occupying powers should act swiftly to minimise and repair this damage. Amongst the urgent tasks will be repairs to standing monuments, prevention of looting at archaeological sites, conservation of objects in museums, and suppression of the illicit trade in antiquities and works of art.' We offered to provide whatever help might be needed to accomplish these aims. We received in reply a letter from an official in the MoD merely assuring us that we (ie the MoD) 'will do all we can to minimise the risk of damage to all civilian sites and infrastructure'.

(4) News of the looting of the Iraq Museum broke on 12 April 2003, when Neil MacGregor and I were in Tehran. Dominique Collon of the BM called on the Coalition forces to protect the Iraq Museum.

(5) On 15 April 2003, Tessa Jowell (UK Minister of Culture, Media and Sport) attended a long-organised press conference at the BM to celebrate the 250th anniversary of the BM. In the event, the meeting was dominated by the looting of the Iraq Museum, and several journalists asked angry questions about the failure of the Coalition to protect museums and libraries in Baghdad. During the meeting, Nick Glass of Channel 4 News and a colleague in Baghdad set up a satellite telephone conversation between myself and Donny George, who was in the Iraq Museum. I was the first person outside Iraq that he had been able to speak to (and see George, chapter 10). He had not yet had a chance to assess the damage, but noted that the Warka Vase, the Bassetki statue and an Assyrian statue were all missing. He said the Museum was still unguarded, and was being protected by local people and vigilantes. I reported to Neil MacGregor that the Iraq Museum was still unguarded, and he passed this news on to the Prime Minister's Office with a request for action. We heard later that shortly after this request tanks were deployed to guard the Iraq Museum, but it is not clear whether this was as a direct result of MacGregor's intervention (and see Bogdanos, chapter 11). Neil MacGregor announced at the press conference that the BM was going to take the initiative in providing assistance to the Iraq Museum, and would act as the coordinator for other museums. It would send a team of three curators and six conservators.

(6) On 17 April 2003, Neil MacGregor and I attended the UNESCO conference in Paris. For a report on this meeting see:

http://portal.unesco.org/culture/en/ev.php-URL_ID=8511&URL_DO=DO_
TOPIC&URL_SECTION=201.html

(7) In the period 22–28 April 2003, I accompanied a BBC team to Iraq. They were
making a film about the looting of the Iraq Museum with Dan Cruickshank. After
travelling overland from Amman, we arrived at the Iraq Museum in Baghdad at 3.00pm
on 24 April, and were met by Jabr Ibrahim, Donny George and Nawalla al-Mutawalli. We
also made contact with Captain Jason Conroy, who was in charge of the site, and Colonel
Matthew Bogdanos, who was in charge of the US investigation. We camped outside
the Museum overnight, and on the next day (25 April) made a careful inspection of the
public galleries in the Museum. At this stage nothing had been done to draw up a list of
missing objects, and there were no realistic plans for drawing up an inventory. Everybody
appeared to be still in shock. I made with Donny George a list of the major missing
pieces. On the afternoon of 26 April, Donny and I left Baghdad bound for London, so
that Donny could describe to the world's media what had happened at a hastily convened
press conference at the BM. After we left Baghdad, Dan Cruickshank and his team stayed
for a few more days to make their film. When it was released in due course it suggested
that the staff of the Iraq Museum had in some way been complicit in the looting. I was,
and still remain, quite convinced that this was not the case, and am of the view that the
senior Museum staff acted entirely honourably throughout this difficult period.

(8) On 29 April 2003, a seminar entitled 'International Support for Museums and
Archaeological Sites in Iraq' was held at the BM, organised by Joanna Mackle and
Hannah Boulton of the Communications Department. It was attended by Tessa Jowell,
Minister of Culture, and Donny George, freshly arrived from Baghdad. George gave a
graphic account of the looting of the Iraq Museum to many representatives of the media
assembled from all around the world. It was now that the list of 47 important objects
mostly missing from the galleries was made available for the first time.

Dr Donny George made the following proposals,[1] which were endorsed by all
present:

1. Staff salaries to be paid by the Office of Reconstruction and Humanitarian Assistance (ORHA),
and an urgent review of salary scales to be undertaken.

2. Staff numbers in the State Board of Antiquities and Heritage to be restored to full strength, ie
c 400 archaeologists, c 1600 guards, c 600 technicians, ie c 2600 staff in the whole country.

3. New equipment and facilities needed (ORHA?): cars, computers and printers, scanners, cameras,
furniture throughout the Iraq Museum, structural repairs to the Iraq Museum, showcases, security
systems, climate control in the Museum, controlled storage, conservation laboratory, photographic
studio, e-mail network.

4. Check of sites and monuments to be undertaken by staff of Iraq Department of Antiquities and
all damage to be recorded within a six-month period. In cases of war damage, results to be verified by
ORHA nominees. Results of survey to be published.

5. List of objects stolen from sites and museums to be drawn up.

6. Conservation assessment (of objects in Iraqi museums) to be undertaken by senior conservator nominated by the BM.

7. Conservation materials to be ordered and supplied.

8. Teams of conservators to be sent to Iraq to work with local conservators.

9. Small groups of curators to be sent to Baghdad to assist with audit of objects in storerooms.

10. Training programmes to be established in conservation and archaeology.

11. Relevant books and publications to be donated to Iraqi institutions.

12. Foreign assistance in addition to ORHA to be coordinated through the BM in consultation with UNESCO and in collaboration with the Iraqi Department of Antiquities.

13. The journal *Sumer* to resume publication as soon as possible.

14. Resumption of archaeological and ethnographic work by the Department of Antiquities.

15. Resumption of archaeological work by foreign teams, following the model established in the 1980s but with more involvement of Iraqi colleagues.

16. A separate plan of action to be drawn up for libraries and archives.

(9) Neil MacGregor was a member of the United Nations mission to Iraq between 17 and 18 May 2003, which inspected the Iraq Museum and various monuments in Baghdad, and drew up a list of recommendations.

http://portal.unesco.org/culture/en/ev.php-URL_ID=14659&URL_DO=DO_
TOPIC&URL_SECTION=201.html

(10) From 6 June to 31 August 2003, Sarah Collins (BM) was seconded to the Coalition Provisional Authority (CPA, formerly ORHA) in Baghdad and worked with the Ministry of Culture acting as a liaison person between the USA State Department and officials in the Iraq Museum. She earned high praise from the State Department for her efforts. For a similar period, Helen MacDonald (British School of Archaeology in Iraq) was also seconded to the CPA and, as well as helping the curators in the Iraq Museum sort out the damaged records, she worked with the military in the Babylon area, advising on the protection of ancient sites.

(11) In the period 11–26 June 2003, a four-person BM team (John Curtis, Dominique Collon, Birthe Christensen and Ken Uprichard) visited Iraq with the following objectives:

(i) To assess damage and loss in the Iraq Museum.

(ii) To examine the circumstances of the looting.

(iii) To assess the conservation work needed in the Iraq Museum.

(iv) To assess damage and loss in the Mosul Museum.

(v) To visit selected archaeological sites (Babylon, Nimrud, Nineveh and Balawat).

Following the trip to Iraq, Birthe Christensen produced a report entitled *Conservation needs in Iraq Museum, Baghdad*. She proposed a programme of international conservation assistance to be delivered in three phases as follows, taking into account the needs for training requested by the Iraqi conservators, and the damage assessment of objects as described in the report. Her conclusions are summarised here:[2]

PHASE 1

Four Iraqi conservators will receive two months' intense conservation training in London during August and September 2003. The areas to be covered are: stone, ceramics, ivory/bone, cuneiform tablets, coins, conservation science and materials, general conservation (management). Part of the training programme will include visits to other museums (outside London) with conservation workshops. The essential training element is hands-on conservation and practical experience.

PHASE 2

A team of 6–8 conservators (led by the BM) selected from the international community will join the Iraqi conservators in Baghdad for ten weeks from October 2003. They will predominantly carry out conservation work on damaged objects as identified in the BM report and prioritised by the Iraq Museum and continue the training of local conservators. It is anticipated that the conservation skills most likely required are: stone conservators, ceramic conservators, organic (ivory/bone) conservators, metal conservators. Offers of help have already been received from, amongst others, the Getty Institute (Los Angeles), the Louvre (Paris), and the Vorderasiatisches Museum (Berlin). Many individual conservators have also expressed an interest in helping with the conservation of Iraq's heritage. The final team of international conservators will be selected following traditional recruitment processes. The selection team will be chaired by the BM and encompass experienced conservators from the UK. It is envisaged that the international team of conservators will be sent to Iraq under BM leadership and under the auspices of UNESCO.

PHASE 3

A senior BM conservator will visit Baghdad to evaluate the success and the impact of the international help programme in October 2004 towards clearing the conservation backlog created by the recent war. The visit will also be an opportunity to discuss any long-term conservation help and re-establish and maintain contact between the international conservation community and Iraq.

CONSERVATION WORKSHOPS

The conservation workshops in the Iraq Museum will be refurbished and re-supplied by the Italian Ministry of Cultural Heritage and Antiquities during August and September. The plan is that the workshops will be operational by October when the international conservation team arrives in Baghdad. The BM coordinator is kept fully informed on the progress of the refurbishing of the workshops and the type of equipment and materials that will be available in Baghdad.

CONSERVATION LIBRARY

The conservation library in the Iraq Museum was small and it is recommended that the international conservation community may wish to help build a professional library by either donating books or funds towards books, and/or by translating texts into Arabic. This is also to be coordinated by the BM, although it is hoped that the United Kingdom Institute of Conservation (UKIC) will take over as the coordination body for this tranche of help in liaison with the BM overall project coordinator. Generous offers of donations of books have already been pledged by the Getty Institute, V&A, UKIC and BM.

ADDITIONAL AREAS TO BE COVERED (OUTSIDE THE SCOPE OF THE BM)

The BM has not been in a position to cover all areas requiring conservation help from the international community. Much remains to do be done in the following areas: Conservation of historic monuments (eg churches, sculptures etc): Building conservation and restoration (eg Saddam's palaces): Archaeological sites: Conservation of archaeological structures (eg standing elements in Nineveh): Paintings conservation (eg modern museum in Iraq): Paper and book conservation (eg libraries, archives, manuscripts).

(12) A session at the 49th Rencontre Assyriologique held at the BM was devoted to 'Looting and Aftermath: the Lost Heritage of Iraq' (7 July 2003). A number of Iraqi colleagues were present. On the next day (8 July) there was a press update on the subject, attended by 16 selected journalists, and on Friday 11 July, Matthew Bogdanos gave an update on the situation at the Iraq Museum.

(13) Three conservators from Iraq (Buthayna Hussain and Tagried Khedher from the Iraq Museum in Baghdad and Sakeina Welli from the Mosul Museum) spent the period 27 January – 27 March 2004 at the BM. They had the opportunity to work in various sections of the conservation department (stone, metals, organics, ceramics) and were also able to consider questions such as storage, environmental conservation and testing of materials for display purposes. Pieces for them to work on were specially chosen to reflect the challenges they would face in Iraq. While the Iraqi conservators were at the BM, the opportunity was taken to organise a round table conference on 19–20 February. BM staff and the Iraqi conservators were joined by representatives from the Berlin State Museums (Uta von Eickstadt), the State Hermitage in St Petersburg (Svetlana Burshneva)

and the Metropolitan Museum of Art (Larry Becker, Jean-Françoise de Laperouse, Bob Koestler). The Louvre in Paris sent its apologies. The purpose of the seminar was for the international team of conservators to establish common ground and discuss the various issues that would be facing them in Baghdad. It was also an opportunity for all the parties to meet and discuss best approaches and thereby be able to give the best advice to the Iraqi colleagues on how to proceed with the conservation of damaged objects. Particular case studies were considered in depth. This was possible because Buthayna had brought with her images of objects from the Iraq Museum, including pictures of ivories and gold from the bank and general items in both the new and old stores.

(14) At the invitation of Iraqi Minister of Culture Mufid al-Jazairi, I joined a meeting at Babylon, between 11 and 13 December 2004, convened prior to its handover by the Coalition forces to the Iraqi SBAH. The meeting was called to consider a condition report prepared by archaeologists attached to the Polish military. I was asked by Dr al-Jazairi to prepare an independent assessment. It was clear that during its occupation by military forces and its use as a military camp, Babylon had suffered substantial damage. This damage was detailed in a report that was published on the BM website on 15 January 2005 (www.thebritishmuseum.ac.uk/the_museum/news_and_debate/debate/iraq_war/summary_of_activity_2005-6.aspx) and attracted a great deal of press interest all around the world. The report concluded:

> (i) About one dozen trenches, the largest 170m long, and about one dozen cuttings, have been made both into previously undisturbed archaeological deposits and into tips or mounds from earlier excavations. In these trenches were found pottery (including a complete vase), bones and fragments of brick with cuneiform inscriptions.

> (ii) About 300,000 square metres of the site have been covered with gravel, sometimes compacted and chemically treated, to be used as a helipad and to create spaces for vehicle parks, accommodation, storage, etc. All the gravel has been brought in from elsewhere, and will in due course work its way into the archaeological deposits, irrevocably contaminating them.

> (iii) Around the site are thousands of sandbags and HESCO barriers that were originally filled with earth scooped up from the Babylon archaeological site (the presence of sherds and bones in the bags is a testimony to the archaeological nature of the deposits used) and from 3 November 2003 onwards, filled with sand and earth brought in from outside Babylon, sometimes no doubt from archaeological sites, thus exacerbating the problem even further.

> (iv) In many parts of the site are wheel marks deriving from the movement of heavy vehicles, and damage is also likely to have been caused by the extensive helicopter traffic at the site.

> (v) There is evidence of environmental pollution (fuel seepage) in the area of the Fuel Farm. This is likely to have a deleterious effect on the archaeological deposits beneath.

> (vi) There is damage to nine of the moulded brick figures of dragons in the Ishtar Gate, in one case serious damage to the body of the figure.

(vii) The brick pavement in the southern part of the 6th-century BC Processional Way has been broken by driving a heavy vehicle along it.

(viii) Parts of the roof of the (reconstructed) Ninmah Temple have collapsed.

And its principal recommendations were:

(i) A full-scale international investigation should be launched into the damage done to the archaeological site of Babylon during its occupation by Coalition forces.

(ii) All disturbed areas should be investigated, recorded and published by archaeologists appointed by the Iraqi Board of Antiquities and Heritage.

(iii) The Iraq Government should be urged to propose Babylon for inclusion on the UNESCO list of World Heritage Sites as soon as possible.

(iv) Once there has been a proper assessment of the damage, the international community should provide every assistance to the State Board of Antiquities and Heritage to enable them to draw up a site management plan for Babylon.

(15) One of the recommendations of my report about Babylon had been that we should offer training to three Iraqi colleagues from Babylon. As a result, Dr Mariam Umran Moussa, Mr Haidar Abdul Wahid Urebi and Mr Raad Hamed Al-Amari came to the BM for the period 30 March–27 May 2005, funded by the Foreign and Commonwealth Office. Under the direction of Sarah Collins, the Museum organised a variety of courses, visits and talks with particular reference to site assessment and management, in association with the World Monuments Fund, English Heritage and the Institute of Archaeology, UCL.

(16) International Training Programme. Two Iraq Museum curators, Mehdi Ali Rahim and Ibrahim Hasan Faraj, joined the International Training Programme at the BM in July/ August 2006. This is an annual programme that provides training for curators principally from areas of the world in which the BM is closely involved, namely the Middle East, China and Africa. During the course of the four weeks at the BM, participants receive training in all aspects of museum work including security, conservation, scientific research, organising loans, the collections database, photography, learning and interpretation, and information technology, and make regular visits to the department that is hosting their visit.

(17) I have attended all UNESCO conferences in my capacity as UK representative on the IIC Group (UNESCO International Iraq Committee), those mentioned, plus Tokyo (31/7/03 – 2/8/03), Paris (22/6/05 – 23/6/05) and Berlin (22/11/05) and other major conferences in New York (6/5/03), Bonn (26/5/03) and Brussels (4/12/03 – 5/12/03).

(18) Irving Finkel has been active in attempts to combat the illicit trade in Iraqi antiquities. This has involved working closely with the Art and Antiques Unit at Scotland Yard (and see Rapley, chapter 6) and with HM Customs. The work has included lecturing to policemen from forces around Britain and organising in 2004 workshops in the BM for customs officers from around the UK. Some 60 officers attended. They were given a series of introductory talks by BM curators, as well as gallery visits and the opportunity to handle and examine classic material of the type that could be expected to surface at ports and airports, such as cuneiform tablets, cylinder seals and Aramaic magic bowls. Also, since 2003, Dr Finkel has been a member of the small Interpol Experts Group (IEG) on Stolen Cultural Property, which has met annually at Interpol Headquarters in Lyon, with responsibility for Iraqi and other material. The group consists of the heads of international police forces, FBI agents, representatives of ICOM and UNESCO and other highly-placed individuals. It serves to pool information and initiatives, focus attention on shared expertise and electronic resources, and issue recommendations for priorities and action that is disseminated throughout the world's Interpol stations and elsewhere.

(19) Various curators in the BM, particularly myself and Sarah Collins, have delivered gallery talks and lectures on the state of the Iraqi cultural heritage, given television, radio and press interviews, and advised some of the many people who are now researching the whole question of damage to the Iraqi cultural heritage.

(20) Following a lecture at the BM on 16 November 2006 by Dr Donny George on 'Iraq and Archaeology', there was a discussion with his successor as Chairman of the State Board of Antiquities and Heritage, Dr Abbas Ali Abbas al-Hussainy. After this discussion, Neil MacGregor announced that an eight-point protocol had been agreed, outlining the range of assistance that the BM would attempt to provide to the Iraqi SBAH.

PROTOCOL

1. To receive two Iraqi curators every year on the BM's curatorial training programme.
2. In partnership with the Iraqi Embassy in London, Scotland Yard, and the SBAH, to help with the identification and repatriation of looted Iraqi antiquities.
3. To help with the conservation of objects in the Iraq Museum, particularly ivories.
4. To supply copies of BM books to the Iraq Museum library and to Al-Qadissiya University.
5. To provide help and advice with the restoration of provincial museums in Iraq, particularly Diwaniya, Nasiriya, Nejev and Mosul.
6. To encourage the establishment of an international museum in Baghdad.
7. To advise on the creation of a 'mobile museum' outside Iraq.
8. To collaborate on setting up a Samarra database.

(21) Following on from reports of interference with antiquities at Ur of the Chaldees, a joint visit to the site was proposed by Dr Donny George, then Chairman of the State Board of Antiquities, and myself, but this visit had not taken place by the time of Dr George's departure for the USA in summer 2006. It was possible, however, to visit Ur in February 2007. The site is now incorporated within the perimeter fence surrounding Tallil Airbase, and I was able to spend the period 21–23 February 2007 in the airbase. The intention had been that I would undertake a condition assessment with Dr Abbas al-Hussainy, then Dr George's successor as Chairman of the State Board of Antiquities and Heritage, but unfortunately although they came down from Baghdad especially for this, Dr Hussainy and his colleagues were not allowed to enter the airbase and visit the site. In the circumstances, a detailed examination of the site would not have been appropriate, but so far as I could see there was no evidence of significant recent damage on the site itself. However, I was able to confirm Iraqi reports that the façade of the ziggurat had sustained shell and bullet damage presumably during Operation Desert Storm in 1991. More seriously, a new front gate (Visitor Control Centre) to the airbase compound has been built right on top of one of the suburbs of ancient Ur, known as Diqdiqqa. Although there have never been proper archaeological excavations at Diqdiqqa it is potentially a rich and interesting site and much damage will have been done by the construction of the Centre (The British Museum 2007).

(22) At the invitation of the British Museum, Dr Abbas al-Hussainy, Chairman of the State Board of Antiquities and Heritage in Iraq, visited the UK in early June 2007. He gave a lecture at the British Museum on 7 June entitled 'The Archaeological Heritage of Iraq: Opportunities and Challenges'. Dr Abbas described how in addition to attacks on historic shrines by religious extremists some monuments were being allowed to deteriorate through neglect. The Iraq Museum was still closed, even though a new security door had been installed. Many sites, particularly in the south, had been extensively looted, although Dr Abbas believed that such looting was now decreasing, partly because of his engagement with the south of Iraq and his involvement with archaeological projects, particularly at Marad. A recent serious problem had been attempts by Coalition troops to force their way into the Iraq Museum. During the visit of Dr Abbas the opportunity was taken to discuss with him the present requirements of the Iraqi SBAH (The British Museum 2007).

(23) At the time of writing, nearly five years after Coalition troops invaded Iraq, the Iraq Museum is closed, with the doorways to the storerooms bricked up, some 8000 objects remain unaccounted for, archaeological sites in the south continue to be looted, and military activities have damaged iconic sites such as Babylon and Ur. There is a pressing need for action to protect and preserve the Iraqi cultural heritage, particularly conservation work on sites, monuments and material in museums and libraries. Unfortunately, the deteriorating security situation has hampered the efforts of the international community to provide assistance to their Iraqi colleagues. Nevertheless, as declared by Neil MacGregor

in 2003, the BM stands ready to offer to the Iraq Museum, if it is wanted by the Iraqi side, as much conservation and curatorial assistance as it can reasonably provide. We will also continue to draw attention to ongoing problems at every opportunity.

NOTES

1. These proposals are presented here as part of the historical record, and to demonstrate the state of thinking at that time. It has not, of course, been possible to implement most of these proposals.
2. As with the proposals of Donny George made on 29 April 2003 (see footnote 1), it has not been possible to implement these recommendations, mainly because of the deteriorating security situation.

REFERENCES

The British Museum, 2007 [online] available from http://www.thebritishmuseum.ac.uk/the_museum/news_
and_debate/debate/iraq_war/summary_of_activity_2007.aspx [26 October 2007]

The European Response to the Destruction of the Iraqi Cultural Heritage (Germany)

MARGARETE VAN ESS

I. GERMAN ARCHAEOLOGICAL ACTIVITIES IN IRAQ

The work of German specialists in Ancient Near Eastern Archaeology and Philology in Mesopotamia, and especially in Iraq, date back to the end of the 19th century, when the German Oriental Society (*Deutsche Orient-Gesellschaft*) began excavations in Babylon followed later by excavations in Fara and Assur. While World War I temporarily halted work, efforts were made to continue this work as soon as Germany's political and economic situation again allowed the undertaking of projects in foreign countries. Excavations in Uruk-Warka (southern Iraq), which were initiated in 1912/13 and after World War I continued from 1927 until 1939, played a special role in the future of German research in Ancient Near Eastern Studies (see Plate 9).

The idea of founding a branch of the German Archaeological Institute in Baghdad (henceforth: DAI-Baghdad) arose during the inter-war years. However, World War II again interrupted research and cultural cooperation. In 1955, shortly after excavations at Uruk had been resumed, the DAI-Baghdad was finally established. Its directors not only focused their archaeological attention on Uruk, but also resumed work in Babylon and started short-term field work at several sites throughout Iraq as well (Deutsches Archäologisches Institut – Orient-Abteilung 2005).

From its very beginnings, the Institute in Baghdad saw its role not only in field work, but also as a cultural institution that cooperated with several Iraqi and foreign institutes in Iraq. Until the establishment of Ancient Near Eastern Studies in the College of Arts at the University of Baghdad, some rooms in the DAI-Baghdad were used for teaching this subject to Iraqi students. The close cooperation with Iraqi institutions was acknowledged when in 1973 the Institute was explicitly accredited in the Iraqi Law No. 132, Article 6 and 8, on foreign and Arab cultural institutions (amendment in the *Iraqi Law Gazette* 2253, 9 June 1973). However, opportunities for cultural activities became more difficult some years later. The political situation following the outbreak of the Iraq–Iran war in 1980 made it necessary to relocate parts of the Institute to Berlin. Nonetheless,

DAI- Baghdad was never closed. Thanks to the enthusiastic and well-organised help of several Iraqi colleagues and local employees of the Institute, research and cultural activities have continued with only brief interruptions until recently.

In 1996, the former 'Baghdad Department of the German Archaeological Institute' was integrated into the newly established 'Orient Department' (*Orient-Abteilung*) of the DAI. It administers the DAI's archaeological field work in the countries of Iraq, Yemen, Jordan, Lebanon, Saudi Arabia, Syria and the Gulf States (http://www.dainst. org/abteilung.php?id=270&sessionLanguage=en).

Whereas the DAI-Baghdad conducted numerous projects and coordinated several official and administrative bilateral projects, there were of course other German institutions that were engaged in archaeological field work as well. In 1988 the German Oriental Society, for instance, resumed field work in Assur, which it had carried out between 1903 and 1914, and in 1973 the University of Munich, in cooperation with the Bavarian Academy of Science, started excavations in Isin (Hrouda *et al.* 1992). Work in Isin was stopped in 1989 and switched to Assur in order to support excavation teams of the Iraqi State Board of Antiquities and Heritage (SBAH). There, rescue excavations by the SBAH had already started in preparation for the planned construction of the al-Fatah dam. Field work in Assur continued, with many interruptions due to several military conflicts, until autumn 2001 (Miglus 2001).

Research in Uruk suffered a similar fate. Field work was possible until the mid-1980s, and again in 1989/90, and from 1999 until 2002. Time was used mainly to focus on several surveys within the huge city. A systematic archaeological survey was carried out in 1982–1984 (Finkbeiner *et al.* 1991) and, in augmentation of the archaeological survey, magnetometric measurements and geological drillings were initiated in 2001 (van Ess *et al.* 2005). Unfortunately, they were interrupted by the war of 2003. These undertakings have enabled a better identification and more exact definition of the entire urban structure, the different sections of the city and their functions (see Plate 10). Furthermore, in 2000 a long standing agreement of cooperation with the Department of Archaeology at the College of Arts of the University of Baghdad was put in place. This involved an archaeological survey of Sippar, a long-term excavation site of the University, and was carried out in 2000 with, and under the direction of, the College of Arts of the University in Baghdad. The work was aimed at introducing students of the Department of Archaeology to advanced survey techniques and digital documentation. It later led to precisely targeted excavations by the University of Baghdad in 2002 (Fadhil and al-Samarraee 2005).

II. ARCHAEOLOGICAL RESEARCH IN URUK-WARKA: AN EXAMPLE OF GERMAN ENGAGEMENT

Uruk-Warka, situated c 300km south of Baghdad, is one of the oldest metropolises of the ancient world. It was inhabited from c 4000 BC to c AD 400 and is renowned as the city where the earliest writing was developed to an advanced level, where the oldest known epic, the Epic of Gilgamesh, took place, and where early forms of state and structured administration reached sophisticated levels.

The metropolis of Uruk, also known as the Biblical Erech, today named Warka, probably evolved from two settlements, Eanna and Kullab, which were located on both sides of the Euphrates river and for which there is evidence as early as c 4000 BC. The city rapidly grew into an integrated urban configuration and at its largest covered an area of 5.5km² around 3000 BC. This made the enclosed city of Uruk the largest known in the ancient world, an accolade it retained until the 6th century BC, when the city of Babylon occupied an even larger area. A huge sacred precinct formed the city's centre. This was surrounded by several living quarters and gardens, which were interconnected by canals and accessible through streets. The city obviously played a major political role during the 4th millennium BC: at the end of the millennium not only did it control the neighbouring cities and villages, but its political system influenced regions as far away as northern Syria, southern Turkey and western Iran.

Uruk gained its power through the specifics of southern Iraq: the extraordinarily flat, alluvial landscape and extremely hot climate. Life was only possible along the rivers or in areas with access to irrigated land. The creation of an organised system of water management was therefore indispensable, and it was obviously the responsibility and role of the city of Uruk to develop the system to an adequate level and to control it. The more complex the management of the water and, dependent upon that, agriculture, became the greater the necessity for a well-functioning and extensive administration. People began to specialise in various spheres of work. Social structure in Uruk and its environs became hierarchical to an extent unknown elsewhere. The introduction of this political structure, which ultimately required the invention of an advanced script that originally was used exclusively for 'memorising' complex administrative processes, was the key contribution of Uruk to the development of human society.

Uruk was inhabited for nearly 5000 years. It became a well-structured city with two major sanctuaries – one for Anu, god of heaven, and another for Ishtar or Inanna, goddess of love and war. Yet, from the middle of the 3rd millennium BC onwards, it ceased forever to play an important political role. Nevertheless, the city prevailed and was renowned for its knowledgeable and scholarly-active priesthood. For approximately 3000 years, the importance of early Uruk remained in the memory of the whole of Mesopotamia. The deeds and inventions of the kings of Uruk were narrated in epics, the most prominent of which is known to us as the oldest in the world – the Epic of Gilgamesh. Through these early narratives we learn about mystic events and cultural endeavours of the rulers of Uruk, and, in addition, we can gain information about the layout of the city, information that can be confirmed today through modern survey techniques.

Research in Uruk has unearthed several thousand square metres of sophisticated architecture and archaeological remains. The largest ensemble of temples and public buildings of the so-called Uruk period (second half of the 4th millennium BC) is to be found there.

However, despite the enormous efforts in archaeological research, excavations have nonetheless touched, thus far, less than 5% of the inhabited area of the city.

III. German response to the destruction of Iraqi heritage

In the winter of 2002/2003, during the lead-up to the 2003 invasion, colleagues and staff of German institutions who had long been concerned with ancient Near Eastern archaeology, art history and philology in Iraq attempted to maintain direct contacts with Iraq. This led to their focus on informing the public and decision-makers about the magnitude and importance of the Iraqi national cultural heritage and about the possible threat to this heritage by war and its aftermath. A long summary of the German and international press, for instance, has been published by Ulrike Löw (Löw 2004a; 2004b). There she provided information about international preparations and warnings concerning the safeguarding of the cultural heritage of Iraq before the war. She summarised the reports on the looting in April 2003 of the National Museum in Baghdad and other cultural institutions in Iraq, as well as on the plunder and/or military use of archaeological sites. She also analysed the various sources and kinds of information and from whom they were derived (governmental institutions, civilians, press) and the origins of exaggerations of data. She further reported on the correct data at the time of publication as to what and how much was stolen from the Iraqi National Museum and commented on the politicising of the reports on plunder.

Since April 2003, many projects and strategies to support and protect the cultural heritage of Iraq have been developed. In 2003 they were coordinated at a national level through regular meetings at the invitation of the German Federal Foreign Office. The meetings have mainly involved staff from German universities and the State Museums: Prussian Cultural Heritage in Berlin, the Roman-Germanic Central Museum in Mainz and the German Archaeological Institute in Berlin. Since then, several projects have been carried out, and some are still continuing today, in cooperation with the University in Baghdad and the State Board of Antiquities and Heritage. These efforts are summarised below.

1. Technical support for the State Board of Antiquities and Heritage (SBAH)

In April 2003, not only the stores and exhibition halls of the Iraq National Museum were looted and vandalised, but so also were all administrative features of the SBAH. Office equipment was stolen or damaged, therefore rendering it no longer usable. Thanks to German Foreign Ministry funding, in the winter of 2003/2004 Germany sent 70 German-made storage cabinets (plan cabinets) to the SBAH, which were intended for storing part of the unique cuneiform tablet collection. Fortunately the collection had been spared from looting, but had suffered in the past from difficult and inadequate storage facilities. In keeping with the wishes expressed by the Museum's staff, the tablet collection is to be transferred to these plan cabinets. In accordance with the special requirements for the preservation of archaeological objects, polystyrene foils and plates were supplied also for the shock-proof storage and transportation of the tablets and other objects.

A small-scale but nevertheless important project in the winter of 2004/2005 comprised the replacement of locks for the showcases of the Iraq Museum. A large number of the showcases had been bought from Germany some decades ago. The majority were not

damaged and were still in good condition, but the fate of their keys since April 2003 is unknown. Therefore new locks were acquired to enable continued use of the showcases. This project was jointly funded by the Museum of the Ancient Near East in Berlin and the German Federal Foreign Office. The German Archaeological Institute assumed the organisation of the project.

In consultation with the SBAH, in the winter of 2005/2006 a large-scale scanner and plotter, as well as storage materials for the paper and photo archives were provided. The plan is to train the staff of the SBAH in the professional use of this machinery and through this to support the staff in duplicating and, thus, preserving original documentation and cartography in the archives of the SBAH. Both areas suffered greatly from the overly dry air which resulted from the lack of proper air conditioning and electricity during the embargo on Iraq and from damages caused during the lootings in April 2003.

2. Provision of guards for archaeological sites

One of the major concerns is the protection of archaeological sites in Iraq. In the province of al-Muthanna, where Uruk is located, contact between the DAI-Baghdad, the local tribes and the guards is still possible. Thus far the site of Uruk has remained more or less untouched.

In 2004, the Iraqi Ministry for Culture hired 1700 additional guards to attempt to safeguard the country's archaeological sites. The German Federal Foreign Office supported this action with 175,000 euros in order to enable the SBAH to cover additional or unexpected costs of the programme with minimal bureaucracy. The project was organised through UNESCO.

3. Books

During April 2003, a large number of libraries throughout the country were looted and burned. One of these was the German library in the University of Baghdad, which was completely destroyed. Germany launched an initiative to rebuild this library as well as to update the libraries of the departments of archaeology at the University of Baghdad, the University of Mosul as well as the library in the State Board of Antiquities and Heritage. This initiative was launched at the Frankfurt International Book Fair. In close correspondence with staff in the Iraqi libraries, the Goethe-Institute and the German Archaeological Institute compiled lists of the books of importance for these libraries. For organisational reasons, the focus was on German publications. This initiative brought together a group of specialists from several German research institutions, such as the German Federal Foreign Office, the organisers of the book fairs in Frankfurt and Leipzig, the Association of German Booksellers, the Goethe-Institute, the German Academy for German Language and Poetry, the Bavarian State Library, the German Archaeological Institute, the World University Service, several German universities, the German Research Foundation, the German Academic Exchange Service and the Union of the German Academies of Sciences. Moreover, many private donors offered help, financial support and books. Around 140 well-known authors of modern German fiction, poetry and modern

non-fiction literature offered copies of their works with a personal dedication. Students of the University of Oldenburg bought their favourite books and dedicated them with a personal greeting to Iraqi students.

Finally, on 2 September 2004, some 11,000 books were presented to the Faculty of German Language and the Faculty of Arts, Department of Archaeology, in Baghdad. The German Federal Foreign Office supported this project with 200,000 euros. The collection and purchase of archaeological books is to be continued. The collection point for books is the German Archaeological Institute in Berlin.

Here it is with great sadness that we mourn the death of Professor Fuad Muhammed, the Iraqi co-organiser of this project and professor of German language at the University of Baghdad, who was deliberately targeted on 20 April 2005, most probably because of his engagement and contact with foreign institutions.

4. TRAINING OF SPECIALISTS IN WORKSHOPS

In 2005, in cooperation with institutions in France, Germany and Jordan, as well as with UNESCO, the Japanese International Cooperation Agency offered two six-week cultural heritage training courses in Jordan for Iraqi scholars in February and March, and in September and October respectively. The aim of the programme was to introduce the participants to different conservation, preservation and management methodologies regarding sites and monuments. German scholars presented theoretical and practical introductions to their own projects in Jordan, especially those concerning the preservation of stone in Petra and the excavations and site management in Gadara/Umm Qais. Another theme was the preservation and maintenance of stone and brick architecture. The German contribution to the funding of this programme was provided by the German Federal Foreign Office. The German Archaeological Institute and the German Embassy in Amman, Jordan, assumed the organisation of the German part of the programme.

Long-term training programmes are currently being developed on special techniques and methods in archaeological field work as well as in the conservation and management of archaeological sites. Furthermore, cooperative work in research programmes, such as the joint publication of Iraqi-German excavations and research studies, which are carried out in Germany, have been initiated. In addition, efforts towards the involvement of Iraqi scholars in national and multi-national research projects have commenced.

5. GRANTS FOR LONG-TERM STUDIES IN GERMANY

The German Academic Exchange Service (DAAD) has launched two special programmes. In 2005, 40 scholars from Iraqi universities, representing all scientific disciplines, were invited to spend a period of three months on scholarship in Germany. This special programme was organised in cooperation with UNESCO and a foundation of the State of Qatar. With additional funding provided by the German Federal Foreign Office, around 70 long-term scholarships for Iraqi graduate students were awarded, two of them to graduate students engaged in Ancient Near Eastern Studies. Each year the German Archaeological Institute offers between four and ten invitations for a two-month stay

in Berlin to graduates from Near Eastern countries. At this time, the majority come from Iraq. The programme aims to provide scholars based in Berlin with the opportunity to participate in projects, pursue their studies and become involved in discussions with colleagues from all over the world.

6. Research on methodology of systematic analysis of satellite imagery

In 2005, the German Archaeological Institute, in cooperation with the German Remote Sensing Data Centre, the Department for Geophysics at the Bavarian State Department for Historical Monuments, the European Space Imaging Company and the Definiens Imaging Company, carried out a joint research project. Funding was again provided by the German Federal Foreign Office. The aim of the project was to demonstrate whether very high resolution optical space imagery – such as that from IKONOS – when fused with traditional maps and geophysical ground surveys, can support the mapping and even detection of archaeological features. A further question was whether space images taken before and after military conflicts can be used to detect looting activities and, specifically, whether there are looting activities in Uruk. A third issue was whether semi-automated image analysis software, such as the object oriented approach in eCognition, can support this process and even find new structures through space imagery (van Ess *et al.* 2006, see Plate 11).

7. Legislation in Germany

The war and its devastating impact upon the cultural heritage in Iraq, such as the plunder of the Iraq National Museum or the looting and destruction of archaeological sites, have shown that quite often national legislation is not sufficiently capable of supporting the safeguard of the cultural heritage of a country. Germany was one of the countries which, after more than 35 years, had still not ratified the 1970 UNESCO *Convention on the Means of Prohibiting and Preventing the Illicit Import, Export and Transfer of Ownership of Cultural Property*. In 2006, a proposal for an act that would implement the UNESCO Convention into German legislation was introduced to the German Cabinet and this finally became law on 18 May 2007. Through this law, the worldwide problem of the destruction of cultural heritage through the looting of sites will receive, at last, the necessary recognition in German legislation under which criminals can be prosecuted – politically, an immensely important step. In comparison with the older legislation of some other countries, the German law for the implementation of the 1970 UNESCO Convention is one of the more progressive and explicit. The law includes paragraphs that explicitly deal with the problem of illegal excavation. Although, of course, the problem of illegal excavations will not be solved as the 1970 Convention itself is mainly focused on declared national cultural heritage.

In addition, we analysed the state of implementation of paragraph 7 of the UN Resolution 1483 of 22 May 2003, dealing particulary with Iraqi cultural heritage, into German legislation (van Ess and Schoen 2006). Although an acquired ownership of Iraqi cultural goods is scarcely possible in Germany, the legal situation is so complicated as a

result of both the revised version of the German Foreign Trade Act of 6 April 2006 and the entwinement of German national law with EU law, that it is almost imperceptible.

These particular legal issues aside, the main task of all archaeologists in Germany in the future will be to increase public awareness of the disastrous situation currently unfolding in Iraq.

BIBLIOGRAPHY

Deutsches Archäologisches Institut – Orient-Abteilung, 2005 *Deutsches Archäologisches Institut – Orient-Abteilung – Außenstelle Baghdad. 50 Jahre Forschungen im Irak 1955–2005*, Deutsches Archäologisches Institut, Berlin

van Ess M, Becker, H, and Fassbinder, J, 2005 Prospections magnétiques à Uruk (Warka). La cité du roi Gilgamesh (Irak), in *Dossiers Archéologie* 308, 20–25, Editions Faton S.A.S., Dijon

van Ess, M, Becker, H, Fassbinder, J, Kiefl, R, Lingenfelder, I, Schreier, G, and Zevenbergen, A, 2006 Detection of Looting Activities at Archaeological Sites in Iraq using Ikonos Imagery, in *Angewandte Geo-Informatik* 2006 (eds. J Strobl, Th Blaschke, G Griesebner), Beiträge zum 18. AGIT Symposium Salzburg 2006, 669–678, Wichmann Verlag, Heidelberg

van Ess, M, Schoen, S, 2006 Das VN-Handelsverbot von 2003 für irakisches Kulturgut: Folgenlos in Deutschland?, in *Archäologischer Anzeiger* 2006/1, de Gruyter, Berlin

Fadhil, A, al-Samarraee, R Z, 2005 Ausgrabungen in Sippar (Tell Abu Habbah). Vorbericht über die Grabungsergebnisse der 24. Kampagne 2002, in *Baghdader Mitteilungen*, 36, 157–224, Philipp von Zabern, Mainz

Finkbeiner, U, *et al*, 1991 Uruk. Kampagne 35–37, 1982–1984, Ausgrabungen in Uruk-Warka, in *Endberichte* 4, Philipp von Zabern, Mainz

Hrouda, B, *et al*, 1992 *Isin – Ishan Bahriyat IV. Die Ergebnisse der Ausgrabungen 1986–1989*, Verlag der Bayerischen Akademie der Wissenschaften, München

Löw, U, 2003 Die Plünderung der kulturellen Einrichtungen im Irak unter besonderer Berücksichtigung des Nationalmuseums in Baghdad, in *Mitteilungen der Deutschen Orient-Gesellschaft* 135, 13–56, Vier-Türme GmbH – Benedict Press, Münsterschwarzach Abtei

Löw, U, 2003 Raubgrabungen im Irak, in *Mitteilungen der Deutschen Orient-Gesellschaft* 135, 57–80, Vier-Türme GmbH – Benedict Press, Münsterschwarzach Abtei

Miglus, P A, *et al*, 2002 Assur – Herbstkampagne 2001, in *Mitteilungen der Deutschen Orient-Gesellschaft* 134, 7–34, Vier-Türme GmbH – Benedict Press, Münsterschwarzach Abtei

The Ongoing Work of the French Archaeological Institutes in the Middle East for Iraq

BERTRAND LAFONT

I admit immediately that it is difficult to settle down to writing about, as I have been asked to do, the role of the French archaeological institutes in the Near East, and especially in Iraq, when news of unprecedented levels of violence in Iraq appears on an almost daily basis, or when, while working on an early draft, in Beirut in August 2006, one realises that oneself is under bombardment.

Is it not somewhat obscene to prioritise research, archaeological cooperation and/ or heritage protection over the immediate and haunting issue of human suffering? Nevertheless, and perhaps now more than ever, present circumstances provoke reflection on what has been achieved in terms of heritage protection since the 2003 invasion of Iraq. Reflection is also required regarding the consequences of what is happening to the cultural heritage of the whole region: a heritage currently under risk of complete and sudden disappearance; a heritage which has instigated and justified the presence and the activity of permanent research institutes dedicated specifically to the archaeology and history of the region. Why are we here? What have we done? What can we do? What future awaits these institutes and their work which, for a century and a half, have brought so many researchers to this corner of the world from the opposite shores of the Mediterranean? In the present context, how can they work, what are their responsibilities on a personal as well as the collective level? These questions, in themselves, are also very daunting.

When, a century and a half ago in 1842, Paul-Emile Botta, newly appointed consul of France in Mosul, undertook his primary research on the site of Nineveh, he did not only inaugurate a new field of research which was to allow the Assyrians to re-emerge in history, but he also began a long period, almost uninterrupted since then, of a French presence and participation in the archaeology of Mesopotamian civilisations and the re-emergence of the ancient heritage of Iraq. The idea of permanent French institutes of archaeology stationed in these lands of ancient civilisations was born, a decade later, in 1853, when, after the initial enthusiasm followed by some disillusionment relating to the failure of new expeditions, Fulgence Fresnel, who was entrusted by the French government to revive the excavations, wrote: 'There is nothing to hope for in this country

in respect to archaeological results of very high interest to science and art, without the creation of a permanent establishment' (Chevalier 1987, 11).

Archaeology, we should not forget, was then an activity associated, in part, with colonisation. Because these ventures and activities appeared and developed at a time when colonial ideology was dominant, there were people to wonder about the nature of the relationship between archaeology and diplomacy, relations that remain quite real even now: we cannot deny nor forget that these archaeological activities, which are an expression of a real intellectual and scientific curiosity, have also contributed to the political environment of their time.

Many French institutes created in the Middle East region still exist today: in Istanbul, Tehran, Beirut, Damascus, Amman, Jerusalem, Sana'a, and Cairo.[1] Their establishment in these different capitals occurred over the course of an entire century (from 1880 to 1982), one of the latest having been that in Baghdad, to which we shall return. Since the beginning, the principal mission of these institutes has been, in each country in which they have been established, to help in writing the history of its origins and to try to address an increasingly pressing social demand: 'to know how to recognise and conserve the vestiges of the past, obtain knowledge from that past and pass this knowledge back to the public, mainly in the form of a national memory', a fact that gives the present archaeologists 'important social as well as political and ethical responsibilities' (Demoule 2005, 105).

At the beginning of the 21st century these institutes are still vehicles for the extension of knowledge and for collaboration between French, other foreign, and local researchers; they are tools facilitating cooperation based on dialogue and better knowledge of one another. And if they have acquired recognition over the long term, such recognition is primarily founded on the quality of their researchers' work as well as the confidence and strength of the links established at ground level with local partners. Their work and publications have resulted in the accumulation of a significant understanding of ancient civilisations and of the modern countries in which they are located.

These institutes research, conserve and protect, train, and disseminate knowledge, but they have also, over time, strengthened their cooperation with local agencies and governments in supporting the development of the various national archaeological agencies. And as this domain of activity touches on delicate questions of identity and development, archaeology must be seen as an eminently political discipline: it forms a foundation for the state as well as the people, for pride in oneself and therefore in any sincere project of cooperation. It is not wrong to maintain a belief in such values, such pride, at least as long as these activities – as the relationship between archaeology and politics – is developed within the framework of a real partnership founded on scientific and ethical rigour, and as long as they satisfy the ethical requirements of both parties.

If the early activities of the research institutes were mainly dedicated to archaeological, historical, or linguistic research, the *raison d'être* of this network of institutes has widened progressively, in what can be described as the 'post Edward Said' era, to embrace the totality of the social sciences. The institutes have accumulated, in the different countries

where they have been established, a significant documentary archive and a considerable intellectual heritage. In matters of archaeology, history and management of cultural heritage, their programmes and activities have recourse not only to local artistic traditions, such as stone cutting or mural painting, but also to increasingly advanced scientific techniques such as geophysical prospecting, computerised reconstruction of landscapes and ancient dwellings, mapping of previous natural resources, cultural and biological classification (DNA analysis) of the peoples and their past way of life, as well as enhanced methods for the conservation and protection of upstanding architectural remains.

Most of the excavations are conducted in cooperation with local teams and include a significant amount of training. The results of these research excavations are regularly published in journals and other publications, and are presented at conferences and expositions. The permanent French institutes have been able to make accessible to all interested researchers their considerable library resources, that include in addition to books and periodicals, major multimedia, picture and map collections (for an overview of all these activities, see Ministry of Foreign Affairs 2005).

IRAQ

For a long time, French archaeological activities in the Near and Middle East relied on the presence of the French Institute of Archaeology in Beirut (see Gelin 2005). Founded in 1946 under the instigation and direction of Henri Seyrig, this institute was initially housed in a beautiful 19th-century mansion in the Wadi Abu Jamil quarter in Beirut. It accommodated the director, visiting researchers, an administration, and a significant library formed during the time of the mandate. The institute also inherited two publications, the review *Syria* and the collection of the *Bibliothèque Archéologique et Historique* (*BAH*). These publications, which cover all research activities carried out across the Middle East, continue to appear regularly to the present day.

Since its inception in 1946, it was agreed that the activities of the new institute 'should extend to control the French excavations in Iraq', given the 'impossibility of establishing an institute in Baghdad' (Gelin 2005, 281, n.14). It was also considered to be an 'inevitable venue of exchange' for all those interested in archaeology and the ancient history of the Near East. In fact, Henri Seyrig recalled in 1959, in an assessment halfway through his tenure as Director:

A two-fold task was assigned to the Beirut institute: on the one hand, it should highlight and publish important archaeological documents not yet published and, on the other hand, pave the way for young French archaeologists, already specialised in the study of Lebanese and Syrian issues, to come over and complete their work in contact with the buildings and peoples of these countries. But another equally important function of the institutes is to put its rich library at the disposal of interested researchers. A number of local researchers frequent it, thus contributing to the dissemination of historical knowledge for which we observe in Lebanon an ever-growing curiosity. Besides, and in part thanks to this library, the institute is frequented by a large number of European and American archaeologists who stop in Beirut on their way to Syria, Iraq, Persia and central Asia. The passage of these scholars, often accommodated in the house whenever possible, creates a very varied movement of ideas whose benefit cannot be overestimated. (cited in Gelin 2005, 315–316)

It is impossible to better define the central role played for a long time, at regional level, by this archaeological institute of Beirut.

The Lebanese civil war of the 1970s brought with it the need for an extensive review of the workings of the Institute. The old house in Beirut was highly exposed and had to be evacuated in December 1975, just before it was looted (except for the library which was saved in time, together with a large proportion of the photographic archive). The Institute was re-housed on the campus of the *Ecole des Lettres*, on Damascus Street. In 1976, accepting the impossibility of carrying out scientific work in Lebanon, the incumbent director, Ernest Will, after having assured the safety of the library, transferred all work to Jordan and Syria. The name of the Institute was then changed to the French Institute of Archaeology for the Near East (IFAPO). Its activities were modified and work was developed in the field in Jordan (excavations of Iraq el-Amir, of Jerash, of Khirbet edh-Dharih) and research was continued in Syria while maintaining the publication, as regularly as possible, of *Syria* and the *BAH*. In Amman the institute was set up in Jebel Amman quarter and, in Damascus, in a house in the Jisr el-Abyad quarter where the creation of an archaeological library was started and where the remains of the picture library from Beirut were stored. It was during this period that links with French archaeological projects, that were becoming increasingly numerous and were working in Syria with Syrian partners, were reinforced.

At the same time as the French Institute of Archaeology for the Near East was being created in Syria, Jordan, and Lebanon, other centres were opened, among them a new centre in Iraq. Here, the long-term main French excavation was at Larsa, the large Sumerian archaeological site in southern Iraq, excavated since 1933 by André Parrot at first, then, starting in 1969, by Jean-Claude Margueron, before the latter handed over to Jean-Louis Huot in 1974. However, as Larsa deserved better than periodic research and because the Iraqi archaeological establishment favoured a policy of large development projects, which necessitated significant archaeological rescue projects, the French and Iraqi partners decided in 1977 to create the French Archaeological Delegation in Iraq (DAFIq), whose management was entrusted to Jean-Louis Huot (for the history of DAFIq and archaeological works in Iraq over the course of the last thirty years, see Huot 1987 and Breniquet and Kepinski 2001).

In response to urgent calls for international collaboration made by the Iraqi authorities, the opportunity was given to some French archaeologists to reside permanently in Baghdad within the framework of the French Archaeological Delegation in Iraq. This allowed a more structured and proactive French participation in the rescue projects, as well as in regular excavations.

Under this arrangement, over the course of 12 years during the construction of large dams on the Diala, Euphrates and Tigris rivers, French archaeologists were able to take part not only in the regular excavations of Larsa and Oueili, but also in three large rescue programmes undertaken in Iraq: Hamrin, Haditha and finally Eski Mosul. In each case, Iraqi calls for international assistance brought a large number of foreign teams ready to participate with their local colleagues in the study of these regions. Under these

circumstances several researchers have worked successively at the DAFIq in Baghdad and received field training in the archaeology of this region (Jean-Daniel Forest, Christine Kepinski, Oliver Lecomte, Axelle Rougeulle, Catherine Breniquet, Regis Vallet). Today, all are acknowledged professional archaeologists who maintain close relationships with their Iraqi colleagues. As long as this generation remains active, it can be relied upon to resume cooperation whenever such cooperation becomes possible.

However in 1990, due to the First Gulf War and echoing the awful events that had brought about the abandoning of Beirut in 1976, much to the distress of those who were hard at work, everything had to stop immediately. We are still waiting for the return of better days.

In 2003 a general reorganisation took place within the permanent French archaeological presence in the Near East, which gave rise to a new French Institute of the Near East (IFPO), joining the old IFAPO (French Institute of Archaeology of the Near East), IFEAD (French Institute of Arab Studies of Damascus), and CERMOC (Centre of Studies and Research for the Contemporary Middle East). It was anticipated that the geographic competence of this new research institute, with centres at present in Beirut, Damascus, Aleppo and Amman, should extend beyond Lebanon, Syria and Jordan to include Iraq and the Palestinian territories with the strong hope that one day it will be possible to resume work in these regions. The IFPO was given the task of following up matters of archaeological cooperation in Iraq. But, at present, during this time of chaos, it is very difficult to see what can be done.

In 2003, guided jointly by the Minister of Foreign Affairs (advised by Philippe Georgeais, at that time Assistant Director for Archaeology and Social Sciences in this Ministry) and the Louvre Museum (through Annie Caubet, then General Keeper in charge of the Department of Oriental Antiquities) a Ministerial Unit was created. Georgeais and Caubet wrote, in June 2003, to all those likely to be interested in, or concerned by, the risk of destruction of the archaeological and historical heritage of Iraq asking them for ideas about how France could help with the safeguarding and conservation of the cultural heritage in Iraq. The plan was to create an electronic network of relevant individuals to help advise and cooperate with international efforts, regarding libraries, museums and archaeological sites, being discussed by agencies such as UNESCO and the European Union.

Through this network a number of initiatives have been undertaken including: the collection of scientific books and works destined for the archaeological research centres and universities of Iraq (led by the René Ginouvès House of Archaeology and Ethnology in Nanterre); initiatives for accepting Iraqi trainees on French excavations carried out in Syria and Jordan (led by IFPO in cooperation with the various archaeological teams); training courses, held in Amman, for archaeologists and others involved in the protection of the Iraqi heritage (in cooperation with IFPO); and invitations to France for university colleagues or officials in the Department of Antiquities. Many of the former students of the DAFIq (notably at the René Ginouvès House at Nanterre) are particularly active in this network and continue to maintain contacts, assist in the post-excavation work

relating to research of Iraqi colleagues prior to publication, help with publication, and welcome Iraqi colleagues to France.

This support and collaboration has resulted particularly in the writing of the book *Studia Euphratica. Le Moyen Euphrate iraquien révélé par les fouilles preventives de Haditha* (Kepinski *et al.* 2007), that reports on the rescue excavations of the valley of Haditha in Iraq. The Louvre Museum, in association with the British Museum and the Vorderasiatisches Museum, continues to receive, train and maintain contact with, Iraqi colleagues. The IFPO is acting as a focal point for information for members of the network who are ready, as soon as circumstances permit, to re-engage in activities in Iraq with the universities, museums and traditional partners with whom links remain as strong as ever.

This chapter has focused on the history of the French institutions created in order to study the cultural heritage of the Middle East and to show the purpose they served until now, to explain their present position, their role and their ambitions. This is also a way of paying tribute to many great predecessors who showed us the way. However, given the appalling current situation, this emphasis has served to avoid thoughts of what we might possibly do when Iraq finally escapes its current hell. With respect to archaeological field research, there is no point in pretending that the future seems to be anything but bleak. In reviewing a recent book on Iraqi archaeology, Jean-Louis Huot wrote:

> The massacre of all of the Babylonian sites by uncontrolled pillage puts us further, every day, from the possibility of seeing archaeological studies resumed in the near future in what was formerly an archaeological paradise. The surface of the sites has since been overturned by clandestine excavations on an industrial scale. In other words, we find ourselves back in the situation this country was in in the middle of the 19th century: A beautiful victory for the American Crusade against the forces of evil. (Huot 2004, 282)

Nevertheless, we do not have the right to sink into despair or stagnation. 'Pessimism of the intelligence, optimism of the will' advocated Antonio Gramsci…

NOTES

1. There are today, globally, about 30 French schools, research centres and institutes for social and human sciences, which are related to the Ministry of Foreign Affairs and the Ministry of National Education. See http://www.diplomatie.gouv.fr/fr/actions-france_830/recherche-sciences_1029/reseau-instituts-recherche_11968/index.html. The French Institute of Oriental Archaeology (IFAO) was founded in 1880 at the initiative of Gaston Maspero. The French Archaeological Delegation in Iran (DAFI) was founded in 1897 by Jacques de Morgan and was replaced, in 1983, by the French Research Institute in Iran (IFRI). The French Institute of Archaeology in Istanbul was established in 1930 and became in 1976 the French Institute of Anatolian Studies (IFEA). The French Institute of Archaeology in Beirut, established in 1946, was renamed the French Institute of Archaeology of the Near East (IFAPO) in 1977. The French Institute of Arab Studies in Damascus (IFEAD) was established in 1922. These two institutes, IFAPO and IFEAD, were amalgamated, in 2003, into the new French Institute of the Near East (IFPO), a regional multi-discipline institute. The French Research Centre of Jerusalem (CRFJ) was founded in 1963. The French Centre of Archaeology and Social Sciences of Sana'a (CEFAS) was established in 1982. Since 1980 the DAFIq has published some ten books in the *Bibliothèque de la Délégation archéologique française en Iraq*, ADPF-ERC, Paris.

Bibliography

Berniquet, C, and Kepinski, C (eds), 2001 *Études mésopotamiennes. Recueil de texts offerts à Jean-Louis Huot*, ADPF-ERC, Paris

Chevalier, N, 1987 *Les archéologues français en Iraq*, in Huot, 1987, 9–11

Demoule, J-P, 2005 *L'archéologie: entre science et passion*, Gallimard: Découvertes Gallimard, Paris

Gelin, M, 2007 L'Institut français d'archéologie de Beyrouth, 1946–1977, *Syria 82*, 279–330

Huot, J-L (ed), 1987 *Délégation archéologique française en Iraq. 1977–1987, 10 ans d'activité*, ERC/ADPF, Paris

Huot, J-L, 2004 Review of E Stone and P Zimansky, *The Anatomy of a Mesopotamian City. Survey and Soundings at Mashkan-Shapir, Syria 81*, 281–282

Kepinski, C, Lecomte, O, Tenu, A (eds), 2007 *Studia Euphratica, Le Moyen Euphrate iraquien révélé par les fouilles preventives de Haditha*, Travaux de la Maison René-Ginouvès 3, Nanterre

Ministère des Affaires étrangères, 2005 *Archéologie, Vingt ans de recherches françaises dans le monde*, Maisonneuve and Larose/ADPF-ERC, Paris

The Contribution of the Centro Scavi di Torino to the Reconstruction of Iraqi Antiquities

Roberto Parapetti

This chapter reports on a number of projects, developed in collaboration with Iraq's State Board of Antiquities and Heritage (SBAH) that attempt to address some of the most urgent problems caused, in the main, by the disastrous events that have followed the military invasion of 2003. Starting in summer 2003, the projects have been made possible through the financial support of the Italian Ministry of Foreign Affairs to the *Centro Ricerche Archeologiche e Scavi di Torino* (CRAST), the Italian institution that has worked in Iraq since 1964 and that founded the Iraqi-Italian Institute of Archaeology and the Iraqi-Italian Centre for the Restoration of Monuments (www.centroscavitorino.it).

THE BUREAU FOR THE RECOVERY OF IRAQI LOOTED ANTIQUITIES (BRILA)

The looting of the Iraq Museum in Baghdad in April 2003 provoked CRAST to extend a project that had been started before the 2003 invasion that had been dealing with the identification, cataloguing and publication of objects looted from the various Iraqi Regional Museums (Basra, Kufa, Assur, Sulaimaniya, Babylon, Maysan, Qadissiya, Kirkuk, Duhok) during the period of chaos that followed the 1991 Gulf War. The project has been carried out in cooperation with the *Nucleo dei Carabinieri per la Tutela del Patrimonio Artistico* (a public security agency attached to the Ministry of Cultural Heritage and Activities, and see Zottin, chapter 24). Through this project, and prior to 2003, some 3500 objects had been identified and declared as looted (Gibson *et al.* 1992; Baker *et al.* 1993; Fujii *et al.* 1996) (see Plate 12).

Between September 2003 and June 2004, still in cooperation with the Carabinieri, a large number of additional stolen objects were identified and added to the list. During the same period, a number of these were returned to the Iraq Museum collections (and see Bogdanos, chapter 11). Between December 2004 and February 2005, taking advantage of the considerable number of Iraqi antiquities confiscated by Jordanian customs and various police bodies which had been handed into the custody of the local Department of Antiquities, another inventory (BRILA, Jordan), this time of found and recovered antiquities, was published (Menegazzi *et al.* 2005). These artefacts only represent, in

reality, a tiny proportion of the archaeological disaster that followed the much wider calamity dramatically referred to by many as 'the sack of Baghdad'. As an illustration of the problem, we know that Jordanian customs officials confiscated 1451 objects in 13 operations between 20 April and 30 November 2003, and a further five operations between 28 March and 14 October 2004. Unfortunately no investigation has been undertaken, to our knowledge, to determine even the provenance of these objects. It must be stressed that of these objects only a few cylinder seals bearing an Iraq Museum (IM) inventory number, together with a well-known Assyrian ivory chair-back from Nimrud, are traceable to the collection of the Iraq Museum. None of the other recovered objects have, to our knowledge, any identification. We can only presume that the majority come from recent clandestine excavation, although it is also possible that some may well have come from private collections of various types and date. Given these circumstances, it is now impossible to assign any of these individual objects a precise archaeological context, an indispensable condition, over and above their stylistic attributes, to enable them to provide the maximum amount of information for the reconstruction of past society. Among the objects currently in Amman there are also a number of forgeries and imitations, 'collages' of fragments of different objects, and pieces undoubtedly not of Iraqi origin. The only exception to this critical loss of context for the seized objects, are some of the cuneiform tablets since, by their nature, in some cases they may contain textual topographical evidence.

RECONSTRUCTION OF THE IRAQ MUSEUM'S RESTORATION LABORATORIES

The vandalism, only partially reported by the media, that took place at the same time as the robberies and looting of April 2003, left the SBAH utterly incapable of safeguarding the cultural heritage of the country or of dealing with damage that had occurred to many of the immovable objects still in the Museum's exhibition hall. The Museum's conservation laboratories in particular, had been looted and irreparably vandalised, and their rehabilitation was identified as a crucial priority by the SBAH.

CRAST worked closely with Iraqi colleagues and, in March 2004, new laboratories, completely furnished and equipped with basic instruments and materials shipped from Italy (sponsored by Telecom Italia SpA), were opened in a different location within the SBAH compound. At the same time, training courses for 14 restorers, including the laboratory's existing staff and new recruits, began (see Plate 13). The project was conducted in cooperation with the Italian Ministry of Cultural Heritage and Activities, through experts of its Central Institute of Restoration (ICR). By the end of June 2004, the following conservation work has been undertaken:

- The Sumerian marble female head from Warka, stolen and returned, has been cleaned;

- One of the two Old Babylonian terracotta lions originally flanking the gate of the main temple in Tell Harmal (smashed down in the Museum) was completely reconstructed and restored.

- A few pieces of the collection of Assyrian ivories from Nimrud, microbiologically

attacked due to incorrect storing both in the Iraq Museum stores and in the Central Bank, have been restored; the main part of the collection has been cleaned and preserved in inert containers for future conservation;

- The Sumerian marble votive vase from Warka, stolen and returned in fragments, has been partly restored.

- Fifteen pieces of Parthian stone sculptures from Hatra, temporarily located in various spaces within the administrative section of the SBAH, have been restored.

Given the serious deterioration of security conditions in Iraq, particularly in Baghdad, as early as June 2004, a second session of full-immersion training courses for restorers and archaeological conservators, that had been planned to take place in Baghdad between December 2004 and February 2005, was transferred to Amman. These students were able to work on material seized by Jordanian customs officials as noted above. The training, held at the Restoration Centre in Amman, concentrated on imparting basic knowledge of archaeological restoration, both theoretical (technology and restoration of ceramics, glass, metals, ivory) and practical (ceramics, stone). Lectures on the history of restoration and the history of Mesopotamian art and archaeology, from prehistory to the Ottoman period, completed the course. Thirteen Italian experts and one Jordanian trained the 14 Iraqis, with six Jordanian auditors. As part of the training, the Iraqi students had the chance to continue to practise restoration of Iraqi archaeological materials and also to catalogue them. Within this framework and with UNESCO's support, an additional course was held on 'first aid conservation' of objects from excavation to the laboratory.

Training Courses

In addition to the training courses on conservation and restoration of archaeological artefacts mentioned above, a three week course was held in Rome in July 2005 on 'Museology and Museography' for six of the SBAH's technical staff that included theoretical lectures and technical surveys of the city's national and municipal museums. Also, from May to September 2006, further training for SBAH's technical staff took place in Rome in collaboration with various institutions of the Italian Ministry of Cultural Heritage and Activity. This 'hands-on' training concentrated on developing strategic expertise regarding the conservation of cultural heritage: two restorers joined staff working on the conservation and restoration of archaeological artefacts at the Central Institute for Restoration; two archaeologists joined the excavation work in the area at the Palatine Hill's foot, directed by the Archaeological Superintendent of Rome; two archaeologists joined the structural and architectural restoration team in the Tiberius Palace on the Palatine Hill, also directed by the Archaeological Superintendent of Rome; one archaeologist joined the cataloguing of the numismatic collection at the *Medagliere* (Cabinet of coins) of Rome's Municipal Archaeological Superintendent; one art historian joined the conservation work on books and manuscripts at the Central Institute of Book Pathology; and finally two painters joined the conservation and restoration work on modern painting and sculpture in the laboratories of the National Gallery of Modern and Contemporary Arts.

SAFEGUARDING AND PROTECTION OF ARCHAEOLOGICAL SITES

This project comprised the preparation of a 'risk map' of archaeological sites on which CRAST has worked in the past (Seleucia, Babylon, Nimrud, Hatra) prepared using a Geographic Information System. In addition, a new 1/2000 map has been produced for the central monumental area of ancient Babylon based on aerial-photogrammetric data plotted by CRAST in 1988. This was especially important to produce given the occupation of the site by a USA, and later Polish, military camp from the beginning of the war until December 2004 (and see Olędzki, chapter 25). An international committee created under the auspices of the Ministry of Culture of Iraq and coordinated by UNESCO, and on which CRAST is represented, has also been working on a reclamation plan for the site.

PARTIAL REOPENING OF THE IRAQ MUSEUM

In October 2003, in agreement with SBAH, it was decided to prepare a plan for the partial reopening of the Iraq Museum. The project was intended, first of all, to provide Iraqi citizens with the first signs of a reconstruction process for their national identity through the re-appropriation of their cultural heritage. In order to guarantee the highest security conditions, even on a short term basis, the project concentrated on the preparation of only a few exhibition areas, where immovable artefacts are already in place, excluding those objects from display which were originally exhibited in show-cases. Given this constraint, the gallery of monumental Assyrian sculpture and the halls displaying the architectural decoration of Islamic Iraq seemed to be the most appropriate spaces for the implementation of the project.

The existing presentation and interpretation in the Assyrian Gallery, where samples of monumental figurative art of the new Assyrian period (9th–7th century BC) from Khorsabad (ancient Dur Sarruukin) and Nimrud (ancient Kalhu) are exhibited, is very dated and requires a significant overhaul in order that visitors might better understand the historical and architectural context of the artefacts. The project will see the reconstruction, by the introduction of a light independent structure, of the barrel-shaped archivolt of Gate A of the walls of the Khorsabad citadel to which the two original gigantic winged bulls in the hall belong. Also planned, in the short term, is the construction of a continuous cantilever-like structure to which a new lighting system will be fitted above the figurative bas-relief marble slab now at the sides of the exhibition hall which came originally from the decorative wall cladding in a number of different rooms in the royal palace. A series of explanatory interpretation panels will also be provided.

The Islamic gallery houses a very rich collection of architectural decoration from all over Iraq from the Umayyad through to the Ottoman periods. Here new partitions with didactic panels are planned to define regional and thematic areas, according to the evolution and development of Islamic visual arts in Iraq. In the medium term interventions, a reconstruction of the prayer hall of the Mirjaniyah School is planned. The decorative brickwork panels from the interior of the 13th-century building, demolished in 1940 and now exhibited in the gallery, are planned to be redisplayed in the new building in context.

The reconstruction is to be built in the adjacent service courtyard, which will be entered directly from the gallery.

The preliminary work for the short term project started in the spring of 2004, for example the new lighting system was shipped from Italy, with a planned completion time of one year. Unfortunately, it is well known how the general situation suddenly deteriorated, and as a result the enthusiastically planned short term project has been inevitably delayed. The work, entrusted to an Iraqi firm, only really began at the beginning of 2006, and has been fully financed by the Italian Ministry of Cultural Heritage and Activities. At present, despite the continued worsening of the Baghdad crisis, the works continue to bring hope of a better future.

There are also plans for the preparation, in the courtyard's porticoes, of an exhibition documenting both the discovery and history of Mesopotamian civilisation and the formation and history of the Iraq Museum collections. Finally, there are plans to exhibit some of the Parthian statuary from Hatra that, since 1991, had been collected from various museums and from the site itself and temporarily housed in emergency conditions in the SBAH compound in Baghdad. At present these are on hold as the result of the continuing security crisis.

BIBLIOGRAPHY

Baker, H D, Matthews, R J, Postgate, J N, 1993 *Lost Heritage: Antiquities Stolen from Iraq's Regional Museums*, Fascicle 2, British School of Archaeology in Iraq, London

Fujii, H, and Oguchi, K, 1996 *Lost Heritage: Antiquities Stolen from Iraq's Regional Museums*, Fascicle 3, Institute for Cultural Studies of Ancient Iraq, Kokushikan University, Tokyo

Gibson, M, and McMahon, A, 1992 *Lost Heritage: Antiquities Stolen from Iraq's Regional Museums*, Fascicle 1, American Association for Research in Baghdad, Chicago

Menegazzi, R, Barello, F, Negro Ponzi, M, Parapetti, R, Pettinato, G, 2005 *An Endangered Cultural Heritage, Iraqi Antiquities Recovered in Jordan*, Monografie di Mesopotamia VII, Le Lettere (ed R Menegazzi), Firenze

Italian Carabineers and the Protection of Iraqi Cultural Heritage

Ugo Zottin

The Carabineers' Cultural Heritage Protection Command (Carabinieri Tutela Patrimonio Culturale (henceforth CCTPC)) has worked for over 37 years in the interests of the protection and conservation of Italy's extraordinary tangible cultural heritage. In 1969 the then Artistic Heritage Conservation Unit (Nucleo Tutela Patrimonio Artistico) was constituted. Over time, this grew from a small, centralised operative unit until it took on its current role as the only department expressly responsible, by law, for its specific functions. The unit is now situated within the administration of the Ministry for Cultural Heritage and Activities (Ministro per i Beni e le Attività Culturali). It was in fact founded one year before the General UNESCO Conference, which took place in Paris between 12 and 14 November 1970. During the 16th session of this conference, the member states were invited to constitute, at government level, a 'service' concerned exclusively with the protection and conservation of tangible cultural heritage.

Today the CCTPC comprises about 300 military operatives specialised within the sector, and has its headquarters in Rome. It has an operational structure divided into three sections (Archaeology, Antiques and Fakes and Contemporary Art). There are 11 centres with regional or inter-regional purview distributed within Italy. The principal responsibilities of the Command can be summarised as: [a] the prevention of crimes against cultural heritage; [b] suppressive activity on the part of specialised Judiciary Police; [c] recovery of cultural objects and works of art; and [d] management of the database of looted or illicitly-removed cultural objects. The CCTPC also contributes actively and frequently to initiatives and activities promoted by UNESCO. This relationship with UNESCO acts as a continuous stimulus for the work of the Command and allows it to operate with purpose. In the context of international peace missions, the CCTPC has worked to protect and conserve art historical material, in respect to the UNESCO (Hague) *Convention for the Protection of Cultural Property in the Event of Armed Conflict* and its Protocols of 1954 and 1999. In particular Article 7 stipulates the need, within the armed forces, for specialised services:

MILITARY MEASURES

1. The High Contracting Parties undertake to introduce in time of peace into their military regulations or instructions such provisions as may ensure observance of the present Convention, and to foster in the members of their armed forces a spirit of respect for the culture and cultural property of all peoples.

2. The High Contracting Parties undertake to plan or establish in time of peace, within their armed forces, services or specialist personnel whose purpose will be to secure respect for cultural property and to cooperate with the civilian authorities responsible for safeguarding it.

As a consequence of its internationally recognised experience and competence in the sector, the CCTPC was asked to work in Iraq on missions, some of which are still in progress, which were organised after the military events of 2003 in two distinct areas: in the Multinational Specialised Unit (MSU) constituted by the Carabineers as part of the Italian military peace contingent engaged in the 'Ancient Babylon' operation; and at the Archaeological Museum in Baghdad.

ACTIVITIES OF THE MSU IN NASIRIYAH

From July 2003, two CCTPC officers, together with other carabineers, have been working with local authorities and the Iraqi police to survey archaeological sites at risk, to make them secure and to obstruct clandestine excavations and illicit trade in archaeological finds. The unit's operative area covers the province of Dhi Qar, in south-west Iraq.

General looting, which also took place at the National Museum, took place across the entire region, with looters sifting archaeological sites in search of gold coins, precious stones and cuneiform inscriptions, using rudimentary equipment for their clandestine excavations which often cause irreparable damage to precious finds. The looters earn the equivalent of just a few Euros from their finds, which travel from the Iraqi capital towards the principal clandestine markets in Europe and the USA. From the onset of CCTPC activity in the area of Assyria until the end of March 2006, 621 archaeological sites have been surveyed, 25 aerial reconnaissance missions using helicopters from the multinational contingent have been carried out, 1636 finds have been confiscated, 127 suspicious persons have been identified and 48 arrested; additionally, six specialised courses for the Iraqi Archaeological Special Protection (ASP) Guard, who are responsible for the protection of archaeological sites, have been organised (see Plate 14).

The numerous ground and aerial surveys have allowed us to monitor the status of the archaeological sites which are considered to be at risk, as well as the clandestine excavations. Indeed, officers' efforts and the checks in which they engage have allowed us to recover numerous archaeological finds which have been subsequently returned to the care of those responsible for Iraqi cultural heritage, to confiscate numerous rudimentary tools used in clandestine excavations and to arrest perpetrators and turn them over to the Iraqi police.

A considerable effort was also made by the team of carabineers required to check and safeguard archaeological sites in the surveying of archaeological sites at greatest risk and in the development of an archaeological map of the Dhi Qar province. In this context, 14 different types of topographical charts of the province were created, including all of the 621 sites surveyed and the information essential to them (size, importance, ancient and modern names, coordinates, civilisation, period, state of conservation, extent of looting, catalogue number), organised in the following way:

- One general chart showing the sites in alphabetical order;
- One general chart showing the sites in numerical order;
- Twelve charts, each of which shows sites only in relation to their dynasty or period of reference.

The mapping of sites, the satellite photographs and the aerial reconnaissance undertaken by the Italian contingent have also been used by the Italian National Research Council (Consiglio Nazionale delle Ricerche)[1] for the purposes of scientific study, for the development of the 'Virtual Baghdad Museum' project currently underway, and for a study of the sites of Ur, Eridu and Ubaid, in the course of which a Sumerian library and a commemorative stone dating from 2100 BC, of which previously only one example was known, have been found.

The interest generated by the activity undertaken in the sector by carabineers within the Italian Multinational Force can also be demonstrated by its profile within the Iraqi press, which has frequently dedicated significant coverage to the carabineers' achievement in safeguarding the cultural riches of the country.

Activity at the National Museum in Baghdad

In a further project, two CCTPC officers worked at the National Museum as advisers, ie as experts from the Italian mission attached to the Provisional Iraqi Government, which was coordinated by the Ministry of Foreign Affairs (Ministero degli Affari Esteri) in partnership with the Ministry for Cultural Heritage and Activities (Ministero per i Beni e le Attività Culturali). The two officers alternated for seven months in a minute and patient operation involving the collation and surveying of information of relevance to the numerous objects looted from the stores and from the rooms of the Museum. The documentation and the imaging of more than 3000 objects, collected in collaboration with Italian archaeologists from the Turin Centre for Research and Excavation (Centro Ricerche e Scavi di Torino) (and see Parapetti, chapter 23) and with Iraqi personnel, were transmitted telematically to the Rome headquarters of the CCTPC; thus, through the national Interpol unit in Rome, the data was sent to the central headquarters of Interpol in Lyon, whence it was also sent to UNESCO.

In parallel, for the purpose of making the stolen objects as well known as possible so as to obstruct their illicit commercialisation, all archaeological objects known to be missing have been included on the web pages of the CCTPC within the general site of the carabineers, at: www.carabinieri.it.

The officers, who in fulfilling their duties have had, understandably, to overcome a series of environmental difficulties, have developed a simple *pro forma* to facilitate the systematic acquisition of data relating to the cataloguing of objects. This *pro forma* is derived from one which has been used for some time by the CCTPC in Italy. Indeed, since 1994, the CCTPC has used the 'Artwork Documentation' form, recently modified and revised as the 'Object ID' in accordance with the international standards established by UNESCO. This form can be downloaded from the institutional website (www.carabinieri.it) and constitutes a useful instrument in the preventive safeguarding of works of art in private possession.

International cooperation

It is important to emphasise the fact that the officers of the CCTPC have not limited their activities to Iraqi territory, having also undertaken a coordinated series of activities to combat the illicit trade of looted objects from Iraq. As early as May 2003, CCTPC representatives participated in the international meeting called by Interpol in Lyon, at the close of which the need to call a further operative meeting emerged; this was held in Rome at the CCTPC headquarters. The work schedule allowed us to focus on and establish the most appropriate measures to be adopted internationally so as to avoid the arrival of illegally excavated Iraqi objects on the market. A further meeting was subsequently held in Lyon with the aim of constituting a committee of experts charged with the tasks of studying the whole phenomenon of the illicit trade in Iraqi objects, developing operative guidelines and suggesting, to the international community, the most opportune and effective countermeasures. These meetings continue to take place periodically, according to need and to evaluations of the situation (and see Rapley, chapter 6). This activity, and the development of accurate intelligence in the sector, has allowed the CCTPC to seize objects in Sardinia and other areas of Italy which had come from clandestine excavations in the Middle East and which had subsequently been circulated internationally. Amongst these objects were 86 tablets from the archaeological site of Nippur and 43 from the Mesopotamian region; five of these in particular can be traced with certainty to Iraqi archaeological sites.

A coordinated investigation is still underway, conducted in Italy by CCTPC officers who are in constant contact with other national police forces. Indeed, only by way of the frequent exchange of information can the police forces of the various nations successfully combat the illicit trade in Iraqi archaeological finds both in European countries and others to which they may be destined.

Training activity

Another important task carried out by CCTPC officers is the training and arming of Iraqi officers responsible for the security of archaeological areas. Carabineers have dedicated particular attention to the training of personnel from the local police with regard to the safeguarding of the archaeological heritage, training which is above all intended to provide officers with the knowledge and understanding required by an initial intervention in cases of clandestine excavation.

In September 2004, upon the request of the Italian representative of UNESCO, four CCTPC officers and another from the General Directorate of Archaeological Heritage of the Ministry for Cultural Heritage and Activities were employed in Amman (Jordan) for the training of Iraqi personnel of the Facility Protection Service (FPS), the special police force which has been developed, but not as yet formally recognised, for the protection of archaeological sites, the prevention and suppression of relevant crimes and to combat the illicit trade of antiquities. On the basis of concrete operational requirements, the professional potential of the trainees and above all in relation to the actual levels of risk which characterise contemporary Iraq, the Italian delegation has developed the training programme with emphasis on practical and technical aspects, furnishing the FPS with the basic understandings required for the safeguarding of cultural heritage.

Also, the carabineers involved in the 'Ancient Babylon' mission have trained 140 archaeological guards from the over 200 personnel in service in the Dhi Qar province, to understand and use surveillance systems at archaeological sites, to suppress looting, and to catalogue confiscated archaeological finds. The sixth specialised training programme was recently concluded, providing 20 archaeological guards who will serve with the ASP Provincial Guard Corps who will be employed at the Museum of Nassiyriah for the safeguarding of the archaeological heritage of the province of Dhi Qar; a further three courses for the remaining personnel are planned. Over the course of the training activities, the trainees have developed the necessary military abilities (such as the use and handling of arms and techniques of arrest, undertaking practical exercises such as shooting practice and simulated interventions). However, they have also developed an understanding of methods of identification, description and cataloguing of archaeological finds, as well as the techniques of intervention for the safeguarding of sites and the prevention of related crimes. In addition, trainees have been provided with useful information on the practicalities of transporting confiscated finds, and, lastly, much emphasis was placed on sensitising personnel to the inestimable value of the cultural heritage in question.

On 26 January 2006 the Archaeological Museum of Nasiriyah was inaugurated; upon this occasion the Archaeological Superintendent of the province of Dhi Qar dedicated one of the rooms to the Carabineers in recognition of their activities and efforts to protect one of the richest regions, archaeologically speaking, in the history of Mesopotamia.

The activity of the CCTPC in Iraqi territory must be contextualised as part of a larger Italian initiative regarding the protection and safeguarding of cultural heritage in areas of the world where it is at risk from conflict or natural disaster. In this sense, thanks to its well-known experience in the area of the protection and restoration of cultural heritage, Italy has become an early port of call in the international community for urgent interventions required to address crisis situations.

An agreement signed on 26 October 2004, in Paris, by the Director General of UNESCO, and for Italy by the Italian Minister for Cultural Heritage and Activities, established the development of a peripatetic Italy/UNESCO 'Emergency Action Group'. This will comprise highly qualified personnel (architects, engineers, art historians, archaeologists, conservators etc) provided by the Ministry for Cultural Heritage and

Activities, the Ministry for Foreign Affairs and by other organisations; these personnel will be able to intervene in any countries in crisis. In this light, the experience and the abilities matured by the CCTPC in Iraq will certainly be of use in the future.

NOTES

1. The Consiglio Nazionale delle Ricerche or National Research Council (CNR) is a public organisation; its duty is to carry out, promote, spread, transfer and improve research activities in the main sectors of knowledge growth and of its applications for the scientific, technological, economic and social development of the country. To this end, the activities of the organisation are divided into macro areas of interdisciplinary scientific and technological research, concerning several sectors: biotechnology, medicine, materials, environment and land, information and communications, advanced systems of production, judicial and socio-economic sciences, classical studies and arts. CNR is distributed all over Italy through a network of institutes aiming at promoting a wide diffusion of its competences throughout the national territory and at facilitating contacts and cooperation with local firms and organisations (www.cnr.it).

Polish Activity on Behalf of the Protection of the Cultural Heritage of Iraq (2003–2006)[1]

Łukasz Olędzki

The problem

With regard to culture and history, contemporary Iraq is an outstanding region. From an archaeological point of view it is exceptional. It was here that the civilisations of the Sumerians, Assyrians, Babylonians and Parthians left hundreds of ruins, of cities, temples, palaces, thousands of burial grounds and other remains of a glorious past. According to the official register of the State Board of Antiquities and Heritage (SBAH) in Baghdad, there are some 10,000 archaeological sites in Iraq. However, experts estimate that the actual number may be between 20,000 and 100,000. Nevertheless, to date, and despite the fact that the government of Iraq submitted a list of six sites for inclusion on UNESCO's so-called Tentative List in 2000, only three sites have been included on the UNESCO World Heritage List (Hatra, 1985; Ashur, 2003; and Samarra 2007). The failure to have more sites inscribed on the List is probably the result of mainly political reasons (Sałaciński *et al.* 2004; Lemiesz 2005). Therefore, Poland's decision to participate actively in the 'stabilisation mission' in Iraq entailed a number of challenges and duties concerning the protection of cultural heritage. When the Polish Command took over its Area of Responsibility (AoR), there were more than 1500 archaeological sites and historic monuments registered there. Field survey actually identified at least 2600 sites, including two, namely the ruins of the medieval city of Wasit and a Sasanid fortress, Ukhaydir, which are included on the UNESCO Tentative List. In the first instance the Polish AoR covered five provinces: An Najaf, Al Diwaniyah, Babil, Karbala and Wasit. Today, the Polish AoR comprises only two provinces: Al Diwaniyah and Wasit. Nevertheless, in these two provinces alone the number of archaeological sites is estimated at around 1000 (Sałaciński *et al.* 2004, Kiarszys 2005). The only site in Iraq which is being excavated currently (December 2006), Tell as-Saddum (ancient Marad), is also situated in the Polish AoR. The excavations are being carried out by the Institute of Archaeology at the Department of Fine Arts of the Al Quadisiyah University in Al Diwaniyah (Kiarszys 2005).

THE CONTEXT

In mid-2003, while establishing the framework for its participation in the stabilisation mission, Poland was actively engaged in the international arena on behalf of the protection of the cultural heritage of Iraq. This was not only due to the special significance of Iraqi cultural heritage, but was also a consequence of international resolutions, ratified by both Poland and Iraq.[2] Apart from the relevant international conventions, Polish activities have been based on the declaration of the Ministry of Foreign Affairs of the Republic of Poland, accepted by UNESCO in July 2003, which provides the foundations for Polish activities regarding the protection of the cultural heritage of Iraq. In the Polish President's resolution, adopted on 5 June 2003, concerning the participation of the Polish Military Contingent in the International Stabilisation Forces in the Republic of Iraq, the protection of cultural heritage was mentioned as one of the eight basic tasks assigned to Polish forces (Dolatowska and Joks 2006, 77). The range of responsibilities was described in detail in the more detailed government document *The Republic of Poland's Concept of Participation in Stabilization and Reconstruction of Iraq*, ratified by the Cabinet on 1 July 2003 (Burda *et al.* 2005).

Since the autumn of 2003, in accordance with the document, the Ministry of Culture and National Heritage of the Republic of Poland (MKiDN), in agreement with the Polish Ministry of National Defence, has assigned archaeologists to work within the structures of the Multinational Division Central-South (MND CS) in Iraq. Anticipating the high probability that artefacts, works of art or handicraft smuggled from Iraq would appear on the international antiquarian market, relevant steps were taken to prevent such an event. In October 2003, the MKiDN wrote to Polish antique dealers reminding them to be aware that illicit antiquities might be offered to them. At the same time, and as soon as Polish forces arrived in Iraq, thorough customs inspections have been carried out in order to prevent possible instances of illegal exportation of such artefacts from Iraq (Sałaciński *et al.* 2004).

One of the most important activities in the protection of the cultural heritage of Iraq is constant cooperation with Iraqi institutions, responsible both for cultural and artistic activity and the protection of cultural heritage. A regular scholarship exchange programme has been set up. Iraqi archaeologists and Iraqi university graduates come to Poland, having been granted various kinds of scholarships, and receive training in universities and other appropriate centres in Poland. In February 2004, the then Iraqi Minister of Culture, Mufid Al Jazairi, paid an official visit to Poland, during which a mutual agreement regarding cooperation and cultural exchange was signed. At the end of May, delegates from the Iraqi SBAH, including the Director General, Professor Abd Al-Azziz Hamid, visited Poland. Following this visit, a delegation of Iraqi archaeologists came to Poland in June 2005 at the invitation of the MKiDN. This delegation comprised representatives of both university centres and regional offices of the SBAH situated in the Polish AoR. The purpose of the visit was first and foremost to establish principles of future cooperation, particularly in the field of archaeology and conservation (Jegliński 2006).

In June 2006 the Director General of the SBAH in Al Diwaniyah province asked for help in the implementation of the plans for the expansion of the SBAH's headquarters in the capital city of the province, Al Diwaniyah. The planned expansion was related to the development of the SBAH in Al Diwaniyah, in cooperation with Al Quadisiyah University in Al Diwaniyah. The request became the basis for the creation of a plan to implement a project to develop a modern research centre and a programme for the protection of cultural heritage in Al Diwaniyah. In September 2006 the Ministry of Foreign Affairs of the Republic of Poland approved the first phase of this project.[3] In 2006, USA $60,000 from Poland's Development Cooperation Programme was assigned to the project which aims to introduce modern practices and to build specialist laboratories and archaeological storerooms, together with a modern archaeological museum. The first phase of the programme was completed by the end of 2006; with successive stages to be implemented in 2007. The project will be continued in 2007 and 2008. The project is particularly important as, in July 2006, the then Director General of the SBAH recognised the expansion of the SBAH's headquarters as a priority in Al Diwaniyah province.

INTERNATIONAL ACTIVITY

An important element of Polish involvement in the protection of Iraq's cultural heritage is its activity in the international arena. Right from the start, the MKiDN has been in contact with UNESCO, keeping it informed of Polish activity in Iraq. Polish specialists regularly participate in a variety of meetings concerning their work in Iraq, undertaken as part of the stabilisation mission. During one such meeting, which took place in the Polish Embassy in Paris on 6 April 2005, Polish activity was presented to the Director General of UNESCO and many other guests. Exhibitions and presentations demonstrating Polish activity have taken place all over Europe, and Polish representatives have participated in the meetings of a special UNESCO committee for the protection of cultural heritage in Iraq. In May 2004, the MKiDN organised a conference in Warsaw, 'Cultural Heritage in the Face of Threats in War and Peace Time',[4] during which the issue of the protection of Iraqi cultural heritage was widely presented and discussed. However, despite this profile raising and international activity, the principal Polish involvement in protecting the cultural heritage of Iraq is the work that takes place in central Iraq. Since November 2003, a number of Polish archaeologists, as civil specialists in the protection of cultural heritage, have undertaken activity within the structures of the MND CS.

COOPERATION, MONITORING, TRAINING AND ADVISORY

The participation of Polish forces in the stabilisation mission in Iraq has been mainly a monitoring and training-advisory mission, which has offered a unique opportunity for Poland to become directly involved in helping to rescue Iraqi cultural heritage. In accordance with the NATO Civil-Military Cooperation Doctrine (AJP-9), the commander of any military unit is responsible for the protection of the civil environment (including cultural heritage) within their area of operation. The unit at the commander's disposal, responsible for the implementation of the tasks related to civil-military cooperation, is

CIMIC (Civil- Military Cooperation). The NATO doctrine CIMIC-AJP 09 defines the character and range of the roles and responsibilities of CIMIC units. One of the most important aspects of the doctrine is basing the activity of CIMIC units on civilian specialists, who use their professional and specialist knowledge in areas such as the economy, law, health care and, last but not least, the protection of cultural heritage. In the context of this chapter, one of the fundamental responsibilities of CIMIC units is the monitoring (inspection, analysis and evaluation) of the monuments and other elements of cultural heritage in the areas for which they are responsible. Within MND CS, which was under Polish command, a CIMIC Group was established which was primarily responsible for civil-military cooperation in central Iraq (Dolatowska and Joks 2006, 78). In the autumn of 2003 the MKiDN, in cooperation with the Polish Centre for the Rescue of Archaeological Heritage, recruited specialists in archaeology and cultural heritage, who joined the CIMIC group of MND CS. Throughout their deployment their work has been coordinated by the Department of Military Affairs of the MKiDN. These staff restrict their activities to a few basic aspects of work, the most important of which is cooperation with the SBAH. This cooperation consists first and foremost of coordinating activity regarding the protection of the cultural heritage of Iraq. One aspect of the cooperation includes aid projects on behalf of the SBAH, financed through the Commander's Emergency Response Programme (CERP). All projects are prepared and delivered in close cooperation with the SBAH, and most crucially, at its specific request. A range of projects have been undertaken which can be grouped as follows:

1. Rebuilding and restoration of the infrastructure of museums and local antiquity inspectorates. Funding was also made available for crucial repairs to the archaeology departments at the University of Babylon in Al-Hillah and Al Quadisiyah University in Al Diwaniyah.

2. Support for the SBAH in the purchasing of vital computer hardware and software, office and specialist equipment. These projects also include the provision of computer training. Similar projects have been planned for the archaeology departments at universities in Al-Hillah and Al Diwaniyah.

3. The protection, through the use of engineering solutions, of archaeological sites threatened by damage as the result of the conflict or looting. These projects are one of the most important spheres of activity concerning the protection of the archaeological heritage. Several projects have been undertaken, including those at Birs Nimrod (ancient Borsippa), Tell el-Okhaymir (ancient Kish), Tell el-Babil (summer palace of the Kings of Babylon), and Tell as-Saddum (ancient Marad) (Fig 1).

4. Specialists in the protection of cultural heritage have been involved not only in the protection of archaeological sites, but also in protecting other aspects of Iraqi cultural heritage such as the restoration of Islamic cultural and religious centres. To date, only a few such projects have been carried out and they were implemented only in exceptional cases, usually at the specific request of those taking care of the centres concerned. Further projects have been started, directed at local cultural centres and the Iraqi media.

5. Finally, projects addressing the needs of the Iraqi Archaeological Police (also called the Guards of Antiquities) who form part of the Facility Protection Service (FPS), and who have special responsibility for the protection of Iraq's cultural heritage, have been undertaken.

Overall, within seven rotations of the Polish Military Contingent in Iraq, Polish specialists in archaeology and the protection of cultural heritage, working with Iraqi colleagues, have drawn up plans for and delivered projects financed by the CERP fund for some US$ 1,500,000 (and see Burda 2005a; Jegliński 2006).

The damage and plunder of the Iraq Museum in Baghdad became the best-known symbol of the destruction of Iraqi cultural heritage (Lemiesz 2005; and see Bogdanos, chapter 11; and George, chapter 10). However, the looting of the Iraq Museum can perhaps be seen as the culmination of widespread damage and destruction over the last decade or more. During the years of international economic sanctions, cases of plundering archaeological sites increased dramatically and the political elite of the former regime are suspected of having been involved in looting. However, although all wars led by Saddam Hussein's regime resulted in the destruction of Iraqi cultural heritage, the so-called Second Gulf War has caused particularly great damage. At a rough estimate, from the beginning of 2004, around 5000 Iraqi archaeological sites and historic monuments have been devastated (Lemiesz 2005; and see Farchakh Bajjaly, chapter 12). At the beginning of the stabilisation period, archaeologists were already reporting that a number of archaeological sites in Iraq

Fig 1. Preparation of protective fences in ancient Marad

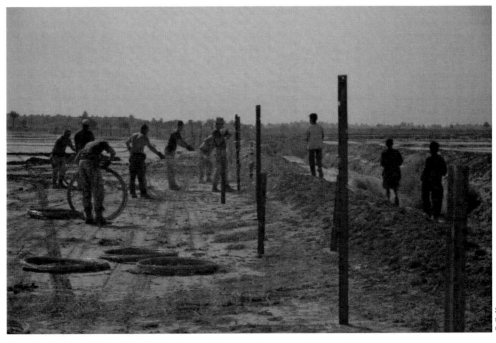

© G. Kiarszys

were in a terrible condition. Plundering of sites then increased on an unprecedented scale and the devastation of sites such as Umma, Larsa and Adab was reported at the time. This was all a consequence of the fact that after the 2003 invasion, the only source of income for many people was through cooperation with groups plundering the sites (Carver 2003, 443). The Coalition forces could only address the issue of introducing peace and order to Iraq once the campaign was over, namely in late April 2003 and the practice of looting and destroying Iraqi public and state infrastructures was a major problem at the time (Garden 2003, 713).

During the period of confusion following the First Gulf War, well-organised, armed groups of looters appeared in southern and central Iraq. A large number of local museums were looted at this time, thus, once the former regime had regained control of the country, the majority of artefacts were transferred to the Iraq Museum in Baghdad. However, with the onset of the conflict in 2003, the whole administrative system of Iraq, together with Iraq's uniformed services, effectively ceased to exist. The lack of authority structures at all levels together with the looters' belief that they might well escape punishment, resulted in the further escalation of plundering in search of attractive artefacts through illegal excavations, theft from museums, the exportation of antiquities and works of art across Iraqi frontiers, and their illegal circulation within the country (Mazurowski 2003).

After the successful invasion and occupation, at the end of April/early May 2003, neither local guards (so called *haraz*), nor the Coalition forces were able to disperse the armed and organised groups' looting sites. In the summer of 2003, when the Coalition forces began the process of stabilisation, sites had been, and continued to be, looted on

FIG 2.

SURVEY WORKS IN
BIRS NIMROD

© M. Lemiesz

a grand scale. The moonscape of archaeological sites devastated by looting shafts covered in particular the area of central Iraq (particularly at the borders of today's provinces of Dhi Qar and Al Diwaniyah). Such famous and important sites as Umma and Isin were completely ravaged (Lemiesz 2005). At this time, in such difficult conditions, the civil administration of Iraq began the process of organising units of civil guards for the protection of governmental property. In December 2003, Coalition forces transferred responsibility over FPS to the Iraqi authorities. Thereafter, cooperation with, and support for, the Iraqi Archaeological Police became a key activity for the Polish specialists in CIMIC.

In 2003, the Archaeological Police faced countless problems, some of the most pressing being the lack of sufficient guards, weaponry and other basic and vital equipment. The Archaeological Police play a key role in the protection of the cultural heritage of Iraq and it is vital for them to be not only well trained, but also well equipped. Thus a number of projects were developed with the aim of providing police officers with basic equipment and to help with the repair, refurbishment, and equipping of their stations. Such stations, usually located within the most important sites or in cities situated in areas with a particularly high number of archaeological sites, are used by mobile units of the Archaeological Police, patrolling archaeological sites in the provinces (such units usually also include archaeological inspectors from the local offices of the SBAH). In some cases (for example, Babylon and Birs Nimrod) additional infrastructure has been provided, for instance observation towers or fencing together with checkpoints. A similar programme, that includes plans for six local stations, four of which will be used as bases by mobile squads, has been agreed for Al Diwaniyah province. Police units in this province have already been equipped with patrol cars.

Another very important activity is monitoring the state of archaeological sites in the Polish AoR. This falls into two distinct parts. The first, which is rare due to safety considerations, includes visiting the sites as part of a special patrol by the Polish CIMIC Group. During such site visits a photographic report is produced and some of those living near the site are interviewed about looting activity and the movements of antiquity dealers. In some cases, GIS measurements are taken (with the assistance of the Geographical Support Group of MND CS), especially in places where infrastructure is to be developed to protect the site (eg fencing or observation towers) (Fig 2). Full ground reports have been produced, for instance for Birs Nimrod (ancient Borsippa), Tell el-Babil (Summer Palace of Babylon), Tell el Okhaymir and Tell el Inghara (ancient Kish), Atlal Nufar (ancient Nippur), Tell Abu Hatab (ancient Kiushura), and Tell as-Saddum (ancient Marad). These reports are made available to the SBAH, will enable inventories of the sites to be drawn up, and will facilitate the future monitoring of their state of preservation.

When site visits are impossible, an excellent way to gain some understanding of the state of preservation of sites has been through helicopter aerial reconnaissance. During the reconnaissance, aerial photographs of the archaeological sites are taken. At present, this method of compiling an inventory has the advantage of being safe and effective, although it cannot be claimed to be a typical or full archaeological inspection. Nevertheless,

aerial photography is a first class source of information for determining the type of a site, its position and general condition. Such aerial reconnaissance allows us to estimate the damage that has occurred at archaeological sites. Due to safety considerations, the helicopters fly at a low level (usually around 10–15 metres) and at high speeds. Thus, the photos are taken at a relatively steep angle and in most cases only fragments of the sites are captured in the photos. Therefore, the condition of the sites, losses and damage can be only estimated (Burda 2005b). So far, it has been possible to produce aerial photographic documentation for more than 80 sites, including Atlal Nufar (ancient Nippur), Bismaya (ancient Adab), Birs Nimrod (ancient Borsippa), Ishan Bahiryat (ancient Isin), Babylon, Tell el Babil (Summer Palace of Babylon), Jamdet Nasr, Tell el Ingharra and Tell el Okhaymir (ancient Kish), Tell Abu Hatab (ancient Kissura), Tell As Sadum (ancient Marad), Tell Fara (ancient Shurupak), Tell Ibzykh (ancient Zabalam), Tell Jokha and Tell Guha (ancient Umma) and Tell Shamit (ancient Klan). It has been possible to produce photographic documentation and gather information on the current condition of not only large and known sites, but also medium and small sites, some of which had possibly never previously been documented (Jegliński 2006). Once the documentation has been compiled, it is transferred in digital form to the SBAH. Where it is possible to do so, precise maps and satellite photos are included in the reports.

The reconnaissance programme has provided detailed information about particular sites. Sites in the south-eastern part of the Al Diwaniyah province are, relatively speaking, in the worst condition. When, in early 2004, the aerial inventory was started the situation was very bad. Some sites (such as Tell Jokha – ancient Umma) had practically ceased to exist. The surface of these sites was, and is, a moonscape of looting shafts, frequently precisely delineating the area of the site. Iraqi colleagues have recently informed Polish specialists that a well-organised group has been operating in the south of Al Diwaniyah province. The group has strong links with an international mafia network dealing in the illicit trade of antiquities. A special section of Italian carabineers, specialising in the fight against this illicit trade, attempted to break the network (and see Zottin, chapter 24). Polish specialists were able to support the carabineers through a number of initiatives including the production of a catalogue of artefacts stored in the local archaeological museum and an archaeological map of the region (Pastore 2004, 26). The peak season for looters is winter, when weather conditions are most favourable. The situation has been slowly improving, however, a variety of factors combine to make it difficult to predict the further success of current activities (and see Farchakh Bajjaly, chapter 12). The situation in Wasit province has recently improved, probably owing to an increase in people's incomes, with new jobs being created following the opening of the state borders for trade and greater economic freedom in Iraq (Jegliński 2006).

EDUCATION AND STOPPING ILLICIT TRADE

During their mission in Iraq, members of the Coalition forces frequently come into direct contact with some of the world's greatest historic monuments. Even following the abandonment of the camp in Babylon (see below and see Bahrani, chapter 16; and

Moussa, chapter 13), Polish troops often visit such places as Ur, Nippur and others. The need for a series of educational initiatives aimed at the staff of the MND CS was thus identified. By making troops aware of the importance and influence of the civilisations of Mesopotamia on the development of the civilised world, the intention was to prevent them from participating in damaging or looting sites or dealing in illicit antiquities. Basic information on the archaeology and history of the region was provided in Poland prior to deployment and additional, supplementary written information, produced by the archaeologists in the Division during their stay in Iraq, was also provided regarding the history of the region and its monuments. The damage caused by the illegal smuggling of artefacts was also addressed in a brochure prepared in both Polish and English of which 10,000 copies were distributed among the members of MND CS. To meet the needs of the educational programme, Polish archaeologists on staff prepared special workshops using multimedia presentations. Within every rotation of the Polish Military Contingent, specialist workshops are held for the officers of the Polish Military Police. These deal with legal regulations regarding the protection of cultural heritage during warfare, methods for the prevention of illicit trade, and also provide basic training on recognising those categories of artefacts most commonly subject to illicit trade. The specialists also brief the civil-military staff concerning their legal responsibility regarding what can, and cannot, be exported (Sałaciński *et al.* 2004; Olędzki 2004).

This briefing is seen as vitally important not only to comply with the international conventions to which Poland is – and by extension all Polish nationals are – obliged to adhere, but also due to the belief that any proven instances of Coalition force members attempting to illegally export antiquities would bring into question the validity of the entire mission. Thus, at the turn of 2003/2004, MND CS guidelines were prepared, regarding the categories of objects that were subject to export restriction, including such artefacts as coins, various kinds of gems and their imprints, sculptures and reliefs, pottery,

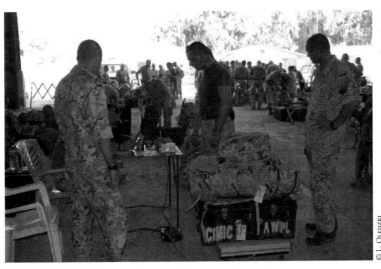

FIG 3.

LUGGAGE CHECK- IN – JULY 2006

© L. OLĘDZKI

manuscripts and old prints, antique bricks and elements of architectural decoration, and all kinds of inscriptions. The year 1945 was identified as the date delimiting historical and contemporary objects (Sałaciński *et al.* 2004; Olędzki 2004). Each rotation of the Polish Military Contingent in Iraq is subject to detailed luggage control by the Military Police, under the supervision of a special group established by the Commander of MND CS. The group always includes a specialist in the protection of cultural heritage, who participates in luggage check-in, assisting the Military Police in situations of doubt (Fig 3). It must be emphasised emphatically that from the very beginning of the mission in Iraq, very few attempts to smuggle historic artefacts have been detected. In each case the artefacts had little historic or financial value. In such cases, the artefacts are seized and, once a report has been produced, they are returned to the Iraqis. In every case the Polish Military Police investigated the crime and punished those involved. Additionally, the cultural heritage specialists have undertaken, in cooperation with the Military Police, a number of initiatives aimed at limiting access to the illegal trade of artefacts, including for example the monitoring of Iraqi bazaars set up close to the camps in Babylon and Al Diwaniyah, and the control of shops run by local people in the vicinity of the camps (Sałaciński *et al.* 2004; Olędzki 2004).

BABYLON

The cultural heritage protection activities undertaken in Babylon were especially difficult and were, unfortunately, frequently carried out within a hostile atmosphere. Ancient Babylon is one of the greatest and largest cities of the ancient world, and thus plays, for obvious reasons, an exceedingly important role in the historic consciousness of the contemporary Iraqi nation. Understandably, the Iraqis regard the events of recent years in extremely emotional terms. Babylon is a well-known symbol, an integral element of the history of humanity. Nowadays, however, it is associated not only with the glorious past, but also with the atrocities of war. The decision to establish a military camp in the very centre of the ruins of an ancient city was undoubtedly a serious mistake. On the other hand, the decision had its advantages; the site was saved from the generalised looting and devastation, and a number of steps were undertaken to improve the condition and protection of ancient Babylon.

The Iraqi Republican Guard left their positions in the area of Babylon in April 2003. The area included a museum compound and a modern palace compound, belonging to one of the sons of Saddam Hussein. At the time, armed groups together with local people looted the modern palace, at the same time looting and damaging the museum buildings. Following the burning of a unique scientific archive, museum staff called on the American military for help. As a consequence of this request, the American decision to occupy Babylon was due in equal measure to strategic military considerations and the need to protect the site from plundering and devastation. This reasoning saw the establishment of Camp Alpha in Babylon, which in time increased in size to cover one eighth of the whole archaeological site. As a result, Babylon has not suffered the dramatic fate of many other archaeological sites in Iraq. Camp Alpha was situated exactly in the centre of the

ancient city, near to the most important monuments. Although from the very beginning the exhibition area was outside the base, its existence had dire consequences.

In early November 2003, the Polish cultural heritage specialist stationed at Camp Alpha compiled an inventory of the state of preservation of the archaeological monuments, taking into consideration the type of destruction and the reasons and chronology relating to it. This first report marked the start of continuous monitoring and archaeological supervision of Babylon by Polish specialists, until the abandonment of the camp in December 2004.

The damage at Babylon has various causes, not all of which relate to the events of recent years: for example, when the Iraqi Republican Army occupied the site prior to 2003, they built shooting ditches, mortar posts and storage bunkers. Recent causes of damage include the negative effects of various natural factors (mainly the consequence of unusually heavy rains at the turn of November/December 2003); damage resulting from the warfare of spring 2003; and damage which occurred during the occupation of the site by Camp Alpha.

When Camp Alpha occupied the site the most severe damage was caused by the choice of location for the helicopter landing ground in the Kulabba zone. This required the levelling of part of the area within the buildings of the ancient city. Sand pits were also dug into a number of tells in the area of Humara and Merkez, and other tells were used as bases for observation towers. In the area of Kulabba, fuel tanks were dug into the earth, and in the area of Sachn, an arsenal was established. All of these activities caused serious damage to archaeological structures. Furthermore, a large number of car parks were built to meet the needs of the camp. Last but not least, the concentration of such a number of people and military equipment in a relatively small space must have had dire consequences for the condition of Babylon (Sałaciński *et al.* 2004; Burda *et al.* 2005; Lemiesz 2005).

The decision to set up a military camp in the very centre of the archaeological site of Babylon led to a serious conflict of interest. On the one hand, the military authorities had the clear duty to protect the archaeological remains of Babylon, but on the other hand, such a large group of people concentrated in Camp Alpha required significant safety measures to be put in place. Therefore, Polish cultural heritage specialists found themselves 'between Scylla and Charybdis' as they faced the very difficult task of developing principles and working practices, which would satisfy both requirements. The first step was to seek the cooperation of Iraqi inspectors and archaeologists employed in the local office of the SBAH. In December 2003, a special report was prepared for the Commander of the MND CS, which outlined the results of the initial inventory regarding the state of preservation of Babylon's monuments. Following the acceptance of the report, a few basic practices were introduced, intended to protect the site. First and foremost, all earth moving and building works at the camp were reduced to a bare minimum, particularly those connected with digging trenches or levelling the topographic profile. A rule was accepted that cultural heritage specialists would be informed without delay of any plans to undertake such works, which would enable them to consult with the Iraqi

antiquity service. Furthermore, a policy of extracting and transporting sand and earth from locations away from the archaeological site was instigated. This was supported by a decision to replace defensive trenches with defensive constructions (barbed wire, walls of concrete, wire-framed boxes filled with sand and earth) installed directly on the surface, therefore not causing immediate damage to the buried archaeology.

At the same time, access to the tourist zone of Babylon in the area of Qasr was restricted using a system of wire fencing. As a result, the area could only be accessed via the Museum, which was controlled by Museum staff. The fencing was repaired several times. Additionally, in May and June 2004, warning signs were placed in areas particularly susceptible to damage and, within the ruins of the so-called Central Palace, tourist routes were marked out, identified by safeguard tape and wooden balustrades (Sałaciński, Lemiesz, Olędzki, Galbierczyk 2004).

At the turn of 2003/2004, a system of monitoring the archaeological site in Babylon was introduced. This was based on the assessment and verification, in the field, of information delivered by the staff of MND CS, as well as information collected during regular inspections of the area within the borders of Camp Alpha, which provided an additional opportunity to register earth works that had not previously been reported (Sałaciński *et al.* 2004).

From the very beginning, the cultural heritage specialists emphasised that the only real solution to the damage being done to the archaeology was to relocate the military camp from Babylon as quickly as possible. Obviously, it was accepted that the relocation of the camp should not create an additional threat to the local community or the site at Babylon. It was accepted also that such a process required time.

In the second half of 2004, the Commander of the Coalition forces in Iraq faced a difficult task in trying to solve the problem of Camp Alpha. In June 2004, the Commander of the MND CS issued a special order requiring the relocation of the camp as soon as possible. Almost at the same time, the command of the Coalition forces formed a special group called the Babylon Working Group. On a number of occasions between June and September 2004, a local inspection in the field was organised in Babylon, in order to estimate the amount of damage that had occurred. In September 2004, Polish cultural heritage specialists, in cooperation with the special group, drew up the directives and schedule for the joint Polish-Iraqi archaeological and conservation supervision for the relocation of the military infrastructure. This group also reviewed the protection of the monuments and museum buildings in Babylon and the limited conservation of those most seriously damaged (Sałaciński *et al.* 2004; Olędzki 2004).

The handing over of responsibility for Camp Alpha to the SBAH, on 22 December 2004, was the last important activity carried out by the Polish cultural heritage specialists regarding the protection of Babylon. As the last military personnel of the MND CS retired from Babylon, the Iraqi Archaeological Police took over. During the hand-over programme, workshops on protective procedures were organised for the Archaeological Police, along with guidance on using weapons and administering first aid (Fig 4). Parts of the old camp infrastructure were adapted to the needs of the Archaeological Police,

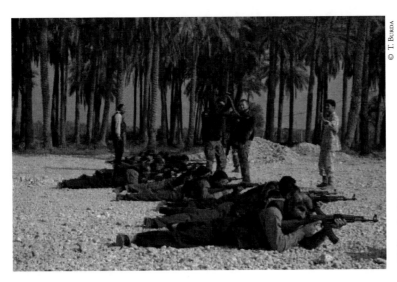

Fig 4.

Training of Archaeological Police in Babylon

namely guard and observation towers, and fortified entrance gates to the area of the former camp were provided. MND CS equipped the Archaeological Police with living quarters, drinkable water tanks, electricity generators, light units, weapons, helmets and bullet-proof vests (Lemiesz 2005).

Between November 2003 and January 2005, Polish cultural heritage specialists undertook a number of projects intended to train the Archaeological Police at a total cost of more than US$ 150,000. In addition, infrastructure projects, intended to improve the condition of Babylon and to develop modern site protection were implemented to a total cost of almost US$ 240,000 (Burda 2005a). When the MND CS units left Babylon, despite the obvious and highly publicised damage that had been caused by Coalition forces, Babylon was left perfectly prepared not only for FPS protection, but also for welcoming tourists. Modern site protection infrastructure has been built (based on Camp Alpha's remaining defensive structures and a modern system of video cameras and sensors, together with a command centre), along with scientific, tourism and administrative infrastructure for the use of Iraqi archaeologists, the Archaeological Police and tourists.

Polish activities in the protection of Babylon were summarised in a report of over 500 pages, which included more than a thousand documentary photographs and figures. The main aim of the report was to present the existing condition of particular sections of the archaeological site that were situated within the camp or had been utilised in some way by the Coalition forces. Through detailed descriptions and figures, the report, handed to Iraqi archaeologists from the SBAH, presented the extent of the damage and sometimes the scale of work necessary to repair the affected parts of the site (Burda *et al.* 2005). Later it was disseminated in the form of a specially prepared CD, distributed by the MKiDN. The report by Dr John Curtis, published on the British Museum website in January 2005, was based on this document (Curtis 2005). A final report on the situation

and condition of Babylon is to be prepared on the basis of three components: the above Polish report, the Curtis report, and a further report by Iraqi specialists. The MKiDN is coordinating the whole undertaking, and assigned USA $25,000 to part-finance the project. The official transfer of funds took place in November 2006 in Paris, during the meeting of the International Coordination Committee for the Safeguarding of the Cultural Heritage in Iraq.

THE WIDER CONTEXT

Contemporary archaeology is a discipline that encompasses a wide range of theoretical, social, and political views. As is the case with contemporary science, there is no commonly accepted vision of what archaeology should be like, either as an academic discipline or as a form of social practice. The history of archaeology is regarded as being full of dubious practice epitomised in statements such as 'academic disciplines, like archaeology, still remain the stepchildren of imperialism' (Meskell 1998, 1). Iraq's past has long been heavily exploited in politics, in various and sophisticated ways. The unique cultural heritage of Mesopotamia has played an extremely important role in academic and cultural ideas regarding the birth of 'civilisation'. Nowadays, it is widely acknowledged that the term 'Mesopotamia' itself bears significant political connotations. The country's archaeology and heritage are not presented as the heritage *of Iraq*, but of Ancient Mesopotamia and thus, as some argue, of an almost mythical, pre-European past. Such rhetoric is related to the discourse of 19th-century colonialism (Bahrani 1998, 166). There is a striking similarity between the way the cultural heritage of Mesopotamia has been treated and the role of Near Eastern petroleum deposits in the world economy. Both petroleum and the remains of Mesopotamia have been treated as international property and the claims of the Iraqi state to both have been largely neglected. Just as the government of the USA is deeply interested in influencing what happens to Iraqi oil, the international archaeological establishment is concerned with having decisive control over the historic monuments of Iraq (Seymour 2004, 352).

Therefore, Polish activity in the protection of Iraq's cultural heritage can and has provoked various responses, particularly in the context of events in Babylon. Undoubtedly, it is difficult to support the idea of establishing a military camp in the very centre of a place such as Babylon and we cannot ignore the reproaches addressed to the Coalition forces, particularly the Polish and American military. However, the case study of Babylon raises another issue, related to the presence of Polish cultural heritage specialists in Iraq in general, and more broadly of their presence within military structures at all.

It must be emphasised that from the onset of the war in Iraq in 2003, the country ceased to be connected to the regime of Saddam Hussein in the eyes of the world's media, and the threat to (and the protection of) Iraq's cultural heritage became a significant anti-war argument around the world. A surprising role of archaeology, or rather the issue of the protection of cultural heritage, has been very apparent in the process of contesting the war in Iraq (Seymour 2004, 360). The case of Babylon and the existence of Camp Alpha became in 2004 one of the most important issues in discussions about the situation of

the cultural heritage of Iraq. The establishment of a military camp in such a place was heavily criticised by the world's archaeological establishment, a matter which was widely discussed in the media.

How can we, therefore, defend ourselves in the face of such major criticism, which is not (necessarily?) aimed at the Polish archaeologists' activities, but nevertheless greatly concerns them? Poland's decision to join the war against the regime of Saddam Hussein has never received the full support of Polish society, and neither has the stabilisation mission in Iraq. This lack of a united front in Polish society is reflected in conflicting opinions within academia, including within archaeology. First, all activities of the specialists in the protection of cultural heritage have been carried out in accordance with international, Polish and Iraqi law (although the latter has been undergoing a fundamental transformation). Second, all activities have been undertaken in agreement with the Iraqi archaeological establishment. Polish specialists have always informed Iraqi authorities about their activities and they have prepared reports for the Director General of the SBAH. Every project has been developed at the specific request of Iraqi colleagues and consultations have occurred at practically every stage. Furthermore, reports on all activities undertaken in Iraq have been presented to UNESCO and are principally an answer to UNESCO's 2003 appeal for help. Polish activity on behalf of the protection of the cultural heritage of Iraq is based on assisting local specialists, providing them with the support and assistance necessary to help them carry out their responsibilities in such a difficult situation, and trying to return them to the pre-1990 situation, when the relevant institutions were among the best developed and most efficient in the Near East.

The events that occurred in and around Babylon are not in fact at the centre of the dispute on the question of the protection of the cultural heritage in Iraq. They did not trigger the debate on any real or imagined 'ethical crisis' in archaeology. Nevertheless, to some extent the criticisms surrounding Camp Alpha reflect the activity undertaken by Polish archaeologists in Babylon and Iraq more generally. In a few instances in 2003, the cooperation of archaeologists with the military, which consisted mainly of providing the military with the coordinates of archaeological sites to protect them from destruction from military activities, was described as highly unethical. By cooperating in this way archaeologists were deemed to have legitimised the activities of the military with their academic authority. In 2003, when the protection of Iraq's cultural heritage generated intense media interest, some archaeologists wrote about a specific ethical crisis in archaeology (eg Hamilakis 2003, 105–111; Bernbeck 2003, 112–116). Archaeologists (individually and as a group) were concerned mostly with how to stop the destruction of Iraqi cultural heritage, whereas the whole world, including academics, contested the war in general, heavily criticising the invasion of Iraq. The reaction of archaeologists (particularly the American Institute of Archaeology) supposedly placed antiquities before human life. An important question was raised: whether archaeologists as a specific group should focus only on the protection of cultural heritage, when thousands of innocent people were being killed in a conflict instigated for the sake of particular interests. It is possible that, for a number of archaeologists, the defence of Iraq's cultural heritage was a

means of protesting over the war itself; however, slogans claiming that 'Iraq's past is our past' are somewhat misleading and caused considerable anxiety. Such opinions were seen by some to be infested with the rhetoric of colonialism, which treated the monuments of countries such as Iraq as the property of humanity, or more specifically and sinisterly as the property of European civilisation. Nowadays, in the postcolonial world, such rhetoric has only negative connotations. Such concerns precipitated a serious ethical crisis at the heart of the discipline, which brought about a dangerous dichotomy between artefacts and people.[5]

Obviously, we must accept criticism on many points. However, the situation in Iraq was slightly unusual and it has raised another debate in archaeology. This relates to the lack of clear and ethically unequivocal guidelines on how archaeologists should react to military conflict in areas where archaeological and historic monuments are situated. When immediate action is required to protect archaeological sites and monuments, not only from damage but potentially from complete destruction, then indecision and uncertainty about the legitimacy of action should surely not be allowed to delay decisions. Is not damage or complete destruction too high a price to pay for respecting ethics? In the contemporary world, archaeologists are perceived as those whose role and responsibility is to protect archaeological sites. We may argue about process, about the legitimacy of any action undertaken, and we may decide to wait until the context of the actions becomes ethically unequivocal; but in doing so we risk the destruction of the material culture we aspire to save. The problem is, however, that in cases such as Iraq during the last conflict, there is no time for a long debate. Such a process must, can, and should be accelerated. Whether we like it or not, war was, and is, a fact and stability in Iraq is far in the distance. The fact of the matter is that the situation in Iraq is becoming more and more complicated. We must be fully aware that, if we want to effectively assist the Iraqis in the protection of their cultural heritage, it must be done there, in Iraq, in cooperation with Coalition forces. It cannot be otherwise. Only the military are able to deliver such activity with respect to protection and logistics. Iraq has been plunged into administrative and political chaos; the people have no electricity, water or work; hospitals operate in extremely harsh conditions. Such institutions as the SBAH attempt to function in an almost impossibly difficult situation.[6] Something must be done, and as Americans or Europeans we are all to a certain extent responsible for the situation in Iraq.

Translated by Agnieszka Tokarczuk-Różańska

NOTES

1. This article is based on the work of many people, but especially Polish archaeologists, who have worked from November 2003 as specialists for protection of cultural heritage within the structures of Multinational Division Central-South: Marek Lemiesz, Agnieszka Dolatowska, Grzegorz Galbierczyk, Łukasz Olędzki, Tomasz Burda, Mirosław Olbryś, Grzegorz Kiarszys and Adam Jegliński. From the beginning the work of the Polish team in Iraq was coordinated by the Polish Ministry of Cultural and National Heritage (MKiDN), Department of Military Affairs, under the supervision of Col. Krzysztof Sałaciński.

2. The most important agreements include three international conventions, namely the Hague *Convention on the Protection of Cultural Property in the Event of Armed Conflict* (14 May 1954), the UNESCO *Convention on the Means of Prohibiting and Preventing the Illicit Import, Export and Transfer of Ownership of Cultural Property* (14 November 1970) and the UNESCO *Convention for the Protection of the World Cultural and Natural Heritage* (16 November 1972).

3. The project covers building modern offices, rooms for Archaeological Police and a car park for the patrol cars of Archaeological Police.

4. One of the most important outcomes of this conference was the statement made by the Minister for Media and Heritage, Lord Andrew McIntosh (2004: 150–152) that the UK Government was going to ratify the Hague Convention.

5. During TAG 2005, in December 2005 in Sheffield in Great Britain, there was a session organised by Umberto Albarello entitled 'An eternal conflict? Archaeology and social responsibility in the post-Iraq world'. The session provided a specific summary of the discussion.

6. For instance in Al-Kufa in 2004, the office of the SBAH and Archaeological Museum was taken over by one of the Muslim parties. Artefacts, archives and SBAH's equipment were removed to sub-standard rooms. At the same time, SBAH in Karbala did not have a permanent office and its workers had to move offices a number of times (Sałaciński, Lemiesz, Olędzki, Galbierczyk 2004).

BIBLIOGRAPHY

Bahrani, Z, 1998 Conjuring Mesopotamia: Imaginative geography and world past, in *Archaeology under Fire* (ed L Meskell), 145–158, Routledge, London and New York

Bernbeck, R, 2003 War-time academic professionalism, *Public Archaeology* Vol 3, no 2, 112–116

Burda, T, 2005a *Specification of projects realized by specialists in archaeology and protection of cultural heritage in Polish Military Contingent in Iraq in period from November 2003 to February 2005*, MKiDN: CD-ROM edition, Warszawa

Burda, T, 2005b Archeologiczna apokalipsa. Wykorzystanie fotografii lotniczej w ocenie zniszczeń na stanowiskach archeologicznych w Iraku, in *Biskupin ... i co dalej? Zdjęcia lotnicze w polskiej archeologii* (eds J Nowakowski, A Prinke and W Rączkowski) 263–269, IP UAM-ODDA-MAP-PTP: Poznań 2005

Burda, T, Dolatowska, A, Olbryś, M, 2005 *Report on the Current Condition of the Babylon Archaeological Site (the Military Camp Alpha site)*, CD-ROM edition, MKiDN, Warszawa

Carver, M, 2003 Editorial, *Antiquity* Vol 77, no 297, 441–444

Curtis, J, 2005 Report on Meeting at Babylon 11–13 December 2004, available from: http://www.thebritishmuseum.ac.uk/the_museum/news_and_debate/news/meeting_at_babylon.aspx [24 October 2007]

Dolatowska, A, and Joks, A, 2006 Doświadczenia wojsk lądowych w ochronie dóbr kultury w trakcie misji w Iraku, *Przegląd Wojsk Lądowych* Nr 9 (567), 77–79

Galbierczyk, G, Lemiesz, M, Olędzki, Ł, and Sałaciński, K, 2004 *Poland's activities in the field of protection of cultural heritage in post-war Iraq. Tasks realized by Polish experts within the Multinational Division Central-South*, MKiDN, Warszawa

Garden, T, 2003 Iraq: the military campaign, *International Affairs* Vol 79, no 4, 701–718

Hamilakis, Y, 2003 Iraq, stewardship and 'the record'. An ethical crisis for archaeology, *Public Archaeology* Vol 3, no 2, 104–111

Jegliński, A, 2006 *Raport końcowy z działalności na stanowisku st. Specjalisty ds. archeologii i ochrony dziedzictwa kulturowego w okresie od 18 lipca 2005 do 2 czerwca 2006, Ad Diwaniyah*, unpub materials of MKiDN

Kiarszys, G, 2005 *Raport o sytuacji w dziedzinie ochrony dóbr kultury w strefie AOR I działaniach podejmowanych przez MND CS w celu ochrony zabytków, Ad Diwaniyah*, unpub materials of MKiDN

Lemiesz, M, 2005 *From land and air ... Polish stabilization mission in Central Iraq and protection of cultural heritage (2003–2005) – some remarks*, MKiDN-MAP, Warszawa

Mazurowski, R, 2003 *Ramowy projekt ochrony dziedzictwa kulturowego Iraku w Polskiej Strefie Stabilizacyjnej*, unpub materials of MkiDN, Warszawa

McIntosh, A, 2004 British initiatives for cultural heritage preservation, in *Cultural Heritage in the Face of the Threats in War and Peace Time* (eds J Nowicki and K Sałaciński) 150–158, MKiDN, Warszawa

Meskell, L, 1998 Archaeology matters, in *Archaeology under Fire*, (ed L Meskell), 1–12, Routledge, London and New York

Olędzki, Ł, 2005, *Raport z działaności na rzecz ochrony dziedzictwa kulturowego Iraku w okresie od marca 2004 do września 2004, Babylon*, unpublished materials of MKiDN

Pastore, G, 2004 Carabinieri for the protection of cultural heritage: structure and activity of contrast against military and terrorist actions directed to the cultural heritage, in *Cultural Heritage in the Face of the Threats in War and Peace Time* (eds J Nowicki and K Sałaciński), 24–46, MKiDN, Warszawa

Seymour, M, 2004 Ancient Mesopotamia and Modern Iraq in British Press, 1980–2003, *Current Anthropology* Vol 45, no 3, 351–368

Forensic Archaeology and Anthropology in and for Iraq; Context and Approaches

MARGARET COX

INTRODUCTION

This chapter examines the context for, and possible approaches to, the application of forensic archaeology, anthropology and other sciences within and for Iraq. This provides a background to the circumstances that potentially exist for Iraq to locate, excavate and identify human remains and other evidence from mass graves and other deposition sites. These grave sites primarily relate to crimes allegedly committed during Saddam Hussein's regime. Within current constraints of space, it is not intended to discuss methodological approaches adopted and adapted by forensic archaeologists (see Cox *et al.* 2008; Hunter and Cox 2005) and anthropologists (Cox *et al.* 2008) when examining forensic landscapes[1] and human remains. Nor will it include more than superficial comment on the increasing politicisation of the Iraq High Tribunal's work within the horrific disintegration of society within that tormented country, or the serious flaws in the recent Dujail trial. It is worth noting, however, that this trial prevented Saddam Hussein and his senior officials from being tried for the crime of genocide in respect of such atrocities as the Anfal campaign (1988), and was impaired by a lack of due process that breached the tribunal's own rules of appeal (see http://www.ictj.org/en/news/press/release/1096.html). This combined with the breaches of international law in the subsequent execution has effectively denied the victims and survivors of the former dictator's regime a sound judicial process that can stand the test of time and a less than clear understanding of the crimes committed. The whole episode has denied justice to all: alleged perpetrators, victims and survivors.

The crimes that Saddam Hussein and his senior officials might have been charged with include war crimes, genocide and crimes against humanity. The misuse of these terms leads to much confusion amongst non-lawyers and a generic term 'atrocity crimes' was proposed by David Scheffer (2001), former US Ambassador at Large for War Crimes Issues; that term is used in this chapter. The use and misuse of these terms is also subject to politicisation to justify the avoidance of international responsibilities by governments and the UN (see Roth 2002).

Demonstrating the evolving concept of what is and what is not acceptable behaviour, and consequently a 'crime', most early written descriptions of what we would today call atrocity crimes are not described in those terms. Mass murder based upon 'group identity' was not labelled 'genocide' until the mid-20th century. 'Genocide' is a term that was coined by Raphael Lemkin in 1944. It involves a denial of the right of existence of part of or the whole of a human group as characterised by such factors as nationality, ethnicity, race, or religion (Kittichaisaree 2001). 'Crimes against humanity' are defined as acts that can occur for a variety of reasons, and within various contexts, but do not inevitably focus on the denial of the right of existence of a human group (ibid). As with genocide, crimes against humanity can include murder, mass murder, extermination, deportation, or other widespread or systematic attacks knowingly committed against members of a civilian population, as well as persecution based on political, racial, or religious grounds (ibid). Most of these categories were applied in the Dujail trial in Baghdad, plus torture. 'War crimes' are those committed in violation of international humanitarian law applicable during armed conflicts (ibid) by forces under military command. As with crimes against humanity, war crimes do not focus on the denial of the right of existence of a human group, although they may target specific human groups. In essence, these crimes usually relate to issues of 'identity', a concept that should interest most theoretical archaeologists and which bring inherent questions to the fore when examining evidence from sites relating to atrocity crimes and conflict.

CONTEXT OF INVOLVEMENT

In sheer numbers, and probably in terms of the percentage of the earth's population that such numbers represent, the last century may have been one of the bloodiest in human history. Fatalities in legitimate warfare are not considered here; this chapter is concerned with archaeological responses to the deliberate killing of large numbers of civilians by their governments.

Deliberate killing is a crime that has always been part of human behaviour (Smith 2002) and further discussion of this can be found in Cox, Flavel and Hanson (2008). In brief, the longevity of murder is seen by reference to such texts as the stories of Cain and Abel as described in the Bible (Genesis 4: 1–15), and the killing of Apsu by Ea in the Babylonian *Enuma Elish* (Spencer 1969). Archaeological evidence of murder and violent death predates such evidence (Thorpe 2003) and the deliberate murder of groups of individuals would appear to have equal longevity. One of the earliest examples of what has been interpreted as Neolithic genocide was in Talheim, south-west Germany (Taylor 1996) and we also find descriptions of what we would describe as atrocity crimes in historical sources dating from the Bronze Age until more recently. An explicit account of genocide described in the Bible is believed to have occurred around the 12th century BC (Numbers 31: 7–12, 15–18). It contains descriptions of slaughter, ideological justification, the transfer of children to the group of the perpetrator, and the enslavement of those not murdered (Smith 2001). Other well-known examples include massacres of the population of Jerusalem by the Romans in AD 70 (described by Josephus), and during

the First Crusade (AD 1099). A description by William of Malmesbury (c AD 1120), describes how Britons were forced from Exeter in the reign of the Saxon King Athelstan (AD 895–939). Today we would describe this as ethnic cleansing (Mynors 1998).

Despite the longevity of such crimes, it was not until the publicity that followed the alleged Armenian genocide (c 1.5 million victims; Harff and Gurr 1994) that the international community began to formally object to such behaviour, though not universally. The phrase 'never again' followed the Holocaust but subsequent events have shown that this only applies to specific peoples and contexts. In the 21st century, ever-evolving and developing international legal instruments, the creation of *ad hoc* tribunals and special courts, and the exposés and protests of NGOs and the media clearly demonstrate that we are now less willing than previously to tolerate such crimes and grant impunity to the perpetrators.

The scale of such crimes in the past is immeasurable, and estimates for the 20th century vary considerably. Rummel's estimate (1997) is generally considered most reliable suggesting that well over 170 million civilians were unlawfully killed by governments. Notable examples include what was probably the first genocide of the 20th century, the extermination of the Herero people of south-west Africa, by German colonists in 1904 (Rittner *et al.* 2002); of over 11 million individuals by the Nazi regime between 1939 and 1945 (Brearley 2001) including Jews, Roma (200,000–500,000), Sinti, and Slavs; of 1.7 million Cambodians by the Khmer Rouge in the late 1970s (Seng 2005). In the 1980s Guatemala witnessed a genocidal campaign 'La Violencia', predominantly against the Maya. In over 600 massacres the army displaced 1.5 million, and murdered more than 200,000 civilians (Sanford 2003). Astonishingly, it seems that Communist regimes may well have murdered up to 148 million civilians. Mao is considered responsible for between 30 (Harff and Gurr 1994) and 77 million deaths (R J Rummel, pers comm) between 1923 and 1987. Somewhere between 20 (Harff and Gurr 1994) and 62 million (R J Rummel, pers comm) died in the Soviet Union between 1917 and 1987. Not all of these peoples were killed in specific acts of violence; many were starved to death by driving them from their lands and deliberately denying them access to food and shelter. Perhaps the most shameful and avoidable of all such recent events was the 100 days genocide in Rwanda in 1994. The sequence of lies, deceit, complacency, and neglect that lead to the murder of over 1 million Tutsis and moderate Hutus was paradoxically facilitated by both the actions and the lack of intervention of the Western powers and the UN (Melvern 2000 and 2004). In Rwanda, as in many genocides, ordinary citizens become 'willing executioners'. Hence, while there is vertical responsibility (and often impunity) afforded to leaders and the hierarchy of those officially involved (down to militia), there is also lateral responsibility with civilian members of the perpetrator group becoming killers (Sanford 2003). Many are seduced into involvement by the insidious processes involved in the eight stages of genocide,[2] particularly polarisation and group identification.

In the 21st century, innocent civilians continue to die in both well-publicised (Darfur) and largely ignored longer term atrocity crimes committed in such places as Myanmar. A recently exposed alleged genocide by the Indonesian government, of indigenous peoples

in western Papua New Guinea, apparently began over 40 years ago. Since that time over 100,000 people have allegedly been killed, their lands seized and the people relegated to the status of animals – all classic genocidal behaviours (Rittner *et al.* 2002). Despite these allegations, as I write the British government is holding meetings with the Indonesian government to discuss trade agreements and will not raise with them these or other alleged human rights abuses (pers comm, R Samuelson and B Wenda, Free West Papua Campaign, 26/01/07). Just as it was expedient for Western governments to support Iraq in the 1980s, so it seems to be with Indonesia and elsewhere in the early 21st century.

It would of course be naïve to think that the current climate, where occasionally solutions are being sought and interventions made, is other than politically or economically driven; Iraq is such an example. At the time such crimes were being committed in Iraq, they were ignored by the West. However, these same killings became one area of justification upon which political decisions and reputations were justified once it was politically expedient to remove a dictatorship. Elsewhere we have seen how a later change of government or democratisation (Cox 2003) can subsequently shift priorities (eg many Central American countries; Doretti and Fondebrider 2001). Political imperatives of governments aside, 24/7 news and globalisation mean that increasingly, where previously there was a culture of impunity fostered by governments and organised religions, there is a growing consensus that applying a rigorous legal process in the interest of justice (Cox 2003) is vital.

Alongside all of this, the number and collective voice of human rights and transitional justice NGOs demanding a just world with effective, fair and meaningful justice is increasing. Inforce is one of these organisations. The continued utilisation and development of forensic archaeology and anthropology in the investigation of atrocity crimes is always set within an evolving and disturbing context. Engagement with such activity brings ethical dilemmas and moral obligations in its wake. While some forensic organisations may seem to work in seeming ignorance of underlying political and/or societal shifts, Inforce does not. We practise rights-based forensic sciences to sites of previous atrocity crimes. Inforce is also dedicated to empowering post-conflict peoples and regions by providing effective and high quality training in the skills required to undertake this work themselves – if they choose so to do. This enables people to take control of their future; it empowers them by building a forensic capacity that can also be used in domestic crime, and in responses to mass fatality incidents (ie transportation accidents, natural disasters and terrorist attacks). Such a capacity may also act as a deterrent to serious crime in the future. Furthermore and of great importance, it empowers post-conflict countries to both recover and interpret evidence of their recent history and thus take ownership of the past, present and future. It is an essential part of truth and reconciliation processes.

Any forensic work, albeit for judicial or humanitarian purposes, can only take place in an appropriate socio-political-legal context and with the availability of adequate resources. In the case of the recent atrocity crimes in Rwanda and the Former Yugoslavia, this occurred relatively quickly within the context of international support for the mandate of the *ad hoc* international criminal tribunals for the Former Yugoslavia/Rwanda

(ICTY/ICTR). Elsewhere, this has often been dependent on factors such as a change of priorities in international politics, most recently the so-called 'war against terror'. In the case of international criminal tribunals (as above) or special courts (eg Cambodia or Sierra Leone), the focus of investigations is primarily judicial. In some investigations the motives for an investigation may be primarily humanitarian, with such factors as amnesty laws (eg some Central American countries) or political expedience (eg Cyprus) preventing a judicial element. The danger with humanitarian work is that this too can be politically driven and can in some circumstances bring with it pressure on forensic teams to ignore and hence conceal evidence (ie by not recording it) of crime. This may include evidence of the restraint of victims, torture and the cause and manner of death. This must be avoided; it is probably illegal and certainly immoral.

It is to date extremely unusual for an investigation to provide evidence in a way, and to standards, that satisfy the needs of both judicial process and human rights.[3] This does little service to either the deceased or the survivors; it also fails to fulfil the requirements of the Geneva Convention (1949),[4] and may lead to the destruction of evidence that could be vital for justice to be served and identifications to be made. Limited mandates and aims detract from justice in its broadest sense.

Another important consideration in the forensic application of archaeology, anthropology and other sciences is that we should all recognise that 'justice' means different things to different peoples (Cox 2003). International courts and tribunals serve the needs of international structures and generally Western concepts of justice. They can reinvest the survivors of atrocity crimes with 'rights as legal citizens' ie individuals with formal rights and obligations (Seng 2005). This is vitally important as most have been subject to periods where their rights as citizens have been purposely dismantled during the processes of dehumanisation (Stanton 1998) almost always adopted by genocidairres prior to genocidal acts (eg in Rwanda, the Tutsi were labelled as cockroaches; Melvern 2000). Further to this, on a local level communities need a form of justice that is relevant to their own culture and ideologies. In our experience of talking to survivors in Rwanda, their local Gacaca system is far more meaningful than what they perceive to be the expensive and ineffective ICTR. It should however be recognised that engagement with courts has benefits above and beyond the obvious and can be crucial in helping to restore rights to disempowered groups and restore the value and worth of their identity as a social group. By assisting judicial and humanitarian processes, forensic practitioners are engaging in restoring social identity to peoples.

The Inforce Foundation was established in 2001 (Cox 2003) as a result of the concern of individuals to the well-intended but ill-considered deployment of numerous international forensic teams, each with different levels and types of expertise and different techniques into post-conflict regions in preceding years. This all took place without an adequate framework of deployment, operation, protocols and standard operating procedures. A similar uncoordinated response threatened to descend on Iraq in 2003–04 (the deteriorating security situation prevented it) and did affect countries affected by the Asian tsunami in 2005 (Rutty *et al.* 2005). This reflects an uncoordinated and ill-

considered response that has been described by Bill Haglund (pers comm 2003) as a 'forensic feeding frenzy'. Aside from ineffectiveness of response, there is a danger that the deployment of international teams to post-conflict regions has undesirable and unethical neo-colonial connotations (for discussion of ethics in forensic archaeology see Cox 2003; Hunter and Cox 2005). Assessment of the broader impact of the involvement of international forensic teams in overseas contexts is generally not undertaken (Newell 2007) but should be.[5] Impact assessments are standard practice for development agencies working in international contexts (Banos Smith 2006; Roche 1999) and are also undertaken in the UK in police operations (ACPO Centrex 2005) with reference to affected local communities.

Forensic engagement in Iraq

The Inforce Foundation has been providing forensic assistance to Iraq since May 2003. While initially (2003) being involved in assisting with strategic development and community assistance (see Plate 15), our more recent involvement has been helping build capacity in relevant aspects of the forensic sciences and crime scene management and working with the embryonic National Centre for Missing Persons in Iraq.

When the US Coalition began what many believe to be their illegal invasion of Iraq in March 2003, Inforce anticipated that we might be asked to assist in the location and excavation of human remains from mass graves[6] relating to the alleged crimes of the former regime. There were, however, significant ethical and moral implications of engagement in Iraq, following a legally disputed war, and serious reservations about the independence and effectiveness of the then Iraq Special Tribunal (later High Tribunal) and its adoption of the death penalty. In order to determine how to respond, we consulted our scientific and legal advisors and our supporters for their views (see www.inforce.org for a list of these individuals). The ensuing debate was extremely interesting and the consensus was that if we were asked to engage, we should. Almost all considered that the need for assistance of local communities engaged in the location and recovery of their missing family and community members overrode moral objections. Only one supporter felt strongly that we should not engage and resigned when we did. The majority also felt that we should do all that we could to avoid the kind of forensic chaos witnessed elsewhere and work with Iraq in developing an appropriate strategy, protocols and standards, and the in-country capacity to locate, recover and identify the missing and recover evidence pertaining to the alleged crimes.

In May 2003, we were asked to deploy a team to Iraq to assist local communities exhuming the dead, and to assess some potential mass grave sites. We deployed the first team four days later and our involvement in the field at this time was humbling, difficult and inspiring. Our first team (three archaeologists, three anthropologists, a scene of crime officer, a liaison officer and a photographer) worked in the field for nine weeks. Work was impaired by post-invasion chaos and particularly by a lack of resources including transport and security, and of course the detrimental effect of very high temperatures (40°C plus) on sensitive equipment (only solid state technology could withstand such temperatures).

While there we witnessed shameful acts of biased reporting by some of the UK media, who were determined to portray the efforts of local communities as inappropriate and inefficient and ignored the silent efficiency and dignity that we witnessed (see Plate 15). Community actions were not in our view inappropriate; the dead were their dead, their family members and friends and they had been deprived of the opportunity to recover their remains and have any form of closure for many years. Their haste was not helpful in terms of efficiency, in terms of being 'good science' or in obtaining complete bodies or accurate identifications but was understandable as there was no indigenous forensic capacity and they feared a small window of opportunity before the former regime was reinstated. What was done seemed to satisfy the immediate need for closure for some. The risk in this is that if it is subsequently demonstrated that some identifications were incorrect, it may do considerable emotional (and possibly legal) damage to the relatives involved. Further outrage and shame was felt by us when we saw evidence of the cluster bombs almost certainly used by Coalition forces during the invasion.

Following this involvement, Inforce teams were deployed from August 2003 to April 2004. Their remits were two-fold. First, to attempt to coordinate the resources necessary for a large programme of mass grave location, excavation and identification and to coordinate any incoming forensic teams' efforts (there were fortunately very few of these). Archaeologists for Human Rights chose to work outside of the framework of our efforts. We completed the development of protocols and standard operating procedures to underpin such activities.[7] The second aim was to undertake an assessment of the indigenous forensic capacity and infrastructure within Iraq. All work was halted in April 2004 because of deteriorating security within Iraq.

Following from this early engagement, we continued to advise the Iraq Policy Unit at the UK Foreign and Commonwealth Office (FCO) as requested on issues relating to the recovery of the missing and forensic evidence for trial processes. Much debate took place around the appropriateness and practical realities of providing training in aspects of the forensic sciences, logistics and crime scene sciences and in the summer of 2005 we were invited to tender for the provision of such services; our bid was successful. Subsequently, Inforce delivered three forensic training programmes to enable Iraq to form their own multi-disciplinary team of forensic scientists and crime scene investigators, and to enlighten lawyers on the potential value of physical evidence from mass graves in trial proceedings. We finally trained those most suitable from the first group of trainees to be trainers. These three programmes were funded by the FCO and cost approximately £1.3 million.

Recruitment of trainees was difficult; a planned visit to interview potential candidates had to be aborted because the Green Zone was under constant mortar attack and all selection had to be done remotely via complex application forms. We were inundated with applicants, many of whom were not suitable in terms of their existing skills and education. We were also under pressure from some Iraqi government officials to take their chosen candidates; such pressure was resisted. For some areas of specialism there was no in-country capacity. Iraq had no physical anthropologists and their police were not trained

in crime scene investigation or management. Some aspects of the skills necessary for locating and excavating mass graves were considered rather demeaning for archaeologists because in Iraq, most professional archaeologists are not field practitioners; technicians are used for that purpose. The same was true of radiography.

The first of these programmes was designed to produce a multi-disciplinary cohort of skilled individuals capable of locating, excavating, recording and analysing a mass grave and analysing human skeletal remains. This was delivered over five months and at Master of Science level.[8] Trainees specialised in one of the following: forensic archaeology (archaeologists), forensic anthropology (medical doctors), forensic radiography (radiologists), crime scene investigation (police officers), mortuary management (an engineer), project management and logistics (a manager). This training was set within understanding of legal and scene of crime frameworks. Thirty-three trainees undertook and successfully completed this programme which included the first ever use of simulated mass graves and a simulated temporary mortuary as vehicles for experiential teaching and learning (see Plate 16 and Fig 1). The outcomes were extremely successful in terms of providing an almost realistic training experience following from theoretical, laboratory and field training.

The second programme was an intensive three-week programme designed to train 39 lawyers who now work for the Iraq High Tribunal. This was co-delivered by Inforce with the Defence Institute of International Legal Studies, Boston, USA. Our role was to provide an eight-day introduction to the scientific aspects of the recovery and interpretation of physical evidence; this is essential if such evidence is to be properly utilised by the courts. Programme three trained 12 of the first group in training skills. This programme comprised four weeks intensive teacher training, skills enhancement (as appropriate but also including forensic pathology for some of the medical doctors) and a professional placement for four weeks. These took place in the UK, Bosnia (courtesy of the International Committee for Missing Persons) and South Africa. The first training courses designed by some of these trainees have since been delivered in Iraq.

Our role in these programmes extended beyond providing training and included the provision of accommodation and pastoral support for the trainees throughout the programmes. Trainees received a stipend to be used to support their families in Iraq and a living allowance for themselves whilst in the UK. We did our best to introduce them to the local Iraqi community, locate appropriate places for religious practice, and support them in their anxieties about their families in Iraq. We later discovered that most of the trainees came to the UK without the knowledge of their families and colleagues. They were anxious to avoid unnecessary risks by being openly involved in a UK government-supported project. We were impotent to help when serious crises in Iraq affected a number of them. Whilst in the UK, some lost family members in random events, some were told of family members taken by security and other forces, some became parents and some lost parents. We could do little to help in such circumstances and witnessed their grief and their strength with humility.

We continue to support Iraq as and when we can and largely through participating

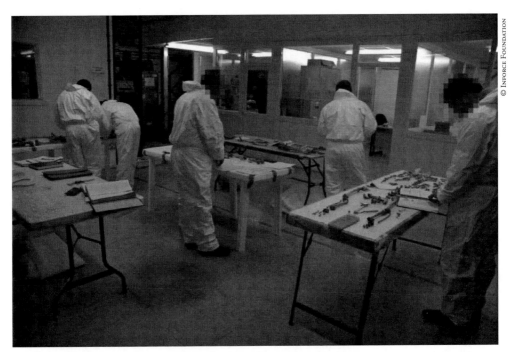

FIG 1. DETAIL FROM A SIMULATED TEMPORARY MORTUARY SHOWING TRAINEES EXAMINING HUMAN REMAINS. RESIN SKELETONS WERE BURIED WITHIN THE GRAVE AND RECOVERED BY ARCHAEOLOGISTS. AFTER THESE HAD BEEN TAKEN TO THE MORTUARY BY SCENE OF CRIME EXAMINERS, THEY WERE REPLACED WITH ARCHAEOLOGICAL HUMAN REMAINS PRIOR TO EXAMINATION BY FLUOROSCOPE AND A FULL ANTHROPOLOGICAL EXAMINATION

in meetings to develop policy and strategy around key issues around the recovery of their missing (eg the development of databases for ante- and post-mortem data, ante-mortem data collection and psycho-social work etc). Further to that we are part of an international team that is supporting the Ministry of Human Rights in Iraq in the establishment of a 'Centre for Missing and Disappeared Persons in Iraq'. We remain in contact with as many of our trainees as possible and continue to be concerned for their safety and their futures. We were honoured to have the experience of working with them and challenged as educational scientists in some aspects of the training. It is easy to forget that individuals who have grown up in repressed regimes do not easily enter into UK-style higher education. Most had never had the opportunity to be free to think or to draw and voice their own opinions and conclusions. One wrote after the completion of the programmes to express his thanks for being given the confidence and freedom to think and have an opinion.

Inforce is of course, not the only forensic organisation to have engaged with the location and recovery of mass graves and associated human remains in Iraq since 2003. It is reassuring to know that at least in the north of the country, some of our trainees are

engaged in the work for which they were trained. Many local government initiatives to recover the dead and evidence of criminal activity have been undertaken in the primarily Kurdish areas where it is relatively safe to do so. Several sites have been located during development schemes. Elsewhere, most work has been undertaken by teams organised by the US government through the Regime Crimes Liaison Office of the US Department of Justice. This has been widely reported upon in the media (eg http://www.nytimes.com/2006/08/17/world/middleeast/17forensics.html; http://kurdishaspect.com/doc1011103.html; http://www.riverfronttimes.com/issues/2006-09-13/news/feature_full.html; Simons 2006). Some of this work has been criticised for apparent breaches of crime scene practice (eg being filmed, allowing the media to get into graves to take photographs [ie potentially contaminating the site] and discussing with them the hope that the evidence would help to convict Saddam Hussein (Wright 2004). The latter expresses an opinion that should not have existed prior to completion of the field and laboratory analysis and interpretation. It presupposes the outcome and suggests that the scientists were not impartial.)

For most of those living outside of the Kurdish areas it has not been possible to put into practice the skills learnt because of the instability and security concerns, nor has the Iraq government been able to initiate such work. We know that some of the team have fled the country; some remain, and of those most dare not discuss their newly acquired skills openly because of the implications for their and their families' safety. Could we and they have predicted that in 2007, Iraq would be in the situation it currently is? Probably not; had we done so then it is likely that the content of this chapter would be very different.

WHY ENGAGE?

When John Hunter first began to explore the application of forensic archaeology in the 1990s (Hunter 1994), the reaction from most non-forensic archaeologists was to shun such engagement (eg Faulkner 1997). Despite that, a not inconsiderable number do engage in the application of both archaeology and anthropology within a forensic and/or humanitarian context. Reasons for that are explored in some depth elsewhere (Cox 2001). Matters of fashion and trends aside, for many practitioners, such engagement allows us to use our skills in a context with immediate social relevance. This is attractive to some. Forensic application of our skills allows us to participate in the resolution of serious crime (both domestic and international), to contribute to mass fatality response, and to have the illusion of contributing to 'safer' world (ibid, Cox in press).

Such engagement is inevitably accompanied by a responsibility to be aware of the overarching socio-political and economic contexts and comment on these as and when appropriate. These responsibilities also extend to commenting on the injustice, justice and quality and appropriateness of international responses to post-conflict and mass fatality contexts. Forensic archaeologists and anthropologists have a moral duty to consider and comment on these matters and also on our collective responses as professionals; these matters have been touched upon here. Clearly such responses must fit into frameworks of

legal and regulatory process and rules of *sub judice*, and should extend beyond professional, methodological and technical issues to those of motive, intent and impact.

Many non-forensic archaeologists and anthropologists engaged with theory might consider that forensic application is, if we focus here on anthropology, one that is purely 'osteoarchaeological', ie that it focuses on biological criteria such as age and sex outside of any broader issues of social identity. This is considered as 'object based archaeology' (Sofaer 2006). Sofaer compares object based osteoarchaeology with one where consideration of the body is as a social construction that is historically and contextually produced (ibid, xiii–xiv). Gallantly, and with some success, she strives to dismantle the perceived incompatibility between the two stances. Sofaer (ibid) examines how the human skeleton reflects a once living body that is modified in life (and I would add, when approaching death) through both intentional and unintentional actions; that living people and aspects of their skeletal remains are created through social practice. I would suggest that nowhere does this theory apply more so than in the examination of remains from atrocity crimes. While it is imperative to recover as much information as is possible to attribute an 'identification' to human remains (so that they can be returned to families for humanitarian reasons, and occasionally to help clarify events leading to a purported crime), most of these crimes were committed for reasons pertaining to social identity. As discussed above, in most instances, people have been deliberately or otherwise categorised according to criteria that allow them to be marginalised and murdered. Our work can help to restore social identity to the disempowered.

NOTES

1. Scenes of crime including mass murder and execution, body processing, body transportation, the construction of mass graves, the deposition of human remains within them and concealment of the sites. (For further details see Hanson, 2004 and Cheetham *et al.* 2008.)

2. The eight stages of genocide include: classification of people into different groups, symbolism, dehumanisation, organisation, polarisation, identification, extermination, denial (Stanton 1998).

3. The ICTY did not attempt to identify most of the bodies recovered during forensic investigations conducted by them. This led to thousands of unidentified victims being recovered and a similar number of families without closure – either emotional or legal.

4. Part III, Section IV, Chapter XI, Article 130 gives the victims of warfare the right to an individual marked grave. To attempt to conceal remains by interring them in an unmarked mass grave is in breach of this section of the Geneva Convention 1949.

5. The wider impact of the work undertaken must be assessed including impact on (1) those directly affected by such work by its very nature, (2) those indirectly affected by the work and (3) incidental impacts caused on local communities and others by the presence of 'foreign' nationals with all of their trappings and expectations.

6. 'Mass grave' is a term widely employed in the media and elsewhere, often without any clear understanding or broader contextual definition. This is discussed in depth in Cox, Flavel and Hanson (2008) and we conclude that a simple definition of a mass grave is as a place of deliberate disposal of multiple victims of crime within the same grave structure.

7. These have subsequently been further developed and expanded and being published by CUP (Cox *et al.* 2008).

8. For some aspects of this programme, trainees joined the MSc forensic archaeology and anthropology units being delivered at Bournemouth University. We are very grateful to the University and staff involved for their cooperation.

BIBLIOGRAPHY

ACPO Centrex, 2005 *Practice Advice on Core Investigative Doctrine*, National Centre for Policing Excellence, Cambridge

Banos Smith, H, 2006 International NGOs and impact assessment: Can we know we are making a difference? *Research in Drama Education* 11:2, 157–174

The Bible, 1960 Oxford University Press, Oxford

Brearley, M, 2001 The persecution of gypsies in Europe, *American Behavioural Scientist* 45, 588–599

Cheetham, P, Cox, M, Flavel, A, Hanson, I, Haynie, T, Oxlee, D, and Wessling, R 2008 Search, Location, Excavation and Recovery, in *The Scientific Investigation of Mass Graves: Towards the Development of Protocols and Standard Operating Procedures*, Chapter 5 (eds M Cox, A Flavel, I Hanson, J Laver, and R Wessling), Cambridge University Press, Cambridge

Cox, M, Flavel, A, Hanson, I, Laver, J and Wessling, R (eds), 2008 *The Scientific Investigation of Mass Graves: Towards the Development of Protocols and Standard Operating Procedures*, Cambridge University Press, Cambridge

Cox, M J, 2001 Forensic archaeology in the U.K.: questions of socio-intellectual context and socio-political responsibility, in *Archaeologies of the Contemporary Past* (eds V Buchli and G Lucas), 145–157, Cambridge University Press, Cambridge

Cox, M J, 2003 A multidisciplinary approach to the investigation of crimes against humanity, war-crimes and genocide: the Inforce Foundation, *Science and Justice* 43(4), 225–29

Cox, M J, In press. A history of forensic archaeology and anthropology in the United Kingdom, in *Handbook of Forensic Anthropology and Archaeology* (eds S Blau and D H Ubelaker), Left Coast Press, California

Doretti, M, and Fondebrider, L, 2001 Science and human rights: truth, justice, reparation and reconciliation, a long way in third world countries, in *Archaeologies of the Contemporary Past* (eds V Buchli and G Lucas), 138–144, Cambridge University Press, Cambridge

Faulkner, N, 1997 Wrong winners, *British Archaeology* 21:10 (February)

Geneva Convention, 1949 Part III, Section IV, Chapter XI, Article 130

Hanson, I, 2004 The importance of stratigraphy in forensic investigation, in *Forensic Geoscience: Principles, Techniques and Applications* (eds K Pye and D Croft), 39–48, The Geological Society, London

Harff, B, and Gurr, T R, 1994 *Ethnic Conflict in World Politics* (Dilemmas in World Politics), Westview Press, Colorado, USA

Hinman, K, 2006 CSI: Iraq [online] available from: http://www.riverfronttimes.com/issues/2006-09-13/news/feature_full.html [30 January 2007]

http://post.gazette.com/pg/05353/624651.stm [30 January 2007]

Hunter, J R, 1994 Forensic archaeology in Britain, *Antiquity* 68, 758–69

Hunter, J, and Cox, M, 2005 *Forensic Archaeology: Advances in Theory and Practice*, Routledge, London

International Center for Transitional Justice, 2006 *Iraq Tribunal Chooses Speed over Justice in Final Ruling* [online] available from: http://www.ictj.org/en/news/press/release/1096.html [30 January 2007]

Kittichaisaree, K, 2001 *International Criminal Law*, Oxford University Press, Oxford

Kurdish Aspect, 2006 *Remains of* http://kurdishaspect.com/doc1011103.html [30 January 2007]

Lemkin, R, 1944 *Axis Rule in Occupied Europe: Laws of Occupation, Analysis of Government, Proposals for Redress*, Carnegie Foundation for International Peace, Washington, DC

Melvern, L R, 2000 *A People Betrayed: The Role of the West in the Rwandan Genocide*, Zed Books, London

Melvern, L R, 2004 *Conspiracy to Murder; the Rwandan Genocide*, Verso Books, London

Mynors, R A B, 1998 *William of Malmesbury: Gesta Regum Anglorum (Deeds of the English Kings) Vol 1*, Oxford University Press, Oxford

Newell, N, 2007 *Towards the Establishment of Impact Assessment Strategies for International Forensic Teams*, Unpublished dissertation, MSc Forensic Archaeology. Bournemouth University, UK

Rittner, C, Roth, J K, and Smith, J, 2002 *Will Genocide Ever End?* Paragon House, St Paul, Minnesota

Roche, C, 1999 *Impact Assessment for Development Agencies*, Oxfam, Oxford

Roth, J K, 2000 The politics of definition, in *Will Genocide Ever End?* (eds C Rittner, J K Roth and J M Smith), 23–30, Paragon House, St Paul, MN

Rummel, R J, 1997 *Statistics of Democide: Genocide and Mass Murder since 1900*, Centre for National Security Law, School of Law, University of Virginia, Charlottesville, Virginia

Rutty, G N, Byard, R, and Toskos, M, 2005 The tsunami: An environmental mass disaster, *Forensic Science, Medicine and Pathology* 1: 3–8

Sanford, V, 2003 *Buried Secrets: Truth and Human Rights in Guatemala*, Palgrave Macmillan, New York

Scheffer, D, 2001 *50th Anniversary of the Genocide Convention*, Accessed: http://www.iccnow.org/documents/USScheffer_Genocide13June01.pdf?PHPSESSID=dacc676a5cc797c9970bbf3fe0096253 [27 October 2007]

Semple, K, 2006 Bodies yield evidence of Hussein-era killings, in *The New York Times* [online] available from: http://www.nytimes.com/2006/08/17/world/middleeast/17forensics.html [30 January 2007]

Seng, T C, 2005 *Daughter of the Killing Fields: Asrei's Story*, Fusion Press, London

Simons, L M, 2006 (January). Genocide unearthed, *National Geographic* 209(1): 28–35

Smith, R W, 2002 As old as history, in *Will Genocide Ever End?* (eds C Rittner, J K Roth and J Smith), 31–4, Paragon House, St Paul, Minnesota

Sofaer, J R, 2006 *The Body as Material Culture: A Theoretical Osteoarchaeology*, Cambridge University Press, Cambridge

Spencer, R, 1969 Enuma Elish, in *Near Eastern Texts Relating to the Old Testament* (3rd edition). (ed J Prichard), Princeton University Press, Princeton

Stanton, G H, 1998 located in: http://www.genocidewatch.org/8stages.htm [6 February 2007]

Taylor, T, 1996 *The Prehistory of Sex*, Fourth Estate, London

Thorpe, I J N, 2003 Anthropology, archaeology, and the origin of warfare, *World Archaeology* 35(1): 145–165

Wright, R, 2004 (16 October) Mass grave on trial. *The Australian*

Iraqi Libraries and Archives in Peril

Jeff Spurr

Dedicated to Dr Saad Eskander and his colleagues at the
Iraq National Library and Archive

This chapter focuses on the Iraq National Library and Archive (INLA) as an example of the destruction that has befallen libraries and archives across Iraq, and the challenges to their rehabilitation.[1] The chapter highlights the lack of care and effectiveness on the part of international bodies (eg IFLA, UNESCO), and governmental entities of the United States of America in publicising, coordinating, funding, and delivering aspects of that rehabilitation, and the consequences of the deteriorating security situation for the INLA and other institutions, those staffing them, and their reconstruction.

Few of the salient international actors have risen to the occasion at a time of desperate need. It is both remarkable and scandalous that they have failed to act in a more provident, sustained, sensitive, and committed way to achieve the redevelopment of Iraqi libraries and related institutions – and higher education generally – a goal which should have been a primary feature of the Coalition project in Iraq, but has manifestly not been, as evidenced by the cancellation of the USAID-HEAD programmes (five three-year projects to aid Iraqi universities cancelled after one year) among many other acts of omission and commission. Despite the many recommendations, it is worth noting that UNESCO's International Coordination Committee has, in fact, promised very little, and its intention to promote training for librarians is already being accomplished by others. In this regard, it is symptomatic that the links on UNESCO'S *Crisis in Iraq* webpage for 'Projects Awaiting Financial Support', 'Ongoing Projects', and 'Projects Completed' reveal no assistance to libraries or archives, despite the recommendations of the UNESCO-commissioned report by Jean-Marie Arnoult. Similarly, none of the great private foundations with a strong interest in education (Carnegie, Gates, MacArthur, and Soros), have made any commitments to Iraqi universities or libraries.

As if in league with this failure, the various Iraqi governing entities have been mired in turf battles, corruption and ideological struggle. For every committed government functionary there appear to have been many others willing to foil or diminish his or her efforts. The extreme state of insecurity, and the consequent haemorrhaging of educated and competent individuals out of the country, bodes ill for the future of the institutions under discussion, and Iraq as a viable polity. Nevertheless, certain developments demonstrate

that different priorities and sensible leadership on all sides could achieve great things. These include the manner in which the Iraq National Library and Archive has grown and improved in every aspect of its functioning since the catastrophe of 2003; positive developments in Iraqi Kurdistan; the remarkable success of specific projects such as the Iraqi Virtual Science Library (IVSL) – one of the few situations where an entity of the US government has supported committed and imaginative individuals to achieve effective goals; the work of WHO to support medical libraries at all institutional levels; and the training programmes for Iraqi academic librarians undertaken by the Simmons GSLIS-Harvard initiative and OCLC.

A reading of history suggests the role that libraries have played as a barometer for the status of civilisation, and reveals that a flourishing and developing society has always been one that privileged libraries, despite destructive and totalitarian episodes. Perhaps because of their importance, such critical cultural institutions have been especially vulnerable when power has been exercised arbitrarily, or when those seeking it have resorted to violent means to achieve their ends, or when the normal controls imposed by authority have been overthrown. This condition applies as well to contemporary Iraq as anywhere. That Iraq's principal libraries and archives are in such a desperate state is a critical symptom of the profound crisis facing this nation and its people.

INVASION, DERELICTION, AND LOOTING

On 7 April 2003, American forces entered Baghdad on a 'thunder run' of tanks and Bradley armoured fighting vehicles that moved from the already-secured airport directly to the area of Saddam Hussein's palaces in the Presidential Zone of central Baghdad, soon to be taken over by the Coalition Provisional Authority (CPA), and dubbed the 'Green Zone'. By 9 April, the 'new order' was declared to be complete: by the next day, pervasive looting was underway. *The Washington Post*'s Rajiv Chandrasekaran was a witness, and has stated (in an interview on National Public Radio), that looters were first hesitant, 'testing the waters', but that when no one got in their way, indeed, looked on impassively, their efforts began in earnest (see Chandrasekaran 2006). By this means was virtually every government, cultural, and educational institution, and many business and industrial establishments eviscerated.

Most infamous was the looting of the Iraq Museum (see George, chapter 10; Bogdanos, chapter 11), however, the almost exclusive focus on that institution by the international media effectively eclipsed the fact that Iraqi universities, their libraries, the National Library and Archive, and other such institutions were not spared this horribly thorough process, in Baghdad and elsewhere in Iraq outside Iraqi Kurdistan.

Due to the fog of war, and unfamiliarity with the country and its institutions, the reportage concerning devastation to critical cultural institutions, including libraries and archives, was nearly as confused and inaccurate as that concerning the Iraq Museum (and see Johnson 2005), which received the great bulk of the media attention in any case. Early reports (for example, al-Tikriti 2003; Arnoult 2003; Deeb *et al.* 2003; and Watenpaugh *et al.* 2003) provided a depressing picture of the dismal state of the libraries and archives,

and how much was yet to be learned about their condition and the status of their holdings in specific terms, particularly outside the principal cities of Baghdad, Basra, and Mosul.

Al-Tikriti's primary focus was major archival collections and very early on identified the need for massive support regarding 'restoration of physical premises, replacement of plundered equipment, reconstitution of respective collections, comprehensive inventory and cataloguing of all MSS collections as they stand today, replacement of published works and non-original document copies lost in the looting, comprehensive microfilming and data storage of all MSS, to guard against future losses, immediate and ongoing collection of contemporary Iraqi publications' (al-Tikriti 2003) Arnoult (2003) noted that not all damage could be blamed on the recent invasion or looting: 'Because of over a decade of considerable budgetary restrictions and the embargo that blindly reduced the opportunities of acquisition, and because of the looting, Iraqi libraries are doubly wrecked.'

Alongside reliable information on several important institutions, Watenpaugh *et al.* provided the first characterisation of the state of Iraqi intellectual life, and identified the universities as sites of contestation by the various social, religious and political forces unleashed by the overthrow of the Saddam regime. The authors' numerous recommendations, included 'The modernization and restocking of university library holdings [as the] highest priority alongside the reconstitution of institutions such as the National Museum or the National Library and Archives. Unfettered access to the tools of information technology and the internet', and a 'centralized international organization' of academic librarians to work with Iraqi counterparts 'to coordinate major acquisitions and to handle donations'.

THE IRAQ NATIONAL LIBRARY AND ARCHIVE (INLA)

'What makes a Kurd or a Sunni or a Shia have something in common is a national library. It is where the national identity of a country begins.'

(Saad Eskander quoted in Raghavan 2007)

THE LOOTING AND LOSS OF COLLECTIONS

Dr Saad Eskander, Director-General of the Iraq National Library and Archive (INLA) since December 2003, outlined the circumstances facing his institution at the Internet Librarian International conference in London, in October 2004. Eskander opened his presentation with the words: 'In Saddam Hussein's Iraq, the National Library and Archive … was an abandoned cemetery, void of progressive culture and critical thinking.' He went on to describe the deplorable level of functioning within the institution under the Saddam regime at some length, but, he also attempted to give 'an honest and frank explanation' of what took place in Baghdad in mid April 2003, when most cultural institutions were looted and burnt, 'a national disaster beyond imagination'. The looting and burning of the INLA, as a premier instance of this phenomenon, was a terrible event by any definition, and its story exemplifies the afflictions incurred by Iraqi institutions at the time of the

invasion and since. Its story also reveals the extent to which subsequent expectations of assistance from the USA have largely been disappointed, and the challenges faced and price paid under dire circumstances to sustain an effective operation.

According to Eskander 'looters and saboteurs' entered the building twice between 10 and 13 April. Library staff had already moved a large mass of archival materials and rare books to the basement of the General Board of Tourism for safety before 10 April. A fire was lit during the initial wave of looting on the 11 April, and, a second, more destructive fire was set on 13 April. However, a large, internal steel fire door had been shut prior to any looting or arson. The looters did not attempt to open it, and the book stacks behind it remained intact. Abdul Mun'im al-Musawi, a Shi'ite cleric, removed some 5% of the total collections (not, fortunately, the 40% first reported) as well as some archival documents to the Haqq Mosque for safekeeping. Although a well-intended effort at preserving Iraq's patrimony, which could have been critical if a third attack had occurred, this act itself resulted in further damage given the way the books were handled and stored. After some negotiation these materials were eventually returned to the custody of the National Library.

It is estimated that approximately 25% of the book collections were looted or burned, but these were already in a poor state of management, and lacked any recent publications from abroad. In addition, a full 60% of the archival collections were consumed by the fires, including much of the Ottoman-era documents, most of the Royal Hashemite-era documents, and all of those from the Republican period. Indeed, in advance of the fall of the city, Saddam Hussein had ordered all critical documents to be destroyed, which accounts for the acts of arson against the Archives. 'The Republican Archive was of a great value politically as well as historically. Apart from covering the history of the Ba'ath Party since it seized power in 1963, this archive contained the transcripts of all court-martials [sic] set up by the Ba'ath regime for the trial of its opponents' (Eskander 2004). The INLA also lost 98% of maps and photos and all of their storage cabinets. Remarkably, Ba'ath-era archival documents from the Interior Ministry dating up to 1978 were discovered in the INLA's basement still in the original boxes in which they had arrived at the institution just two weeks before the invasion. As the arsonists were unaware of their existence, they remained unmolested (personal communication from Saad Eskander, November 2007).

The archival documents (including important rare books), which had been placed for safe-keeping in the basement of the General Board of Tourism, were soaked when the basement was deliberately flooded after looting by those committing the crime, who broke water pipes to obscure what had been stolen. The soaked documents were moved in early autumn of 2003 to a space above ground level, where the US Library of Congress mission saw them in November exhibiting 'extensive and active mould growth' (Deeb *et al.* 2003). As first reported, some weeks thereafter they were finally placed in four large freezers at the Officer's Club where they awaited conservation. Unfortunately these units were in fact coolers, not freezers, so their contents had never been frozen to the level a conservator would advise under the conditions. They thus continued to deteriorate, albeit more slowly (Teijgeler, pers comm, and see chapter 17). René Teijgeler, then Senior

Consultant for Culture to the Embassy of the United States, finally secured a deep-freezing unit in a truck, to which they were moved, at the same time being transferred from the original metal trunks to archival boxes imported from the USA. The truck was then moved to a heavily-protected, purpose-built shed next to the INLA, where the archival materials remained until the end of 2005, when they were moved into the INLA, the drying completed, and conservation begun.

As this story unfolded Dr Eskander was able to successfully retrieve the Monarchical and Presidential Collections, largely comprising a great mass of books and other gifts to the Iraqi heads of state between 1921 and 2003, from a garage in the former presidential palace complex in the Green Zone. Other stories are not so positive. An important group of stolen documents appeared in Amman in early 2007 with a demand for US $50,000 for their safe return. Given the fact that the total budget of the Library for new acquisitions in the year 2007 is a mere US $7,000, even less than in 2006, this far exceeded any available resources. No-one in the government proved willing to seriously address the issue. Under these conditions, $50,000 might as well be a million.

POST INVASION SUPPORT

After some drama and uncertainty over a replacement site for the INLA, it was determined that the original site could, after all, be successfully renovated. Due to generous Italian assistance, rehabilitative work proceeded with the collections of the National Library. Much of the necessary work simply involved vacuuming, sorting and cataloguing. The first two phases of renovation – repairing the structural damage to the building and supplying it with basic services – were completed by March 2005. At the same time staff had been replacing the old card index system with an automated one. As of February 2007, the National Library had six computers with Internet access, although none are available to the public. From a count of zero after the looting, the total number of computers in the INLA now comes to 140, located in every department of the institution. The first four computers, replacing those few that had been owned by the INLA before the invasion, were purchased by Dr Eskander against the orders of the then Minister of Culture, who thought the Americans should be supplying them. The next 16 computers were paid for by the regional government of Lombardy (Italy). Several small funds donated to UNESCO specifically to benefit the INLA, plus a Japanese gift of US $78,000 provided via the same means, were finally allocated to purchase the rest of the computers now present.

The third phase of renovation – an air-conditioning system, furniture, computer installations, etc – has continued during 2007. By July 2006, all departments were functioning, and library and archive reading rooms received scholars and students every day they were open. The INLA also had two new labs: a well-stocked microfilm lab, and a restoration lab stocked with traditional and modern equipment. The new furnishings were the best available on the local market, and the institution had its own water purification system. Against all odds, the National Library succeeded in publishing the National Bibliography for the period 1996–2006, as well as two specialised bibliographies, one for women, the other for MA and PhD theses.

It had been intended to send a number of Iraqi conservators to the Library of Congress in spring 2005 for a specialised course on deep freezing, freeze drying and defreezing, and subsequent treatment protocols to preserve archival materials. However, horrendous American visa hassles made this impossible. This is one of countless ways in which American policies and actions alienate Iraqis, by their insensitivity and failure to show genuine commitment to Iraqi needs. Unfortunately, the alternative, American conservation experts coming to Baghdad, was obviated by the security situation. The continuing visa problems finally caused the proposed visit to be cancelled. It fell to the local government of Florence (Italy) to underwrite the costs of the Florence National Library providing advanced training to three Iraqi book conservators in lieu of the Library of Congress. It also supported the design and development of a website for the INLA (http://www.iraqnla.org/wpeng/).

Other help has been forthcoming: The regional government of Lombardy (Italy) have paid the wages of 30 librarians, and are committed, in principle, to continuing this support, begun in 2004, through 2008. Five National Library conservation staff members received a two-month basic conservation course in the Czech Republic along with colleagues from the Iraq Museum as early as 2004 (including the three who went to Italy for further training in 2005). The Czech Republic underwrote the installation of a complete conservation lab at the INLA, and Czech conservators actually came to Erbil in Iraqi Kurdistan in 2006 to provide further conservation training, while four staff members trained in Italy, and another group received training in Prague and Litomysl, run by staff from the University of Pardubice, in 2007. The British Library has completed the first stage of reproducing archival materials and rare publications related to Iraq held in its own collections. It awaits further government funding to complete the project.

A memorandum of cooperation has recently been signed between the US Library of Congress and the INLA regarding the World Digital Library Project. This effort is an extension of the American Memory Project, (http://memory.loc.gov/ammem/index.html) which presently contains 10,000,000 records, and is dedicated to supporting the scanning of important and unique textual, visual and sound documents so that they may be made freely available on the internet. The INLA is pinning its hopes on this project to scan a huge portion of its collections of invaluable historical newspapers and journals, before they are lost forever.

René Teijgeler also commented that the National Library had been offered prospects for further funding from European sources, but that he had been short of staff to write up project proposals. Teijgeler's office at the American Embassy was underfunded and understaffed, without immediate access to funding that could be used to acquire something as simple as bookshelves for the many institutions in need of them. Teijgeler left his job in Baghdad in February 2005. He was not replaced, a further sign of American unwillingness to take responsibility for culture, cultural institutions, and the consequences of Coalition forces actions jeopardising them, although glimmers of responsiveness on a modest level from the cultural attachés have been intermittently in evidence during 2006 and 2007, according to Dr Eskander. With the cooperation of the author, and with the intention of

seeking further assistance, Dr Eskander has created a comprehensive needs assessment for both library and archival divisions, which itemizes all furniture, installations, equipment (including upgrades), and materials.required for the the INLA to be fully functioning and achieve its potential. The costs have yet to be established but this document should facilitate the acquisition of future aid.

The INLA has put in place long term plans, two important, practical elements of which are the Archive Storage Project (to result in a new, five-story facility) and the Library of Pioneers. The former building is a critical addition if ambitions to consolidate national archival materials at one institution are to bear fruit. This is necessary in light of the free-for-all that occurred during the period of absolute chaos immediately following the 2003 invasion. At that time, numerous parties, principally the US Army in search of evidence of weapons of mass destruction and al-Qaeda links, but including the Iraq Memory Foundation led by Kanan Makiya, grabbed whatever they could lay their hands on. The new Library of Pioneers will collect the 'works, private papers, photos and letters of outstanding Iraqis [who have] played a significant cultural and scientific part in the development of modern Iraq in different fields' (Eskander 2004). This vision of the new Library of Pioneers, which applies equally well to the proposed Archives, is based on a belief 'that the religiously and ethnically fragmented Iraq needs such a library, a library that can play a role in shaping a new modern historical memory and national cultural identify for all Iraqis, regardless of their ethnic and religious background' (Eskander 2004).

Staffing issues

The staffing structure for the INLA has been completely revised with a view to breaking the accepted protocol of only acting on orders. New staff have been appointed and existing ones promoted, including a number of qualified young female staff to higher positions, in an attempt to encourage everyone to be proactive and creative. By the end of 2006, the staff of the INLA had grown to a remarkable 425, excluding 39 guards, from the 95 present in November 2003 in the then moribund institution. One hundred and sixty of these were directly engaged in various aspects of librarianship, and another 100 were undertaking archival work. Seven heads of departments, the majority of the deputy heads, and the person responsible for Internet connection are women. The remaining staff support these core teams as technicians, administrators, receptionists, cleaners, gardeners, and drivers.

The breakdown of the INLA's link to the Internet and its inability to maintain its official website also illustrate the consequences of the prevailing lack of security. The contract for Internet service was with the Ministry of Communication, and direct service was to be provided by the local Bab al-Mudham Communications office. However, the largely Shi'ite staff was under constant threat from Sunni extremists, three of them had been assassinated, and they simply refused to come the short way to the INLA. Consequently, the INLA had no Internet service, and staff resorted to using Internet cafés. The solution, made possible by the donation by the ever-helpful Italians, was to

introduce a new satellite Internet system. Even so, problems remain at the INLA with this critical feature of contemporary institutional life, not entirely resolvable until stability is achieved.

SECURITY

In 2004, René Teijgeler commented that he had not been out of the Green Zone for a number of weeks and that 'Besides, me going over there will also put the people at the library in danger. The head librarian has again been threatened with death.' The decision, in November 2006, by Saad Eskander to place his diary online on the British Library website (http://www.bl.uk/iraqdiary.html) has offered a vivid idea of the harrowing realities of daily life in Baghdad, including a direct attack on his own car, and of keeping his institution running. In 2006 the known impact of the violence on his staff included 4 assassinations, 66 unlawful deaths of relatives, 2 kidnappings, 6 kidnappings of relatives, 58 death threats, and 51 forced displacements. A full 30% or more of the total budget goes to transporting his staff to and from work. In this process, three of his drivers had been killed. In an attempt to avoid the extortionate demands of transport contractors the INLA has decided to buy a small fleet of eleven minibuses to transport staff to work. This will use up 50% of the entire INLA budget for 2007, with more to be acquired in 2008.

In January 2007 violence around the INLA, which included direct attacks on the INLA itself, caused the institution to be shut for about a week. It has been open and shut since, leading to the establishment of a system whereby every staff member works only four days a week to minimise the danger for each. Furthermore, 11 members of staff have recently applied for early retirement, the insecurity around the INLA, and the terrifying commute being the primary reason.

After the fighting in the vicinity of the INLA, the building incurred major damage when a rocket took out a long section of its fence, more than 100 windows were blown in, furniture destroyed, and a generator and other features damaged. The damaged fence posed a major security risk and the loss of a generator and other damage a gross inconvenience. The problems and inherent time-delays of getting approvals for repairs from the Ministry of Culture exacerbate this situation as in all problems requiring significant expenditure of funds.

CONCLUSIONS

Despite some of the positive developments cited here, the story of assistance to Iraqi academic libraries is as much one of plans thwarted and hopes dashed as goals achieved, and needs to be viewed in the general context of higher education in Iraq. John Agresto, higher education czar under the CPA, asked for US $1.2 billion to make Iraqi universities viable centres of learning; he received US $9 million (Chandrasekaran 2007, 5; specific cost figure from p 167). In light of the overwhelming needs, and the wanton squandering of funds elsewhere, such meagre budget allocations have made the achievement of reasonable and necessary targets impossible.

Those efforts to assist that appear to have been most successful in achieving manifest results are those addressing the training of Iraqi academic librarians. Schemes such as the OCLC and the Simmons-Harvard efforts in Amman, and the latter's at United Arab Emirate University in Al-Ain (which have included INLA librarians, Italian and Czech support for conservation and website development at the INLA), and those achieving access to online resources, such as the IVSL (so far not available to the INLA, although the latter are predicated to be available upon infrastructure development), and must consequently be measured in terms of degrees of access from within Iraq.

The prevailing political situation in Iraq, perilous and uncertain as it is, has made concerted and effective efforts at reconstruction ever more difficult, and one cannot but be concerned over what has been lost in terms of human contacts, developing understanding, and effective process with each political transition, and as talented and committed Iraqis have been forced to flee the country. Furthermore, the universities have become the battlegrounds for every interest group and ideology, although there have been some reports that many students have lately grown disenchanted with the allure of ideologies as they contemplate the results. Sectarian and grudge murders continue, as do the kidnappings, whether motivated by the need to raise funds for the insurgency, sectarian groups, criminal greed, or some combination thereof. As things stand, there will soon be more Iraqi academics abroad as refugees than teaching in their universities and working in their institutes.

Despite this highly fraught situation, any viable Iraqi state of the future will be reliant upon a thriving and effective system of higher education. Well-stocked, well-functioning libraries with adequate Internet access will be its very foundation. Any effort that makes a clear contribution to this end is to be welcomed.

NOTES

1. This chapter provides an update and summary of a 2005 review (Spurr 2005), and a 2007 report (Spurr 2007) augmenting, updating and correcting the former. It draws heavily on information supplied by Dr Saad Eskander and René Teijgeler.

282 JEFF SPURR

BIBLIOGRAPHY

al-Tikriti, N, 2003 *Iraq Manuscript Collections, Archives & Libraries Situation Report 8 June 2003*

Arnoult, J-M, 2003, *Assessment of Iraqi Cultural Heritage: Libraries & Archives*, June 27–July 6, 2003, UNESCO, Paris

Chandrasekaran, R, 2006 *Imperial Life in the Emerald City: Inside Iraq's Green Zone*, Alfred E. Knopf, New York

Deeb, M J, Albin, M, and Haley, A, 2003 *Library of Congress and the U.S. Department of State Mission to Baghdad. Report on the National Library and the House of Manuscripts*, October 27 – November 3, 2003

Johnson, I M, 2005 The impact on libraries and archives in Iraq of war and looting in 2003 – a preliminary assessment of the damage and subsequent reconstruction efforts, in *The International Information & Library Review*, 37(3), September, 209–271

Loughlin, S, 2003 Rumsfeld on looting in Iraq: 'Stuff happens', CNN.com, 12 April 2003, online at: http://www.cnn.com/2003/US/04/11/sprj.irq.pentagon/ [4 November 2007]

Makiya, K, 1998 *Republic of Fear: The Politics of Modern Iraq*, updated edition with new introduction, University of California Press, Berkeley (originally published under the nom de plume, Samir al-Khalil)

Marx, G T, 1970 'Issueless Riots' in *Annals of the American Academy of Political and Social Science*, 391, Sept. 1970, 21–33. online version: http://web.mit.edu/gtmarx/www/issueless.html [4 November 2007]

Pipes, D, 2003 'Blame Iraqis for the Pillage' in *The American Daily* (22/4/03)

online: http://www.americandaily.com/article/2443 [4 November 2007]

Ricks, T E, 2006 *Fiasco: The American Military Adventure in Iraq*, Penguin, New York

Spurr, J, 2005 *Indispensable yet Vulnerable: The Library in Dangerous Times. A Report on the Status of Iraqi Academic Libraries and a Survey of Efforts to Assist Them, with Historical Introduction*, Middle East Librarians Association, Committee on Iraqi Libraries website, at: http://oi.uchicago.edu/OI/IRAQ/mela/indispensable.html [4 November 2007]

Spurr, J, 2007 *Iraqi Libraries and Archives in Peril: Survival in a time of Invasion, Chaos, and Civil Conflict, A Report*,

http://archnet.org/library/documents/one-document.jsp?document_id=10241 [4 November 2007]

Sudarsan, R, 2007 'An Archive of Despair: Saad Eskander works to protect Iraq Library from bombs and mold', p C01, *Washington Post* Foreign Service, 7 April 2007, online at: http://www.washingtonpost.com/wp-dyn/content/article/2007/04/06/AR2007040602196.html?referrer=emailarticle [4 November 2007]

Ullman, H K, and Wade, J P, 1996 *Shock and Awe: Achieving Rapid Dominance*, National Defence University, online version: http://www.globalsecurity.org/military/library/report/1996/shock-n-awe_index.html and

http://www.ndu.edu/inss/books/books%20-%201996/Shock%20and%20Awe%20-%20Dec%2096/ [4 November 2007]

Von Wagenen, W, 2005 'shock and awe: aerial bombardment, american style, *Electronic Iraq*, 6 July 2005, at: http://electroniciraq.net/ [4 November 2007]

Watenpaugh, K, Méténier, E, Hanssen, J, and Fattah, H, 2003 *Opening the Doors: Intellectual Life and Academic Conditions in Post-War Baghdad*, A Report of the Iraqi Observatory, 15 July 2003

Mohamed is Absent. I am Performing:[1] Contemporary Iraqi Art and the Destruction of Heritage

BERNADETTE BUCKLEY

'There is, really, no such thing as heritage. I say this advisedly and it is a statement that I will qualify, but it needs to be said to highlight the common sense assumption that "heritage" can unproblematically be identified as "old", grand, monumental and aesthetically pleasing sites, buildings, places and artefacts.' (Smith 2006, 11)

'There is no Iraqi art.' (Muemin, pers comm 2007, 1)

'Because you see, I don't believe that there is an Iraqi Art. There is art in Iraq.' (Porter, pers comm 2007, 9)

'What is discovered right off if one does get back to solid ground for a re-starting place is that there is no such thing as "art" in general, no such thing as an "aesthetic object", and no such things as universally applicable aesthetic standards and judgements. Also, there is no such field as "aesthetics".' (Jessup 1963, 223–233)

'I think there is really no such thing as contemporary art. There is an artist. There is a time, the age in which he creates and lives. And there are his contemporaries. Whatever is created within their period of time will be "contemporary" art for them.' (Borisovich 2004)

'There is no Iraq,' (Cohen 2006)

'You know, there is no such thing as Iraq. Iraq's a line drawn on maps around 1922 by the Brits and others.' (Moos 2004, 241)

COMPLEX BEGINNINGS, UNSTABLE TERMS

I begin with the above quotations, not because I believe them to be true or untrue[2] (The BRussells Tribunal 2006), but because collectively, they make clear the complexity involved in any discussion about 'contemporary Iraqi art' and its relation to 'heritage'. The instability of the terms under discussion means that it is unwise to assume the existence of common, untroubled conceptual grounds. This is apparent even with an initial cursory

interrogation of the terms. For example, by 'contemporary Iraqi art' do we mean art made only *within* or also *outside* of Iraq? Do we mean art made *before* or *after* occupation in Iraq? If contemporary 'Iraqi' art is damaged (or not made) then what effect, if any, does this have on 'Iraqi heritage'? What is 'Iraqi heritage'? When and by whom was (or is) it being destroyed?

Questions raised by the opening quotations make it clear that there are no *stable* positions from which to begin discussing 'contemporary Iraqi art'. For example, to suppose that 'art' (contemporary or otherwise) stands for one thing alone must necessarily be an error. Similarly, it must be erroneous to suppose that 'heritage' stands for 'one thing'. Perhaps, as the last two quotations seem to claim, we cannot even rely here on the notion of an 'Iraq' as a stable entity. Because, (in the case of the latter) even if one were to put aside the ideology that drives many contemporary assertions of this kind (ie that Iraq must be subdivided into three separatist states if civil war is to be averted) then one still has to contend with the argument as put forward by Benedict Anderson (ie that nation states are not in any case, stable 'entities' but rather, that they are 'imagined communities' which have been artificially contrived in order to serve political and/or economic ends (Anderson 1991, 5–7)). And, if national narrative is, as Anderson and then Trinh T Minh-Ha have suggested, 'plurally unstable' (Minh-Ha 1992, 192), then 'contemporary Iraqi art' cannot be homogenised or subsumed under the sign of an all-embracing national (Iraqi) 'identity'.

WHO SPEAKS?

In addition to the above difficulties, there are other complications, which must be considered before proceeding. There is, for example, the important difficulty raised by the question, 'Who is speaking?' Does the author of this essay – an Irish citizen who has never visited Iraq – have anything of value to say about Iraq, 'Iraqi heritage', or 'contemporary Iraqi art'? How and to what extent does the framer *frame* the work? In this respect, it has been important in writing this essay, to consider the works, the experiences and the life stories of 'Iraqi' artists and writers – not for an assumed 'authenticity' of experience, but in order to indicate the multitude of differing fictions that can exist under any supposed-to-be-singular 'position'. And, if this writing has been framed by the author's 'Irishness' – then that is to say that it has also been framed by the experience of living in Britain in the early 1990s – when the IRA was conducting its bombing campaign, most notoriously in Birmingham, Manchester and London. I was then concerned about the ubiquitous presentations of 'Irish art' – the latter of which, all too easily insinuated a kind of commodity/ethnicity, which could be passed off as the 'next new thing' by a 'mainstream' contemporary art world.[3] (see for example Bluecoat Gallery 1991, Douglas Hyde Gallery 1998, Kidd 1991/1993, Wolverhampton Art Gallery & Museum 1990–1992) It should also not be forgotten here however, that while the *author's* background can be fore-grounded, the reader's *cannot* and that consequently, (since both writer *and* reader are together implicated in the framing of meaning), there is a level of complexity at work here, which, though active, is unaccountable.

Because of this perhaps tedious, but *necessary* complexity, the aim of this chapter is not to articulate any (assumed-to-be) 'singular' position, but instead to generate a *useful dissensus* from within a nexus of problematical concepts. It is not my intention to underwrite this essay with some kind of 'personal' dimension, but to acknowledge as *primary*, as *a priori*, the clouded, confused condition of writing when pressed with the task of addressing such questions at all (see Derrida 1998, and Derrida 1978). I do not intend to 'translate' the disparate views of Iraqi artists, and by so doing, to produce some kind of 'authoritative' perspective on the relationship between 'contemporary Iraqi art' and 'Iraqi heritage'. The challenge here is to present (something of) the circumstances that affect and have affected the production of 'contemporary art' both within and outside of Iraq, but without pretension towards any assumed 'comprehensiveness'.

THE 'SITUATION'

Even with the above provisos in place however, there are still more complexities which need to be worked through. The most pressing of these, to put it bluntly, is to do with 'the situation' – a phrase used by all those interviewed for this chapter – in Iraq at present. Does it make sense to speak about 'Iraqi contemporary art' at a time when mortality rates in Iraq are soaring to their highest levels ever (Howard 2007)?[4] Is it right to speak about 'Iraqi art and heritage' while remaining, as Robert Fisk says, '*silent* about the horrors the people of Iraq are now enduring'? Fisk goes on: 'We do not even know – are not allowed to know – how many of them have died.' (Fisk 2005)[5] And even if we were able to put a figure on the death toll, such a figure could never encompass the full scale of the human tragedy in Iraq – with an estimated two million refugees having fled Iraq and another estimated 1.8 million internal refugees, having been driven from their homes[6] (BBC News 2007). Is it, as Adorno suggests in his oft-quoted phrase, 'barbaric' to 'write poetry after Auschwitz' (Adorno 1995, 34)?

Perhaps it will be argued that I am making too many abrupt transitions between disparate issues – that I should 'stick to art' and leave 'the rest' to policy makers and politicians. However, as Edward Said said, on the 25th anniversary of his classic publication *Orientalism*, to do so would be 'to lose a sense of the density and interdependence of human life, which can be neither reduced to a formula nor brushed aside as irrelevant' (Said 2003). Iraqi-German novelist and writer Najem Wali faced a similar dilemma while making an analogous attempt to write about the condition of 'contemporary Iraqi literature'.

Here Wali asked:

What can literature possibly accomplish in a country whose cities are barricaded behind sandbags? A country where, between the politics and the pollution, most people can barely breathe, living the squalor of overcrowded quarters where the mortality rates climb to staggering heights?

Wali goes on to say that, what this has meant for Iraqi writers since the end of the 1970s is that they have had to choose between going into exile, and ceasing to write at all. But, he adds:

even those who chose to quit writing saw themselves forced to write something that did not rile the dictator, because even silence was considered a crime. (Wali 2006, 52)

In this respect, 'contemporary Iraqi literature' has a marked parallel with 'contemporary Iraqi art'. On the one hand, many Iraqi artists, while continuing to practise at home throughout decades of war and conflict, did so with varying degrees of complication in terms of their relationships with the Hussein regime (and see below). Consequently, such artists are sometimes seen as having (had to) produce 'compromised' work, or at the very least, as having had to produce something other than that which they would have produced, had 'the situation' not existed. On the other hand, in speaking about 'contemporary Iraqi art' one must include also those Iraqi artists who live abroad; whose production has not been, or is no longer dominated by the same ideologies, politics and/ or working conditions faced by artists living in Iraq. However, artists of the diaspora are also highly constrained in terms of the work that they produce. They are subject to the very real pressures of having been somehow divided or separated from that of which they can now no longer be a part. In these instances, to be thought of as 'an Iraqi artist' can be problematic – a burden with which not everyone is comfortable with. I will deal more closely with these issues later, when considering some specific works by and interviews with contemporary artists from Iraq. However, one last but important complication must be dealt with before proceeding further.

WHAT IS MEANT BY THE 'DESTRUCTION OF HERITAGE'?

If the general theme of this book is that of 'the destruction of heritage in Iraq', then it needs to be asked how specifically the 'contemporary art of Iraq' relates to that of its 'heritage'? And underlying this question, there is an even deeper conceptual undercurrent – one rarely touched on in journals either of heritage or of art, but one which must be addressed before turning to the specific nature of the relationship between 'Iraqi heritage' and the 'contemporary art' of Iraq. This 'undercurrent' is that of the (de)differentiation between 'heritage' and 'contemporary art'. For not only are these two *not* normally thought of as 'natural alibi', but also they are often understood as being antithetically opposed to one another. Acknowledgement must be made of this apparent 'opposition' in order to grapple fully with the relationship between, specifically, the *destruction* of 'heritage' and current conditions of practice for those 'contemporary' Iraqi artists living both inside and outside of Iraq. Is it legitimate, in focusing on the destruction of 'heritage' in Iraq, to consider 'contemporary art as 'heritage' in the first place? In order to answer this, we first must look at the commonplace assumptions, which routinely presuppose that 'contemporary art' does not 'belong' to the category of 'heritage'.

DIFFERENTIATIONS BETWEEN 'HERITAGE' AND 'CONTEMPORARY ART': ASSUMED AESTHETIC, MORAL AND NATIONAL VALUES

Categorical distinctions between 'heritage' and 'contemporary art' are normally made, not on the basis of any *qualities* fundamental and/or intrinsic either to 'heritage' or 'contemporary art', but in terms of the *normative* values and readings that are

routinely ascribed to both. In fact, commonplace differentiations between 'heritage' and 'contemporary art' are mostly based on two factors: their supposed relation to 'the past' and their supposed relation to 'value'.

I shall turn firstly, to the question of an object, a site or a work of art's relation to 'the past'. Here decisions as to whether something is seen as 'heritage' or as 'contemporary art', are often matter-of-factly made – simply based on how 'old' the object, work, site etc in question is and whether is it viewed as *belonging* to 'the past' or to 'the present'. This kind of differentiation is prominent for example in documentation relating to the management and regulation of 'heritage', as opposed to the management and regulation of 'contemporary art'. Thus, in 'heritage' management and exhibition, 'old' objects (or traditions or intangibles) are seen as belonging to 'the past'. Moreover, it is thought that such 'objects' (etc) must be maintained, precisely so that that 'past' can continue to be 'passed down from preceding generations in a tangible or intangible form'[7] (see Edson 2004, 333–348; Phelan 1998, 20–23; Loulanski 2006, 207–233). The notion of *continuity* with 'the past' is therefore also a key factor in the differentiation of 'heritage' from 'contemporary art'. For an example of this reliance on the age of the object (or intangible) in order to construct a continuity with 'the past', one can turn to the Irish 'National Heritage Act', set out in 1995 by An Comhairle Oireachta (The Heritage Council). The act, which seeks to regulate and control 'Irish heritage', contains a section entitled 'Interpretation', in which 'heritage' is described as:

> monuments; landscapes; archaeological objects; seascapes; heritage objects; wrecks; architectural heritage; geology; flora; heritage gardens and parks; fauna; inland waterways and wildlife habitats.

It may be noted in passing that, in such a construction, 'heritage' is also understood as being a alibi of 'nature' (indeed the term 'natural heritage' is often evoked at the level of policy) since both 'heritage' and 'nature' are interpreted as offering continuity with '*the past*'. Thus the Irish Heritage Act further interprets 'heritage objects' as '*objects over 25 years old* which are works of art or of industry (including books, documents and other records, including genealogical records) of cultural importance' [my italics] (An Chomhairle Oidhreachta 1995). Such an understanding of 'heritage' has thus been constructed in terms of a commitment to the preservation and fostering of (in this case, the predominantly tangible) *older* objects of the past[8] (see Smith 2006). That is to say, it is recognised that 'old' objects (etc) play a role in constructing the 'past' and in ensuring that continuity with that 'past' can continue to be demonstrated.

'Contemporary art' on the other hand – at least as it is constructed and understood by (Western) institutions of art – is largely governed by its desire to be or to generate the 'new'. In comparison with 'heritage' then, 'contemporary art' is (traditionally) read in terms of its participation in a 'historical' march towards '*the future*' (see Poggioli 1994; Deleuze 1994; Groys 2002). For example, one of the most influential 'working' methods for identifying the 'contemporary' was set up by the Museum of Modern Art, New York. In an historic attempt to prevent its collections becoming fossilised with too many 'old' works, MOMA arranged (in 1933) to deaccession all works 50 years old or more, to the neighbouring Metropolitan Museum of Art New York (see Altshuler 1994; 2005, 6–7;

Staniszewski 1998). Such logic was grounded on a commonplace differentiation between perceived-to-be-'old' objects (which were thought to belong to 'tradition') and perceived-to-be-'new' objects (which in contrast, were thought to belong to 'modernity' and/or the 'contemporary' moment). By inference then, 'heritage' and *contemporary art*' are often distinguished in relation to their age and (as in the latter example) are therefore imagined to be mutually exclusive, if not antithetical to one another.

The second common assumption by which 'heritage' is normatively differentiated from 'contemporary art' relates to the issue of the supposed 'value to the nation' of each of these. To assign a 'value' to an object, resource, tradition etc, 'there must be an equivalent measure against which to judge that worth of meaning' (see Edson 2004, 345). Thus, works, events objects etc, when constructed as 'heritage' in the media and the popular press, are often highly valued, while works, events or objects which, when constructed as 'contemporary art', are comparatively, poorly valued. This perpetuation of commonplace assumptions as to the difference between 'contemporary art' and 'heritage' is further based on two notions of 'value': firstly there is the question of the 'aesthetical' and 'ethical' value attributed to objects/works/artefacts/events etc; and secondly, there is the question of the monetary value ascribed to them and/or the cost of caring for them.

Let us firstly consider the question of art's 'aesthetical' and 'moral' 'value', when popularly constructed as 'heritage'. 'Masterworks' of art are commonly considered, for example when discussed in the media, as works of 'outstanding value'. Their retention and protection is thus thought to be a matter of 'national pride' – as witnessed for example, by the public media-led campaign in the UK to 'save' Raphael's *Madonna of the Pinks* (c 1506–1507) 'for the [British] nation'[9] (BBC News 2002). On the other hand however, art critics in the general media (and indeed in the specialist art press) routinely dispute the 'aesthetic value' of 'contemporary art' (see Kramer 2006). Brian Sewell for example, is infamous for his condemnations of 'the Serota tendency' in contemporary British art – most of which, he condemns as 'idiocy'[10] (see Sewell 1995) or as 'a travesty in the name of art' (Cousins 2001).

And likewise, the '*moral* value' of 'contemporary art' is also relentlessly questioned by those who see it as, at best 'passive' and 'pointless', and at worst, 'profane' and 'pitiless' (see Virilio 2003). This is not however, to suggest that 'heritage' is popularly valued while 'contemporary art' is not. Such a position would be wholly reductive. The point being made here is that the 'aesthetic' or 'moral' value of 'contemporary art' is popularly and routinely contested (at least while it is thought of as 'contemporary'). However in contrast with 'contemporary art', to classify something as 'heritage' is to secure for it a value, which is popularly considered to be great if not 'priceless' in both aesthetic and monetary terms (see Kirshenblatt-Gimlett 1995, 370). And the reluctance to confer 'aesthetic' value on 'contemporary art', leads in turn, to questions about the cost of conserving and displaying 'contemporary art'. So while for example, to secure an object of 'heritage' is to make 'an acquisition on behalf of the nation as a whole' (Saumerez Smith, *Telegraph*, 2004), the cost of making, storing and preserving 'contemporary art' is commonly questioned. (Aaronovitch, *Observer*, 2004; See also Peretti, *Guardian*, 2004)

Continuities between 'Heritage' and 'Contemporary Art'

Commonplace differentiations between 'contemporary art' and 'heritage' are exacerbated by the fact that 'contemporary art' lacks any presence in the field of 'heritage studies' and is rarely (if ever) considered part of the 'natural' landscape of such a field. This is partly to do with the fact that 'heritage' itself, is a continually evolving concept:

> The concept of heritage is susceptible to change and is actually changing. The new environment and developments in heritage … have contributed towards the evolution and expansion of the 'cultural heritage' concept in both scope and direction. Heritage is increasingly described as an evolutionary notion, possessing a multifaceted construct with dynamism, complexity and multiplicity as primary features. (Loulanski, 2006)

In addition to the expansion of the notion of 'heritage', one must also consider the continuities that exist between the 'spheres' of 'heritage' and 'contemporary art'. One of the most striking examples of continuity between these spheres relates to the way in which both 'heritage' and 'contemporary art' are frequently used as vehicles to support the construction of 'national identity' (See Duncan 1995; 1999; Hooper-Greenhill 2000; Macdonald 2003; Coombes 2004). Indeed, when 'contemporary' or 'historical' art is regarded as 'cultural' property, or property owned by the nation, both are commonly understood as operating at different ends of the same spectrum. For example, as already noted above with regard to *Madonna of the Pinks*, when such a painting is 'saved for the nation', then 'values' for 'heritage' are simultaneously being constructed and played out on a national stage. However, 'contemporary art' also offers opportunities to explore the relation between the struggle for and the power of national identities (see Stupples 2003, 127–139). The Venice Biennale, for example, has long since exhibited and promoted contemporary artworks, by 'nationality'. To be invited to show in Venice is to procure two different opportunities for national identity construction: first, by showcasing 'talent' by nationality, it allows for the construction of national pride and second, it infers that exhibiting artists/countries are part of an 'international' playing field for 'contemporary art'. This use of contemporary art to *foreground* the construction of national identity could furthermore, be seen as increasing in prominence, as the number of 'international' biennial exhibitions across the world continues to escalate annually.

'Heritage' and 'contemporary art' are therefore, seen as implicated both in *demonstrating* and in *constituting* the *living* principles of 'the (national) people'. 'Heritage' – thought to be founded in the 'past' and underpinned by pedagogy and scholarship – constructs an 'accumulative', 'continuative' temporality for national identity whereas 'contemporary art' asserts the vitality of the 'nation-people' both *in* the present and *for* the 'future'. Because 'heritage' as we have seen above, is frequently read as having its authority based on some pre-given or constituted historical 'past', it can also be used to supplement and support narratives of nationhood (see Evans and Boswell 1999). 'Contemporary art' on the other hand, in being dedicated to the production of the 'new', can be constructed as a process of signification, which ultimately will provide the nation with its future 'heritage'. In this way, 'heritage' and 'contemporary art' are both bound to constructions of the 'nation-people' – the latter of which is thought of, in historical, contemporaneous

and/or future terms. Or, as Homi K Bhabha puts it, the 'nation's people' – for whom 'heritage' and 'contemporary art' is safeguarded/displayed – is thought in *double-time*:

> The people are the historical 'objects' of a nationalist pedagogy, giving the discourse an authority that is based on the pre-given or constituted historical origin *in the past*; the people are also the 'subjects' of a process of signification that must erase any prior or originary presence of the nation-people to demonstrate the prodigious, living principles of the people as contemporaneity: as that sign of the present through which national life is redeemed and iterated as a reproductive process. (Bhabha 1990, 297)

DE-DIFFERENTIATING BETWEEN 'CONTEMPORARY ART' AND 'HERITAGE' IN IRAQ

It is at this point then, that the relationship between Iraqi 'contemporary art' and (the destruction of) Iraqi cultural 'heritage' comes into focus. For if objects, places, traditions, works of art and other manifestations, can support or reinforce narrations of nationhood, then at times of war, conflict and/or national crisis, such narratives become even more important: they bolster national pride, promote continuity between past and present and sustain national hopes of prolonged continuity into the projected future. That is to say, if 'cultural property' as Marilyn Phelan has argued, 'constitutes one of the basic elements of civilisation and national culture' (1998, 55), it can, particularly in times of war and crisis, be thought of as able to operate both culturally and *symbolically*. This is why Iraq's archaeological and cultural property (which before the Gulf War, had 'remained largely free of theft and vandalism' (Brodie 2005, 491)), when ransacked, destroyed and sold during and since the Gulf War, represents not just the destruction of specific instances of cultural property, but the threat of breakdown of an entire culture. And the more substantial that the loss of cultural property is, at such times, the more important it becomes to continue to create the cultural property of the 'future'.

Michael Seymour has shown for example, that (both before and during Saddam Hussein's regime), 'ancient history provided a cultural resource emphasizing unity, continuity, and stability' in Iraq:

> In a state whose ethnically, religiously, and linguistically diverse population was united by British mandate rather than any cultural affinity, the assertion of ancient Mesopotamia as a common Iraqi heritage is an obvious and essential tool in the construction of Iraqi national identity. (Seymour 2004, 355)

However, while less commented upon, 'contemporary art' is similarly implicated in the construction of Iraqi national identity, since by symbolising communal bonds, it too creates visual representations, which can sustain national identity and/or create new social and political formations. For example, Amatzia Baram has shown how Mesopotamian-inspired festivals, art, theatre, and poetry all received encouragement under the Ba'ath party's rule, and how cultural and religious differences were largely transcended by placing emphasis on works that had been inspired by ancient Assyria and Babylon (Baram 1991, 55). In such a construction, the roles of 'contemporary', popular and 'ancient' art are united in the constitution and consolidation of national identity in Iraq.

For this reason, there are sound reasons for *de*-differentiating between Iraqi 'heritage' and 'contemporary art'. In fact, 'contemporary art' can be said to *belong* to 'heritage' (albeit in an unpredictable way) in that it too has 'the ability to serve a people's need for a sense of identity and belonging' (Merriman 1999, 8). Furthermore, it could even be argued that the elasticity and dynamism of cultural 'heritage' is *most* pronounced in its expression as 'contemporary art' – the latter of which guarantees both the *prolongation* of culture and its *changeability* over time (see Loulanski 2006, 210).

Thus, 'contemporary art', regardless of subject matter or style, is doubly charged, doubly *purposeful*, as a sign of cultural continuity and renewal. That is to say, it is both the sign of 'heritage' being sustained *and* the sign of a particular culture being renewed for and into the future. In this respect then, 'contemporary art' is 'heritage' *in transit* – 'heritage' that has, partially or temporarily, taken leave of its 'origins'. And this is why 'contemporary art' by Iraqi artists is an important facet of Iraqi 'heritage'. It has a stake in the creation and maintenance of national identity at a time when that identity is experienced as being under threat and/or in transition. And this national identity is expressed not in terms of geographical origins, but in terms of the prolonged, shared cultural experiences and relationships which it represents. This is not to say that 'contemporary Iraqi art' represents 'the construction of Iraqi identity', so much as to argue that contemporary Iraqi art – like heritage – has the ability to offer that image of a coherent cultural identity as an enduring one. The production of 'contemporary art' therefore symbolises the survival of 'Iraqi culture' – not just in Iraq, but also in and to each locality in which migrants have settled. As 'Iraqi culture in transit', 'contemporary Iraqi art' represents that aspect of 'heritage' that resists the urge to be locked into a trajectory determinable by geographical origins. Likewise, it is that aspect of 'heritage', which guarantees the continued evolution of itself as multifaceted and dynamic.

The work and writings of Rashad Selim make for a good case in point here, in that they demonstrate the *continuity* that exists between 'heritage' and 'contemporary art' from Iraq (and/or that 'contemporary art' is the principle of evolution inherent within 'heritage'). I first met Selim in 2001, when he was contributing to *Intervention* – an exhibition put together in response to George Bush's declared 'war on terror'. Asked to respond to the question, 'What is the proper role of the artist in times of war and crisis?' Selim spoke of a 'last minute intervention to turn the steering wheel at failure's edge'. These 'last-minute aspirations' he described as 'the dreams and hopes of all the generations of artists and thinkers contemporary to the previous cycles of war and conflict'. He went on to say that:

> We as artists, I think have a particular role in righting the table that has been overturned; not just to frame the wreckage with our art. I know this is a departure from the traditional myth of modern art as a breaker of rules and boundaries. (Selim, pers comm, 2003)

In 'righting' the 'over-turned table', Selim argues that 'contemporary art' has a potentially important position, since it can help to maintain continuity and connections with the past whilst at the same time representing renewal in the future. Themes of continuity, renewal and hope are captured most poignantly in Selim's own practice. For example, in

2003, in post-invasion Baghdad, Selim initiated and organised the *Rasim hur fil Sama* (*Free Drawing in the Sky*) project.[11] (Selim 2003) The project occurred in November – the traditional season for flying kites – and involved a wide range of Iraqi artists, children and professional kite-makers. Scores of newly created kites were flown in Saddam's old parade ground in order to 'reoccupy the sky with our dreams [and] regain the future with our imagination' (Cook 2004; Bouchebel, 2003). In this way then, the 'traditional' became one with the 'contemporary', at once affirming the past and at the same time, representing Iraqi aspirations for a better future. 'Even Saddam over 30 years could not dominate the Iraqi spirit fully'. Thus, in Selim's practice, contemporary art is integral to the cultural reconstruction of Iraq. It prevents the destruction of tradition and at the same time, functions as an expression of the indomitable Iraqi (national) spirit. As Selim explains in relation to the kite project:

> It's something, an object that one can control in a time where there is no control. It has these properties that are natural and also straightens up one's self. It's a physical action that literally raises the head and this is what we need.

In this way then Selim sees a role for contemporary art in 'over-rid[ing] cynicism' and in re-establishing 'civilisation':

> I think we can imagine and create a *world civilisation* of great freedom and peace in a sustainable state of well being, economically and spiritually, with others sharing the Planet, and with the Earth we are bound to, and the complexity of nature and life that we are indebted to. [My italics] (Selim, pers comm, 2003)

Here, notions of an enduring 'heritage' or 'civilisation' are sustained – and in the same moment, enduring 'civilisation' is shown to be *evolving* over time. From such a purview, the role of 'contemporary art' is to continue to strive for a better future and by so doing, to create a bridge between the future and the past. Selim's argument thus builds on definitions of 'heritage' and 'cultural property', the latter of which grows by accretion, with 'each new creator, building on the works of those who came before' (see Anderson 2002, 1). 'Contemporary art' is that principle of renewal inherent in the conditions of 'heritage'. As such, it is the 'contemporary' that guarantees 'heritage' as that which is necessarily, elastic and changeable over time.

In personal interviews, Selim was direct and clear about his view as to the relationship between 'contemporary art' and 'heritage'. 'As soon as something is done,' he argues 'it's heritage.' (Selim, pers comm, 2006) Elsewhere, Selim has spoken even more directly about the connection between the 'contemporary art' and the 'heritage' of Iraq. In his essay 'Diaspora, Departure and Remains' for example, Selim speaks about the works of Iraqi artists as illustrated by the exhibition *Strokes of Genius*, 2001–2002:

> The point, clearly seen in the work of many of the artists disclosed, is the *shared heritage* as seen from individual experience and the affirmation of life that is their creativity. There are shared plastic concerns and a *shared relationship* to connections and circumstance but few that extend in the same way to them all. [My italics] (see Faraj 2001, 47–48)

There are three points to be noted in relation to the above remarks about the relationship between Iraqi 'heritage' and Iraqi 'contemporary art'. Firstly, Selim argues that there is a direct continuity between 'contemporary Iraqi art' and the 'heritage' of Iraq. For, he says, 'Mesopotamian art from any epoch … is not confined to fine art,' but also includes a long tradition of 'folk art'. According to Selim then, all Mesopotamian art – including the traditional and the ancient – is 'a prime inspirational lodestone' for 'contemporary' Iraqi artists (Faraj 2001, 47). Secondly, and again with respect to the relationship between 'contemporary Iraqi art' and 'heritage', Selim makes the point that these realms are part of a shared project which bears upon the formation of (national/cultural) identity. Thus, he says, 'contemporary' art by Iraqi artists plays a strong part in the 'preservation' of something enduring:

> In the work of artists of this latest generation, as in those preceding, can be found a will to express an
> essential humanity and love that counters reactionary pessimism; a creativity opening on to a vision
> of transformation at best and the *preservation of significance* at least. [My italics] (Faraj 2001, 48)

Thirdly, in Selim's argument, 'contemporary art' can be seen to be the principle of change inherent within the notion of 'heritage'. For him, what is at stake in the creation of contemporary art is 'the necessity of creating an expressive visual language … in reaction to the confusion of a corrupted reality' and 'the *survival and continuity* of a creative and expressive spirit that is peculiarly 'Iraqi' despite, or even due to overwhelming odds' [My italics] (Faraj 2001, 48).

These points are well illustrated by Selim's own family history which spans several generations of artists. Rashad's uncle for example, was the acclaimed Jewad Selim (1921–61), credited as being co-founder of the Baghdad Group of Modern Art formed in 1951. His aunt, Lorna Selim, is also a celebrated artist. Along with Faiq Hassan (1914–1992) Jewad Selim is argued to have brought the 'modern vision' to Iraq (Muzaffar 2003, 69).

Thus the creation of a 'new' role for 'Iraqi art', for Jewad Selim and for those many contemporary artists that he influenced, necessarily meant bolstering the existing relationship between 'contemporary art' and 'heritage' in Iraq.[12] For example, in 1944, when 'called to work in the Iraqi Museum', Jewad worked with Iraqi historical masterpieces and assisted archaeologists in any restoration that was deemed necessary (Inati 2003, 72). These encounters with ancient history 'evoked a new awareness of the question of national identity, a matter that seriously preoccupied Selim'[13] (Inati 2003, 72). Nada Shabout also names Jewad Selim as being instrumental in the reconstruction of 'an iconic visual language recognisable to this day as markedly Iraqi' and as redefining symbolism in accordance with his and his contemporaries' 'new national consciousness'.

> The work of Selim and others not only asserted their visual identity, but actually *contributed to the*
> *formation of modern Iraqi identities*. These experiments were continued by subsequent generations
> allowing for Iraqi cultural identities to continuously evolve. [My italics] (Shabout 2006a, 57)

The interplay between 'contemporary art' and 'heritage' in Iraq is however, not confined to arguments made in Selim's work, but is supported by a myriad of other sources. For example, Makiya notes the endurance (and strategic use of) the arts and the notion of

'turath' (heritage) and its alliance with the 'new' as a means of bolstering identity formation in Iraq, particularly during Saddam's regime:

> In no Arab country is the fixation with *turath* more evident than in Iraq, where official patronage in the last decade has resulted in record sums being spent on promoting it in culture and the arts ... Everyone who was anyone in the arts was involved because however harsh the regime, all identify with the idea that creative expression and *turath* march hand in hand against the twin evils of slavish adherence to the past and imitative Westernism, as Saddam Hussein so nicely put it during a one-week conference on 'Our Architectural Heritage and the New Arab Architecture' held in Baghdad in the same week he launched the Iraq-Iran war. (Makiya 2004, 70)

Similarly, in her essay, 'Contemporary Artists from Mesopotamia', May Muzaffar emphasises an enduring connection between 'heritage', 'contemporary art' and the formation of Iraqi identity:

> With vision inspired by the bitterness of reality, the march of creative output goes on unhindered, both inside Iraq and outside it, as though art is a spirit kindling over the soil of this time-honoured land and engendering one generation after another. (See The Khalid Shoman Foundation and Muzaffar 2000)

DISMANTLING 'CONTEMPORARY ART': THE DESTRUCTION OF IRAQI 'HERITAGE'?

Connections between 'contemporary art' and 'heritage' in Iraq can therefore be seen to be both powerful and enduring. Likewise, both have been shown to have significant implications for the formation and long-term sustainability of an Iraqi national identity. Thus, when 'heritage' and/or 'contemporary art' are removed, destroyed or dismantled, such removals have direct repercussions for narratives of Iraqi nationhood and/or Iraqi national pride. Nada Shabout argues for example that 'contemporary Iraqi art in the aftermath of USA-led invasions has taken on various roles, be that of resistance, documentation, testimony, prediction and hope' (Shabout 2006b). Shabout goes on to say that, within a framework of occupation: 'contemporary works further expose a campaign for "visualising" Iraqi culture and spatially reconfiguring Baghdad in an effort to construct images for a "new" Iraq through ideological cultural construction'. Supporting her argument here, she contrasts the fate of Jewad Selim's *Freedom Monument* with that of the dismantling of other public works such as that of *The March of the Ba'ath Party* by the sculptor Khalid al-Rahal. Selim's work 'glorified a nation' and was as 'timeless in its iconography as Picasso's Guernica'. Thus Shabout argues, it was given a 'desperately needed' restoration by the interim Iraqi government 'in order to "display their act of good faith in restoring Iraq's most important pre-Saddam public monument"'. *The March of the Ba'ath Party* however (which Shabout sees as also honouring Iraqi soldiers captured by Iran) was by contrast, dismantled by the Debaathification Commission. This move, Shabout claims, should be seen as an attempt to change the status of Iraqis who died during the Iran/Iraq war – from 'martyrs' to that of 'victims of Saddam'[14] (Shabout 2006b, 4). In Shabout's assessment, such a move enacts a 'policy of erasure and replacement' – one that is 'continuously transmitted and sustained through the media'. Whether one agrees with

Shabout or not however, the existence of such debates (at the very least) demonstrates how ancient, modern and more recent 'Iraqi art' have become embroiled in questions about the status of Iraq as a nation-state.

> Questioning the validity of the Iraqi nation, thus, necessarily implies the disunity of its cultural facets. Iraq has been pondered, defined and negotiated as a collection of different and conflicting sects lacking any national coherence. Such an assumption directly problematises the notion of an Iraqi art. How could a non-nation posses a visual self-expression with a clear identity that goes beyond the tribal or sectarian. In consequence, the 'representation' of this identity in terms of art and aesthetics is equally problematised. (Shabout 2006b, 54)

The roles of Mesopotamian 'heritage' in the construction of 'Iraqi identity' have been increasingly commented on (see Seymour 2004, and Tripp 2000). However, less has been said about the role that 'contemporary art' specifically, plays here. Undoubtedly, this is to do with the very contemporaneity of recent art and the fact that, in being 'contemporary', such work is potentially responsive to political sensitivities in an immediate and prescient way. Nevertheless, the extent to which debates about the destruction of 'cultural heritage' in Iraq routinely omit any mention of 'contemporary art' is indeed striking. Nada Shabout strongly makes this point when she says that:

> Contemporary art in Iraq has been forgotten about. The occasional mention in academic circles of the wanton destruction, lack of protection and neglect of Iraq's archaeological sites and museum collections has always glossed over the destruction of the modern cultural heritage of a country which was a leader in the development of a regional and an Arab response to the changes of modalities of the 20th century. (Shabout 2006b, 53)

This routine differentiation between (a highly valued) Iraqi 'heritage' in comparison with the (assumed to be less important) 'contemporary art', is in line with remarks made earlier as to normative differentiation between 'contemporary art' and 'heritage' in terms of 'value'. Iraqi artist and curator of the Aya Gallery in London, Maysalou Faraj concurs with this point however:

> something that was, really, completely ignored and not mentioned, and nothing has really been done about, was the looting of the formerly named Saddam Art Centre, which was the largest – one of the largest – the largest centres in the Middle East to host such important works of art … not just by prominent Iraqi artists, but also by world renowned artists … And that was looted and burnt under the noses of the Americans and the British. (Faraj, pers comm, 2006)

Prof Nada Shabout, of the University of North Texas, has similarly complained about the 'unavailability of any monetary funds to "save" [Iraq's] modern visual heritage'[15] (Shabout 2006a, 63):

> The Iraqi Museum of Modern Art was one of the buildings severely damaged during the coalition bombing raids over Baghdad. The museum's collection of over 7000 works of art was viciously looted as the Ba'ath regime collapsed, and the occupying power was lax in providing security to protect Iraq's important cultural institutions. (Shabout 2006a, 63)

Exasperated by the complacency surrounding the loss of 'contemporary' and modern art from Iraq, Shabout launched a campaign in 2003 to attempt to save damaged, lost and stolen artworks. Using information collected from the Iraqi Ministry of Culture and other sources, she is currently building an archive to document works missing from the Iraqi Museum of Modern Art. (Because IMMA's archives were destroyed in the bombings of 2003, no comprehensive catalogue of its collection currently exists.) Based on her own investigations and information collected from the Iraqi Ministry of Culture, Shabout warns that some works have been smuggled outside of Iraq, and that 'others are still being traded on the black market in Baghdad' (Shabout 2006a, 63). She cites for example the discovery of a statue by Jewad Selim, bought for USA $200 in a local market in Baghdad (Shabout 2006a, 63). On a more optimistic note however, Rashad Selim says that some missing works were not actually stolen, but were taken for safe-keeping by concerned citizens and that these will be returned when a credible infrastructure is again in place (Selim 2006, pers comm, 5). Nevertheless, only 1300 of the 8000 pieces missing from the IMMA have been so far been retrieved (Shabout 2006a, 63). However, the level of complacency as regards the loss of contemporary and modern artworks is indeed breathtaking. As Shabout puts it:

> many valuable pieces will disappear without even documentation. More importantly, a nation will lose a substantial part of its modern narrative, and contemporary Iraqi art will remain invisible. (Shabout 2006a, 63)

'IRAQI ART' AND THE DESTRUCTION OF THAT WHICH HAS NOT YET BEEN CREATED

Investigation into the destruction of heritage in Iraq cannot however be confined to the *literal* elimination of existing objects/traditions. Is not the removal of the artist's ability to make work of his/her own choosing, itself a kind of destruction – the destruction of that which has not yet and can never be created? In addition to the loss and destruction of *collected* Iraqi Modern and 'contemporary' artworks however, there is another even more difficult question to be raised – how is it possible to understand the impact on the *production* of 'contemporary art', of the enduring political turmoil which Iraqis have had to withstand, since the turn of the century and earlier. That is, to fully appreciate the impact of such instability on the production of 'contemporary art', we need to consider, not just the damage to and loss of existent, 'tangible' artworks, but also the effects of changing political conditions on the very nature, evolution and production of 'contemporary art'. It is of course, far beyond the scope of this chapter to map the effects of such changing conditions on artists in (and beyond) Iraq since the turn of the century. However, it is nevertheless important to acknowledge that such continued unrest has had a huge effect on (what is commonly thought of as) 'contemporary Iraqi art' today.

This question will therefore be dealt with, in reference to the testimonies of selected Iraqi artists – those who, in interviews with the author, have reflected on their experiences as artists, both during and since Saddam Hussein's regime.[16] In conducting such interviews, two major factors have emerged as having had a profound effect on contemporary artists' ability (or lack thereof) to create art. The first of these concerns the restrictions placed

upon them as artists operating under and since Saddam Hussein's regime. The second concerns the effect of the continuing exodus of artists from Iraq on (what is commonly thought of as) the narrative of 'contemporary Iraqi art'. Both of these strands must be explored in order to understand how 'contemporary art' and the construction/destruction of heritage have been affected in recent decades in Iraq.

Ultimately it is impossible to determine (let alone quantify) how consecutive decades of flight from and turmoil within Iraq have affected the (non)production of 'contemporary art' by Iraqi artists. Neither however, is it sensible to ignore the testimonies of Iraqi artists – either those who are still living in or who have now left Iraq – as to the huge impact of such events on their practices. For this reason then, first-hand accounts of artists' experiences were collected by interview and, though the number of interviews are relatively small, they nevertheless testify both to the diversity within and the continuity between the experiences of contemporary Iraqi artists. As stated above, sources have been selected largely because of their availability to the author and as such offer no guarantee of comprehensive or 'factual accuracy'. They do however, (at the very least) demonstrate the need for extensive research to be conducted in this area, in order that the full scale of the destruction of 'heritage' in Iraq can be further mapped and understood.

The Role of Migration in the (Non)Production and/or Imposed Production of 'Contemporary Art' in Iraq

Taking the latter of these two factors first, mass emigration (and mass internal migration) of Iraqi artists is an important factor to consider in relation to the (non)production of 'contemporary art' by Iraqi artists. Rashad Selim wrote in 2001 about 'the continued exodus of Iraqi artists from Iraq' – an exodus, which he says, has 'grown exponentially through the 20th century as each generation faced some form of radical transition or intense conflict':

> Four generations of artists each passing through major political turmoil demarcated the transitions of the 20th century as it resonated in the making of their art. (Faraj 2001, 15; see also Fouskas 2007, 167)

Similarly, in her preface to the major *Strokes of Genius* exhibition of contemporary Iraqi artists (2001), Maysalon Faraj talked of having organised the exhibition, partly because of her desire to 'bring together Iraq's scattered "talents in the wind"' (Faraj 2001, 15). However, six years on, Faraj says that Jordan, Syria and Egypt have become 'hub[s] for Iraqi artists' and that 'entire streets' of artists are now living in Cairo (Faraj 2006, pers comm, 13).

Indeed all of the artists and curators interviewed in the course of this research spoke about the consequences for themselves and their contemporaries of such an exodus on the contemporary art production in Iraq. For Kurdish artists living in the north of Iraq, Wahby Rasul (Head of Fine Art at the Institute of Art in Sulaimaniya) says that 'the only alternative' for those who would not collaborate with Saddam's regime was 'to leave the country': 'Mostly the Kurdish artists went to the mountains to join the Kurdish opposition' (Rasul, pers comm, 2007).

Likewise, Man Ahmad Hamid, Head of the Institute of Art in Kirkuk, says that when Saddam Hussein was in power, artists 'left because they didn't have any home and … because of the threat to their lives' (Hami, pers comm, 2007). But he continues: 'after Saddam Hussein was removed, the features of the political situation in Iraq changed. Now you have Al Qaeda, you have coalition, you have different forces' and [in the relatively stable northern part of Iraq] 'people now stay here' to become art teachers, or to work in publishing houses or with TV stations. In Kirkuk, by comparison, 'all the contemporary art galleries' are 'closed' (Hami, pers comm, 2007). Likewise, Adalet R Garmiany, originally from Kader Karm, first fled his city in 1991 because 'it was controlled by Saddam Hussein' and because his 'house was completely destroyed'. After setting up in Sulamainya, he was again forced to flee and eventually settled in the UK in 2000. Similarly, Emily Porter, who lived in Baghdad throughout the whole of the Iraq–Iran War and up until 1991, eventually fled Iraq because:

> during the Iran–Iraq War, we woke one morning when the first aeroplanes start bombing and shelling. I lived in a very important area in Baghdad which is now … it's the Green Zone. I looked up our street and it was full with tanks and missile launchers. On our street! So if anything will happen, they've hidden all these tanks with fuel where we live. And all the missiles and the launcher in the street. That's Saddam, that's what he did. All the parks, all the schools – my son's school was filled with missile launchers. So but nobody talked about it at that time. That's why I managed to get my son out because he came with a letter from the school. He was only 13. They were going to take him to the Front … the front-line … he was 13 years old! So, I managed, in a very, very difficult way, to get him out of Iraq. But all his classmates, they had to go and they were killed. So, the generation born in 1966, there are few of them alive. Nobody talks about this. A whole generation wiped out, but nobody talks about it. (Porter 2007, pers comm, 2)

During Saddam's regime, the mass migration of artists (and other Iraqis) was compounded by embargos, which further isolated those artists attempting to continue working in Iraq. As May Muzaffar says in her essay, 'Contemporary Art from Mesopotamia':

> Iraqi's cultural isolation, brought about in consequence of the now decade-long embargo imposed on it, has given rise to exceptional circumstances that in addition to rendering the standard of performance disjointed and dispersed have split Iraq into an inner and outer halves. (Muzaffar, 2003)

And finally here, the artist Mohamed Abdulla has commented rhetorically on the cultural devastation which continuing crisis in Iraq has brought about, by asking the question:

> What contemporary cultural products do you expect from Iraqi cultural practitioners living in Iraq under more than three decades of dictatorship, wars, siege, and most recently, direct occupation? What contemporary cultural products do you expect from Iraqi cultural practitioners living excluded and isolated in exile? (Abdulla 2005)

DESTRUCTION BY INTERFERENCE/IMPLICATION?

This brings us to the second important factor which needs to be raised in terms of the 'destruction of heritage in Iraq' in recent decades – namely the impact of the Hussein regime and the continuing political unrest since his removal – on the production of

'contemporary art' in Iraq. One impact was that new art was not made at all: according to Porter (who was a co-founder of the Iraqi Visual Art Association in 1967[17] (Porter, pers comm, 2007, 4)), artists were only able to practise in Iraq if they, in some way, promoted Saddam Hussein as a personality or as a regime. In the late 1960s, Porter was working in the Iraqi Museum (she worked there for 14 years), but when the Ba'ath Party took over in 1968, 'they started what they called the "Intellectual Committee"':

> Superficially, this was a committee, which doesn't belong to the Ba'ath Party but is *supported* by the Ba'ath Party. So all intellectuals have the right … are *encouraged* to join this Intellectual Committee but they won't have obligation to attend the party meetings regularly with weekly basis; they have no obligation to be part of any military trainings (which were for everybody); nor any other obligation like going and demonstrating on the street in support of the Party or whatever. That's what they *said*. So, they sent a letter or they came to talk to all the intellectuals. So they came to my husband. They came to us. The people who came, I can give you their names … And they came to our house and they said 'this is good because this will give us the opportunity to work in a very artistic environment … you have no obligation towards the Ba'ath Party … supported by them but *not part of* the party'. Well I couldn't buy it. I couldn't buy it at all. I said, 'I'm not interested'. They said 'well you will have very limited chance to do what you want'. I said, 'I don't want to do anything. I don't want to do anything. I'm not going to paint.' (Porter, pers comm, 2007, 4)

Porter argued also that people could not attend university if they did not declare themselves members of the Ba'ath Party:

> You have to fill this form, stating in the form … which party do you belong to and *why*. You can't say I belong to any opposition party because there isn't anyway … they were all killed. Are you a member of the Ba'ath? Are you a member of the Ba'ath? If you say no, '*Why?*' Do you have anybody in prison? Do you have anybody in prison? Do you have anybody being killed for treason or for love or for this or that? Do you have anybody lives abroad and why? Have you been abroad? How many times? So, if you fill this form, how could you escape being part of the Ba'ath Party? So I don't believe them. I could face them and tell them. (Porter, pers comm, 2007, 3)

Porter was subsequently excluded from official structures and survived by running a children's nursery, and then a toy-making business while her husband was imprisoned in Abu Ghraib in the late 1960s for treason against the Ba'athist party. Similarly, Mohamed Abdulla was imprisoned and tortured during the Hussein regime because of a drawing that his made in a school assignment:

> You know when I used to work in Iraq, I am sure I was taking a big risk, but at the same time, I was honoured to take this risk – not risk of losing a job, *risk of life*. Like my brother … he had been arrested in 1981–83. He was in the second year of a postgraduate in Baghdad Academy. He had been taken. And four months afterward, I had been taken as well and I was 16 years old. One of the reasons … I made a drawing in a school assignment, one of the reasons they had taken me and I had been tortured for two months. (Abdulla, pers comm, 2007, 9)

Kanan Makiya concurs with this view when he says: 'Art does not have any power. Under Saddam Husain, that power was co-opted and corrupted. The arts became collaborators, or the arts fled' (Makiya 2004, xiv).

It should be noted however that some of the artists interviewed for this article disagreed with such a statement and with the implication that there were no positions *between* those of collaborator and/or exile for Iraqi artists practising during Saddam's regime. For example Hashim Al-Tawil, thought that such perseverance on the part of the regime in their pursuance of Emily Porter, was directly related to the fact that, although born and bred in Iraq, Porter's father was British and that it was her dual nationality which made her more suspicious to the regime (Al-Tawil, pers comm, 2007). In line with this, artists from the Kurdish north of Iraq felt that they had more choices facing them than simply to either practise, or to cease practising art. For example, asked how the regime affected the work of contemporary artists in the Kurdish north of Iraq, artist Afan Sediq said that:

> Some of the artists did not have choice and were set to work in the way the regime asked them to. In figurative work, it was quite difficult to express yourself. But the other alternative was a type of expressionistic art. The artists manage *symbolically* to express themselves in a new style of artwork. (Sediq, pers comm, 2007, 9)

Similarly, Sami Muemin (Director of ArtArt Laboratory) argued that:

> It was like paying a bill. You had to pay a fine. For instance in the Middle Ages in Europe, many artists worked for the church and managed to be free to do something besides that. It's the same. Most of the very good Iraqi artists in that time, did some painting for Saddam Hussein. When you did this, you got credit so that you could do something else. (Muemin, pers comm, 2007)

This view of life under Saddam (as a time when it was not necessarily difficult to produce art of choice) was not shared by Emily Porter:

> I'm not happy with America. I'm not happy with the British but you have to see the truth and when they portray Saddam's regime was better, I get very annoyed … they started coming to my house … they came with the forms. [They said] why don't you contribute to the Ba'ath Party exhibition here? I said 'Because I stopped painting. I don't paint anymore'. So they would come at least once every two months to my house to see if there is any new paintings … most of them [artist-colleagues known to Porter] are practising now. The majority of them left Iraq. Went to England, went to Europe, went to America … The *majority* of them. The minority who stayed there of my generation … either they've been part of the regime, they supported it in one way or another, although privately they would criticise it when they felt safe, or they were part of the regime. Because I know loads of my colleagues, they were executed … I know at least of over 30–40 of them being executed … for making comments. For not accepting openly … but those artists who were compromising they had the best chance, to travel, to see what was going on, to have access to everything.

Wahby Rasul (Head of Fine Art at the Institution of Art in Sulaimaniya) also was clear about the personal cost to artists who were forced to cooperate with the regime:

> The artists who remained mostly struggled – they were punished both emotionally and physically. They weren't able to express themselves as artists. It wasn't just visual artists, but also actors, singers and musicians. If you wanted to sing or to act, Saddam Hussein forced them to act or to sing all about him and his regime. (Rasul, pers comm, 2007, 9)

Both Wahby Rasul and Emily Porter claimed that 'the regime executed some artists' who refused to cooperate[18] (Rasul, pers comm, 2007, 9; and Porter, pers comm, 2007, 7).

On the other hand, Man Ahmad Hamid, Head of the Institute of Art in Kirkuk maintained that one of the effects on the production of 'contemporary art' during Saddam Hussein's regime was that it was easier to work in an 'abstract' style than in a figurative one:

> That's why if you had an abstract style of art, like expressionism etc, the regime didn't know exactly what you were trying to express – it was more to do with the artist themselves. Whereas if you worked in figurative way, it was [your subject matter was] quite obvious [and therefore open to be questioned]. (Rasul, pers comm, 2007)

For these reasons then, the effect that Hussein's regime had on the production/destruction of 'contemporary art' in Iraq can never be fully known, since no evidence of works *not* made can ever be produced. However, Nada Shabout certainly speaks for many Iraqi artists when she says that: 'The general censored atmosphere at the time [during Saddam's regime] subdues the optimism and excitement of the previous decades and crushed the spirit of experimentation' (Shabout 2006b).

However, some artists argue that even since the Fall of Baghdad, the production of 'contemporary art' in Iraq has again become extremely difficult. Most artists interviewed spoke about their initial euphoria after the removal of Saddam: 'We were happy … very very happy'[19] (Porter, pers comm, 2007, 1). The effects of cultural isolation had been deeply felt by those Iraqi artists who continued to live in Iraq throughout embargoes, and thus when the regime was removed, artists rejoiced that they could again communicate with the outside world.

Dr Al-Tawil, Professor of Art History at Henry Ford College in Michigan and former faculty member of the college of Fine Arts at the University of Baghdad also stressed the paralysing effect of isolation on every cultural activity in the country: 'Cultural activity was severely wounded by the US bombing of 1990–91, followed by 13 years of brutal sanctions and isolation ended by the US-British invasion of 2003' (Durrani 2004) However, the initial rejoicing after the removal of Hussein, was short-lived: 'Within 6 months they put obstacle. No NGO could work. They could register, but they couldn't work – they didn't get any funding' (Porter, pers comm, 2007, 1–2).

And now, according to artist Dhikra Sarsam, currently resident in Baghdad, 'the situation' has again deteriorated. Attendance at universities in Baghdad has become difficult because of targeted attacks by suicide bombers and even though the Iraqi Museum of Modern Art is now open, Dhikra says, 'it's a very dangerous place now, so nobody is going there. Even though it is open nobody will go there' (Sarsam, pers comm, 2007, 5).

Similarly, Rashad Selim agrees with this assessment but argues also that the structures of modern art which had been more or less consistent under Saddam were, since occupation, now crumbling: 'All the structures of modern art were destroyed after the invasion of Iraq, we hear nothing in the media about that, we only hear about the past … we need a new art … and part of culture is art'[20] (Selim 2006).

Artist Muayad Muhsin (who lives about an hour from Baghdad in Al Hillah in the city of Babylon) echoed these sentiments also:

> My life now is difficult, and as you know, the traps, the bombs and the explosive belts are everywhere in the country. You might even be afraid of leaning on a car for fear that it might explode. You might even feel afraid to kiss your girlfriend because she might be wearing an explosive belt. Artists here practise their activities with permanent fear, anxiety and horror. The only and maybe the last resort now is a dialogue among artists, performers and writers and anyone who is a creative artist. Some simple exhibitions or some unannounced activities are being held because of the fear of bombs and explosive belts. I exhibit my paintings now in the dialogue hall of 'Alazia' and I do not sell them in Iraq because of the current situation which prevents moving around from place to place ... I am trying to save some money to build a house, a small one and to build a compartment and make it as a humble institute for teaching painting and helping the talented poor ... so that they can avoid what I went through. (Muhsin, pers comm, 2007)

The latter is an interesting example, because, while some artists interviewed were keen to stress the fact that they were continuing to work, and that life was not wholly governed by 'the situation' (Sarsam, pers comm, 2007, 16), others like Muayad wanted 'to let the people in the West know how we work under such an eternal destruction':

> Excuse me Dr Bernadette, I am not here to complain since you are not the Security Board of the UN but I am honestly and accurately describing my condition to you, and being honest with you in answering your question so that you can have the clear truth and let people in the west know about my personal suffering and how I worked heard to be on this level in painting, and how I worked hard to get a place in life. (Muhsin, pers comm, 2007)

The 'truth' of course is always contestable. Some commentators on 'Iraqi' art today are suspicious as to why certain Iraqi artists have been valourised as examples of Western-endorsed 'liberated Iraqi art'. Hashim Al Tawil, for example, has strongly criticised those artists and 'experts' who 'ignore the long-established modern art and culture of Iraqi art' and 'go on highlighting insignificant Iraqi art students and amateurs, and praising mediocre art as the rising new "post Saddam Iraqi art".' He goes on to say that such emphases are part of a larger attempt to 're-identify' Iraq – what he calls the 'de-Arabicisation' or 'de-Islamicisation' of Iraqi culture and art (Al Tawil 2006). And whether or not one agrees with this assessment, such a debate shows, at the very least, the way in which contemporary art is integral to the cultural reconstruction of Iraq and the perceived role of contemporary art in preventing the destruction of tradition expressing an enduring Iraqi (national) spirit.

CONCLUSION

Clearly, the complexities involved in discussing 'Iraqi art', 'Iraqi heritage', the 'destruction/non-production of contemporary art' – are significant. Such complexity is not, in itself, a sufficient reason for not discussing the production, non-production and/or destruction of contemporary art/heritage, in/out of Iraq. That such categories are permeable, is surely apparent at this stage. However, despite such 'instability' or 'elasticity', these categories

nevertheless perdure – they continue to exist as conduits, rather than as evidence of any discrete, autonomous or permanent 'thing in itself'. In conclusion then I want to refer briefly to Mohamed Abdulla – who in interviews was consistently hesitant about taking on such a category as that of 'Iraqi artist'. Despite being included in (and supposed to belong to) exhibitions of 'contemporary Iraqi art', Abdulla's works and writings resist such cursory categorisations. Rather, they connote an uncertain, albeit persistent proximity to 'Iraqi identity' – one, which makes for a fitting hesitation with which to end this essay. In his poetic statement entitled 'The Beauty of Resistance', Abdulla expresses his concern about the (Western curatorial) tendency to position him as an *Iraqi* artist. He quotes from a conversation he has had with a colleague: 'We have become an illustrative item for a curator initiating a presentation about the Iraqis, the Muslims, the Arabs or the others' (Abdulla 2005).

Abdulla's statement goes on to express his lack of conviction as to the Western preoccupation with 'Iraqiness' and the way in which he has been positioned within such a category: 'I was an artist in Baghdad and then became a modernist when I went to the Netherlands. But as of three years, I have become an Iraqi contemporary artist living in Europe' (Abdulla 2005).

Living in the Netherlands at the time of writing this statement, he incorporates into his works and writings, the tension between his personal search for identity and the 'Iraqi' identity which Western curatorship has foisted upon him.

> I'm not a Persian carpet
>
> I'm not a Chinese vase
>
> I'm not an Indian spice
>
> I'm not Scheherazade
>
> but,
>
> Neitherlander.[21]

Abdulla's experience is therefore that 'Iraqi art' has to be performed for the West and ironically, it is this performance which somehow obscures his own sense of self:

> Mohamed is absent,
>
> I'm performing. (Abdulla 2005)

He continues:

After three years of working in this imposed territory, I realised that I'm polishing this imposed label instead of questioning it. I have to play the role of the Oriental artist and export this label to my own kind over there, in order to gain the Western institutes' recognition and suit the cultural globalisation demands. (Abdulla 2005)

Nevertheless, despite this sceptical approach to the way in which he has been positioned as an artist, Abdulla returns to his experience of separation from Iraq as a key impulse in his desire to make work. Asked by Predrag Pajdic, (Curator of *In Focus: Art from the Middle East*, Tate Modern, Dazed Gallery, Imperial War Museum, 2007) what drove him to create work, Abdulla replied:

It is the pain of my failure to be a citizen for the second time. It is the pain of being accused of being 'the others'. It is the pain of missing the meaning of the occupation of Iraq. (Pajdic, pers comm, 2006)

It is with this hesitation then about the artist's relation to 'Iraqi art' that I end this meditation on the role of contemporary art in the destruction of heritage in Iraq – a hesitation which returns us to the starting point for the chapter and to the unrelenting instability of the terms upon which this discussion depends. Such a situation is not cause however for the surrender of all attempts to find meaning. On the contrary, it necessitates the description of a new aesthetic practice – one which is neither 'Iraqi' nor 'not-Iraqi'; but one which has a relation to both of these terms and one which explores new forms of practice built upon the wreckage of decades of destruction, turmoil and dispersal. Like Walter Benjamin's angel of history, we can only move into the future with our faces turned towards the wreckage of the past:

This is how one pictures the angel of history. His face is turned toward the past. Where we perceive a chain of events, he sees one single catastrophe which keeps piling wreckage and hurls it in front of his feet. The angel would like to stay, awaken the dead, and make whole what has been smashed. But a storm is blowing in from Paradise; it has got caught in his wings with such a violence that the angel can no longer close them. The storm irresistibly propels him into the future to which his back is turned, while the pile of debris before him grows skyward. This storm is what we call progress. (Benjamin 1940, 249)

And thus, 'Iraqi' artists, in the face of the destruction of their 'heritage' are seizing their own moment of opportunity.

NOTES

1. This phrase is borrowed from the title of a contemporary artwork by Mohamed Abdulla about which I will elaborate further below.

2. The last two quotations in particular are obviously ideologically driven statements. Many contemporary commentators argue that such statements are intended to make the subdivision of Iraq into three separate states a foregone conclusion. For example, a statement by writers, journalists and intellectuals from Iraq, organised under the banner of The BRussels Tribunal, released a public statement protesting that: 'We believe that the federalism law, introduced quickly and without a proper nationwide debate, is but an old scheme to destroy Iraq by dividing it. Iraq will be divided into small bickering entities to weaken it and erode the authority of its central government.'

3. See for example the following exhibitions of 'Irish Art' which coincided with IRA bombing campaigns in the UK: Douglas Hyde Gallery, A New Tradition: Irish Art of the Eighties, Dublin: 1998. Bluecoat Gallery Parable Island, Part Two, Liverpool: 1991. Elizabeth Kidd, The Fifth Province: Contemporary Irish Art, Touring exhibition: 1991/3. Wolverhampton Art Gallery & Museum, Cease-fire Reflections of Conflict Wolverhampton: 1990-1992 [included works by both Irish and British artists].

4. For example, a recent news report (at the time of writing) stated that Baghdad 'endured one of its most wretched days in four years of slaughter, with nearly 200 people killed and more than 200 injured in a volley of afternoon bomb attacks' Michael Howard, '"We'll be in control by end of 2007" says Maliki. In Baghdad, Carnage Continues' in *The Guardian*, 19 April 2007.

5. Robert Fisk, 'Only justice, not bombs, can make our dangerous world a safer place', *The Independent*, 30 December 2005. Fisk goes on to say: 'We do not even know – are not allowed to know – how many of them have died. We know that 1100 Iraqis died by violence in Baghdad in July alone ... But how many died in the other cities of Iraq, in Mosul and Kirkuk and Irbil, and in Amara and Fallujah and Ramadi and Najaf and Kerbala and Basra?'

6. 1.8 million is the figure for 'internally displaced Iraqis' as quoted by BBC News on 15 Feb 2007. The same article numbered externally displaced Iraqi refugees at being between 1.87 and 2.37 million. The question of how many Iraqis have died since US occupation is a hotly contested one. At the time of writing, www.iraqbodycount.org (accessed 1 May 2007) reports deaths of civilians 'due to military intervention' as being between 62086 (min) and 68083 (max). However, an academic report released in October 2006 and conducted by researchers at the Johns Hopkins Bloomberg School of Public Health and the Al Mustansiriya University in Baghdad reported that as many as 654,965 more Iraqis may have died since hostilities began in Iraq in March 2003 than would have been expected under pre-war conditions. See http://www.jhsph.edu/refugee/research/iraq (accessed 2 April 2007). The latter was an estimation of 'deaths from all causes – violent and non-violent'. The public health experts who directed this study cautioned however that the real death toll could be significantly higher and attributed nearly one third of it directly to US military operations.

7. Definitions and deconstructions of said definitions of 'heritage' are too numerous to mention, but for a good discussion of the problem of how to define 'heritage', see Edson 2004, Phelan 1998, Loulanski 2006.

8. The traditional bias of 'heritage' towards the tangible and the monumental, has in recent years been critiqued. This critique culminated in 2001 in the first UNESCO Proclamation of Masterpieces of the Oral and Intangible Heritage of Humanity which took place in Paris. The intangible 'masterpieces' nominated on that occasion were extremely varied and covered all sorts of socio-cultural phenomena ranging from theatre and music to folklore and traditional royal and popular rituals. However critics such as Laurajane Smith and others continue to criticise the 'common-sense assumption that "heritage" can unproblematically be identified as "old" grand, monumental and aesthetically pleasing sites, buildings, places and artefacts'.

9. BBC News report, Thursday 31 October 2002: 'An appeal to raise £30m to save a Raphael masterpiece for the nation has been launched by London's National Gallery. The current owner of Raphael's *Madonna of the Pinks*, the Duke of Northumberland, has agreed to sell the painting to a US gallery to prop up his estate's ailing finances.'

10. For example, in describing Damien Hirst's work, Sewell says 'It is no more interesting than a stuffed pike over a pub door' (Sewell 1995). See Sewell 1995, for Brian Sewell interview by Andrew Cousins. See also for example, Sewell's review of Tate Modern's exhibition by Francine Germaine Wilson. Saying that it is 'banal' and 'devoid of wit or imagination (let alone talent)', he writes: 'Never in my life have I witnessed such a travesty in the name of art' (Ibid, 193).

11. The project was conducted in association with the Society of Iraqi Plastic Art, Baghdad, Artists Against Oppression and iNCiA, London.
12. Some slippage has opened up here between the notions of 'modern Iraqi art' and 'contemporary Iraqi art'. Jewad was of course associated with the development of the Modernist movement in Iraq. However, the point that I am making here still holds since it shows how that work when still 'contemporary' in the 1950s was at first rejected by and then absorbed into 'heritage'.
13. It should be noted that Selim was particularly fascinated with the achievements of the famous 13th-century Baghdadi miniature painter Yihya al-Wasiti.
14. Shabout goes on to say that: 'According to Khalid al-Shami, Director for the Culture and Education Department of the government's De-Ba'athification Commission, "we just want to tell [Iraqis] that the Ba'athists are part of a dirty history that will not come again".'
15. Dr Shabout's voice has been accompanied by Dr Hashim Al-Tawil, who in an article by Anayat Durrani entitled 'Iraq's Forgotten Modern Art' says that the 'US British invasion of 2003 … has paralysed every cultural activity in the country'.
16. Though small in number, these interviews with contemporary artists comprise the views of those currently working in Baghdad, Kirkuk (and other areas in Iraq-Kurdistan), Basra, UK, Spain, and Germany. Interviews were conducted with Rashad Selim (artist, curator and writer); Maysaloun Faraj (artist, curator of the Aya Gallery for Iraqi artists in London, curator of *Strokes of Genius* as cited above); Mohamed Abdulla (contributor to the *Iraqi Equation; In Focus* etc); Emily Porter (Iraqi artist, writer and art historian); Adalet R Garmiany (co-founder of Art Role, which was formed to 'build cultural bridges between Middle East and UK'); Wahby Rasul (Head of Fine Art at the Institute of Art in Sulaimaniya); Ali Raza (Director of the Kosk Gallery, columnist for *The New Art* magazine, set designer for the acclaimed *Turtles Can Fly* film); Sami Muemin, (co-founder and director of ArtArt Laboratory in Sulaimaniya); Man Ahmad Hamid (Head of the Institute of Art in Kirkuk); Afan Sediq (exhibiting in Mainz, Munich, Cologne etc); and Dhikra Sarsam (practising artist resident in Baghdad) and Jananne AlAni (resident in London). Interviews were also conducted with Predrag Pajdic, curator of *In Focus: New Art from the Middle East*. E-mail correspondence was established with Muayad Muhsin currently resident in Al Hillah in the ancient city of Babylon.
17. Porter 2007: 'Well I was one of the co-founders of the Iraqi Visual Art Association. There were ten of us. That was '67, '68. There were loads of Iraqi artists in our group. It was an association. It became like a trade union.'
18. Porter goes on to say: 'One of my relatives … he's a good artist … a good sculptor … but he was working for Saddam Hussein's regime and he informed of at least six, seven artists and they were killed and I know that.'
19. Interestingly, this testimony as to the initial euphoria of Iraqi artists following the removal of Saddam Hussein, is repeated in the film *Dreams of Sparrows*. Directed by the Iraqi film-maker Hayder Mousa Daffar and made in collaboration with the Iraq Eye Group and Harbinger, this documentary sought to 'show the world what life was like in Iraq' in December 2003. Co-director Haydar Jabar says early in the film: 'I graduated during the war, a year last year. I couldn't make a film because of the war situation, financial hardship and I didn't have a camera. I've got ideas. But now some of our dreams have been realised by having cameras and some technical support. And I would like to thank another person. I have his picture with me because I very much love this man [opens wallet and shows picture of George W. Bush] because he rescued us from the dictator's regime. I love him as much as I love my father.' However by the end of the film (one year after occupation) one of the film-maker's crew had been killed in an explosion and in an epilogue to camera, director Hayder Mousa Daffar says: 'Baghdad is hell. Really it's hell … In the start, when Baghdad is falling, when Saddam is gone, I am very happy. Not just me, believe me! Iraqi people, maybe all Iraqi people, we were very happy … but nothing's new. Same same. More explosions. US troops is very hard-hearted, confused and all troops is very scared from anything … why I don't know … the situation here is very bad. No safe. I thanks for God, because one year after Occupation, I am still alive. I don't know.'
20. Rashad Selim, 'A Contemporary Perspective on Arab Modern Art', talk to coincide with *The Iraqi Equation*, given at the Zenith Foundation.
21. *Mohamed is Absent* and *Neitherlander* are also the titles of two of Abdulla's works.

BIBLIOGRAPHY

Aaronovitch, D, 2004, Ashes to Ashes, *The Observer* on Sunday, 30 May

Abdulla, M, 2005 *The Beauty of Resistance* [online] available from http://universes-in-universe.org/eng/islamic_world/articles/2005/abdulla [12 September 2006]

Adorno, T W, 1995 *Prisms*, MIT Press, Cambridge, Massachusetts

Al-Tawil, H, 2006 From Pomegrate to Dearborn: The Loss of Iraqi Art, in *Arab American News* 16/12/06 [online] http://www.arabamericannews.com/newsarticle.php?articleid=7106 [20 December 2006]

Altshuler, B, 1994 *The Avant-garde in Exhibition: New Art in the 20th Century*, University of California Press, London

Altshuler, B (ed), 2005 *Collecting the New: Museums and Contemporary Art*, Princeton University Press, New York

An Chomhairle Oidhreachta/The Heritage Council, 1995 *The Heritage Act, 1995*, Kilkenny. See Part I, Preliminary and General – sections 1–2. Available from http://www.heritagecouncil.ie/publications/heriact95/part1.html#2 [3 January 2007]

Anderson, B, 1991 *Imagined Communities: Reflections on the Origin and Spread of Nationalism*, Revised Edition, Verso, London and New York

Anderson, K, 2002 The International Theft and Illegal Export of Cultural Property, in *Journal of International and Comparative Law* 8(2) 1, citing Joseph L Sax, *Playing Darts with Rembrandt* 3, 1999

Baram, A, 1991 *Culture, History, and Ideology in The Formation of Ba'athist Iraq, 1968–1989*, St Martin's Press, New York

BBC News, 2002 *Appeal to save Raphael for UK* [online] available from http://news.bbc.co.uk/1/hi/entertainment/arts/2380817.stm [31 October 2002]

BBC News, 2007 *UN welcomes US Iraq refugee plan* [online] available from http://news.bbc.co.uk/1/hi/world/middle_east/6362289.stm [15 February 2007]

Benjamin, W, 1940 Thesis on the Philosophy of History (IX), in *Illuminations* (ed H Arendt) 1999, Pimlico, London

Bhabha, H K, 1990 DisseminNation, in *Nation and Narration* (ed H K Bhabha), 297, Routledge, London and New York

Borisovich, M, 2004 Museum Director: Interviews with the Director [online], interview first published in the Petersburg magazine *ART City* (February 2004) available from http://hermitagemuseum.org/html_En/02/hm2_6_0_8.html [20 November 2006]

Bouchebel, R, and CNN, 2003 *Dreams of Iraq's Future Take Flight at Kite Fest* [online] available from http://www.cnn.com/2003/WORLD/meast/11/06/sprj.irq.nilaw.kite/index.html [4 November 2006]

Brah, A, and Coombes, A E (eds), 2000 *Hybridity and Its Discontents (Politics, Science, Culture)*, Routledge, London

Brodie, N, 2005 A Future for Our Past: International Symposium for Redefining the Concept of Cultural Heritage, in *The International Journal of Cultural Property* 12, 491

The BRussells Tribunal, 2006 [online] available from http://www.brusselstribunal.org/AgainstDivision.htm [23 November 2006]

Cohen, R, 2006 Iraq's Biggest Failing: There Is No Iraq, in *The New York Times* [online] available from http://www.nytimes.com/2006/12/10/weekinreview/10cohen.html [12 December 2006]

Cook, W, 2004 National healing, *New Statesman*, 19 January

Cousins, A, 2001 The Video Art of Francine Germaine Wilson, in *Netribution Film Network* [online] available from http://www.netribution.co.uk/features/carnal_cinema/76.html [4 December 2006]

Deleuze, G, 1994 *Difference and Repetition*, Trans. Paul Patton, Athlone, London

Derrida, J, 1978 *Writing and Difference*, Chicago Press, Chicago

Derrida, J, 1998 *Of Grammatology*, Johns Hopkins University Press, London

Duncan, C, 1995 *Civilising Rituals: Inside Public Art Museums*, Routledge, London

Duncan, C, 1999 From the Princely Gallery to the Public Art Museum, in *Representing the Nation: A Reader: Histories, Heritage and Museums* (eds J Evans and D Boswell), Routledge, London and New York

Durrani, A, 2004 *Iraq's Forgotten Modern Art* [online] available from Fine Art Registry: http://www.fineartregistry.com/articles/durrani_anayat/iraqs_modern_art.php [Accessed 12 October 2006]

Edson, G, 2004 Heritage: Pride or Passion, Product or Service, in *International Journal of Heritages Studies* 10(4), 333–348

Ethnomusicology, 1995, Fall, 370

Evans, J, and Boswell, D (eds), 1999 *Representing the Nation: A Reader: Histories, Heritage and Museums*, Routledge, London and New York

Faraj, M (ed), 2001 *Strokes of Genius: Contemporary Iraqi Art*, ex cat., Saki Books, London

Faraj, M, 2006 Personal interview at Aya Gallery [interview by author], 24 November 2006

Fisk, R, 2005 *The Independent*, 30 December

Fouskas, V, 2007 Iraq and Meta-Conflict, in *Political Conflict* 1

Groys, Boris, 2002 On the New, in *Artnodes: E-Journal on Art, Science and Technology* [online] available from http://www.uoc.edu/artnodes/eng/art/groys1002/groys1002.html [29 February 2007]

Hami, M A, 2007 Personal communication [with the author, through a tramslator] 23 February 2007

Hooper-Greenhill, E, 2000 *Museums and the Interpretation of Visual Culture*, Routledge, London

Howard, M, 2007 'We'll be in control by end of 2007' says Maliki. In Baghdad, carnage continues, *The Guardian*, 19 April

Inati, S C (ed), 2003 *Iraq: Its History, People and Politics*, Humanity Books, New York

Iraq Body Count, 2007 [online] available from www.iraqbodycount.org, [1 May 2007]

Jessup, B, 1963 Analytical Philosophy and Aesthetics, in *British Journal of Aesthetics* 3, 223–233

Johns Hopkins Bloomberg School of Public Health, 2006 [online] available from http://www.jhsph.edu/refugee/research/iraq [2 April 2007]

The Khalid Shoman Foundation, 2000 [online] available from http://www.daratalfunun.org/main/index.html [2 October 2006]

Kramer, H, 2006 *The Triumph of Modernism: The Art World, 1987–2005*, Ivan R. Dee, New York

Loulanski, T, 2006 Revising the Concept for Cultural Heritage: The Argument for a Functional Approach, in *International Journal of Cultural Property* 13, 207–233

Macdonald, S J, 2003 Museums, National, Postnational and Transcultural Identities, in *Museum and Society* 1(1), 3

Macdonald, S (ed), 2006 *A Companion to Museum Studies*, Blackwell, London

Makiya, K, 2004 *The Monument: Art and Vulgarity in Saddam Hussein's Iraq*, IB Tauris, London and New York

Merriman, N, 1999 *Beyond the Glass Case: The Past, The Heritage and The Public in Britain*, Leicester University Press, Leicester

Minh-Ha, T T, 1992 *Framer Framed*, Routledge, New York and London

Moos, F, 2004 *Turning Victory into Success: Military Operations after the Campaign*, (ed B M De Toy), Combat Studies Institute Press/Fort Leavenworth, Kansas

Muemin, S, 2007 Personal interview transcription with Kurdish-Iraqi artist [interview by the author] 23 February 2007

Muhsin, M, 2007 Personal email communication [with the author], trans. Ali Allaham, 25 April 2007

Muzaffar, M, 2000 *Contemporary Artists from Mesopotamia* [online] available from http://www.daratalfunun. org/main/activit/pressc1/Muzzaffer.html [2 October 2006]

Muzaffar, M, 2003 Iraqi Contemporary Art: Roots and Development, in *Iraq: Its History, People and Politics* (ed S C Inati), Humanity Books, New York

Pajdic, P, 2006 Interview with Mohammed Abdulla [interview by Predrag Pajdic; information received by author in personal communication between Pajdic and author], December 2006

Peretti, J, 2004 Burning Shame *The Guardian*, 5 June

Phelan, M, 1998 *The Law of Cultural Property and Natural Heritage: Protection, Transfer and Access*, Kalos Kapp Press, Evanston Illinois

Poggioli, R, 1994 *The Theory of the Avant Garde*, Harvard University, London

Porter, E, 2007 Personal interview transcription with Iraqi artist/writer [interview by the author] 12 March 2007

Rasul, W, 2007 Personal communication (interview by the author), (translated by Adalet R Garmiany), 23 February 2007

Said, E, 2003 A Window on the World, *The Guardian*, 1 August

Sarsam, D, 2007 Interview transcription [interview by the author], 9 April 2007

Saumerez Smith, C, 2004 'Why the 'Madonna of the Pinks' was worth £22m, *The Telegraph*, 18 October

Sediq, A, 2007 Interview transcription [interview by the author] (translated by Adalet R Garmiany), 23 February 2007

Selim, R, 2003 Personal communication with author, September 2003

Selim, R, 2003 Personal email communication with the author, 6 July 2003

Selim, R, 2003 *Rasim hur Sama* (artwork project), see: http://www.incia.co.uk/4775.html Accessed [11 November 2006]

Selim, R, 2003 *Kite Flying: Reoccupy the Sky with our Dreams. Regain the Future with Our Imagination* [online] available from INCIA (International Network for Contemporary Iraqi Artists): http://www.incia. co.uk/4556.html [11 November 2006]

Selim, R, 2006 *A Contemporary Perspective on Arab Modern Art* [online] available from www.zenithfoundation. com/art_workshop_salim.htm [23 November 2006]

Selim, R, 2006 Original interview [interview by the author] 24 November 2006

Sewell, B, 1995 *An Alphabet of Villains*, Bloomsbury, London

Seymour, M, 2004 Ancient Mesopotamia and Modern Iraq in the British Press, 1980–2003, in *Current Anthropology* 45(3)

Shabout, N, 2006a Historiographic Invisibilities, The Case of Contemporary Iraqi Art, in *International Journal of the Humanities* 3, 57

—— 2006b The 'Free' Art of Occupation: Images for a 'New' Iraq, in *Arab Studies Quarterly*, 22 June 2006

Smith, L, 2006 *The Uses of Heritage*, Routledge, London and New York

Staniszewski, M A, 1998 *The Power of Display: A History of Exhibition Installations at the Museum of Modern Art*, MIT Press, London

Stupples, P, 2003 Visual Culture, Synthetic Memory and the Construction of National Identity, in *Third Text*, 17(2), 127–139

Tripp, C, 2000 *A History of Iraq*, Cambridge University Press, Cambridge

Virilio, P, 2003 *Art and Fear*, trans. Julie Rose, Continuum, London and New York

Wali, N, 2006 Words Without Borders Anthology, *Literature from the Axis of Evil: Writing from Iran, Iraq North Korea and Other Enemy Nations*, The New Press, New York and London

Author Biographies

Al-Gailani Werr, Lamia

Born in Baghdad in 1938, Lamia Al-Gailani Werr received her early education in Baghdad; a BA in Archaeology and Anthropology from Cambridge; an M.Litt in Archaeology from Edinburgh; and a PhD in Babylonian Archaeology from the Institute of Archaeology, London. She worked in the Iraq Museum for eight years between 1961 and 1969. At present she is editor for Edubba archaeological publications and an honorary research fellowship at UCL. After the looting of the Iraq Museum in 2003, she worked in the Museum as consultant for the Iraqi Ministry of Culture.

She has written two books, edited several more, and has published numerous articles on the archaeology of Iraq, particularly on cylinder seals. She has lived in London since 1973.

Bahrani, Zainab

Zainab al Bahrani is the Edith Porada Professor of Ancient Near Eastern Art History and Archaeology at Columbia University. Zainab is a specialist in the art and archaeology of Mesopotamia and has written extensively on the cultural heritage of Iraq. She is the author of, among other publications, *Women of Babylon: Gender and Representation in Mesopotamia* (London: Routledge, 2001), and *The Graven Image: Representation in Babylonia and Assyria* (Philadelphia: University of Pennsylvania Press, 2003) and most recently, *Rituals of War* (New York: Zone Books, forthcoming 2008). Zainab was born in Baghdad, Iraq, and educated in Europe and the United States. She received her MA and PhD degrees in Art History and Archaeology from New York University's Institute of Fine Arts. Prior to her appointment at Columbia University, Zainab taught at the University of Vienna in Austria, and The State University of New York, at Stony Brook, New York and was a curator at the Metropolitan Museum of Art's Near Eastern Antiquities Department from 1989 to 1992. She is the recipient of numerous fellowships and awards including awards from the American Schools of Oriental Research, The Metropolitan Museum of Art, the Getty Foundation, the Mellon Foundation, and most recently, the Guggenheim Foundation. In the summer of 2004 she was Senior Advisor to Iraq's Minister of Culture, and negotiated the closing and removal of the US and Coalition military base in Babylon on behalf of Iraq's State Board of Antiquities and Heritage.

BOGDANOS, MATTHEW

Matthew Bogdanos has been a homicide prosecutor in New York City since 1988. A Colonel in the US Marine Corps Reserves, middleweight boxer, author, and native New Yorker, he was graduated *cum laude*, receiving a Phi Beta Kappa award, with honours in Classics, from Bucknell University in 1980. He also holds a Recognition of Achievement in International Law from the Parker School of International Law in 1982, a law degree and a master's degree in Classics from Columbia University in 1984, and a master's degree in Strategic Studies from the Army War College in 2004. Commissioned a Second Lieutenant in the US Marine Corps in 1980, he served as a Judge Advocate until he left active duty to join the New York District Attorney's Office. Remaining in the reserves, he later served in South Korea, Lithuania, Guyana, Kazakhstan, Uzbekistan, and Kosovo. He was recalled to active duty after September 11, 2001, receiving a Bronze Star for counter-terrorist operations in Afghanistan. He then served several tours in Iraq and one in the Horn of Africa, receiving a 2005 National Humanities Medal for his work recovering Iraq's treasures. He has returned to the District Attorney's Office in New York and continues the hunt for stolen antiquities. All his royalties from his book, *Thieves of Baghdad*, are donated to the Iraq Museum.

BRODIE, NEIL

Neil Brodie graduated from the University of Liverpool with a PhD in Archaeology in 1991. He has held positions at the British School at Athens and the McDonald Institute for Archaeological Research at the University of Cambridge, where he was Research Director of the Illicit Antiquities Research Centre from 1998 to 2007. He is now at Stanford University's Archaeology Center in the USA. He maintains an active profile in Greek archaeology.

BUCKLEY, BERNADETTE

Bernadette Buckley is a Lecturer in International Relations, in the Politics Department at Goldsmiths College, University of London. Bernadette graduated in 2003 from Goldsmiths, University of London and was awarded her PhD in Art Theory and History of Art. In recent research she has focused closely on the relationship between art, terrorism, war and democracy and has written and published broadly on these themes. She also has a long-standing interest in the theorisation of contemporary curating – in particular here, her research has explored the collapsing boundaries between art, curating and educational practices. Prior to her current position, she was a lecturer at the International Centre for Cultural and Heritage Studies in Newcastle University and, before that, was Head of Education & Research at the John Hansard Gallery, University of Southampton.

COLE, SUE

Sue Cole is an archaeologist now specialising in managing and protecting World Heritage Sites, international policy and emergency planning for cultural property. She is secretary

to the United Kingdom and Ireland Blue Shield and observer to the International Committee. She graduated from Birmingham University as an Egyptologist and worked extensively in the Middle East. She subsequently worked in the field in the UK before working for the Greater London Sites and Monuments Record in 1987. She joined English Heritage in 1992 working for the Greater London Archaeology Advisory Service and headed the unit before working as Inspector of Ancient Monuments for the West Midlands. In 1999 she joined English Heritage's Stonehenge Project as Acting Project Director and left in 2001 to go on maternity leave. She returned to English Heritage in 2002 as Senior Policy Adviser World Heritage and International Policy.

Cox, Margaret

Margaret Cox is Professor of Forensic Archaeology and Anthropology at Cranfield University, Shrivenham. She was formerly Professor of Forensic Archaeology and Anthropology at Bournemouth University where she developed and directed their internationally acclaimed post-graduate educational provision in these subjects. She advises UK police forces in the investigation of serious crime through the Forensic Search Advisory Group and the National Crime Faculty. Margaret has also worked in Kosovo, Rwanda, Iraq and Cyprus and has been Consultant Forensic Anthropologist for the Ministry of Defence since 2000. Committed to human rights and humanitarian work she is Founder and Chief Executive of Inforce where, with colleagues, she has taught forensic sciences for capacity building and empowerment purposes. She designed the training programmes Inforce delivered for Iraq in 2004–5. Determined to enhance investigative procedures in order to provide a deterrence to help prevent atrocity crimes, she advocates adopting a rights based approach to forensic investigations where possible. Professor Cox was awarded the prestigious European Woman of Achievement Award (Humanitarian section) in 2002.

Curtis, John

John Curtis is Keeper of the Department of the Middle East at the British Museum and specialises in the archaeology of Iraq and Iran between 1000 BC and 330 BC. He has published widely on these subjects. Between 1983 and 1989 he directed excavations at eight sites in Iraq including Nimrud. He maintained close links with colleagues in Iraq even after the First Gulf War in 1991, and was the first foreign archaeologist to visit the Iraq Museum after it was looted in April 2003. He returned for a longer visit in June 2003, and in December 2004 he inspected the site of Babylon.

Delanghe, Philippe

Philippe Delanghe was born in 1965 in Louvain, Belgium. During and after completing his Masters degree in Prehistory & Archaeology and Anthropology, Philippe assisted in periodic archaeological excavations at Pessinus, Turkey, with an excavation team from Ghent University, Belgium (1989–92). In 1994, after lecturing for a short period at Ghent University, Philippe joined the UNESCO Jakarta Office as an Associate Expert for

Culture in charge of culture heritage projects in Indonesia, Malaysia and the Philippines. In 1998, Philippe was appointed Programme Specialist for Culture with the Jakarta Office and continued his work on tangible and intangible heritage conservation. By the end of 1999 his sub-regional responsibilities included the independent region of East Timor. A specific focus, resulting in two major UNESCO publications, was given to rock art conservation in West Papua (Irian Jaya) and the Democratic Republic of Timor Leste and support to the Borobudur restoration project. In 2004 Philippe joined the UNESCO Iraq Office in Amman, Jordan, where he worked to support tangible and intangible heritage conservation in Iraq, mainly focusing on the rehabilitation of the National Museum in Baghdad and the World Heritage Nomination of historical parts of the city of Samarra. In 2007 Philippe moved on to Cambodia to become the head of the Culture Unit in the UNESCO Phnom Penh Office, mainly in charge of the international coordination efforts for the conservation and preservation of Angkor and Preah Vihear.

FARCHAKH BAJJALY, JOANNE

Joanne Farchakh Bajjaly is a Lebanese archaeologist and a journalist; she is responsible for the 'Archaeology & Heritage' pages at the Lebanese newspaper *Al Akhbar* and is the Middle East correspondent for the French magazine *Archéologia*. She has been working on the situation of, and events surrounding, the Iraqi heritage since 1998 and has visited Iraq more then ten times over the last few years. She investigated the looting of the Iraq Museum and witnessed the destruction and looting of the archaeological sites in southern Iraq before and after the 2003 invasion. In 2005, she was invited to lecture in 14 universities in the USA on this issue.

GEORGE, DONNY

Donny George Youkhanna is Visiting Professor at Stony Brook University, USA. Donny was born in Habbania, Al-Anbar province, Iraq in 1950 and obtained his BA in Archaeology in 1974, his MA in Prehistoric Archaeology in 1986, and his PhD in 1995, all from the University of Baghdad. He has been a member of staff in the Iraq Museum since 1976. In 1980 he was appointed Director of the Museum's Documentation Centre, and between 1986 and 1987 was Field Director for the restoration project in Babylon. In 1988, he conducted archaeological investigation around the eastern wall of Nineveh and in 1989 was Scientific Supervisor for the Bekhma Dam Archaeological rescue project. Between 2000 and 2003 Donny was Director General of Research and Studies and was, between 2003 and 2005, Director General of the Iraqi Museums. In 2003 he became a Member of the International Regional Committee of Interpol and in 2004 a Member of the Iraqi National Committee for Education, Science, and Culture, Iraqi UNESCO. In 2005 Donny was appointed Chairman of the Iraqi State Board of Antiquities and Heritage. Donny has lectured and published extensively on the archaeology of Iraq and, more recently, on the looting and destruction of museums and archaeological sites in Iraq.

Gerstenblith, Patty

Patty Gerstenblith is Professor of Law, at DePaul University in the USA. She is founding President of the Lawyers' Committee for Cultural Heritage Preservation and served as a public representative on the President's Cultural Property Advisory Committee in the US Department of State. She is the author of From Bamiyan to Baghdad: Warfare and the Preservation of Cultural Heritage at the Beginning of the 21st Century; (*Georgetown Journal of International Law*), of *Art, Cultural Heritage and the Law*; and of *Iraq Beyond the Headlines: History, Archaeology and War* (co-author). She received her J.D. from Northwestern University and a PhD from Harvard University.

Ghaidan, Usam

Usam Ghaidan, a native of Iraq, is a corporate member of the Royal Institute of British Architects. He has practised, taught and carried out research in the Middle East and Africa. He was a UNESCO architect for 16 years, first as a school-building specialist and later in the role of 'Focal Point for Culture in Iraq', responsible for assessing and recording the damage suffered by Iraq's culture as a result of the most recent war and the neglect that preceded it. Among his publications are *Lamu – A Study of the Swahili Town* and *Lamu – A Study in Conservation*. The latter was awarded first prize of the Organization of Islamic Capitals and Cities in 1983. He also contributed to *The Looting of the Iraq Museum*.

Gibson, McGuire

McGuire Gibson is Professor of Mesopotamian Archaeology at the Oriental Institute of the University of Chicago. His PhD (1968) was related to the site and area of Kish, in southern Iraq. He has done archaeological research in Iraq since 1964, acting as Director of the Oriental Institute Expedition to Nippur since 1972. He has also conducted research in Saudi Arabia, Yemen, and Syria. His excavations at Hamoukar in Syria (1999–2001) exposed evidence of one of the oldest cities in the world. Prior to and after the Gulf War of 1991 and again in 2003, he was very active in efforts to protect the cultural heritage of Iraq. Recently, he has been a co-convenor of a conference at the Rockefeller Brothers Fund Center in Pocantico, New York, in which scholars, active and retired military officers, and active and retired State Department officials discussed the lessons to be learned from the 2003 war, with the object of presenting policy recommendations on safeguarding cultural property in time of war. He has recently (2006) written a review article on Magnus Bernhardsson's *Reclaiming a Plundered Past* (Austin, Texas, 2005), which deals with the history of the Antiquities Service in Iraq and the use of antiquities as part of nation-building.

Hamdani, Abdulamir

Abdulamir M al-Hamdani, was born in Nassiriyah in 1967 and awarded his Bachelor of Archaeology and Ancient Antiquities from Baghdad University in 1987. He was appointed to the State Board of Antiquities and Heritage in 2002. He has participated in

the survey, documentation, and classification of archaeological sites in Thi-Qar province as member and team director. He led the archaeological sites survey team in the south marshlands, and the team carrying out archaeological test-holes at Tell Laham (near Ur). He has been the inspector of Thi-Qar Province Archaeological Office since 2003.

HUOT, JEAN-LOUIS

Jean-Louis Huot is Emeritus Professor of Oriental Archaeology at the Sorbonne University, Paris. He was the leader of French archaeological excavations in Iraq between 1974 and 1990 and then was director of l'Institut français d'archéologie du proche-orient (the French Institute of Near-East Archaeology – Beirut-Damas-Amman) between 1999 and 2003. He was personally responsible for the missions in Iraq of Larsa and Tell el Oueili. He is the author of more than ten books and over 160 articles. Recent publications include the two volumes of *Une archéologie des peuples du Proche-Orient* (Paris, Editions Errance 2004).

LAFONT, BERTRAND

Bertrand Lafont is an Assyriologist and historian of ancient Mesopotamia. He is a research director attached to the Centre national de la recherche scientifique (CNRS, Paris). His work focuses essentially on the history of the ancient Near East (3rd and 2nd millennia BC). Having previously worked for many years as part of the team deciphering the Mari tablets and Sumerian texts held by the Museum of Instanbul, Bertrand Lafont is currently research director of l'Institut français du proche-orient (French Institute of the Near East (IFPO) – Beirut, Damas, Amman). He is chief editor of the periodical *Syria* and an associate member of the CDLI (Cuneiform Digital Library Initiative, Berlin and Los Angeles).

OLĘDZKI, ŁUKASZ

Łukasz Olędzki was born in 1975 in Poland. After graduating from the Adam Mickiewicz University, Poznan in 2003, he started postgraduate study at Poznan. His main research interests include the archaeology of nomads in the Early Iron Age and also theory and methods of archaeology, especially research of ritual actions and performance studies. In 2004 he took part in the special project of the Polish Ministry of Culture and National Heritage regarding the protection of Iraqi cultural heritage during wartime. He has spent 15 months in central Iraq as a specialist for protection of cultural heritage in the Multinational Division, Central-South in Iraq. He was responsible for cooperation with, and support for, the Iraqi State Board of Antiquities and Heritage in the provinces of Al Diwaniyah, Babil and Wasit.

MOUSSA, MARIAM

Mariam Moussa is an Iraqi archaeologist. She studied at Baghdad University and holds a PhD in archaeology. She is a member of the State Board of Antiquities and Heritage of Iraq, working as Director in Charge of the site of Babylon.

Parapetti, Roberto

Roberto Parapetti is an architect by training and profession. He has been Director of the Iraqi-Italian Centre for the Restoration of Monuments (established in 1969 according to the cultural agreement between the two countries to create technical and scientific cooperation through Centro Ricerche Archeologiche e Scavi di Torino) since 1972 and, since 1977, Director of the Italian Archaeological Expedition in Jerash, Jordan. His work in Iraq has centred on: restoration projects in Babylon (town planning, Southern Palace, Ishtar Gate); documentation and studies for the conservation of the Islamic monuments of Baghdad (al-Haydar Khaneh mosque, Shaykh 'Omar as-Suhrawardi mausoleum, al-Khadhimain shrine, al-Kraimat quarter); documentation and project for the reuse of the buildings of the Ottoman Seraglio in Baghdad for cultural activities; and documentation and study of the main sanctuary of Hatra.

Rapley, Vernon

Vernon joined the Metropolitan Police Force at 18 and enjoyed a diverse police career before taking up his current position as the head of the Art & Antiques Unit for New Scotland Yard. Vernon has been dedicated to the investigation of art crime for seven years, dealing with criminal networks involved in the theft, forgery and laundering of all aspects of art and antiques. His investigations extend from the sale of looted items from the Baghdad Museum, to the forgery of Victorian fairy paintings and from the looting of underwater archaeology to the theft of Chinese jade from London's museums. With his team of just three officers, to police the world's second largest art market, he recovers an average of seven million pounds of stolen art a year, and removes a similar amount of fakes and forgeries. By working with the London art community Vernon has taken crime prevention and detection into unchartered waters. The introduction of schemes such as 'ArtBEAT', the recruitment of art professionals into the police as part time volunteers has helped to reduce museum thefts in London by 50%. Vernon has sought to actively engage with international policing partners. He is a founding member of the Interpol Tracking Task Force for Iraq and chaired the 2006 Interpol conference, investigating the illicit trafficking of cultural goods, attended by representatives of 96 counties. He is an adviser for working groups seeking to protect the cultural heritage of South America, Eastern Europe and Afghanistan. In his spare time he is a trustee and consultant for the Association for Research into Crimes against Art, a group bringing together academics, police and private industry to tackle the increasing complexities of art crime. He has lectured extensively on the subject.

Russell, John

John Malcolm Russell teaches the art and archaeology of the ancient Middle East and Egypt at the Massachusetts College of Art in Boston. He is the author of numerous articles and four books on ancient Assyria, one of which, *The Final Sack of Nineveh* (Yale), investigates the destruction of Sennacherib's palace in Iraq by looters in the 1990s. Prior to the 1991 Gulf War, Professor Russell was Associate Director of the archaeological

excavations at Nineveh, Iraq. From September 2003 to June 2004 he served in Baghdad, Iraq, as a Senior Advisor for Culture for the Coalition Provisional Authority, where he focused on renovating the Iraq Museum and protecting archaeological sites.

SPURR, JEFF

Jeffrey B. Spurr is Islamic and Middle East Specialist at the Documentation Center of the Aga Khan Program for Islamic Architecture, Fine Arts Library, Harvard University. In that capacity he manages one photographic collection documenting Islamic visual culture in its broadest definition, and another comprising historical photographs of the Middle East and adjacent regions, irrespective of subject. He has published on the photographic history of the Middle East, and classical carpets and textiles. He has a sustained interest in human rights, cultural heritage, and the fate of libraries and archives in countries subjected to conflict, for which reason he coordinated the Bosnia Library Project, dedicated to rehabilitating destroyed and damaged Bosnian academic library collections from 1996 to 2005, and has systematically addressed the plight of Iraqi libraries and archives from 2003 to the present, about which he has written extensively. He is Chair of the Middle East Librarians Association Committee on Iraqi Libraries, a member of the Harvard University Committee on Iraqi Libraries, and is on the Advisory Committee of the Sabre Foundation of Cambridge, MA, is a member of the Visiting Committee of the Department of Textiles and Fashion Arts at the Museum of Fine Arts Boston, of the Collections Committee of the Harvard University Art Museums, and of the Advisory Council of the Textile Museum, Washington, DC.

STONE, PETER G.

Peter G. Stone is Professor of Heritage Studies in the International Centre for Cultural and Heritage Studies at Newcastle University, UK. He has published widely on heritage management, interpretation and education. Peter has worked extensively outside the UK and advised UNESCO's World Heritage Centre in the development of the World Heritage Education Programme and the drafting of the World Heritage Education Kit. Peter is Honorary Chief Executive Officer of the World Archaeological Congress, a member of the Culture Committee of the UK National Commission for UNESCO, Chair of the Hadrian's Wall World Heritage Site Management Plan Committee, and was the Council for British Archaeology's special adviser on the implications for road changes at Stonehenge. In 2003 he was the adviser to the Ministry of Defence with regard to the identification and protection of the archaeological cultural heritage in Iraq.

TEIJGELER, RENÉ

René Teijgeler has been advising heritage institutions all over the world since 1996. Today he also lectures in the Museology Faculty of the Amsterdam School of the Arts. Before this he worked as a research assistant at Utrecht University, as a researcher at Leiden University, as a bookbinding teacher at the Amsterdam School of Printing and as a conservator at the Royal Library of the Netherlands. He holds degrees in sociology,

bookbinding, conservation and anthropology (with honours) and has published extensively on the history of non-Western papermaking, preservation issues in tropical climates, conservation science and preservation in times of conflict. René is an active member of many professional bodies.

Van Ess, Margarete

Margarete van Ess is Scientific Director of the Orient-Department of the German Archaeological Institute and Acting Director of the Baghdad branch of the Institute. She has specialised in Near Eastern Archaeology and holds a PhD from the Free University in Berlin. She has carried out archaeological field work in Uruk and Sippar in Iraq as well as in Baalbek, Lebanon. In 2003 she was member of the UNESCO Experts Group on the Safeguarding of Iraqi Cultural Heritage. Since that time she has been the German representative and rapporteur of UNESCO's 'International Coordination Committee for the Safeguarding of the Cultural Heritage of Iraq' as well as of the proposed subcommittee on Babylon.

Zottin, Ugo

Ugo Zottin is a graduate in Law and in Internal and External Security, and holds a Masters in Art Historical Studies and in the conservation and preservation of cultural and natural heritage. After Military Academy Ugo Zottin became Commandant of training departments from 1973 to 1977 and went on to assume the role of Commandant of Courses at the official School of Carabineers until 1981. He has undertaken territorial activities including Provincial Commandant of Venice and Vice-Commandant of the Carabineer Region of Calabria. He then went on to cover various roles pertaining to Stato Maggiore, including Head of the Officers' Personnel Office and Head of the 5th Division of the Commando Generale dell'Arma. His most recent roles have been as Director of the Operative Centre for anti-mafia investigations in Rome and, from 1 September 2001, Commandant of the Carabineers' Cultural Heritage Protection Command. Amongst other awards, he has received the Medaglia d'oro ai benemeriti della cultura, della scuola e dell'arte.

In January 2007 he was appointed Commander of Carabinieri Region of Tuscany which is based in Florence and stepped down after almost four and a half years as commander of Carabinieri Headquarters for the Protection of Cultural Heritage. The new Commander for the Protection of Cultural Heritage, since 10 January 2007, is Brigadier General Giovanni Nistri.